SCHOOL ART

in American Culture

SCHOOL ART

in American Culture
1820–1970

Foster Wygant

Interwood Press
Cincinnati, Ohio

Library of Congress Catalog Card Number: 93-077475
ISBN: 0-9610376-1-X

Printed in the United States of America

*This book is dedicated to the veteran art educators
who have taught through some of the chronicled decades.
Each of them, reading in the light of their own experience,
might find unforgivable omissions, factual errors, and failures of judgment.
Yet the author hopes that they would find a general truth in this offered record
that would seem fit to pass on to the next generation.*

❧ Brief Contents ❧

Introduction ...xix

CHAPTER 1
The Nineteenth Century ..1

CHAPTER 2
1900–1915 ...19

CHAPTER 3
1916–1929 ...41

CHAPTER 4
1930–1945 ...69

CHAPTER 5
1946–1959 ...99

CHAPTER 6
1960–1969 ...137

Epilogue ..197

Bibliography ..199

Index ..209

❧ Contents ❧

Introduction ..xix

CHAPTER 1
The Nineteenth Century 1

Before the Civil War 1

The Conditions of American Schools..................... 1
European Influences 1
The Beginnings of School Art........................... 2
*Public Ideas of Drawing 2, Drawing
in Public Schools 2, Aesthetic and Moral
Values 4*

The Era of Industrial Drawing 6

Industrial Drawing.................................. 6

The Late Nineteenth Century 7

Social and Cultural Conditions 7
The Visual Arts 9
Conditions in Education 10
*The "New Education" 10, The Child
Study Movement 11, Francis Parker 11,
Manual Arts 11, Unchanging Concerns
in Public Education 12*
Art Education 12
*The Status of Art Education 12, The
Curriculum 13, Change Evidenced in
Prang Publications 16, Contradictions
at the Turn of the Century 17*

Further Readings 18

CHAPTER 2
1900–1915 19

Social and Cultural Conditions 19

Industrial Expansion 19
Social Factors.................................... 19
Intellectual Currents 19
Culture and the Arts.............................. 20

The Visual Arts.................................... 21

Conditions in Education 22

Art Education 24

Introduction 24
The Status of Art Education.......................... 24
Publications 25
The New Idea: Composition and Design 26
The Mainstream: Purposes and Issues 29
The Art Curriculum............................... 29
*The Elementary Art Curriculum 29, The
Secondary Art Curriculum 29*
The Contents of the Art Curriculum 31
*Representation 31, Design 33, Construction 33,
Industrial Education 34, Photography 35,
Appreciation 36*
Research ... 37

Summary....................................... 38

Further Readings 39

CHAPTER 3
1916–1929 41

Social and Cultural Conditions 41

Social Factors.................................... 41
Intellectual Currents 41
Culture and the Arts.............................. 42

The Visual Arts.................................... 44

Conditions in Education 45

Art Education 47

Introduction 47
The Status of Art Education........................... 47
Publications 48
Purposes and Issues 49

The Art Curriculum...........................51
 The Elementary Art Curriculum 52, The
 Secondary Art Curriculum 54
The Contents of the Art Curriculum....................56
 Drawing and Painting 56, Design 57,
 Appreciation 62
Progressivism in Art Education............63
Research.................................64

Summary.....................................67

Further Readings.............................67

CHAPTER 4
1930–1945 69

Social and Cultural Conditions...........69

 Social Factors.................................69
 Intellectual Currents..........................70
 Culture and the Arts...........................70

The Visual Arts.................................72

Conditions in Education.....................76

Art Education...................................77

 Introduction...................................77
 The Status of Art Education.................77
 Publications 80
 Purposes and Issues.........................81
 The Art Curriculum..........................82
 The Elementary Art Curriculum 83, The
 Secondary Art Curriculum 86
 The Contents of the Art Curriculum....................87
 Drawing and Painting 87, Printmaking 88,
 Murals 89 Photography 89, Sculpture 90,
 Design 90, Crafts 94, Related Arts 94,
 Appreciation 95
 Research...................................97

Summary.....................................97

Further Readings.............................98

CHAPTER 5
1946–1959 99

Social and Cultural Conditions...........99

 Social Factors.................................99
 Intellectual Currents.........................100
 Culture and the Arts..........................101

The Visual Arts.................................104

Conditions in Education.....................109

Art Education...................................111

 Introduction..................................111
 The Status of Art Education.................111
 Publications 113
 Purposes and Issues.........................115
 The Art Curriculum..........................119
 The Elementary Art Curriculum 120,
 The Secondary Art Curriculum 121
 The Contents of the Art Curriculum....................121
 Drawing and Painting 121, Print-
 making 124, Photography 124,
 Sculpture 125, Design 126, Crafts 131,
 Appreciation 132, Related Arts, 133
 Research...................................134

Summary.....................................135

Further Readings.............................135

CHAPTER 6
1960–1969 137

Social and Cultural Conditions...........137

 Social Factors.................................137
 Intellectual Currents.........................138
 Culture and the Arts..........................139

The Visual Arts.................................143

Conditions in Education.....................150

 Curriculum Movements......................151
 The Disciplines Approach 151, The
 Behavioral Curriculum 152,
 Humanizing the School 152

Art Education...................................153

 Introduction..................................153
 The Status of Art Education.................153
 Federally Funded Conferences 155,
 Publications 158
 Purposes and Issues.........................159
 The Art Curriculum..........................163
 Pressures for Change 163, Curriculum
 Research and Development Projects 167,
 "Depth versus Breadth" 170
 The Elementary Art Curriculum 171,
 The Secondary Art Curriculum 172
 The Contents of the Art Curriculum....................173
 Drawing and Painting 173, Printmaking
 175, Photography 177, Sculpture 177,
 Design 179, Crafts 185, Appreciation 188
 Research...................................190
 Art Appreciation 190, Creativity 192,
 Other Research 193

Summary ...**194**

Further Readings**195**

Epilogue ..197

Bibliography.......................................199

Index ...209

~§ Illustrations §~

1-1. Pages from Fowle's translation of Francoeur's *Linear Drawing* — 3

1-2. Drawings from Peale's *Graphics* — 3

1-3. Advertisement for Mrs. Mann's *Primer of Reading, Spelling, and Drawing* — 4

1-4. Landscape from Nutting's *Initiatory Drawing Cards* — 4

1-5a. Card K, No. 21, from Whites's Industrial Drawing Cards — 5

1-5b. Lesson to accompany Whites's Drawing Card K, No. 21 — 5

1-6. Advertisement for Walter Smith's system of drawing manuals, books, and cards — 6

1-7. Page from Smith's *Teacher's Companion to the American Drawing—Slates and Cards* — 7

1-8. Student drawing from Smith's *American Text Books of Art Education* — 7

1-9. Table of contents from *The Antefix Papers* — 8

1-10. Diagram from Parker's *Talks on Pedagogics* — 11

1-11. Examples of picture study from the *Perry Magazine* — 13

1-12. Page from Prang's *Elementary Course in Art Instruction, Books 5 and 6* — 14

1-13. Examples of classroom equipment for form study from Hicks and Clark's *Use of Models* — 15

1-14. Example of type forms from Hildreth's *Clay Modeling in the Schoolroom* — 15

1-15. Page from Daniels's *Teaching of Ornament* — 17

1-16. Page from Prang's *Elementary Course in Art Instruction, Books 9 and 10* — 17

2-1. Seventh- and eighth-grade room, about 1912 — 24

2-2. Title and facing page from Prang's *Industrial Art Text Books* — 26

2-3. Illustrations from Dow's *Composition* — 28

2-4. A high school art curriculum approved for college admission credit (1909) — 30

2-5. Student object drawings in tempera — 30

2-6. Student drawings of natural specimens showing progression in skill — 31

2-7. Student preliminary studies and final drawing — 32

2-8. Schedule of studies in drawing over eight years — 32

2-9. Student designs of pen work, of postcards, and from seed packs — 34

2-10. Student designs in two and three dimensions — 35

2-11. Illustration from an article on picture study — 37

3-1. Curriculum resources: folios and books — 50

3-2. Evaluation for art ability from Snow and Froelich's *Industrial Art Text Books* — 51

3-3. Curriculum planning objectives from Mathias's *Art in the Elementary School* — 52

3-4. Illustrations of sand tables as examples of industrial education in the elementary grades — 53

3-5. A list of projects from Winslow's *Organization and Teaching of Art* — 54

3-6. List of advanced art courses offered in schools in New York state — 55

3-7. Eleventh-grade lino-cuts from Boas's *Art in the School* illustrating Dow's ideas of *notan* and space-cutting — 56

3-8. Scale for diagnostic evaluation from Mathias's *Art in the Elementary School* 57

3-9. Student figure drawings reflecting modern dance, styles, and sports 58

3-10. Student drawings of futuristic heads 58

3-11. Student batiks 59

3-12. A lesson in house planning from Ware and Hooe's *Practical Drawing* 60

3-13. Student posters reflecting contemporary subjects and styles 61

3-14. Correlation of picture study with music 63

3-15. Student work from a progressive school 64

3-16. Assessment of the value of art as a school subject from Whitford's *Introduction to Art Education* 66

4-1. Suggestions for correlation of art activities with literature from Klar, Winslow, and Kirby's *Art Education in Principle and Practice* 83

4-2. Planning guide for the Owatonna Art Project from Ziegfeld and Smith's *Art for Daily Living* 84-85

4-3. Relation of required and elective art courses to social and vocational objectives 86

4-4. Student drawings for a study of transportation 87

4-5. Student drawings of the American scene 88

4-6. Student drawings in contemporary styles 89

4-7. Student mural 89

4-8. Student soap sculpture 90

4-9. Bauhaus-influenced study of texture by a sixth-grade student 91

4-10. Art in student study of the community 92

4-11. Student model of low-cost modern house 92

4-12. Student poster in Art Deco style 92

4-13. Student abstract design for a yearbook divider 93

4-14. Student studies of the circle in furniture design 93

4-15. Students engaging in crafts for the study of production and appreciation 94

4-16. Student border designs inspired by music 95

4-17. Student nonobjective composition inspired by music 95

4-18. Plan to promote appreciation of architecture from Klar, Winslow, and Kirby's *Art Education in Principle and Practice* 96

5-1. Developmental analysis from Lowenfeld's *Creative and Mental Growth* 113

5-2. Evaluation chart from Lowenfeld's *Creative and Mental Growth* 114

5-3. Position statement by National Art Education Association 115

5-4. Comparison of old and new teaching methods 118

5-5. Student study of "Purism" 122

5-6. Student experiment in "drip painting" 122

5-7. Student work employing symbolism 123

5-8. Student study of texture and transparency 123

5-9. Student contour line drawing 124

5-10. Students demonstrating silk screening 124

5-11. Student photogram 125

5-12. Student sculpture employing "Primitivism" 126

5-13. Student mobile 126

5-14. Student designs in plaster 127

5-15. Student design in toothpicks 127

5-16. Series of student experiments in poster design 128

5-17. Student poster 129

5-18. Student model redevelopment plan 130

5-19. Student demonstrating weaving 131

5-20. Student stitchery on burlap 132

5-21. Student designs in enameled jewelry 132

6-1. Student ink drawing made with broken tongue depressor 173

6-2. Abstract student tempera painting 173

6-3. Student tempera painting of a car carrier 173

6-4. Student representation of an inner-city neighborhood 174

6-5. Student work of Pop Art 174

6-6. Student contour line drawing from a classmate model 175

6-7. Student work of Op Art 175

6-8. Student linoleum print in psychedelic style 176

6-9. Student block print for a book illustration 176

6-10. Student sculpture in metal 178

6-11. Student sculpture in wood inspired by Nevelson 178

6-12. Student sculpture in plaster of a "hippie" 179

6-13. Student sculpture inspired by Marisol 180

6-14. Student conception of organic design 180

6-15. Student design combining positive and negative shapes 181

6-16. Student experimental mosaic 181

6-17. Student construction of wood, tooth-picks, and bristol board 181

6-18. Student structural design 182

6-19. Student montage using shattered safety glass 182

6-20. Student construction of a model shelter 183

6-21. Student construction inspired by Buckminster Fuller 184

6-22. Student representation of an inner-city neighborhood 184

6-23. Student terra-cotta pot 186

6-24. Student work of Pop Art in clay 186

6-25. Student weaving on a reed form 187

6-26. Student work of macramé 188

6-27. Student crayon drawing to illustrate an article on Africa 190

⸘ Acknowledgments ⸙

I feel profoundly indebted to all those colleagues who have contributed to the recent development of scholarship in the history of education and to a great many teachers and students. I owe special thanks to Diana Korzenik, John Michael, and Peter Smith, who emerged from their reading of the manuscript with supportive and specific recommendations for its improvement. For the most steadfast assistance, tolerance, and love, my deepest gratitude goes to my wife, Rae.

The manuscript was edited, designed, indexed, and typeset by Custom Editorial Productions, Inc., Cincinnati, Ohio. Any author could appreciate the direct collaboration of CEP president, Mary Lou Motl, and her staff, most especially project editor Judy O'Neill and designer Julie Hotchkiss. The book was paged by Babs DeArmond and Vancy Brown.

Reproduction of the majority of illustrations was made possible by the permission and assistance of Wyatt Wade, publisher, *School Arts*, Davis Publications, Worcester, Massachusetts.

This book was printed and bound by Book-Crafters, Chelsea, Michigan.

Introduction

This book is intended primarily as a text for students in art education. That purpose has governed the selection and organization of its content as well as its volume. Since its content is not entirely like that of any other book, it may be of some interest to others.

Within the history of art education, the concern here is directed toward elementary and secondary public schools in the United States. Faculty colleagues responsible for coursework in this history who aim to lead students beyond the text into individual explorations have advised brevity. Some twenty years of similar effort have shown the author that a straightforward factual base is needed to stimulate independent thought and question. Philosophy and theoretical argument, therefore, have been avoided, and detail has been suppressed in the interest of succinctness, with the exception of the treatment of the 1960s.

If this book has any theoretical base whatever, it is simple and obvious. Art education, as the contents and format insist, is influenced by currents in art and education, which themselves respond to broader sociocultural forces and events. But for most college students preparing to become art teachers, the secondary school curriculum gave them little acquaintance with cultural, educational, or even social history. Their college courses seem to add no more. Therefore, as the book moves forward chronologically, conditions in those influencing domains are introduced or recalled in the beginning sections of each chapter.

These contextual reminders were guided mainly by the stated concerns of educators in each period but also in part by the retrospections of this author and many others. Change in education is a complicated process, and in addition to external pressures, each field has its own internal dynamics. It is in the nature of art, as a school subject, to be especially responsive to social and cultural tendencies. Leaders in art education always have been ready to explain the conditions that influenced their thinking. We need to know what they thought, but their explanations may be incomplete; cultural movements are complex beyond individual apperception. The arts and literature, in particular, give us a composite expression of their time, but that cumulative import may not have been apparent to an art educator at the time, even in the midst of what we might later discern to have been a significant trend.

To be clear about the foregoing comments, a set of what may be called "truisms" is offered:

■ Fundamental decisions in art education must balance the needs of the individual, the needs of society, and the possibilities of art as a school subject.

■ Because conditions in art, education, and society are in constant flux, no fixed equilibrium between individual, society, and subject matter is possible.

■ While the conditions of each of these influencing factors change, the interdependent effects of these changes are only partly apparent immediately and are sometimes erroneously perceived. These effects become topics for historical study.

■ Sometimes the terms used in the continuing debate about these perennial problems seem unchanged. But in fact the *meanings* of words like *creativity*, *expression*, and *modern*, for example, have changed: evolution in the concepts represented by these words is an element of cultural movement. We can learn much by tracing fundamental problems through the years, studying the subtle shifts in the wording of arguments.

■ The problems of balance that are identified above are inherent and thus unavoidable.

■ What we call "issues" can often be understood as current manifestations of these inherent enduring problems.

■ Fundamentally, such issues are never resolved, though they may be transformed in changing conditions.

The conditions *within* art education, in some respects, can only be described in generalizations. National surveys of school programs, enrollments, teachers, facilities, and so on have been rare. With each of the thousands of school districts across the country responsible for its own curricula and with art teachers often free to do whatever they wished, no one can say what was done in any "typical" art class. Professional organizations in art education have never enlisted a majority of art teachers. Our history reliably represents only the more professionally active and earnest art educators (not necessarily the most effective teachers) and, through photographs and reports, the work of some of their students. Yet these, like books popular through several editions, have left us a record of changing ideas, problems, research, and practice—the "why, what, to whom, when, and how" of art education. Simply to offer such a record is the aim of this book.

More explicitly, the sources upon which this record relies were selected through the following assumptions:

■ The words of the leading, or at least the vocal, figures represent the relevant diversity of opinions on the issues of the day.

■ Their arguments, rationales, and justifications reveal both the current beliefs and assumptions and the influences of external conditions in art, education, and society.

■ Most of what was being done in most schools probably fitted the leading thinking of some years earlier.

■ Programs in schools that gained notice are most worth the historian's attention because they tend to show more differences and more significant evidence of changing conditions influencing education than the great majority of programs that remained more "normal" and less noticed.

■ It is to the ideas and the more noteworthy programs that we must pay attention if we want to understand what goes on in education, recognizing that there is a large, more stable core of belief and practice.

Now, then, how is our professional history worthwhile? The understanding of the efforts of our predecessors should build awareness of the forces at work in the present. Art teachers gain strength by using history to explain current theory and practice, to defend curriculum activities, to judge the validity and implications of recommendations, to perceive new directions. Command of the professional history gains respect for art educators as professionals. Even more important is self-respect and confidence: a new art teacher should find in this history an identity, a sharing of mission and problems, a feeling of continuity and momentum.

This book is intended to promote a sense of the continuous responsiveness of school art to changing conditions and the recognition that certain public expectations have not changed, even while school art has been transformed. These may be the most important considerations in the first chapter, which quickly describes art education in nineteenth-century America. The art education that we know today began to develop around 1880. From that point, this account will gradually become more detailed. The decade of the 1960s, however, was so eventful and the developments in art education were of such scale and intensity that brevity in the description seemed a disservice. The proposals for curriculum change that filled the sixties, with their related conferences, projects, and research, have supplied the impetus and direction for art education since that time. As a basis for investigation and understanding of recent trends, a substantial fund of information about the sixties seemed essential. A brief epilogue attempts to stimulate perceptions of the developments in art education in the ensuing decades.

Now, with the first level of introduction thus completed, a few more personal comments may be offered, with less formality, to students preparing to become art teachers.

When I first came into art education from commercial art studios, I simply expected to help youngsters make art. I was a college graduate, but I was not at all prepared for the complexity of theory about purposes and methods of art education. When I went out into schools, I was surprised and puzzled by the differences among art programs—differences in what individual teachers chose for art activities in the classroom and how they went about teaching. When I began to take more advanced courses, while I was teaching in a junior high school, I still was naive. A professor told a couple of us that before we offered all our bright new ideas, if we wanted to be professionals, we should find out what had been done in the past. That advice became the reason for this book.

What did I have to begin to learn, or remember? Our Constitution makes the states reponsible for education, but curriculum decisions are made in each local school district. All of these decisions, at both levels, are the products of disagreements. The most basic disagreement was whether there should be public education. If so, who should pay for it, who should go, who could afford to go, and what should be taught? With practicality as a governing principle of

education, it is surprising that school art in any form was supported by taxpayers. This opposition has never disappeared. I learned about an unending struggle, about generations of art teachers sharing a mission.

There has never been a national plan. There has been no straight line of development. Needs and possibilities, and compromises, have changed with the times—the wars, depressions, inventions, populations, jobs, ambitions. Art teachers before you have had to be perceptive, to think about their responses. My professor was right.

No school subject has been more free of direction than visual art, partly because teachers had to please people who didn't claim to know much about art; partly because art has many possible forms and values; partly because art has changed so rapidly. Some teachers changed faster than others—some, perhaps, too quickly. As you enter the profession, you would do well to recognize that there are "family feuds" in art education, disputing those perennial issues that reappear in times of change.[1]

All of these changes—in social and cultural conditions, in education, art, and art education—can only be recounted quickly in such a book as this one. Only the most directly relevant information could be included. Even so, the relevance often may seem unclear: many connections have been implied but not explored. The value of the book, therefore, depends heavily on your curiosity and enterprise as a reader. One person's loose ends may be another's connections.

Something more may be said about relationships between society, the arts, education, and art education. At some times, changes in general education and art education seem to have come simultaneously—a shared response to some sociocultural condition. Sometimes art education seems to have led the way. But often school art has been slow in response to the influence of professional movements in the arts, for at least three reasons.

For most of the past two centuries, communications have been meager. The ordinary art teacher had little access to museums or travelling exhibitions. Full-color reproductions, well-illustrated texts, and audiovisual materials have been common for only a few decades. Even with radio in the twenties, an art teacher heard little contemporary serious music. Ballet was almost unknown in the United States before World War I; modern dance had no wide audience before the fifties; dance is still not a common activity in public education.

Communication accelerated cultural activity, changes of style in the visual arts, and interaction between the arts. But an understanding of new styles comes gradually, even among experts, and not all that is presented among new styles seems useful or appropriate to K-12 education.

Curriculum change requires public assent. Any new educational content or method can be difficult to test. A generation may pass before a promising possibility discerned by an alert educator gains even tentative approval from school administrations, the public, or indeed, colleagues in the same subject area. Given such a time lag, connections between external developments and art education may seem quite apparent but difficult to demonstrate.

Another suggestion. (Certain advisors were concerned that this book might be "inaccessible" to undergraduate students in art education.) As the book took form, it was apparent that its organization made some degree of repetition unavoidable. But repetition can be useful in education: redundance is a principle of effective communication. In this book, the ideas or information that are repeated are probably the most basic and important. The introductions and summaries in each chapter, however simplistic, are intended to be usefully redundant.

Illustrations include a few documentary materials that may help to illuminate or explain certain developments. A sampling from early instructional books may indicate something of the nature of the activity. Reproductions of student art generally have been chosen to typify early entries of newer conceptions and styles rather than the most common work of the period.

Finally, let the hawkeye of the reader circle above the facts, constantly ready to question. Why is this social situation relevant? Is there a connection between strikes or women's suffrage and the subsequent importance of creative self-expression in the classroom? Was the introduction of aesthetic dance in turn-of-the-century schools related to the art of Matisse and the later demand for large brushes and paper in kindergarten? Are the changes in art teaching through the years adding up to a more complete profession of art education? Can such questions be discussed in a college class? Is there something we want to know that the book hasn't told us?

To aid individual explorations, short lists of further readings are offered at the end of each chapter: these readings mostly are books, chosen with concern for accessibility. Footnotes and the bibliography themselves may be suggestive. A more philosophical discussion of school art in the United States,[2] set in a

1. For this suggested advice, I am grateful to Dr. Diana Korzenik.

2. Arthur D. Efland, *A History of Art Education* (New York, 1990).

much longer contextual span, can be found in Arthur Efland's recent *A History of Art Education*. A fascinating account of two brothers learning to become artists after the Civil War is told in Diana Korzenik's *Drawn to Art*.[3] Frederick Logan's *Growth of Art in American Schools*, though out of print for many years, still offers much of judgmental value.[4] Should you want a fuller presentation of school art in the nineteenth century, with many reproduced drawing lessons and plans for teaching, see my earlier work devoted to that subject.[5] A similar treatment for the years 1900–15 is ready for publication to supplement the second chapter of the present text—two books in a projected series that is unlikely to be completed.

A number of art educators have concentrated their research on closely defined topics in recent years. Their papers contribute much to professional conferences; their articles are published most frequently in two journals of the National Art Education Association: *Art Education* and the more scholarly *Studies in Art Education*. Your ideas for personal study may be stimulated by the variety and topicality of two recent collections of historical research—the insights, diggings, and creativity of fellow art educators.[6] The list of related doctoral theses, which appears at the end of bibliography, may also be suggestive.

At whatever level the present book is read, as so brief a history of one hundred and fifty years of art education, its full utility can be realized only if the reader is indeed guided beyond its limits. As a text, because of its brevity, much depends on the wisdom and inspiration of the instructor. For the professional art educator, a different value may be gained through comparison with the realities of personal experience. For others less directly engaged in the field, the book may help to demonstrate the essential contribution of school art to the complex process of public education.

3. Diana Korzenik, *Drawn to Art* (Hanover, N.H., 1985).

4. Frederick M. Logan, *Growth of Art in American Schools* (New York, 1955).

5. Foster Wygant, *Art in American Schools in the Nineteenth Century* (Cincinnati, Oh., 1983).

6. Brent Wilson and Harlan Hoffa, eds., *The History of Art Education: Proceedings from the Penn State Conference* (University Park, Pa.: Pennsylvania State University, 1985); and Donald Soucy and Mary Ann Stankiewicz, eds., *Framing the Past: Essays on Art Education* (Reston, Va., 1990).

The Nineteenth Century

If the history of art education is to have any effect on a teacher's understanding, it must be considered profoundly significant that art teaching of any kind entered American public schools while the idea of a universal free education was still widely debated. Public funding for even the first eight grades of the "common school" was hardly secure before the Civil War. Although public high schools existed in the 1830s, secondary education was not a common expectation before the end of the century. Indeed, compulsory attendance was not legislated by all states until 1918.

As late as 1870, only about 57 percent of American children aged five to eighteen were enrolled in school, and the average number of days of school attended annually was just under forty-five. For several decades, teachers were itinerant short-term employees, with little or no professional education.

Public education was expected to be practical. Until late in the century, the elementary curriculum consisted mainly of the "three R's," geography, and perhaps a bit of history. It was practical for most high school curricula to require studies expected for college entrance because most teenagers already would have left school to work.

BEFORE THE CIVIL WAR

The Conditions of American Schools

The intended knowledge, especially before mid-century, was authoritatively established in commonly recognized texts. The dominant theory of learning, known as "faculty psychology," supposed that each inborn human capability, or "faculty," was governed by a separate part of the mind, which could be exercised like a muscle. Thus practice in memorization was believed to increase the ability to memorize, and reciting "fine thoughts" would strengthen the "moral" faculty.

Accordingly, the typical mode of learning was either rote memorization or practical skill. In the usual method of teaching, an individual recited at the teacher's desk while the others studied. In "monitorial" schools, one hundred or more pupils could be led through simple lessons in one room; monitors were more advanced students who could drill a group without requiring the effort of the teacher.

Within such limited educational conditions, any new subject would be introduced only if it seemed highly important and could be taught by the methods indicated above. Evidently the importance of drawing was both cultural and practical. The nature of school drawing then was such that it could be taught through copying and could be graded simply for its accuracy.

European Influences

Americans interested in education could observe a variety of provisions for public schooling in Europe. The Prussian system, which was most influential, had standardized programs of teacher preparation coordinated with schools designed for specific types of academic or vocational education, with drawing required throughout. Early in the century, the teaching of **Johann Heinrich Pestalozzi** (1746–1827) spread throughout Europe. In the United States, some of the most significant reports on European education gave particular attention to the importance of drawing in Pestalozzi's method.

Pestalozzi believed that the development of individual perception was essential for the formation of clear concepts and that all perceptions were organized through either form or number. Drawing was important to such development, both because it registered perceptions of form and number and because it involved measurement and proportion. Thus the beginning exercises in Pestalozzi's *ABC of Sense Perception* (1803) simply required the student to mark off equal subdivisions of parallel lines: personal judgment and action would build concepts of division and fractions. But Pestalozzi also considered drawing a form of writing through which the most particular visual qualities of observed objects and phenomena could be conveyed. Drawing, therefore, might be construed as an activity essential to the development of conceptions and language in the child. The use of lan-

1

guage and drawing together was important in the studied perception of things in the real world; thus Pestalozzian "object study," when it became popular in American schools in midcentury, helped to promote the extension of drawing in the curriculum.

The Beginnings of School Art

Public Ideas of Drawing

Through most of the nineteenth century, public interest in learning to draw encouraged the publication of so many instructional manuals that one historian of the phenomenon referred to it as "the art crusade." The idea that drawing was important in many occupations was ancient: Aristotle's advice on the value of drawing was quoted, for example, by Richard Mulcaster in the 1560s in his role as headmaster of a school for tailors. Benjamin Franklin, in his youth, had read the well-known writing of John Locke on the educational importance of drawing and quoted Locke in arguing for drawing in his *Proposals Relating to the Education of Youth in Pennsylvania* in 1749.

Drawing also had been honored as a cultural attainment since at least the Renaissance. Young men and women aiming toward culture in the American colonies sought instruction in drawing and related arts, and the popularity of such studies in private academies probably affected the higher aspirations for public education as it developed. Culture was important in the idea of social advancement; thus Franklin could cite the ability of his father, though a businessman, to sing and fiddle and to "draw prettily."

Less directly supportive of school art early in the century, but doubtless important later, were the traditions of handicraft among men and the common expectation that the housewife should be skilled in needlework and other decorative arts.

In the early nineteenth century, young men and women learned practical drafting skills in private classes and schools. By the 1830s, such instruction became more widely available through such organizations as the Young Men's Mechanical Institutes. However, such practicalities could not be called upon to support an approach to "high art" in the public schools, despite the general interest in paintings and prints. "Picture-making," though it was indeed promoted in drawing manuals, could be opposed as neither necessary nor possible for the common school because the artist was thought to be endowed with uncommon talent that could be developed only through long years of training.

Drawing in Public Schools

The academic approach to the learning of drawing in the early nineteenth century can be represented by the beginning of the "general directions" in George Hamilton's text, printed in London in 1812:

Having provided yourself with the above-mentioned materials, begin by drawing upright lines, and simple geometric figures. . . . After being able, from some practice, to draw upright lines, squares, polygrams, ovals, etc., without rule or compass, proceed to the elementary parts of the human head, a few examples of which are given in the plates.[1]

Drawing was a representational skill to be gained through practice of exercises developed by logical analysis from the simplest elements to the most typical forms. Based on this common understanding, most of the drawing taught in public schools in the United States before the Civil War can be represented by two small early texts prepared especially for such students.

The introduction of drawing in American public schools is credited to William Bentley Fowle, who volunteered to conduct a monitorial school in Boston in 1821. Fowle was not a drawing teacher nor was he an artist, but he knew about the importance of drawing in Pestalozzi's teaching. Napoleon had commissioned a text in basic drawing, which Fowle translated. The book followed Pestalozzian principles. It presented exercises in drawing, in subdividing straight lines, and in constructing two- and three-dimensional forms; it devoted a few pages to the classic architectural orders; it ended with problems in arithmetic and geometry.[2] This text and the kind of instruction it offered remained popular for the next two or three decades.

Another popular text for schools that represented a more general interest in representational drawing was published first in 1834 by the artist Rembrandt Peale.[3] Peale also was influenced by Pestalozzi, whom he quoted directly through most of his preface. Like Fowle's and other contemporary drawing books, Peale's began with practice in drawing lines and simple geometrics. Conventionally, such exercises began with horizontal and vertical lines, which were considered simplest, and proceeded to diagonals and then to curves. Unlike Fowle's book, Peale progressed quickly to drawings of facial features, simple objects, and landscape motifs and gave some attention to techniques of perspective and shading. All but the last edition of his book (1866) included a section on handwriting, which he considered simply another form of

1. George Hamilton, *The Elements of Drawing, in its various branches, for the use of students; illustrated by fifty-one engravings, plain and coloured, containing several hundred examples from the works of the greatest masters* (London, 1812). The quoted description is given on the title page.

2. Louis Benjamin Francoeur, *An Introduction to Linear Drawing*, trans. William Bentley Fowle (Boston, 1825). There were several editions; the last, printed in 1847 and 1849, was titled *The Eye and the Hand*.

3. Rembrandt Peale, *Graphics: A Manual of Drawing and Writing for the Use of Schools and Families*, 2d ed. (New York: B. & S. Collins, 1835).

Figure 1-1. Two pages from Francoeur, *Linear Drawing,* trans. Fowle (Boston, 1825), 33, 38.

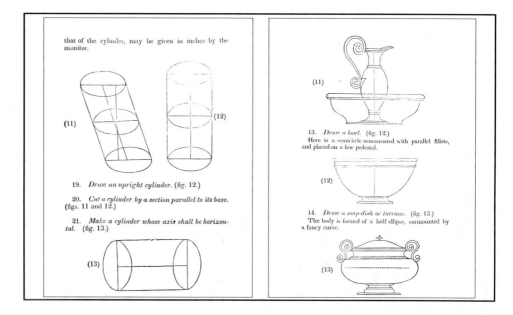

drawing. Between 1840 and 1844, Peale taught as a volunteer in a Philadelphia high school, where an inquiry by the school board resulted in testimonials from several distinguished artists, engineers, and men of affairs. Although Peale's teaching was relinquished, these testimonials show that the kinds of drawing that he taught were regarded as highly important to the developing industries of the nation.

As early as 1838, the promotion of drawing was a responsibility of educational leadership for two of the nation's first state superintendents of schools, Horace Mann and Henry Barnard. Horace Mann was largely responsible for the development of the state school system in Massachusetts. In 1844, reporting on his observation of Prussian schools, he recommended drawing as a valuable kind of language, as an aid in teaching writing, and as a means of developing accurate perception and an appreciation of beauty. Consequently, drawing became a required subject in teacher education at the state's public normal schools. Henry Barnard did much to promote drawing in a similar position in Connecticut and Rhode Island. Both men edited educational journals for their states that carried frequent articles about the teaching of drawing and both conducted teachers' meetings for the improvement of classroom practice.[4]

During this period, drawing was introduced in a number of schools in northeastern states. By the

1840s, drawing had entered schools west of the Alleghanies, in Cincinnati and Cleveland, for example, and by 1860, the development of this new subject had become a matter of enthusiastic rivalry among leading cities. Usually the classroom teacher was responsi-

Figure 1-2. Examples of common devices for teaching drawing, from Peale, *Graphics* (New York, 1835). Pages clockwise from upper left: 22, 89, 91, 95, 93, 85.

4. In successive issues of his *Common School Journal,* Mann published one volume of drawing lessons by the Prussian teacher Peter Schmid. In these exercises, children drew from wooden geometrical solids to learn basic forms and perspective as preparation for the imitation of nature—a typical instance of logical analysis in nineteenth-century education.

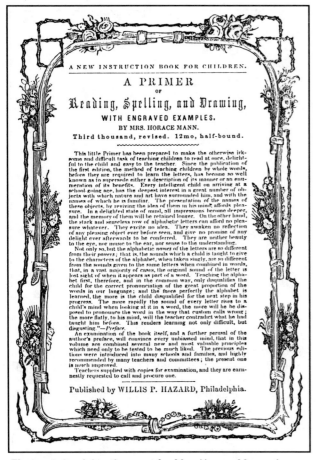

Figure 1-3. Advertisement for Mrs. Horace Mann, *A Primer of Reading, Spelling, and Drawing,* 2d ed., reprinted in Hannah H. Lee, *Historic Sketches of the Old Painters* (Philadelphia, 1852), n.p. Of interest is the collection of values claimed for children's drawing. Note also that what the book provided was "copies for drawing."

ble for actual instruction, under the guidance of a drawing supervisor, who might have one or more assistants in a few of the larger cities. Such unskilled instruction was made possible by workbooks that provided each child with drawings to be copied on the adjacent blank page or by sets of "drawing cards" that were to be copied. Probably the best-known author of such books was a Boston artist, William Bartholomew, who began to teach gratuitously in Boston's Girl's High and Normal School and the English High School in 1853. Bartholomew was not regularly appointed until 1862, but he became the drawing supervisor in Boston after 1864, when drawing was made a required subject in all grades.

Typically, school drawing still began with lines to practice and with simple geometrical constructions then progressed to common objects that exhibited basic geometrical forms. Along with such simple representation, some workbooks asked children to copy sketches of picturesque landscapes typical of an artist's notebook—culture along with practicality. After midcentury, "historic ornament" became a common addition to the drawing program in imitation of the programs for preparation of industrial designers in European schools, especially in the English system. For such study, the workbook provided model drawings of classic motifs, like the key, egg-and-dart, rosette, fleur-de-lys, or others derived from natural forms. Usually these were presented and copied in pencil outline, the younger children using chalk and slate. Shading was not commonly approved, though flat "tints" might be rendered by parallel lines. Color was not usually found in school drawing before the Civil War.

Aesthetic and Moral Values

Even though practical values dominated the claims for drawing in the common schools, its proponents did not overlook the general belief in the unity

Figure 1-4. A model drawing of a picturesque landscape, from B. F. Nutting, *Initiatory Drawing Cards* (Boston, 1849), card no. 38.

of the good, the true, and the beautiful. Whereas Fowle thought that "fancy drawing" could not be taught in such schools, Peale and Mann expected that representational drawing would nurture an appreciation of beauty as it developed accurate perception. In a survey questionnaire sent to Connecticut teachers in 1838, Barnard called for "the development of the sentiment of the beautiful, and a love of order, harmony, and suitableness in nature, art, literature, and life" as well as the teaching of drawing, and he recommended nature walks, music, and recitation as elements in the "aesthetic department."[5] Aesthetic interests were evident also in private schools, which could be more free of convention. An important instance was the Temple School, operated in the early 1830s by Bronson Alcott ("the American Pestalozzi") and Elizabeth Peabody, who were closely associated with Mann and Barnard. Not only did they display paintings and sculpture in the classroom, but they hired a German artist as a teacher who encouraged drawing of objects in daily experience and actually assigned such drawings to be done as homework.

Beyond drawing and the display of art objects, the idea began to develop, as early as the 1840s, that the entire school and its grounds should be beautiful, to provide an aesthetic environment for pupils and a model for the community.[6]

5. Henry Barnard, ed., *American Journal of Education* 1 (1856): 686-95.

6. Barnard, in his capacity as editor, reprinted an address by Lydia H. Sigourney, "The Perception of the Beautiful," in *Connecticut Common School Journal* 2, no. 8 (February 1, 1849): 117-18. Evidently the "school beautiful" idea had popular interest; the same address was reprinted in *Gody's Lady's Book* 20 (January-June 1840): 9-11.

82 *DICTATION LESSONS IN DRAWING.*

CARD K. No. 21.

DICTATION LESSON I.

CONVENTIONAL LEAF SYMMETRICALLY ARRANGED IN A
SQUARE, FORMING A ROSETTE.

Use Dictation Lesson IV, Card E, No. 9, in drawing a square, its diameters and diogonals; draw similar parallel, horizontal and vertical lines forming an inner square. Mark the centre of each semi-diameter and semi-diagonal of the inner square. From the upper end of the left semi-diagonal of the inner square draw two curves touching the semi-diameters just below the dots, then turning upward and uniting with the diagonal at the dot, and taking its direction forming the midrib of the leaf. Proceed to dictate the remaining leaves. Connect the leaves by simple curves tending toward the centre.

DICTATION LESSON II.

CONVENTIONAL LEAF SYMMETRICALLY ARRANGED IN A
QUATREFOIL WITHIN CIRCLES.

Use Dictation Lesson· III. Card F, No. 11, in drawing a circle and its vertical and horizontal diameters: draw its oblique diameters. Mark the centre of each vertical and horizontal semi-diameter; from the centre of the upper ver-

Figure 1-5b. S. F. Buckelew, "Card K, No. 21, Dictation Lesson I," in *Dictation Lessons in Drawing, for Primary Grades, to Accompany White's Primary School Drawing Cards* (New York, 1878), 82.

Figure 1-5a. *White's Industrial Drawing Cards* (New York, 1878), card K, no. 21. See Figure 1-5b.

THE ERA OF INDUSTRIAL DRAWING

As the industrial revolution accelerated in the United States, the early school drawing programs gained powerful support. By midcentury, the leading European nations had well-established systems to train designers, beginning with drawing in elementary schools. In the 1860s, American manufacturers began to complain that they could not compete with the superior design of European products. In 1870 the legislature in Massachusetts responded to pressure from industrialists, educators, and interested citizens by creating the first statewide program for industrial drawing—not only in public schools but also in evening classes for adults.

Walter Smith was brought to Boston from England's industrial drawing system to replace Bartholomew as supervisor of drawing in the city schools and to become the first state supervisor of drawing. In 1873 he also became director of the new State Normal Art School, the first public institution for the preparation of art teachers.[7] Owing to the strength of these positions and to his ability as author, organizer, and promoter, Smith's programs of industrial drawing became the model for enthusiastic emulation throughout the industrial sectors of the country.

Industrial Drawing

Though he did not originate industrial drawing in this country and though many others published graded manuals for schools, Smith's program was by far the most thoroughly developed.

Industrial drawing, as Smith promoted it, was sharply distinguished from the fine arts. Pictorial drawing was eliminated. In the elementary grades, in Smith's system and in others, drawing was concerned with lines, geometric forms, and simple common objects. Children were to learn by following the teacher's step-by-step dictation, by copying from blackboards, cards, and workbooks, and by drawing these later from memory. Drawing from geometric models and actual objects came after such copying. Smith worked out in great detail, for each grade, the progression of exercises in the teaching of historic ornament and the development of decorative motifs from botanical forms. In upper elementary and high school classes, perspective and light and shade were studied, and designs were undertaken for the decoration of utilitarian objects. In the primary grades, drawing slates were used with chalk; thereafter, only pointed pencils were allowed. Smith strongly opposed children's interest in color: not until high school were color washes permitted and then only sparingly.

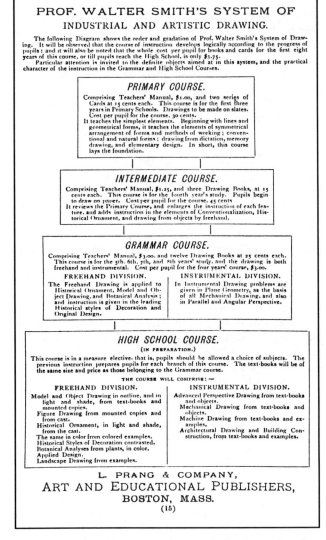

Figure 1-6. Smith's system of manuals, books, and cards, as advertised in *The Antefix Papers* (Boston: Massachusetts Normal Art School, 1875), 15.

To promote these studies, Smith devoted much effort to the collection of examples of good design in wallpapers, fabrics, carpets, tiles, and pottery. Students at the State Normal Art School consulted the best available texts on design and art history. Smith was charismatic: students shared their researches in weekly readings before the Massachusetts Art Teachers' Association as early as 1875.[8] (See Figure 1-9.)

7. The school founded by Smith continues as the Massachusetts College of Art, still the only publically supported independent art college in the nation.

8. See *The Antefix Papers: Papers on Art Educational Subjects, Read at the Weekly Meetings of the Massachusetts Art Teachers' Association, by Members and Others Connected with the Massachusetts Normal Art School* (Boston, 1875).

FREE-HAND DRAWING.

PART I.

A.—Single Lines, Vertical, Horizontal, and Oblique Lines, and Parallel Lines.

FIRST EXERCISE. Draw any vertical straight line. Mark equal distances of any length down the line from the top toward the bottom; then dis- tances of a given length, as one inch, one and a half, and two inches. To be repeated on ob- lique and horizontal lines.

SECOND EXERCISE. *a.* To draw finite straight lines, and to divide them into equal parts. These lines may be either vertical, horizontal, or ob- lique. The illustrations given are vertical lines. No. 1, two equal parts; No. 2, three equal parts; No. 3, four equal parts; No. 4, five equal parts; No. 5, six equal parts. The parallel lines should be drawn from top to bottom or side to side of slate, the full length and width. In dividing a line into four equal parts, first divide it into two, and then each half into two; so also with lines into six or eight equal parts, first dividing them into two, and then subdividing each half into the number of parts required.

Figure 1-7. Walter Smith, "Free-Hand Drawing," in *The Teachers' Companion to the American Drawing–Slates and Cards* (Boston 1872), 9. In this first lesson, Smith still used the approach employed by Pestalozzi (1803), Fowle (1825), Peale (1835), Chapman (1847), and others, training the hand, the eye, and the judgment of proportion and promot- ing the concept of fractions.

Figure 1-8. Design by a student, drawn in pencil on a work page. Walter Smith, *American Text Books of Art Education,* no. 4., rev. ed. (Boston, 1879), n.p.

Another major effort was the instruction of class- room teachers in these methods, since Smith was con- vinced that only through their responsibility would children learn industrial drawing. His insistence that even the advanced work in high schools should be con- ducted by regular teachers became one of the points of contention that led to his return to England in 1881.

For about twenty years, beginning around 1860, industrial drawing was a matter of competitive excite- ment, regarded as an innovative achievement in American education. By 1873 Bartholomew's publish- ers could list 155 cities in which his graded drawing books were "adopted and in use." Not only Smith but a number of other drawing teachers gained consider- able reputations as authors of graded systems of instruction. At the Philadelphia Centennial Exposition in 1876, many cities exhibited drawings from their schools. These were evaluated primarily as industrial drawing, and mere "picture-making" was ridiculed.

Yet, beginning in the 1880s, the emphasis on industri- al drawing waned rapidly, and through the next two decades, the basic nature of the twentieth century school art curriculum emerged.

THE LATE NINETEENTH CENTURY

Social and Cultural Conditions

After the Civil War, the population moved west- ward: in 1876 seven of thirty-eight states were west of the Mississippi. As the Industrial Revolution intensi- fied, education was affected by the same egalitarian spirit that joined agrarian and labor interests in pop- ulist political struggles. As immigration continued and cities grew, schools were given more responsibili- ties for "Americanization" and social welfare. With the common (elementary) school finally established and with more children staying in school longer, the demand for practical industrial education was met by a variety of manual art, manual training, and voca- tional programs. Though the completion of high school was still unusual, the classical curriculum was increasingly challenged by practical concerns.

CONTENTS.

CHAPTER		PAGE
I.	THE GREATNESS OF GREAT MEN. *Walter Smith*	1
II.	FRESCO, ENCAUSTIC, ETC. *Chas. C. Perkins*	18
III.	COLOR.—THE ORIGIN OF PIGMENTS AND THEIR CHEMICAL ACTION	32
IV.	HARMONY AND CONTRAST OF COLOR	41
V.	HARMONY AND CONTRAST OF COLOR (*Continued*)	46
VI.	THE APPLICATION OF PRINCIPLES OF DESIGN TO CAST METAL OBJECTS	51
VII.	DESIGN AS APPLIED TO WROUGHT METAL	56
VIII.	DESIGN APPLIED TO CARVED OBJECTS	66
IX.	DESIGN APPLIED TO PRINTED FABRICS	72
X.	PRINCIPLES OF DESIGN AS APPLIED TO WOVEN FABRICS.—COLORED MATERIALS	75
XI.	FLAT OR SURFACE DECORATION	91
XII.	WATER-COLOR PAINTING	98
XIII.	TEMPERA PAINTING	105
XIV.	FRESCO PAINTING	109
XV.	OIL PAINTING	116
XVI.	TECHNICAL TERMS	122
XVII.	STRUCTURAL BOTANY	124
XVIII.	BOTANY AS APPLIED TO INDUSTRIAL ART	135
XIX.	APPLICATION OF ORNAMENT TO INDUSTRIAL PURPOSES	141
XX.	ORNAMENT AS APPLIED TO INDUSTRIAL PURPOSES	150
XXI.	REPRODUCTIVE PROCESSES	157
XXII.	THE APPLICATION OF PHOTOGRAPHY TO ENGRAVING	162
XXIII.	GLASS—CAST, CUT, AND ENGRAVED	168
XXIV.	POTTERY AND PORCELAIN	173
XXV.	HISTORICAL ORNAMENT	179
XXVI.	HISTORICAL ORNAMENT.—MIDDLE AGE STYLES	185
XXVII.	HISTORICAL ORNAMENT (*Continued*)	193
XXVIII.	HISTORIC SCHOOLS OF PAINTING DOWN TO THE SEVENTEENTH CENTURY	199
XXIX.	HISTORIC SCHOOLS OF PAINTING (*Continued*)	212
XXX.	CHARCOAL DRAWING. *Wm. R. Ware*	223

Figure 1-9. Table of contents, *The Antefix Papers* (Boston: Massachusetts Normal Art School, 1875), n.p., showing the range of individual research reports supporting studio classes. Italicized authors were not students.

Scientific advances profoundly altered ways of thinking and thus greatly affected education. Investigation by direct observation and experimental or laboratory work, in particular, became recognized as the "scientific method." As lives were changed by the steamship, cotton gin, telegraph, and electric light bulb, invention became the model for productive thinking. Theories of evolution, especially Darwin's major work (published in 1859), implied the perpetual improvement of the species but, at the same time, showed the human as only another of nature's organisms. Sociology and anthropology, largely nineteenth-century inventions, suggested that human societies were another kind of evolving organism and showed how many beliefs, customs, and organizations were valid only in reference to group acceptance and survival. Thus, toward the end of the century, most of the foundations of education were confronted by such relativism: the uncertainty of knowledge, the provisional status of law and custom, and the weakening of the authority of traditional texts. The response in philosophy was *pragmatism*, with its confidence in independent perception and thought, in an experimental attitude, and in an acceptance that truths were revealed in consequences. Art, and art education in its own way, shared in this response.

Psychology had an especially strong impact on education. The first experimental laboratory for physiological psychology was established in Germany in 1879 by William Wundt. In the United States, William James was the more broadly based early leader; several of the others who developed educational psychology were students of Wundt. Before the Civil War, in the logic of drill and recitation, little thought had been given to the learner. Now, contrary to idealism, psychology as an empirical science showed the mind as integral to the physical organism. This was a concept that fitted with evolutionist theory: "learning" was seen as responding to environmental stimuli and developing a repertoire of adjustive behavior. "No impression without expression" was the dictum of William James. As another manifestation of the individualism that marked the century in Western culture, psychology explored the repressed elements of human nature—the emotions, the subconscious, and the psychopathologies. Joining with geneticists, psychologists began to study patterns of physical, mental, and behavioral development. With the development of statistical methods, the study of pathologies extended into the measurement of intelligence.[9]

Travel and communication were increasingly important means of informal education. For the affluent, and for teachers, trips to the cultural centers of Europe became an accepted norm of social and professional advancement. For graduate students and artists, study abroad was a practical possibility. Industrial fairs and great expositions brought the world's arts, technology, and customs within reach. The proliferation of national magazines and the development of photographic reproduction brought to the average household an unprecedented wealth of art imagery. Home education with books, cameras, stereopticons, and pianos was enriched by travelling actors, dancers, and musicians.

"Self-culture" thus became part of the American ethos in the late nineteenth century. It assumed individuality, the inherent goodness of human nature, the free exercise of all that was natural, and thus the reduction of constraints of custom and manner. Education was the key to success, but self-culture

9. Binet's scales and tests for the measurement of intelligence were first published in 1905.

went beyond the merely material to the refinement of taste, even to the spiritual. One believed in the perfection of one's potential as a responsibility of democratic citizenship and an obligation to the progress of the species. As millionaires aspired toward aristocracy, as cities vied for regional dominance, as the United States grew in wealth and power, the great house, the collection of old masters, and the endowment of a museum represented self-culture on a monumental scale. Most of the major art museums east of the Great Plains were founded before 1900, and public culture was their primary mission. All of these aspirations contributed to the development of art education.

The Visual Arts

Briefly before midcentury, the Art Union had distributed prints annually to as many as nineteen thousand subscribers.[10] But histories of art, guides to appreciation, and college lectures on art and aesthetics were rare. Self-culture through art began with knowledge of the old masters in painting and sculpture and the Western tradition in architecture. "Modern art" began with the Renaissance. For aesthetics, especially where moral issues were important, the eminent English critic John Ruskin enunciated the commanding principles. Art embodied the good, the true, and the beautiful; without virtue, no nation, no artist, nor any subject matter could produce high art. In the making of art—in observation, concept, delineation, color, and fidelity to the medium—honesty in subordination to nature was the ultimate virtue. Among artists, the nature of "truth" in art was hotly debated, but art appreciation for the public was mostly a memorization of names, dates, titles, and conventional opinions.

University studies in the fine arts were offered at Yale in an endowed building completed in 1867; studio was emphasized over history. At Harvard in 1874, Charles Eliot Norton began two decades of influential lectures on the history of art, following generally the moral outlook of his dear friend John Ruskin; classes in drawing were of secondary importance. Princeton had included art as an element of studies in the classics and archaeology beginning in the 1830s; the department of fine arts was established for the history of art in 1882, with no instruction in studio.[11] A heavily moralistic treatise on art criticism and history, "designed as a text-book for schools and colleges," was authored in 1868 by the president of Columbian

College, the future George Washington University.[12] One of the most respected early surveys, Goodyear's *History of Art*, had gone through six editions by 1889: it was offered for "classes, art-students, and tourists in Europe."[13]

As public interest grew and foreign study became common, the capability and diversity of American artists expanded apace. By the nineties, alert school art teachers were familiar with the leading contemporary artists in the United States, many of whom were well known as illustrators. In terms of style and content, these artists mainly were naturalistic renderers of landscape and genre or more particularly followers of the Barbizon painters, the Pre-Raphaelites, or the American Luminists. Before the turn of the century, art teachers, like the general public, were not much influenced by Impressionism, which seemed daringly experimental in color but lacking in discipline. Such Post-Impressionist innovators as Seurat, Van Gogh, Gauguin, and Cezanne were scarcely known in Europe. As the restraints of the Victorian era weakened and as the ethos of a pure and innocent return to nature became fashionable, a special sort of neoclassical subject came into vogue: youth and maiden in diaphanous pastel tunic and gown, serene in the glade, dancing to the harp and the panpipe. Such were the works of Puvis de Chavannes, Frederick Leighton, Alma-Tadema, and other *Hellenists*—the iconography of Greek legendry, of freedom for the senses and emotions, balanced by reason.

Apart from these more general trends in taste was the development, through the latter half of the nineteenth century, of an analytical, abstract, "synthetic" approach to art and design. The art of other, and especially older, cultures was studied in the search for principles governing all art forms. Examples of historic ornament, or decoration, were compiled and published for the guidance of designers and teachers. Natural forms were studied as a source of new motifs and as further evidence of the "natural laws" of design. Lists of such laws were promulgated. Painters and designers began to work with lines, shapes, textures, color, and space as distinct elements, with particular properties of form and expression that could be rationally combined or "synthesized."

This broad trend is represented historically by several groups or styles—including the Aesthetic Movement, Art Nouveau, and various Secessionists—of which two most strongly influenced school art at the turn of the century: the Arts and Crafts Movement and the interest in everything Japanese.

10. The Art Union began in 1839 and ended in 1852. For a lively brief description, see Oliver Larkin, *Art and Life in America*, rev. ed. (New York, 1966), 151–53.

11. See Arthur Efland, *A History of Art Education* (New York, 1990), the source of these facts about early university courses in art, for further discussion.

12. G. W. Samson, *Elements of Art Criticism*, abridged ed. (Philadelphia, 1869).

13. William Henry Goodyear, *A History of Art*, 6th ed. (New York, 1889).

The **Arts and Crafts Movement** developed in England as a protest against the dehumanizing effects of the Industrial Revolution and the ugliness of its products. The leader of this reform movement was William Morris, a follower of Ruskin, a respected poet, and ultimately a champion of socialism. Morris taught himself to work and design in fabrics, furniture, type, and printing. He founded a firm for the design and fabrication of interiors and furnishings. As a model for a healthy system of manufacture in which the artisan could proudly identify with the quality of an honest, well-made, harmonious product, Morris and his followers looked back to the guilds and home industries of medieval society.

In many cities in the United States around the turn of the century, arts and crafts societies exhibited, opened shops to sell their work, sponsored lectures, and conducted classes. Such magazines as *Better Homes and Gardens* and the *Craftsman* promoted public interest. Crafts communities were commercially successful, notably Elbert Hubbard's *Roycrofters* and Gustave Stickley's *United Crafts*. Stylistically, the movement borrowed from medieval and folk arts, in which simplicity was considered a virtue, but it also related to the newer approaches to design described above. The implications for moral and aesthetic education and for the development of handwork as an integration of the intellect and the whole personality were of fundamental importance to art educators. The high point in the influence of the Arts and Crafts Movement on school art, according to writers through the next few decades, came at the St. Louis Exposition in 1904.

Japanese art and design began to influence artists in Europe and the United States as soon as trade relations were reinstituted after 1854. Public interest was stimulated by handsomely illustrated books on Japanese arts and by exhibits at international expositions. By the 1890s, Japanese prints, pottery, fabrics, clothing, and utilitarian objects were at the height of fashion.

The Japanese concern for beauty, their close observation of nature, and their legendary devotion to craftsmanship fitted well with the Arts and Crafts Movement, the Aesthetic Movement, and Art Nouveau. Western artists, in the development of abstract styles, adapted from the Japanese their flat depiction of space, their asymmetrical composition, and their inventive use of line, shape, color, and texture. In the United States, these same qualities were valued in school art, especially through the work of Arthur Dow, from the 1890s through the first quarter of the twentieth century.

Conditions in Education

Between 1870 and 1900, school population more than doubled; by 1900 thirty-two of the forty-five states had enacted measures for compulsory education. More teachers were graduates of two-year normal schools, but many others gained certification to teach simply through locally administered examinations. After the legality of municipal taxation for high schools was established in 1872, the number of high schools rose from about five hundred to more than ten thousand. At the elementary level, the reconception of purpose, content, and process, arising from the changes indicated above, came together in what was called the "new education."

The "New Education"

Much of the change in elementary education late in the century resulted from the work of three Europeans.

Pestalozzi's ideals and methods were promoted especially by Edward Sheldon at the normal school in Oswego, New York. The "Oswego Movement" was important to art education not only because illustrations were increasingly wanted as an extension of "object teaching" but also because drawing was valued as a mode of expressing the individual's thoughts about schoolwork and personal experience. Incidentally, one of Sheldon's leading teachers, **Hermann Krusi**, whose father had assisted Pestalozzi, authored sets of drawing workbooks and thus became nationally influential as probably the leading exponent of the role of drawing in Pestalozzian education.

Friederich Froebel (1782–1852), a follower of Pestalozzi, established the first kindergarten in Germany in 1837. His writings had already reached this country; by 1873 St. Louis had begun the nation's first lasting public kindergartens. Because drawing, painting, the study of forms, and handwork were essential to Froebelian education, the kindergarten movement was a major factor in the reconception of art education.

Johann Friedrich Herbart (1776–1841), a German philosopher who also educated teachers, developed a standard plan for lessons that its proponents hailed as the first "scientific" teaching. His procedure, as revised by midcentury followers before it reached the United States, had five steps:

■ **Preparation** was planned by the teacher to arouse interest and to bring to consciousness the related prior learnings.

■ **Presentation** of new information was to be clearly organized for linkage to prior learnings.

■ **Association** to a variety of the students' existing understandings was to be explicitly led by the teacher.

■ **Generalization** worked inductively toward principles, rules, or constructs that were objectives of the lesson.

■ **Application** referred these generalizations to specific relevance and utility, using the deductive process of thought.

Despite great initial enthusiasm in the late eighties and nineties, American critics soon observed that the method gave too little room for the imaginative, reflective, or problem-solving thinking that was wanted in the new education. Nevertheless, where the presentation of new information was the teacher's purpose, some descendant from the Herbartian method remained to guide the planning.

The Child Study Movement

The first concerted effort in the United States to study children as learners began around 1880, when G. Stanley Hall, a young psychologist who also was interested in genetics, began a study titled "The Contents of Children's Minds on Entering School." Through the next two decades, Hall, his graduate assistants, other professors, and many enthusiastic school teachers developed surveys of children's physical, sensory, and cognitive growth and their ideas and behavior. By the end of the century, educators were generally aware of, and attentive to, children's common developmental stages, their differences, and their needs. Researchers recognized that children's drawings, if they were free from adult direction, could reveal much that would be inaccessible through language. Several such studies showed that such drawing was valuable not only for research but as a natural mode of expression and learning as well. The child study movement thus contributed greatly to the extension of school art beyond the previous industrial drawing and produced the first significant body of research in art education in the United States.

Francis Parker

In the last quarter of the century, probably the best-known leader of the "new education" was Francis Wayland Parker (1831–1902), a one-time teacher, principal, and superintendent. He later headed the Cook County Institute, which became the School of Education of the University of Chicago. Parker attributed his ideas largely to Pestalozzi, Froebel, and Herbart. He believed that education should be child-centered; that self-governance could be achieved in place of punishment; that the child was naturally a self-active learner; and that all learning, including moral education, should be developed in the context of the child's daily life. From Pestalozzi and Froebel, he considered drawing an essential in all schoolwork,

with form as one of the two modes of comprehension of the natural universe and drawing (with painting and modeling) as a natural means of expression of ideas. Thus Parker was the leading representative of the relationships between the new conceptions of elementary education and school art.

Manual Arts

During the last quarter of the century, as the demand for effective industrial education increased, psychologists and educators began to believe that constructive handwork was an essential part of general education. With secondary education devoted to the requirements of college admission, a variety of manual training high schools were introduced. The handwork of the Froebelian kindergarten—the learning aids known as "gifts and occupations"—was carried naturally upward through the elementary grades. Parker's slogan, "art in everything," applied to making as well as drawing. Moreover, when children made simple practical items "to take home," the school carried on, to some extent, the traditional early training in household skills.

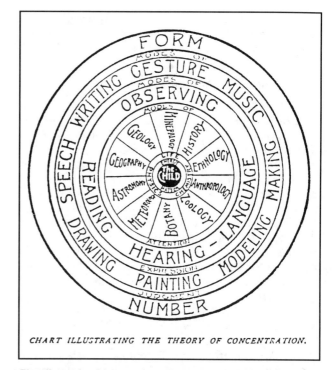

CHART ILLUSTRATING THE THEORY OF CONCENTRATION.

Figure 1-10. Diagram from Francis W. Parker, *Talks on Pedagogics: An Outline of the Theory of Concentration* (New York, 1894), 56, showing *form* as a basic mode of perception and art activities as fundamental expressions of thought.

Unchanging Concerns in Public Education

Looking back to this period of change, which at the same time appears as a first stage of maturity in the schools of the nation, it is instructive to find specific public expectations that were expressed repeatedly in subsequent decades. The National Education Association (NEA) convention of 1888 built its agenda around three acknowledged public criticisms that faulted the whole educational effort: critics claimed that the schools failed to teach morality or develop religious feeling; that subject matter was not mastered; and that studies lacked practical outcomes.

Art Education

Beginning in the early 1880s, while the growth of manual training released school drawing from its earlier vocational responsibilities, the leaders of the new education found a wider range of values in art as an integral part of the expanding curriculum. It is important to note that this development of art education beyond industrial drawing was supported by intense public commitment to cultural uplift. A parallel shift occurred in some of the earlier major art museums, which originally were intended not only to house the fine arts but also to exhibit and promote the quality of arts in industry. The latter purpose was abandoned toward the end of the century, just when most of the great collectors began to move away from an eclectic interest in a wide variety of decorative objects toward concentration on masterpieces in the fine arts.

The Status of Art Education

PROFESSIONAL ORGANIZATIONS. In 1830, at the first official conference of the American Institute of Instruction, Mr. W. R. Johnson of Philadelphia was invited to travel to Boston to lecture to two hundred participants on the teaching of drawing in the high school of the Franklin Institute. Such organizational interest in drawing was not uncommon through the next few decades, but it was not until 1883 that art teachers could form a national organization as a department of the National Education Association. A decade later, at the Columbian Exposition in Chicago, the Western Drawing Teachers' Association became the first independent professional body in American art education.

In the East, the association created at the Massachusetts Normal Art School in 1874 had continued for only three years. In 1888 the Connecticut Valley Art and Industrial Teachers' Association was organized with such success that, in 1899, its president, Solon P. Davis, led the creation of the Eastern Art Teachers' Association.

A Southern Art Teachers' Association was established in 1898 with a program of meetings at the conference of the Southern Educational Association. Officers for the coming year were elected, but within a decade, the organization apparently had disappeared.[14]

CHANGE AND GROWTH. After the Art Department of the National Education Association was formed in 1883, their first study committee was directed to suggest a "thoroughly graded course of study" in industrial drawing, and so they did. But the dominance of industrial drawing was declining abruptly. The activities of the Froebelian kindergarten had extended to the elementary grades, where children were freely painting with color and working with other materials. Topics at the annual meetings of the department went beyond drawing to modeling, construction, and appreciation and to broader concerns like relations to libraries and museums, the role of art in education for citizenship, the work of the art supervisor, and art instruction for future classroom teachers.

Art teachers themselves had come into education through training in art schools or through apprenticeships and diverse work experience. A few state normal schools, with their two-year programs, provided added study for specialization in drawing. Some of the young leaders were products of the Massachusetts Normal Art School, where "normal instruction" was part of studio classwork after 1880, and a "public school class" had its first graduates in 1889. By 1900 a total of 1,024 students had completed at least one of its three- or four-year courses; 133 had earned diplomas for the public school class. At Teachers College, Columbia University, most of the faculty had studied in Europe or at the Massachusetts Normal Art School or both. The college's program offered fourteen courses in fine arts in 1898–99, with a total of 301 enrollments and 23 diploma candidates.[15] Though the college had instituted a four-year program in 1893, two-year diplomas were continued for many years in domestic arts, fine arts, manual arts, and kindergarten: a baccalaureate degree in art education was uncommon into the twentieth century.

PUBLICATIONS. Books and periodicals relating to school art, other than graded series of drawing books, were scarce. Among several books on art history and appreciation, only a few were directed toward

14. The best single source of information on early organizations in art education is Frederic Lyndon Burnham, "Art Societies Connected with the Public Schools," in James Parton Haney, ed., *Art Education in the Public Schools of the United States*, (New York, 1908). J. C. Witter's *Art Education* described the first meeting of the Southern Art Teachers' Association in the issue of February 1899.

15. Teachers College, Columbia University, was the former New York Training College for Teachers, which had evolved from a welfare project called the Kitchen Garden School.

schools. A small handful addressed the new possibility of color in the classroom. A manufacturer of school supplies, Milton Bradley, Inc., and to a greater extent, the Prang Educational Company, were responsible for most of the useful books. The Perry Picture Company, the leading purveyor of reproductions for art and other school subjects, introduced the *Perry Magazine* in 1899, a monthly that carried articles by leading art educators. Apparently the first monthly devoted to school art, *Art Education*, was published somewhat irregularly from 1894 through May 1901.[16] A few other educational periodicals, like the *Inland Educator*, *Primary Education*, *Common School Education*, and *Normal Instructor*, included simple drawing and construction activities among their subjects and probably were considerably more influential through their wider readership among classroom teachers.

The Curriculum

CORRELATION. In 1886 the National Education Association Committee on the Relation of Drawing to Other Subjects reported that "making" had become as important as drawing and that both were being introduced as learning activities in all the other elementary school studies. Such correlation became a new ele-

16. *Art Education* was published by James C. Witter, New York. "Devoted to art and manual training as essential elements of education, industry, and general culture," the magazine reported the doings of the NEA Art Department and the nascent regional art education organizations, along with relevant items from the art world and articles by leading art educators. Witter also offered a "Paris Summer School" in art and French language and literature.

ment in the rationale for art in schools, with such eminent educators as Francis Parker and John Dewey as advocates. Children in Dewey's Laboratory School at the University of Chicago drew, modeled, constructed, wove, and cast metal as integral learning activities in their study of various cultures. Nevertheless, many educators still thought of drawing as a separate study, and the question whether art merited status as a subject or should be a correlational learning activity first became an issue in the 1890s.

AESTHETIC EDUCATION AND PICTURE STUDY. In the development of art (not simply drawing) as a subject, a major factor was recognition of the aesthetic as a corollary to moral education. Moreover, the aesthetic domain and art masterpieces in particular were part of the popular configuration of self-culture. Among the champions of aesthetic education was William T. Harris, the U.S. commissioner of education. As a Hegelian idealist, Harris spoke of the mission of education in opening windows for the aspiring soul of the young learner, even in industrial education. Toward that goal, he said that the study of the history of art, with an emphasis on the Greeks, was essential. The idea of the interpretation of art gained further support as a kind of individual expression and language study. The use of newly available photographic reproductions of masterpieces fitted readily into the tradition of object study descended from the Oswego Movement. The moralistic, anecdotal response to a painting was feasible for the elementary classroom teacher, even if he or she could not discuss its formal qualities as specifically artistic means.

Figure 1-11. Examples of picture study, from the *Perry Magazine* 2, no. 3 (November 1899): 108.

Picture Study by Children in Brookline, Massachusetts, Public Schools, Grade V.

"A Helping Hand."¹ "Can't You Talk?"

RENOUF.

I HAVE here one of Renouf's pictures. The name of it is "A Helping Hand." It is very beautiful. There is a man in a boat and with him a little girl. The man is rowing with a large oar.

The little girl has her hands on the oar. She thinks she is helping, but I think she is hindering, if anything. The man looks very kind, so he does not tell her so. They have on wooden shoes. They are starting to go fishing. I think she has been out fishing very many times by her looks. They are not out very far because you can see a lot of boats and rocks. I like best the earnest way she looks and the way the old man smiles at her, as much as to say "I couldn't get along without you."

NATALIE WHITING.

HOLMES.

THE picture I am looking at is a dog and a little baby just about three years old. The picture is painted by Holmes. The little baby is looking up into the dog's face and asking him if he can't talk. The dog is looking into the little baby's face with a full heart and seems to say, "I really wish I could talk!"

The baby is on her hands and knees. The floor is made of stones. A kitten is coming in the door, and it looks as if it was taking it all in. The child is in her bare feet and I think she was just getting dressed and ran to see her pet. She has a robe thrown around her.

LEONA M. HOLLOWAY.

¹ This picture was published in the January-February number of THE PERRY MAGAZINE.

"Picture study" thus became an important new part of the curriculum. Attention to the aesthetic element in educational experience also led to public interest in the beautifying of the school, and in many cities local art societies were formed to provide reproductions for the hallways and the study collection.

DRAWING. This "aesthetic movement" in education, together with research into children's art, contributed to gradual changes in drawing. What had been a rule-governed skill to be approached through rigorous exercises began to be considered a medium for the expression of thought, imagination, and feeling. Without directed technique, children were encouraged to illustrate incidents from history, fiction, or their own lives. As nature study became an enthusiasm in the curriculum, drawings of directly observed natural forms were expected to promote not only objective observation but also a sensitive aesthetic response. "Pencil painting," with attention to values and textures, replaced the uniform hard outline of industrial drawing and in turn could lead smoothly

Figure 1-12. A page from *Teacher's Manual, Part III, for the Prang Elementary Course in Art Instruction, Books 5 and 6, Fifth Year* (Boston, 1898), 159. Note the attention to such new concerns as composition, Japanese examples, expression of feeling, and watercolors.

REPRESENTATION. 159

In preparing for the exercise lead to a thoughtful arrangement of a few flowers for each pupil. Lead them to see that the principles of composition must be considered even in this. They will discover how thoughtfully these principles are observed in the illustration on the drawing-book page. In **Suggestions for Pupils** and in **Space Relations** in the Manual text for Book 5, page 3, — Fifth Year Book, page 3, — are many suggestions that will be applicable and helpful in this exercise. A careful study of the space relations in the example on the drawing-book page, and also in the little Japanese panels, Book 3, page 2, — Fourth Year Book, page 2, — will assist the children in arranging the flowers and in their drawing. Lead them to see also the different nature of the different flowers — some with delicate stems and tender almost transparent blossoms — others stronger, fuller, firmer — so that their drawings should tell of this difference. The contrast is well shown by a comparison of the narcissus on the drawing-book page and the harebell on Plate XII. Let them study the illustration as an example also of suggestive rendering. See **Expression of Feeling**, page 24. Direct the attention thoughtfully and lovingly to the living flowers before them. The work may be in watercolor, if the teacher desires. It must not be forgotten, however, that the children should be given abundant opportunity to draw with the pencil as it is the *one* medium readily available under ordinary circumstances.

Suggestions for the Pupils. — Choose an arrangement of flowers that you think will make a good picture. Lightly sketch the stems and indicate the size and position of the flowers by blocking-in. Study your drawings, thinking of the space relations produced. Consider also the space to be filled in the drawing-book. You may wish to choose a different arrangement and sketch again. See if you have selected the most beautiful aspect of the arrangement.

Study the flowers again, and draw in the books trying to produce beauty in the space relations, and to express the delicate grace of the flowers.

Added Interest. — Many of the familiar flowers possess some mythological significance or associated tradition that will interest and charm the children. Classical mythology furnishes a multitude of myths of flowers as well as of trees and plants. Many of the more familiar of these are doubtless known to the children — perhaps those of the crocus, the hyacinth, and the syringa — and will now be recalled with pleasure.

into the use of the Japanese brush with ink or water-color. Attention to aesthetic quality and to master-pieces of painting brought into school art a new topic of study, "composition."

FORM STUDY. Drawing also was used in "form study," which continued the representation of geo-metric solids that descended from both academic art instruction and the educational practices of Pestalozzi, Froebel, and other early nineteenth-cen-tury school teachers. Form study, the drawing of "type forms," was supposed to develop the concepts of the spherical, the cylindrical, the pyramidal, and so on, as possessing not only physical but also quasi-spiritual attributes—an educational goal more elevat-ed than the simple ability to draw. Children drew from "dictation," following the teacher's blackboard example, copied models in their workbooks, or drew wooden models that were sold in sets by Prang, Milton Bradley, and other early school suppliers.

MEDIA. Industrial drawing had no interest in the exploration of a variety of media: its demand for accu-racy was fulfilled by the point of the pencil, with occa-sional recourse to color washes in upper grades. In the new education, beginning with kindergarten and later in form study, the Froebelian tradition called for manipulable media so that publications began to advise the classroom teacher in the pedagogy of paper folding and clay modeling. Clay further lent itself to the study of historical ornament in low relief and to the appreciation of Greek pottery through modeling half-round vases. Simpler Froebelian paper weaving and pea-work extended into the upper elementary grades.[17] As manual arts assumed responsibility for

17. Pea-work (sticks or wires meeting in the pea as a point) was intended to help the child to move from concrete and physical means toward abstract conception of form.

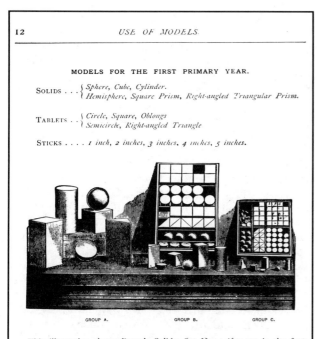

This illustration shows Prang's Solids. Set No. 1 (for use in the first Primary year) in three groups, *A. B, C.* The Solids, group C (sphere one inch in diameter). can be obtained in boxes containing 20, 40. or 60 of each Solid, as may be desired. See Appendix, p. 185, for full descrip-tion.

Figure 1-13. Classroom equipment for form study, from Mary D. Hicks and John S. Clark, *The Use of Models: A Teacher's Assistant in the Use of the Prang Models for Form Study and Drawing in Primary Schools* (Boston, 1887), 12.

CLAY MODELING IN THE SCHOOLROOM. 39

TYPICAL OBJECT, CAT.

Have the half-oblate spheroid upon the table, also the clay or wax cat previously made by the teacher. Compare the two objects and talk about the cat, its form and curves. During this talk the fact will or should be brought out that in different positions the cat represents different forms. Kitty rolled up with her head next to her tail resembles most a ball of fur; when lying at rest or watching, she resembles the half-oblate spheroid and when leaping a cylinder. This kitty is going to be made at rest.

TYPICAL OBJECT, CAT.

Distribute the clay half-oblate spheroids already prepared. While the children sing, distribute small pieces of clay to each child. A little practice by the teacher is necessary so that too much may not be given; about one-fourth as much as is in the half-oblate spheroid is sufficient. This is for the cat's head. Follow Formula I with the clay just given, while the half-oblate spheroids remain untouched upon the table, the elliptical side down. Flatten the sphere until it is almost a hemisphere. Attach it to one end of the half-oblate spheroid a very little higher than the top of the back; putting it in just the right position constitutes the secret of resemblance. A small bit of clay is then given to each child for the cat's ears. This is di-vided and pinched into small egg-shaped pieces and attached to the head, with the pointed ends toward the front. When the ears are fastened to the head they stand out roundly. Notice a cat and have the children do so, telling the result of their ob-servations. A piece of clay is then given about half the size of the head. This is divided and rolled into two ropes thick and

Figure 1-14. Type forms studied in clay, from Ellen Stephens Hildreth, *Clay Modeling in the Schoolroom* (Springfield, Mass., 1892), 39.

the practical in art education, decoration was studied in the production of such useful products as boxes, book covers, and pen-wipers. By the end of the century, weaving and metalwork—even forging—were introduced, both as manual arts and in correlation with studies of other cultures, especially of the native American.[18]

Color came into art education, as it came into American life, late in the century. As an element in the changing culture, color had a profound significance: Josephine Locke, supervisor of drawing in Chicago, exclaimed in 1890 that "the American public are slowly awakening to the fact that color has to do with healthy, wholesome human living, that there is an eternal word in nature and in art that we must heed, for the heart of man feels the need of it."[19] In Froebelian teaching, sensory experience was important: watercolors, chalks, and colored papers were increasingly common in the 1890s, and high-quality crayons were available by 1902. Just as the technology of color in manufacture and printing excited the public, the availability of color media in schools made pencil drawing even less interesting for children. At the same time, there was much doubt whether theories or "laws" of color could be taught usefully to young children and, on the other hand, much distrust of freedom for children to experiment with color. But at least two companies, Milton Bradley and Prang, sold sets of colored papers in uniform strips of, for example, one-quarter by one inch, which could be pasted into workbooks to illustrate elements of color theory, such as graded tones, simultaneous and complementary contrasts, and various color harmonies.

Changes Evidenced in Prang Publications

All of these changes in school art are well represented by the texts published by Louis Prang through the 1890s. Prang was a midcentury German immigrant who settled in Boston and became one of the country's foremost chromo-lithographers. In 1875 he attracted Walter Smith's editor, John Clark, and secured the rights to Smith's *American Text Books of Drawing*. From that beginning, through the rest of the century and even into the 1920s, Prang publications became a major influence in American art education, and Clark was treated as a leading art educator. Prang provided summer classes and travelling workshops for teachers and, as early as 1879, offered a "normal

art course" to assist teachers by correspondence. In view of this diverse clientele and because a considerable number of art teachers served the editors as an advisory group, the changes of purpose and content stated in Prang's publications can be considered as mainstream trends. Moreover, Prang's manuals for teachers give a very thorough presentation of the thinking and the activities in school art: the 1899 edition for the sixth grade alone had 273 pages.

In the 1880 edition of Smith's manual for teachers, art education was to be based on "geometry, as the science of form," with three types of study: construction (making diagrams or working drawings), representation, and decoration (the design of ornament).[20] In 1888 Prang's course emphasized "form study and drawing": its new purpose was "mental development" through exercises designed to strengthen perception and expression. Both "making" and drawing, furthermore, were expected to contribute to progress in other subjects. In the early nineties, the announced purposes changed again, to the development of "creative ability," through exercises planned toward the appreciation of the beautiful. (At that time, it was natural to speak of creativity as an ability to be developed by exercises.) By 1898 still another purpose was stated, reflecting the problems of urban growth and immigration and the demand for moral education: art education was to combine individual expression with preparation for good citizenship. Representation, construction, and decorative design continued as the three main branches of school art, but the role of art in the school, the understanding of children's art, and the forms, media, and activities all had changed rapidly. Appreciation became important: as early as 1883 Prang had published *Text-book to the Illustrations of the History of Art*.[21] But historic method could not fulfill the call for aesthetic nurture in elementary grades: in 1898 Prang provided one of the early, and most useful, books on picture study.[22] Appreciation at the end of the century had another typical aspect: the study of historic ornament under the general heading of decoration. Eighth-graders following the Prang series of 1900, studying Moorish, Gothic, or Renaissance style, were to learn how those people lived and furnished their houses, how they dressed, and how their books and fabrics were decorated. Especially would they study architecture—the

18. Strips of thin metal could be bent into curvilinear forms copied from the tradition of decorative arts. Forging was recommended as an experience in resistant material that would strengthen the will power of the young learner.

19. Josephine C. Locke, "The Mission of Color," in *NEA Proceedings, 1890*, 800.

20. L. Prang and Company, *The American Text-books of Art Education, Teachers' Manual, Part I, to Accompany Drawing Books I and II*, rev. ed. (Boston, 1880), 9.

21. Margaret Hicks Volkmann, trans., *Text-book to the Illustrations of the History of Art* (Boston, 1883). Translated from the German. The original author is not identified.

22. M. S. Emery, *How to Enjoy Pictures, With a Special Chapter on Pictures in the School-Room by Stella Skinner* (Boston, 1888).

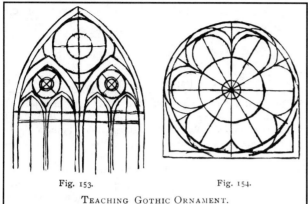

Fig. 153. Fig. 154.

TEACHING GOTHIC ORNAMENT.

An outline of the work is suggested, as follows:

1. Talk on Gothic ornament; Gothic cathedral; characteristics—vertical tendency, pointed arches, rose windows, capitals, statues, by whom built and where; ornament considered as to its symbolism and beauty; influence on later art.

2. Sketches of Gothic elements, such as foils, crosses, circles, triangles, fleur-de-lis, windows and capitals.

These sketches may be made with a pencil, or with ink and brush, or both. It a is good plan to label them. Let each pupil draw those which most interest him. The method of beginning drawings of the pointed arch and rose window are in Figs. 153 and 154; large forms first, details last.

3. Mounting collected illustrations of Gothic elements, such as pictures of Gothic capitals, windows, crosses, triangles, foils and fleur-de-lis forms. (Some of the latter elements are common in dress goods, draperies, wall-papers, etc.) (Fig. 155.)

4. Analysis and careful drawing of one of the Gothic surface designs.

The use of the ruler, tracing paper and any other mechanical aid is allowable in drawing the surface design. Allow individual pupils to choose which surface pattern they will

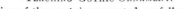

Figure 1-15. From Fred H. Daniels, *The Teaching of Ornament* (New York, 1900), 184.

development of the style with its variants; its characteristic structural features; the design of arches, capitols, mouldings, carvings, stained glass, and painted walls. The company also furnished the necessary illustrative prints in color.

Contradictions at the Turn of the Century

In 1898 the Art Department of the National Education Association appointed a Committee of Ten to make curriculum recommendations. A fifty-item questionnaire was sent to leaders in the field. The report finally was issued in 1902.[23] One committee member considered it outdated; another found insufficient consideration of the Child Study Movement;

23. Langdon S. Thompson, chairman, "Report of the Committee of Ten on Elementary Art Education," *NEA Proceedings, 1902* (Chicago, 1902), 596–614.

GENERAL PLAN OF EXERCISES FOR THE SEVENTH YEAR.

BOOKS 9 AND 10.—SEVENTH YEAR BOOK. SHOWING THEIR PURPOSE, SEQUENCE, AND INTERRELATION.

THE exercises for the Seventh Year are chosen to open to the pupil more widely still than in previous years the world of nature and of art, by the presentation of the drawings of artists, and of exercises for drawing from life, and from familiar and beautiful objects. These exercises appeal to him through his innate delight in beauty of form and color,—a beauty resulting from simplicity, harmony, and repose,—and thus lead him to creative activity.

The exercises include the following : —

FROM NATURE.	Grain. Flowers. Landscape — window study. Figure studies. Animal studies.	Life in growth. Life in growth, action, and feeling.
FROM ART.	Familiar and beautiful objects. Fine buildings. Type forms. Working-drawings — views, sections, plans, patterns, and development. Beautiful objects. Historic ornament — Roman, Byzantine, and Romanesque. Historic architecture — illustrations, capitals, plans.	Association. Idealization. Construction. Rhythm and beauty. Radiation — tangential union. Space distribution.
CREATIVE WORK BY PUPILS.	Space relations in panels, mouldings, doorways. Space relations in flower forms and simple landscapes. Patterns of type forms and objects. Plans and elevations of rooms. Grilles — constructive design. Decorative arrangement.	Individual power.

These exercises are classified generally as above, yet all are closely interrelated as pages 74–77 show. To maintain closely this interrelation, the illustrations on the

Figure 1-16. From John S. Clark, Mary Dana Hicks, and Walter S. Perry, *Teacher's Manual, Part V, for the Prang Elementary Course in Art Instruction, Books 9 and 10, Seventh Year* (Boston, 1899), 73.

and a psychologist found its philosophical language unintelligible.

The graded curriculum was organized in four categories. *Form study and modeling* progressed from type forms to natural objects and then to modeling natural objects, historical ornament, and human features. *Aesthetic study and drawing* included picture study; design for surface decoration, ironwork, and stained-glass windows; and studies of color and landscape composition. *Pictorial drawing* included "imaginative" and "sight" drawings, nature subjects, historic ornament, and illustration. *Working drawings* contributed to industrial education.

Aesthetic pronouncements were derived from the nineteenth-century idealism represented by William T. Harris. Yet such terms as "free spirit," "self-consciousness," and "self-realization" belonged to the new education and pointed to twentieth-century attitudes.

In Columbia University's Teachers College catalog for 1898, the old faculty psychology was pervasive: courses were expected to develop the power of appreciation, the power of concentration, the power of observation, the power to work hard, even the power to imagine and create. These powers were built

through discipline and hard work. Drawing required form study, "blocking in," and the use of plumb line and pencil measurement to give teachers the power to detect inaccuracies in student efforts.

At the same time, school children were encouraged to draw freely from their own observations and experiences. One normal school teacher found it necessary to *drill* her elementary education majors in freedom of the whole arm and hand in drawing. At the Paris Exposition in 1900, the American exhibit of children's work was praised for its free expression, but some American art educators found the European work far superior in the quality of drawing.

Expression was valued, but in the late nineteenth century, expression still referred commonly to qualities perceived in the subject depicted, not to the emotions of the artist. In a period of rapid change, new ideas would give old words new meanings.

Some of these "contradictions," however, were not temporary. This quick review of the varied values and purposes stated through two decades shows how quickly art educators encountered oppositions—alternatives that through the next century have constantly required reconciliation: correlation versus art as a separate subject; exercises versus self-expression; creative individuality versus social responsibilities. Certainly most of these terms had not yet acquired their twentieth-century meanings. But the impotant consideration is that these alternatives, because they are inherent in the nature of art, were recognized as

soon as school art, in the new education, replaced industrial drawing.

FURTHER READINGS

Clarke, Isaac Edwards. *Art and Industry, Industrial and High Art Education in the United States*, Part I, *Drawing in Public Schools*. Washington, D.C., 1885. The best single documentary source for the period, though biased toward industrial purposes.

Efland, Arthur. *A History of Art Education: Intellectual and Social Currents in Teaching the Visual Arts*. New York, 1990. For the nineteenth century, see chapters 4, 5, and 6.

Korzenik, Diana. *Drawn to Art: A Nineteenth Century American Dream*. Hanover, N.H., 1985.

Logan, Frederick M. *Growth of Art in American Schools*. New York, 1955.

Marzio, Peter C. *The Art Crusade*. Washington, D.C., 1976. The best study of early drawing manuals.

Smith, Walter. *Art Education, Scholastic and Industrial*. Boston, 1872. Rare but the best presentation of Smith's convictions and proposals for industrial drawing. His graded plan of instruction is most thoroughly detailed in his *Teacher's Manual of Free-Hand Drawing and Designing, and Guide to Self-Instruction, Intended to Accompany the American Text-books of Free-Hand Drawing and Designing by the Same Author*. Boston, 1874.

Wygant, Foster, *Art in American Schools in the Nineteenth Century*. Cincinnati, Oh., 1983.

◈ 1900-1915 ◈

The United States had become a world power by the beginning of the twentieth century. Until the First World War, the public mood was optimistic. At the annual conventions of the National Education Association, speakers cited the educational implications of territorial expansion, Pan-American relations, foreign trade, and other global concerns. Educators shared the spirit of "manifest destiny": they spoke with new confidence and with a sense of responsibility to the world's peoples. The earlier dependence upon European educational systems was replaced by equal participation in international conferences that addressed the common problems of industrialized nations.

Art education at the turn of the century was not directly affected by current stylistic innovations in painting. But the established emphasis on form study and representational or constructive drawing was challenged by a new American approach based upon analysis of the elements of design and composition. Around 1907, the relation of manual arts to art education became a major issue as part of an educational concern for practicality. Just before the onset of war, the idea of building the general curriculum around learning about industry threatened to absorb art education. Through these years, "picture study" became the common method of promoting art appreciation, whereas the Arts and Crafts Movement and the new study of composition aimed to develop good taste in all personal choices.

SOCIAL AND CULTURAL CONDITIONS

Industrial Expansion

World power was generated largely by industrial triumphs. By 1900, the United States was the foremost manufacturing nation in the world. New technology changed people's thinking, their values and attitudes, their ways of living. The nature of factory work affected the older sense of individuality and self-advancement. "Scientific management" became a national enthusiasm: the assembly line laborer was analyzed as a machine, and "efficiency experts" assessed the daily routines of everyone and everything from housewife to clergy, factory to school.

Social Factors

With the admission of Arizona and New Mexico to statehood in 1912 and the development of the world's largest railroad system, the nation was geographically mature and less dependent on the Northeast in regard to industry and finance. State universities across the country were relatively free from tradition, oriented toward practicality, and ready for innovation.

Between 1890 and 1915, the population grew by 60 percent, to more than one hundred million. The rate of immigration and urbanization increased. As factories replaced farms and mothers went to work, schools became responsible for much that formerly had been taught at home. Violent conflict between industry and labor organizations, together with political radicalism, stimulated fear of social upheaval, which led to demands for better "citizenship education."

The **Progressive Movement** stimulated further expansion of the responsibilities of the schools. Beginning in the last quarter of the nineteenth century and especially in the decade before the First World War, the Progressives campaigned for universal suffrage, child labor laws, civic and political reforms, improvement of health and hygiene, playgrounds, day nurseries, and consumer standards. Women's organizations, labor unions, politicians, and many newspapers and magazines looked to public education as the essential instrument of participatory democracy. In the general effort to improve the quality of living, progressivist teachers could claim an important role for art education.

Intellectual Currents

The pragmatist thought of Charles Pierce, William James, and John Dewey had its counterpart in the public turn of mind. The claim that the truth of an idea could be found only in its results was fundamental to the experimental outlook that Dewey con-

sidered essential to progressive democracy. The pragmatic attitude was pervasive: it challenged the authority of tradition, social strata, religion, and classical texts; it supported sociological surveys, scientific management, universal suffrage, and feminist freedoms. For education, it implied learning through direct experience and a curriculum planned for practical applicability.

In Europe, and to a lesser degree in the United States, the power of rationalism gave rise to a variety of reactions—mysticisms, intuitionist philosophies—and stimulated interest in the emotions, the subconscious, and the irrational. In American education, however, there was little interest in such concerns.

Psychology, as an experimental science, entered a new phase in the work of Edward L. Thorndike. His dissertation, *Animal Intelligence* (1898), established the basis for his several "laws of learning," which were important in the growth of behaviorist psychology and influential in education. A related development important to education was the testing of intelligence, initiated in France by Binet in 1905 and adapted in the United States in 1908 by a student of G. Stanley Hall. The further revision of the Binet test by Lewis Terman at Stanford in 1916 became one of the main tools for advocates of "scientific education" through the following decades.

The beginnings of clinical psychology and the Mental Hygiene Movement in the first decade of the century provided the first steps toward the provision of psychologists and speech therapists on school staffs.

Psychoanalysis had its official introduction in the United States in 1909, when G. Stanley Hall invited Freud, Jung, and Ferenczi to meet with American psychologists. The early spread of Freudian ideas was limited mostly to metropolitan intellectuals and did not influence education generally before the twenties, with one exception. In 1915, Margaret Naumburg founded the Children's School, with the purpose, she said later, "of applying the principles of analytic psychology to the education of normal children,"[1] a purpose that made her work enormously significant in art education.

Genetics, as a new field of science, began to inspire some Americans with ideas of infinite improvement of the citizenry as human stock, thus adding to fears of technology and social engineering.

Anthropologists studied the culture of isolated aborigines abroad and heightened interest in native Americans. The drawings of school children were compared to the art of "savages." The educational and social development of the child was likened to the progress from the cave to modern society, and "cultural epochs" became the basis for school curricula.

Culture and the Arts

The conditions indicated above produced a mood of buoyant optimism through much of Europe and the United States. Writers recalled the period from the nineties to the First World War as "the age of innocence," "the cocksure era," the time of "the new freedom," "the new hedonism," or "the new paganism." What was natural was good. Clothing became more casual. Women accepted fewer restrictions: instead of wading, they swam; they took to cigarettes; they showed themselves capable of driving cars. Artifices of social decorum were weakened; the passing of good manners was a fruitful topic for cartoons.

At the same time, there were pessimistic undertones. Complexity, regimentation, and uniformity seemed characteristic of modern life. Industrialization and the growth of cities weakened social structures and reduced the personal sense of status.

Literature reflected both moods. Naturalist writers like Dreiser, Norris, and Crane and the "muckraking" journalists who reported the sins of big business and urban corruption showed the individual as a victim of social and technological forces and the evils of human nature itself. At a more popular level, all the major subjects of best-selling fiction were already available, and leading magazines joined the progressivist campaigns. Juvenile fiction moved from the moralizing genre represented by Horatio Alger (will power, hard work, and honesty ensure success) to the sophisticated adventures of such prep school paragons as Nancy Drew and the Rover Boys.

In poetry, an American "renaissance" was claimed, in which style and subject were to be finally free from Europe. Durably important were Carl Sandburg, whose work has been classed as "proletarian"; Edgar Lee Masters, whose *Spoon River Anthology* combined naturalism with regional lore; and the Imagist poets, such as Ezra Pound and Amy Lowell.

Publishers developed new markets for elaborate editions of famous books through subscriptions, club memberships, and reduced price coupons for teachers. Within the Arts and Crafts Movement, small presses produced fine limited editions. Such attention to the book as an art form became an important part of the school art program, including writing, illustration, lettering, printmaking, design, and the craft of bookmaking.

As mass manufacture led to mass marketing, advertising budgets supported high-quality illustration by well-known artists. Art teachers clipped their work from magazines as examples for the classroom, where realism prevailed and illustration provided correlation with other studies.

1. Margaret Naumburg, *The Child and the World* (New York, 1928), 4.

Dance became an important medium for expression of new values: freedom, naturalness, and the unity of mind and body. Loie Fuller, Ruth St. Denis, and Isadora Duncan won international acclaim and later recognition as predecessors of modern dance. In school, girls wore knickers or tunics and learned the "aesthetic" polka, waltz, or schottische. But social dancing abandoned older group forms, the polka and the schottische, in favor of "ragtime" novelties that featured intimate sharings of impulse and emotion, close contact and bouncy energy, rather than decorum and grace.

Music had an earlier and stronger position in American schools than did the visual arts. Carefully chosen songs were considered valuable to moral education, and singing was a common attainment; unlike drawing, it seemed to require no rare talent. While European audiences encountered Schöenberg's atonality and Stravinsky's rhythmic and tonal complexities, Americans began to hear the classical repertoire as concert bands and symphony orchestras proliferated. The operettas of Romberg, Friml, and Herbert and musical reviews like the Ziegfeld Follies provided popular tunes that fed the thriving sheet music industry and the player piano. Ragtime music reflected new social freedoms and technological innovations—cars, telephones, cigarettes. Gradually, the phonograph replaced personal abilities in home entertainment.

Theatre provided light entertainment—popular stars, romance, sentiment, light comedies—more than serious thought, but major European stars toured frequently, and every city would have had its "opera house" for travelling shows. Amateur theatre was popular. "Dramatization" became a standard educational technique intended to stimulate the imagination, train the memory, and develop self-control. Pageants and festivals were popular: in schools, they combined the arts, correlated the curriculum, promoted community relations, and accommodated large numbers of children.

Film was the new popular entertainment, developing rapidly from the nickelodeon into five-reel treatments of more and less important literature and of serious and titillating social problems. It was both condemned as sinful and hailed as a truly democratic and educational art. The poet Vachel Lindsay, who saw the film as art in motion, described its future in schools and social crusades—a serious medium for scientists and artists together.[2]

Lindsay's vision helps to illustrate the progressivist enthusiasm for the arts that was an important element among the conditions for art education in

the early twentieth century. Especially in the development of the motion picture, however, it should be clear that much of the cultural change represented in the arts did not reach into the schools before the First World War.

THE VISUAL ARTS

Before the famous Armory Show in 1913, the American public had little idea of the drastic changes in art that had been seen in Europe since the eighties and nineties. The same may justly be said of school art teachers. Although the wealthiest collectors were being led to old masters—the Italians, the Dutch, and the English portraitists—the general taste still favored Barbizon and Pre-Raphaelite descendants, history and genre painting, travel exotica, and neogrecians like Alma-Tadema. Impressionism was enjoyed as outdoor sketching in adventurous color, and among the many respected American painters were Impressionists like Cassatt, Hassam, Robinson, and Twachtman. Homer, Whistler, Eakins, and Sargent have remained most significant, but dozens of able artists now remembered only by specialists had substantial reputations.

Most American painters progressed from local academies to Europe. Many leaders from the older generation of American artists, like Chase and Duveneck, spent years in Munich and Dusseldorf. Paris, however, was now the center for study abroad, and the younger Americans saw the first major exhibitions of Cezanne, Van Gogh, and Gauguin and the early showings of the Fauves.

In New York, two important new groups had emerged before 1910: the so-called Ash Can painters, led by Robert Henri, and the circle around Alfred Stieglitz. Neither group had a marked early effect on school art. Henri wanted a democratic art, and naturalism was praised as an appropriate American style, but the Ash Can painters offended standards of good taste in subject matter and technique. According to critics, they were "apostles of ugliness." Social criticism was unwelcome; a more healthy naturalism would show the majesty and vigor of the great cities, the optimism of its workers, and so on. Stieglitz, in his magazine *Camera Work* and in his gallery *291* gave the first public showing to many of the most significant American and European artists, but there would have been no reason for revolutionaries in art to be taken as models for children, even if art teachers had known them.

Sculpture was in a somewhat similar condition. The few American sculptors who had gained world reputations tended to stay in Italy, but many capable sculptors worked at home early in the century, including several young women. Portraiture, cemeteries, and architectural ornament provided commissions. The classical tradition still dominated: European

2. See Vachel Lindsay, *The Art of the Moving Picture* (New York, 1915).

innovations were scarcely known before the Armory Show. However, there was little sculpture in American schools. Drawing, two-dimensional design, and manual arts filled the curriculum; the media common then in sculpture would have been problematic in the schoolroom; and art teachers were generally unprepared in sculpture.

Architecture still was mainly eclectic, and public appreciation focused on classical monuments. Just before World War I, the influence of the Arts and Crafts Movement produced interiors that were simple, clean lined, and quite free of ornament so that high school students were able to draw plans and render elevations. The skyscraper, however, despite the successes of Chicago architects, was not a symbol of modernism in school art before the 1920s.

Art museums had been founded in most major cities by 1915, usually within the previous decade or two. As educational institutions, they commonly provided public lectures and art academies, with adult classes for amateurs as well as for professional training. By 1907, docent service, travelling exhibits, and cooperative programs with schools were offered in several cities. In 1915, the first conference of art museum instructors attracted participants from city museums as well as colleges, universities, and other educational agencies.

Libraries increased during the same period, often with an affiliated museum. Both institutions in Newark, New Jersey, were directed by John Cotton Dana, who developed two- and three-dimensional loan collections and mounted a pioneer program of exhibitions of contemporary American and European art and design.

Publications on art had begun to increase rapidly by 1900. The public was interested, publishing was profitable through wider marketing, and many artists and writers were adequate by this time as authors in specialized fields. The quality of reproductions was enhanced through halftone photoengraving and lithography and four-color printing. Nearly thirty magazines on art were available by the turn of the century, including three devoted solely to art appreciation: *Great Pictures, Masters in Art,* and the *Perry Magazine,* which promoted reproductions for school and institutional instruction. Probably equally important in the forming of public opinion on art were the prestigious monthlies of general cultural interest like *Harper's, Scribner's,* and *Century,* which carried substantial reviews and articles by some of the most respected critics and occasionally by well-known artists. Newspapers were more numerous in those days. In most cities, at least one newspaper could name its art critic; in 1907–08, New York City claimed twenty-one.

Organizations for support of art existed in most cities; by 1915, the American Federation of Arts (visu-

al arts) had more than two hundred local chapters. Many of these were dedicated mainly to promotion of art in schools, but public lectures, classes for drawing, painting, and crafts, and travelling stereopticon slide presentations were commonly offered.

The **Armory Show**, The International Exhibition of Modern Art organized by the Association of American Painters and Sculptors in 1913, was the culminating cultural event of the prewar era. In New York, more than two thousand works were listed; later showings in Chicago and Boston were smaller. Estimates of the total attendance in the three cities range from well over one hundred thousand to twice that number. Much of the work was conventional, but the "moderns," especially the French Post-Impressionists, Fauves, and Cubists, had been sufficiently vilified to encourage the press to cover the show sensationally. The pungently negative reactions of public figures and conservative critics added to its impact.

For those who were able to respond openly to the more challenging works, vitality of color, interest in form, and individual freedom seem to have made the strongest impression. Some later commentators saw the Armory Show as a triumph for American modernism, whereas others saw little direct change in teaching in the art academies. The style of school art was not immediately affected: the one substantial journal in the field, the *School Arts Magazine,* seems not even to have mentioned this sensational exhibit.

Nevertheless, the Armory Show was the peak event in a wave of enthusiasm for art in the United States, which provided a very favorable climate of support for a wide range of educational programs. Furthermore, this may have been the last period when public ideas about art and those of art educators were generally in agreement.

CONDITIONS IN EDUCATION

In the first fifteen years of the new century, the momentum of the "new education," with its advances in psychology and method, continued. The most urgent problems in public education were caused by social changes. Not only were there more pupils more of the time but they were less likely to be similar in age, ethnic or social background, and educational development.

As the most important "melting pot," schools were responsible not only for literacy and the common subjects but also for citizenship and vocational preparation. Most young men, if they finished high school, would not go on to college; yet college entrance requirements still dominated the curriculum. The adult needs of women included a formidable array of older household techniques, the mastery of a few new appliances, and increased attention to

hygiene and consumer standards. To meet these needs, education was expected to be instrumental, pragmatic, and above all, practical.

Industry and technology were taken as the purpose and the model for such practicality. A variety of vocational education programs were tried, including manual training schools, "continuation" classes for young workers who had left school, and shop work for those still within the age limits of compulsory education. The American Federation of Labor and the National Association for Industrial Education pressed for a full public system of vocational education.

"Efficiency," "economy," and "scientific management" became key terms in discussions of school administration. The "platoon system," or "Gary Plan," which originated in that midwestern steel center in 1908, tried to match the factory ideal in full use of the school plant and in rigid scheduling of groups of students. Hundreds of cities copied the platoon system through the next three decades.[3] Students were considered as products, and a subject like art, which showed a low level of production per dollar, could fail the administrative test of cost-efficiency.

The **Progressive Movement**, regarding the public school as an essential agency for social reform, promoted medical examinations, instruction in hygiene, and school playgrounds. The general goal was equal opportunity for all students, which implied a more diversified curriculum as well as programs of special education for exceptional students, especially the disabled. Women's education was important: home economics developed as a regular school subject, and in 1908, the National Education Association established a Department of Women's Organizations, open to "any professional or volunteer worker in education."

John Dewey (1859–1953) had become the leading figure in progressive education by 1915. Educated in philosophy and psychology, he arrived at the University of Chicago in 1894 with added responsibilities in pedagogy. In education, he was much influenced by both Herbart and Parker. As director of the Laboratory School, he developed a curriculum that brought the usual subjects together in student projects for study of exemplary societies, including those of the native Americans, the Pilgrims, and the antebellum South. Because the arts and the means of production were important in these societies, construction, weaving, metalwork, drawing, and painting were essential activities in the integrated curriculum.

In his psychology, Dewey followed Darwin and James: mind and body were physiologically unified in the organic response to the environment. Social experience was essential to human development. Experience was a flux of doing and undergoing, of action and reflection, of impression and expression. Learning was a reconstruction of experience for the society as well as the individual. Art was one means of achieving expression or reconstruction, attaining unity from the common disorder of experience. Art was a mode of thought, and for Dewey, the complete process of thought was like solving a problem in science or design: a need or incongruity sensed and analyzed; a hypothesis tested; a fault corrected or an alternative hypothesis attempted. The school, including the art curriculum, was to provide such experience not as a preparation for later life but as life itself.

Dewey's thinking was complex and often misunderstood. But his was the most comprehensive educational theory of the period, and it represents well the mixture of ideas in art education at the time.

Educational psychology continued to bring together the benefits of the Child Study Movement. Probably the most important new development was Thorndike's "connectionist," or "stimulus-response," theory, which gave the basis for his laws of learning and, as noted above, related to subsequent behaviorism. Such thinking had several more general implications. It provided optimism through the indication that almost anyone could be taught if correct techniques were applied. The importance of connections to daily life fitted well with the current emphasis on practicality. The prospect of controlled technique based upon laboratory experiment also fitted well with the calls for efficiency and scientific method in education.

Standardization of tests, curricula, and measurements of learning developed at the same time to meet the same demands: school superintendents and citizen groups alike were said to want "standard measures of educational efficiency." The chairman of a National Education Association committee observed that standards were needed for a variety of school programs; that they should be viewed as "central tendencies" rather than as targets for uniformity; and that they could assist in individuation. But this trend was not without opposition: G. Stanley Hall warned against the threat to individuality and the implication of a nationally uniform and rigid curriculum.

Teacher preparation gradually was extended in recognition of the social responsibilities of the school, the diversification of the curriculum, and the complexities of new theory. In 1900, only a minority of teachers had any professional education. By 1914, some states were able to require high school graduation for admission to normal schools. The two-year college program for teacher training still was com-

3. John Michael, in conversation, recalled the introduction of the platoon system as late as 1942 in the elementary schools of Cincinnati, where he taught both art and practical art—an example, he noted, of the slow pace of change in American education.

mon, but baccalaureate programs were available, and a strong majority of high school teachers in the better city systems would have had at least some college or university education. Art was common in the normal school curriculum, but few teachers, especially in elementary schools, were likely to be capable of teaching art without strong supervisory support.

As we turn to concentrate on art education, it will be important to remember that teachers were influenced not only by trends in educational theory and practice but also by the social and cultural changes that affected them as individuals. Before World War I, the leaders in the field were products of the nineteenth century; only the younger teachers had grown up in the nineties and the early ragtime years. Finally, the fact that art education, like any special field, has its own inner dynamics, requires us to remember that the art teachers of that period varied greatly in their education as artists and in their knowledge and understanding of contemporary art.

ART EDUCATION

Introduction

The consolidation of changes in art education that began during the last fifteen years of the nineteenth century was scarcely complete before 1915. At the same time, there were several further developments. For many art teachers then and later, the most significant of these was a new approach to teaching art—through abstract principles of composition or design rather than through representation. Others would have cited the expansion of the art curriculum, the increased attention to art appreciation, and the effort to make school art useful to everyone, either vocationally or in adult daily life. Before discussion of these matters, a few comments on the general conditions of school art should be useful.

The Status of Art Education

In 1914, a national survey showed that art was a required offering in thirteen states and that strong programs also existed in other states. Massachusetts, New York, and Pennsylvania had state directors of art, and most cities had art supervisors, whose efforts set the model for those positions through future decades. Nearly all elementary schools required art, including "handwork," which was taught by the classroom teacher guided by an art supervisor. In most high schools, art was not required, but elective. The time allotted weekly to art ranged from the common sixty minutes in primary grades, with added time for manual training, to as much as five hours in the upper grades.

Materials and equipment were generally improved. A variety of special papers were available for work in charcoal, watercolor, and wood block printing. Blueprint paper was used to make images by sunlight. The program also could offer crayons, clay, plasticine, cardboard, wood, brass and copper, reeds and raffia, yarns, strings, jute, and cloth for stenciling

Figure 2-1 A seventh- and eighth-grade room in Minneapolis, about 1912, shown in the monthly "School Beautiful" section of the *School Arts Magazine. School Arts Magazine* 12, no. 6 (February 1913). Reprinted with permission of *School Arts.*

and appliqué. New lines of artroom furniture were on the market. In technical schools and in big city high schools, completely furnished studios for jewelry, ceramics, textiles, and industrial or applied arts could be found.

Illustrative resources were more often available. Citizen groups in many cities provided reproductions. New York State before World War I had a loan collection of three hundred thousand lantern slides, twenty-eight thousand photographs, and eighteen hundred wall pictures. The St. Louis course of study described their collection of pottery, draperies, books, casts, art journals, alphabets, initial letters, examples of design, Japanese books, prints, and reproductions. Museums assisted school art programs. Dana's pioneering study collections in the Newark Public Library were a model for others.

Professional organizations were active, beyond the annual meetings of the Art Department of the National Education Association. Changes in regional groups reflected the fact that art and manual arts were often administered and taught as indistinguishable. The Western Drawing Teachers' Association became the Western Drawing and Manual Training Association in the meeting of May 1904. Similarly, the Eastern Art Teachers' Association and the Eastern Manual Training Teachers' Association met jointly in 1909 and merged: the Eastern Art and Manual Training Teachers' Association continued until 1915, when the name was changed to Eastern Arts Association.

This duality was evident also in the Council of Supervisors of Manual Arts, organized in May 1901. The council was concerned with "manual arts of drawing, design, and construction work in the public schools," and its presidents through 1908 were as much identified with art as with manual training.

The **American Federation of Arts** was founded in 1909 through the National Academy of Art, a society established by Congress in 1892. The objectives of the new organization were diverse, ranging from promotion of parks and playgrounds to support of art schools and the creation of a national gallery. The second of its stated purposes was the promotion of art in public schools.

International conferences of drawing teachers (Paris, 1900; Berne, 1904; London, 1908; Dresden, 1912) testified to the importance of the subject. The enthusiasm of the Americans was evident: the boat trip to Europe was lengthy and expensive, yet as many as two hundred fifty teachers attended in London. The International Federation for Art Education, Drawing, and Art Applied to Industries was formed in Dresden, and before the outbreak of the war, it had published its first bulletin, titled *Art et Dessin*. Conferences helped to unify the field and raise the sense of profes-

sionalism among art teachers in the United States, with hundreds brought together in the planning, exhibiting, and preparing of papers and reports.

Publications

The strengthened status of school art in the early twentieth century is evident in the increased number and quality of publications in the field—books, classroom texts and workbooks, and the first enduring journal for art education.

THE *SCHOOL ARTS MAGAZINE*. In the spring of 1901, the country's first commercial journal of art education, *Art Education*, ceased publication. Three of its contributors then joined with a friendly printer in Worcester, Massachusetts, to found a magazine that since then has represented the common practice of American art education. They called it the *Applied Arts Book*, copied the "medieval" style of a popular journal of the Arts and Crafts Movement, and listed themselves as "guildmaster" and "guildcraftsmen" of the "Applied Arts Guild." Soon retitled the *School Arts Book*, it became the *School Arts Magazine* in 1912. In 1935, its name changed again—to *School Arts*.

The three founders were art supervisors. Their magazine was confident, dedicated, and practical. A regular feature was an annotated outline of the next month's lessons, which carried out a published plan for the year. Beginning in the first issue, the monthly "Junior Craftsmen's Competition" awarded prizes to grammar and high school pupils for entries in specified media on announced subjects. Most of each issue concerned classroom practice and current developments of interest to art teachers; there were few discussions of child psychology or general educational problems. By 1911, forty thousand readers were claimed. The editor from 1903 to 1917, Henry Turner Bailey, became probably the nation's best-known art educator.

THE PRANG ELEMENTARY TEXTBOOKS. The teacher's manuals published by Prang periodically through the 1890s were not continued after 1899. Instead, a series of individual classroom texts, which were deservedly popular for many years,[4] were issued in 1905–06 for grades one through seven. Written at the level of expected reading ability for each year under the advice of a group of leading art educators, these texts guided the child through well-planned lessons and must have done much to offset the limitations of the classroom teacher. Hard-backed, illustrated in full color, and printed on high-quality stock, they also were acclaimed as confirming the importance of art education.

4. Hugo B. Froelich and Bonnie E. Snow, *Text Books of Art Education*, Books 1–7 (New York, 1904–05).

ART RELATED TO INDUSTRY. Around 1909, the close identity of art and manual training stimulated new competition in publications for the classroom. The *School Arts Book* was a major promoter of crafts in the best sense but also of the gamut of patterned objects for the home. Prang and other publishers issued several series of workbooks combining drawing, design, and construction and featuring "manual," "practical," or "industrial" in their titles. Prang's *Industrial Art Text Books: A Graded Course in Art in Its Relation to Industry* were continued through several editions into the late twenties.[5] Its fourth-grade book, for example, divided sixty-four pages about evenly between lessons on drawing and design and lessons on art in dress, home, and handwork. A statement facing the title page asserted a new principle to guide art education—that the ability to draw was less important than the needs of the average adult in choosing tasteful clothing, furnishings, and other industrial prod-

ucts. The authors allowed, however, that such appreciation could include "pictures and sculpture, the so-called fine arts."

High school art had no such variety of texts: in 1909, the curriculum was said to be still "experimental." Prang's *Art Education for High School*, published in 1908 with a twelve-page manual for the teacher, seems to have been alone in the field.[6]

The New Idea: Composition and Design

The most excitement in the first two decades of the century was inspired by the teaching of two men who showed how all art could be understood and taught through universal principles of design, with represention demoted to a subordinate position.

Arthur Wesley Dow (1857–1922) taught at the Pratt Institute beginning in 1895, and at Teachers College, Columbia University, from 1903 until his death in 1922. Dissatisfied with the French academic

5. Bonnie E. Snow and Hugo B. Froelich, *Industrial Art Text Books* (New York, 1915). These continued through several editions into the late 1920s. This series was preceded by Prang's *Manual Arts Drawing Book*s (eight volumes), issued in 1909.

6. The Prang Educational Company, *Art Education for High Schools* (New York, 1908), and *Outline in Drawing* (New York, 1908). In 1914, Prang issued a series of *Topic Books* based upon parts of the 1908 text with the *How to Teach Drawing: A Teachers' Manual*.

THESE "INDUSTRIAL ART TEXT BOOKS" ARE BASED UPON A NEW AND SIGNIFICANT THEORY OF ART - THE THEORY THAT "REPRESENTATION" IS NOT A BASIC OR FUNDAMENTAL ART PRINCIPLE. ABILITY TO DRAW IS IMPORTANT AS A MEANS TO AN END; IT SHOULD NOT BE CONSIDERED AS AN END IN ITSELF.÷ PUBLIC SCHOOL ART COURSES EXIST NOT FOR THE PURPOSE OF TRAINING CHILDREN TO MAKE PICTURES. PICTURE-MAKING BELONGS TO THE SPECIALIZED PROFESSIONS OR VOCATIONS WHICH ARE FOLLOWED BY PAINTERS, ILLUSTRATORS, SCULPTORS, ETC. THESE ARE LEGITIMATE AND HONORABLE LINES, BUT ARE OPEN ONLY TO THE COMPARATIVELY FEW, ESPECIALLY GIFTED BY NATURE FOR SUCH WORK. THE AVERAGE MAN NEEDS TO KNOW HOW TO FURNISH HIS HOUSE, HOW TO CHOOSE HIS CLOTHING, HOW TO ARRANGE HIS BUSINESS ADVERTISEMENTS. THROUGH THESE CHOICES HE CONSTANTLY CULTIVATES HIS TASTE, AND DEVELOPS A GENERAL APPRECIATION OF THE MOST SUITABLE, THE MOST USEFUL AND THEREFORE THE MOST BEAUTIFUL. THERE IS NO REASON WHY THIS APPRECIATION SHOULD NOT INCLUDE PICTURES AND SCULPTURE, THE SO-CALLED FINE ARTS.
THESE "INDUSTRIAL ART TEXT BOOKS" BEGIN WITH ARRANGEMENTS OF COLORS AND SHAPES. REPRESENTATION FINDS ITS PLACE, AS ABILITY TO DRAW BECOMES NECESSARY TO SELF-EXPRESSION. DRAWING IS NOT SLIGHTED IN THIS SERIES OF BOOKS. IT IS GIVEN ITS RIGHTFUL PLACE AS THE INSTRUMENT AND THE LANGUAGE OF ART, RATHER THAN THE HIGHEST PLACE BELONGING TO ART ITSELF.

INDUSTRIAL ART TEXT BOOKS
A·GRADED·COURSE·IN·ART·IN ITS·RELATION·TO·INDUSTRY

AUTHORS

BONNIE E. SNOW
FORMERLY SUPERVISOR OF DRAWING IN THE PUBLIC SCHOOLS, MINNEAPOLIS, MINN. RECENTLY HEAD OF THE DEPARTMENT OF NORMAL ART IN THE NEW YORK SCHOOL OF FINE AND APPLIED ART.

HUGO B. FROEHLICH
DIRECTOR OF THE DEPARTMENT OF MANUAL ARTS IN THE PUBLIC SCHOOLS, NEWARK, N.J. FORMERLY INSTRUCTOR IN DESIGN, PRATT INSTITUTE, BROOKLYN, N.Y.

ILLUSTRATED BY

GEORGE W. KOCH

· PART·FIVE ·

THE·PRANG·COMPANY
NEW YORK · CHICAGO · BOSTON · ATLANTA · DALLAS

Figure 2-2. Title page and facing statement, from Prang's *Industrial Art Text Books* (New York, 1915).

training that had launched him on a promising career, he began around 1890 to study the art of the Aztecs, Egyptians, Japanese, and other cultures, looking for principles common to all visual art. Through the 1890s, under the guidance of Earnest Fenollosa, the foremost American authority on Japanese art, he developed a "synthetic" method of teaching based upon what he called "art structure." His book *Composition* (1899) was the most influential book in art education for many years: the last, twentieth, edition was published in 1941.[7]

Dow's new "synthetic system" approached the study of visual art through putting together lines, colors, and "dark-and-light masses" according to five principles: opposition, transition, variation, repetition, and symmetry. The application of these five principles required one further fundamental principle: "proportion of good spacing." Experience in the application of these principles would develop aesthetic perception and judgment and thus would build an appreciation of all forms of visual art. Individuality would be promoted from the outset because the exercises in Dow's system also required independent decisions in devising variations of format, spacing, and distribution of light and dark. These were Dow's basic convictions. However unexceptional they may seem in a later era, they were the basis of an approach that was excitingly new at the beginning of this century.

The lessons called for the disciplined use of the Japanese brush and ink, charcoal, and color in woodcuts or flat washes. Each of the five principles was to be explored in line, in arrangements of two or three flat values, and finally in color. The principles also operated in what Dow called "space-cutting," and in dark-light relations, for which Dow used the Japanese word *notan*—a word that became commonplace in art education. The subject matter for these exercises emphasized landscape, flowers, and other natural forms composed in simple pictures or in ornamental patterns, borders, or book covers. Although the principles were illustrated in furniture, architecture, mosaics, textiles, and graphics, such media were not employed in the lessons in *Composition*.

In his teaching, however, Dow made a second major contribution to art education by extending the application of his ideas to work in batik, weaving, printmaking, ceramics, photography, and other media, which helped much to elevate their status in schools. A third contribution was his assertion that appreciation in all art forms would be developed better through creative work requiring individual judgment than through the popular method of "picture study."

Under Dow's direction, the art education program at Columbia University's Teachers College surpassed the Massachusetts Normal Art School in national importance. The prestige of his ideas in a foremost graduate program in the nation's leading cultural center attracted students of high potential. Spreading across the country as art supervisors and college faculty, Dow's graduates—and, in turn, their students—exerted a permanent influence in American art education.

Denman Waldo Ross (1853–1935) was not directly involved with school art, but he influenced art teachers through his summer courses in design at Harvard University between 1899 and 1914. Like Dow, he developed his theory from analysis of world art, and he distinguished design from representation. But unlike Dow, he approached design as a science based on natural laws of perception and visual dynamics, just as music proceeded from natural law.

For Ross, design was order, and he cited Plato and Aristotle as authorities. His analysis began with the proposition that any mark in a visual field is an attraction and that all such attractions have force, which can, in theory, be quantified and measured. Thus, even a single dot in a defined space has measurable dimensions of position, shape, and tone that determine its force in relation to other forms. Rhythm, harmony, and balance—analyzed separately in line, shape, value, hue, intensity, and texture—depended further upon positions, directions, and distance. Such relationships, lawful and theoretically measurable, were actually to be judged only by the sensitive eye as "occult balance." His diagrams of exemplary relationships resemble some of the theoretical work of the Bauhaus, the German school of design that influenced all Western art beginning in the 1920s.[8]

Ross also developed a theory of color for painting. He was an important collector of art in many forms and media and gave thousands of Oriental and Western works to Harvard and the Boston Museum of Fine Arts, where they are still exhibited.

To summarize, Dow and Ross brought into art education the trend toward abstraction that developed through the last half of the nineteenth century. They were very much a part of the general situation that included the Arts and Crafts Movement, Art Nouveau, the Aesthetic Movement, and the Secessionist groups in Germany and Austria. Both men intended to replace traditional academic methods with principles of design derived from analysis of world art and made applicable to all art forms.

However, as products of the nineteenth century, neither was comfortable with the radical new styles of

7. Arthur Wesley Dow, *Composition* (Boston, 1899). No major changes were made until the seventh edition, which was published by Doubleday Doran in 1913.

8. Denman W. Ross, *A Theory of Pure Design* (Boston, 1907).

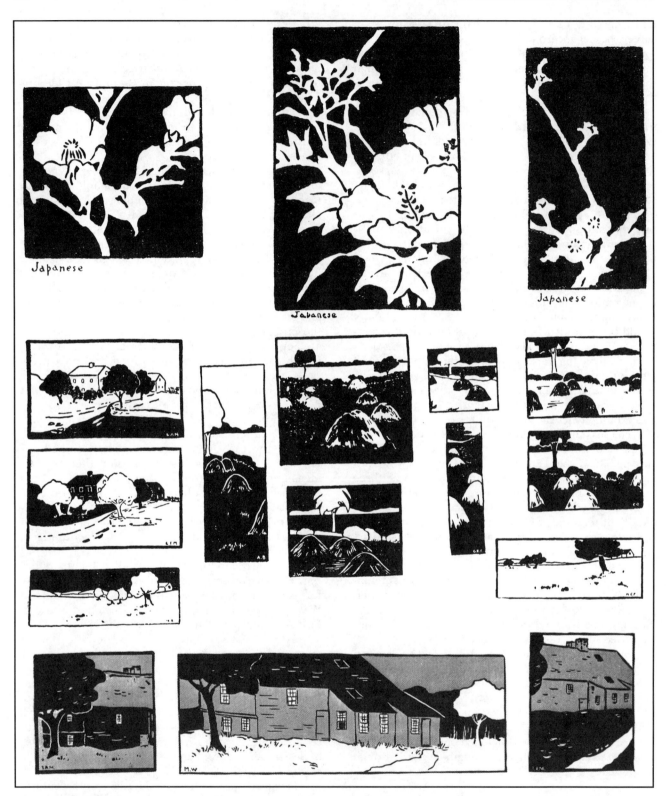

Figure 2-3. Illustrations from pages of Arthur W. Dow, *Composition,* 2d ed. (New York, 1899), showing Japanese derivation of *notan* in two and three tones (top row of three, 47); alternatives in balancing light and dark (middle group of eleven, 54); and composition by selection and placement of portions of the subject (bottom row of three, 74).

the early twentieth century. For them, expression in art meant a quality of the whole work and a power achieved only through long and earnest study. What was expressed was an attribute of the subject, not an inner condition of the artist. Both men taught mostly adults, not children. In art education, Dow has been remembered as the major innovator of his time, but the recognition also accorded to Ross at the time demonstrates that both were agents through whom broad trends entered school art.

The Mainstream: Purposes and Issues

Given the importance of moral education and "character building," art teachers were ready to say that their classes would develop the power to concentrate, observe, imagine, express, create, and generally work hard. The appreciation of beauty was important to the progressive spirit of cultural uplift for everyone; beauty, also, was still closely linked to morality. As pressure mounted for vocational education, the earlier "economic" argument was reasserted, and manual arts became nearly unified with art education. All of these purposes, in sum, could be grouped under three headings: the cultural, the practical, and, increasingly, the development of the individual personality.

The new educational theories brought about the beginning of enduring tensions between the wish to systematize the teaching of art as a subject, the widespread enthusiasm for the correlation of art with other subjects, and the need to attend to the interests and developmental patterns of learners. Moreover, the practicality and the handwork that were recognized as essential in the new education were not easily fitted with the orientation toward the fine arts in the aesthetics of art education.

The Art Curriculum

The Elementary Art Curriculum

The graded courses of study in drawing that were developed beginning around the 1860s, like the plans for other subjects, were governed mainly by an analysis of the learnings into levels of difficulty. It was expected that each new learning would be mastered thoroughly before proceeding to the next. This idea of schooling, however, was challenged by the research of the Child Study Movement and the pedagogical theories of Parker, Dewey, Thorndike, and others, which were concerned with the interests of the learner, the development of the "whole child," and a variety of learnings beyond the particulars of school subjects.

Art teachers observed that older children who continued to progress in art were those who had been helped to draw naturally and readily. Thus, "freedom of expression" could be a more important early goal than any particular skill. It became generally under-

stood that scribbling was a normal phase of development that should be not only tolerated but encouraged and that the subsequent early naming of symbols should be sympathetically supported rather than criticized or outlawed. As the natural interests of children became an important concern, progress in the increasingly diversified areas of art was planned to fit with seasonal topics, school and community activities, and correlation with other subjects.

Thus, in curriculum planning for the primary grades, the aims were rather general if not modest: the development of natural readiness for drawing and construction; the beginning of an appreciation of beauty, proportion, orderly arrangement, and harmonious color; and the nurturing of perception and imagination. In the grammar grades, children were considered ready for work in the crafts media. They were said to be interested in accurate representation and ready to develop other techniques. Longer and more complicated projects were possible and recommended for the development of the sense of planning and good procedure. Up through the seventh and eighth grades, accuracy and skill in drawing were more emphasized; principles of color, composition, and design were more deliberately taught; and mechanical drawing, shop work, and household skills assumed greater importance. In short, basic principles of child development were applied in the elementary art curriculum early in the twentieth century.

The content of the elementary curriculum changed somewhat through the years before World War I. Of the three major categories of study stated at the beginning of the century, *representation* and *construction* remained useful, but *decoration* became subordinate to *design*. Within these categories there were changes, while "appreciation," manual arts, and the relations of art to daily life gained importance.

The Secondary Art Curriculum

In 1909, it was estimated that only one-third of the original school population completed the eighth grade. Most of that portion did not enter high school. In the secondary curriculum, vocational education was sharply differentiated from the traditional college entrance program. The aims of high school art accordingly might be rather directly phrased in practical or cultural terms. It seems doubtful that art classes existed in half of the high schools, though in some cities it was required for as many as four years.

Completion of some art study began to be required for admission to normal schools. By 1909, a course of study in drawing had been approved by the North Central Association of Colleges and Secondary Schools as a basis for awarding credit toward college admission. That particular course design was said to be

Figure 2-4. The high school art curriculum approved in 1909 for college admission credit, from W. H. Elson, "A Course of Study in Freehand Drawing and Applied Arts," *NEA Proceedings* (1909): 661.

NORTH CENTRAL ASSOCIATION OF COLLEGES AND SECONDARY SCHOOLS

DEFINITION OF UNITS IN FREEHAND DRAWING AND APPLIED ARTS ADOPTED MARCH 27, 1909

HOUR BASIS FOR CREDIT (2 UNITS) 240 HOURS FOR EACH CREDIT

Approximately one-third the time should be given to representative drawing and two-thirds to decorative composition, constructive and decorative design, construction and applied design.

　a) PICTORIAL—Plant Study (Flowers, sprays of leaves, seed pods, etc.)
　　　Object Study—(Perspective).
　　　Landscape—Roof studies, buildings, etc. (Perspective).
　　　Pose Drawing.
　　　Composition.
　b) DECORATIVE COMPOSITION—Plant forms, object study, landscape, pose.
　c) DECORATIVE DESIGN—Plant analysis (for the purpose of design).
　　　Conventionalized plant forms.
　　　Decorative units, borders, surfaces, corners, rosettes, posters, book-covers, etc.
　　　Stencils—Wood-block printing.
　　　Historic Ornament.
　　　Arrangement of straight lines, and of straight and curved lines.
　　　Geometric design.
　　　Lettering—Illuminating.
　　　Schemes for Interior Decoration.
　d) CONSTRUCTIVE DESIGN—Designs for pottery, leather, metal, bookbinding, furniture, cardboard construction, textiles, etc.
　e) CRAFTS—Pottery, leather, metal, bookbinding, furniture. (Choice of one or more of the above crafts.)
　f) APPLIED DESIGN—Design applied to the crafts and to cardboard, textiles, etc.
　g) ILLUSTRATION.
　h) TALKS ON HISTORY OF INDUSTRY AND ART, on civic planning, domestic architecture and decoration.
　i) INSTRUMENTAL DRAWING to be given as needed to meet the requirements of practical designing and construction.

NOTE.—Mediums used—pencil, charcoal, water-color, crayons, brush and ink, and a combination of the pure mediums.

Figure 2-5. "Object drawing in tempera, DeWitt High School, third year. Time, two periods per week." *School Arts Magazine* 14, no. 5 (January 1915). Reprinted with permission of *School Arts*.

aimed toward the appreciation of art in relation to manufacture, to homemaking, and to "personal living."

In contrast to the many art manuals for elementary grades, there apparently was no book on high school art before 1908, and the curriculum was left more to the discretion of the teacher, who usually was an art specialist. The high school student in art was expected to be capable of thoroughly disciplined work: the concern for developmental interests and spontaneous expression had been diminished in the upper elementary years and is little in evidence in descriptions of high school art of this period.

The Contents of the Art Curriculum

Representation

Form study in elementary grades was less popular after the nineties: the painstaking drawing of geo-metric solids was considered too abstract and remote from the child's interests. Instead, type forms were exemplified in common objects, like fruits, vegetables, or utensils, which also would provide study in color and composition.

Nature drawing was very important around the turn of the century. In the 1870s, an early champion of nature studies in the elementary curriculum was the influential Parker, who wanted "art in everything." Nature had deep spiritual significance in that era, and in school art, the influence of Ruskinian aesthetics still was strong. "Naturalness" was in vogue in intellectual currents and common behavior. Motifs from nature were featured in Art Nouveau and in the Arts and Crafts Movement. In drawing natural forms, the child could be led to observe the qualities of line, texture, and color; the relation of parts to each other and

Figure 2-6. "From grade to grade there should be a notable improvement in the skill with which the natural specimens are rendered." *School Arts Magazine* 12, no. 1 (September 1912). Reprinted with permission of *School Arts.*

to life functions; and the expressive spirit of the whole. Nevertheless, art educators warned that in the correlation of nature drawing with science, literal factuality could dominate over art values. In the high school, studies of natural form followed the examples of professional artists.

Landscape and still life, which had been derided in the heyday of industrial drawing, became important for the study of color, composition, and expression. In the primary grades, watercolors could be introduced in simple studies of objects or in exercises of sky and ground plane on papers as small as three by five inches. Fourth graders were considered ready for a more deliberate approach: thereafter, rules of composition and perspective were studied; a "finder" of cardboard was used to choose a good composition; and successive pencil tracings might be required for improvement of the composition. The correct drawing of the usual still-life objects was stressed from the upper elementary years through high school, with careful attention, for example, to ellipses, shading, and perspective. Before the First World War, however, there were signs of more liberal approaches: at least a

few teachers reported success in sketching trips outside the school.

Illustrative drawing included spontaneous drawings from personal experience as well as depictions related to history, literature, or other school subjects. In the primary grades, imagination could be given freedom with criticism restrained in order to stimulate the child's readiness to draw, though the ideal teacher would begin with class discussion of the topic and its possibilities for illustration. Beginning as early as the fourth grade, it was recommended that pictorial references be available, that the final solution be developed through several preliminary studies, and that the product be put to use in a booklet or exhibit. High school students were guided by the styles of professional illustrators.

Methods of teaching drawing were much discussed, especially for elementary grades. Some educators, including John Dewey, emphasized individual thoughtful observation. Generally, however, the development of accuracy was pursued more systematically. The academic methods of measurement, plumb lines, connection of salient points, and "blocking in" were

Figure 2-7. "Preliminary studies and final drawing to illustrate Central Africa." Walter Sargent and Elizabeth E. Miller, *How Children Learn to Draw* (Boston, 1916).

This general outline represents a suggestive plan showing where and when the various elements of drawing are taught.

SUBJECT	WHERE TAUGHT	WHEN TAUGHT
Object Drawing Each year Fall		
Position		
Placing 1 and 2 years Winter		
Perspective 1 and 2 years Winter		
Composition 3 and 8 years Winter		
Direction		
Lines 1, 2, 3 and 4 years Winter		
Surfaces 2 year Winter		
Action of growth 3 year Winter		
Action of inanimate form 4 year Winter		
Action of birds 5 year Winter		
Action of animals 6 year Winter		
Action of human figure 7 year Winter		
Action of human face 8 year Winter		
Action of Rhythm — Rhythmic Exercises 1, 2, 3, 4 and 5 years Winter		
Decorative design 5, 6, 7, and 8 years Winter		
Proportion		
Relative size of object 3 year Winter		
Form		
Triangles and rectangles 3 year Winter		
Circles, ellipses and ovals 3 year Winter		
Triangular and rectangular prisms 4, 5 and 6 years Winter		
Cylinders and spheres 7 and 8 years Winter		
Flat Drawing 1, 2 and 3 years Winter		
Parallel drawing 4 and 5 years Winter		
Oblique drawing 6 year Winter		
Mechanical drawing 7 and 8 years Winter		
Color		
Colored Crayons 1, 2 and 3 years Spring		
Water colors — Object painting 4, 5, 6, 7 and 8 years Spring		
Tints and shades 4 year Spring		
Hues and complementary tones 5 year Spring		
The Graded wash 6 year Spring		
The Broken washes 7 year Spring		
Light 8 year Spring		

Figure 2-8. Studies in drawing, scheduled over eight school years. D. R. Augsburg, *The New Augsburg's Drawing, Seventh Year* (Boston, 1916).

important in the teacher's own studies, just as in the professional art schools; these techniques were passed along to children. Shapes were studied through silhouettes in ink or cut paper. Copying from the blackboard, even tracing from printed copies, was still respected by many teachers in the belief that skill must precede artistic expression. Stick figures and stereotypic combinations of "correct" lines were reported to give children recognizable images that satisfied and encouraged them. (It was Dow's alternatives to such methods that attracted enthusiasm across the country.) High school classes were guided more confidently by the methods of professional art schools.

In international exhibitions of school art, which elsewhere usually still meant drawing, the American examples from the elementary grades were praised for their freedom and spontaneity. But many American teachers returned to say, with deep concern, that European children were far superior in accurate representation and that, until a full system of vocational schools could be established, there would be little possibility of matching European standards for high school drawing.

Design

The growing importance of design activities had at least three roots: the Deweyian idea that it exemplified and developed productive thinking; the increasing demand for practical outcomes in all schooling; and the enthusiasm for the Arts and Crafts Movement, with its implications for the ethics of good craftsmanship and affordable good taste. Some art teachers also shared the idea, stimulated by Darwinism, of the infinite variety and order in the natural universe as the grand design of the Supreme Intelligence: nature study and design brought toward a spiritual goal.

Decorative design continued the tradition of "historic ornament," which began as part of industrial drawing, including the arrangement of geometric units, the development of conventionalized plant forms, and the tedious drawing of repetitions of such units. At the turn of the century, children still studied the typical motifs of each of the accepted great periods of ornament—Egyptian, Greek, Roman, Byzantine, Saracenic, and Gothic. But historicism diminished as nature study provided common plants for motifs, and drawn repetitions were commonly replaced by stenciling or block printing. These changes were expected to promote individual invention so that decorative design could be claimed as the most creative activity in the art curriculum, while drawing still was taught as a discipline.

Applied design brought a sense of realism and problem solving into the curriculum. "Decorations" were put to use in the production of practical objects, using a variety of crafts media—wood, leather, clay, or fabric. Lettering and bookbinding became important and provided applications for illustration. Here the distinction from manual arts apparently depended mainly on the teacher's concern for individuality and aesthetic quality. The principles of design stated by Dow and Ross became a standard element of the curriculum from the fourth grade on, together with the tenets of the Arts and Crafts Movement—economy; the virtue of the handmade; and the fit of form to function, materials, and tools.

As many activities in drawing, design, and construction were brought together in a design project, an important long-term effect developed. The standardized sequence of separate learnings became inadequate as the sole basis for curriculum planning. Categories of learning content still could be useful, but the progress in each would be organized into extended, correlated units. Such planning, moreover, could scarcely be dictated by any single standard text. Instead, the art curriculum would tend to be the responsibility of the individual art teacher.

Color was a teacher's problem, not so much one of media or technique but rather of taste and theory. The question of taste reflected one clear influence of changing styles in professional art, as the quiet harmonies of grayed, low-intensity tones gave way gradually to brighter contrasts. The question of theory, to the extent that it troubled the more alert teachers, arose from controversies over the designation of *primaries*, *secondaries*, or *complementaries*; the number of gradations of intensity and value that should be attempted; and doubts about the utility of such theoretical schemes and exercises in school art. After the Armory Show, Arthur Dow himself—despite his contributions to the teaching of design, batik, weaving, and block printing in schools—confessed that he had no solutions to the teaching of color. But whatever the problems associated with color, the increased variety of media and the pervasive cultural excitement over color created by new technology changed the look of school art from the gray and black of pencil and ink and provided a new level of interest for children.

Construction

As a recognition of an important kind of learning activity, the term *construction* had durable validity. But the category came to include anything three-dimensional, from kindergarten blocks, to the modeling of an Indian village, to the planning of a residential interior. For some curriculum planners, construction was a term to account for the crafts, for paper folding and cardboard patterning, for working drawings—floor plans, elevations, or the design of shop products—and for other prevocational activities. Here again, there often was little to separate the "fine" from

Figure 2-9. Student work in design, from issues of the *School Arts Magazine.* Reprinted with permission of *School Arts.*

(a) "Examples of good pen work by high school students." 13, no. 2 (October 1913).

(b) "Post cards printed from linoleum blocks. Notice the different interpretations of the same subject, the Ashland School, Denver, Col." 12, no. 3 (November 1912).

(c) "Designs from seed packs, by seventh grade children under the direction of Mrs. Minna P. McClay, Supervisor of Drawing, Piqua, Ohio." 13, no. 2 (October 1913.

the "manual" arts, and many art educators increasingly denied any such distinction.

Industrial Education

The most extreme development of "construction" and "applied design" was proposed shortly before World War I, as a number of educators began to advocate a curriculum concept that actually had been initiated during the nineties at Dewey's Laboratory School in Chicago. The aim was to develop an understanding of the society as a system of manufacture and commerce. The child was to learn about the conversion of

Figure 2-10. "Designs by grammar school children, Grades Five to Seven, under the direction of Mrs. Lenore Austin Eldred, Birmingham, Ala." *School Arts Magazine* 13, no. 8 (April 1914). Reprinted with permission of *School Arts*.

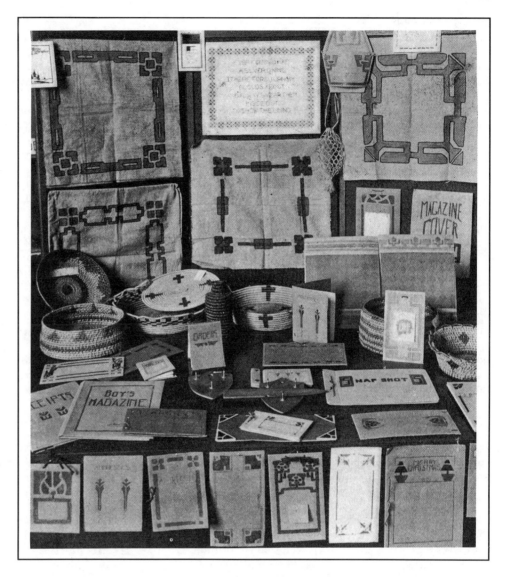

raw material into finished product, about the nature of the factory in major industries, and about the networks of transportation and distribution of goods. Because this would be a curriculum for general education, not merely a vocational training, a radical change in the purpose and content of art education was predicted. This kind of industrial education never dominated the curriculum. Through the twenties, however, the idea was so strong that some art educators spoke of fine art in schools as a part of industrial arts.

Photography

Photography was one of the keen personal interests of Henry Turner Bailey. The camera was used at least as early as 1906 at the Ethical Culture School in New York City by Lewis W. Hine, who became an important photographer of socioeconomic subjects.

Hine and his students used the camera mainly for recording such activities as field trips and nature studies. But experience in the darkroom also was valued, and Hine described photography as an important medium in art education:

> In the art work it is of great assistance in the appreciation of beauty, and is especially valuable in gaining a realization of composition. The recognition of what is good composition in art never becomes so vital as when one is able to select from the infinite variety of objects about him some bit that is pleasing to the eye, and then transfers to the photograph the lines and groups in the form of his idea of composition.[9]

9. Lewis W. Hine, "The School Camera," *Elementary School Teacher* 6 (March 1906): 346.

Appreciation

The belief that the common school should develop the love of beauty, advanced by such New Englanders as Alcott, Barnard, and Mann in the 1830s, had never died, though industrial drawing gave it little direct attention. In the late eighties, that belief gained renewed force: the relation of aesthetics to moral education was powerfully expounded by the commissioner of education William T. Harris; in the era of the "grand tour" and the founding of museums, self-culture seemed right for everybody; halftone reproductions brought inexpensive pictures to the "object study" promoted by the Oswego Movement; and reproductions of famous paintings were a major feature of the campaigns to beautify the schools.

Picture study was not restricted to art education nor to art objects. But, beginning in the late nineties, Perry Pictures and its competitors found that postage-sized black-and-white reproductions could be supplied profitably to each child for a half-penny each. (Several larger standard sizes were also available.) Teachers unskilled in art could work toward several educational goals by leading children in the discussion of persons, objects, scenes, and relationships depicted in paintings. Powers of observation, description, and imagination could be nurtured, and moral lessons were readily illustrated. Most of the talk, even when related to art, considered the subject matter as illustrative of history, family life, or worthy sentiments and behavior. With a bit of printed guidance, the classroom teacher could pass on a few historical or biographical facts and analyze the composition as a kind of theatrical staging, which indeed was often important in the painter's approach. By around 1907, as art teachers found that picture study was irresistibly popular, and the study of composition and design gained momentum, some of them developed exemplary commentaries on masterpieces, with due attention given to the artists' techniques and resulting expression. A considerable number of books were published for classroom or home use, most of them little more than collections of stock commentaries on commonly recognized paintings; a few of them added recommended questions for discussion. Before the movement peaked during the twenties, local curricula, and indeed some state authorities, began to specify the paintings to be studied in each grade. Picture study was much criticized in later years, but the return in the 1960s to the study of art history and criticism brought renewed significance to the earlier effort.

Beyond picture study, or closely linked to it, were a number of other ways of teaching for appreciation. In some high schools, studies in the history of art were included in the curriculum for each year. In larger cities, museums assisted: in New York in 1915, the School Art League sponsored a visiting docent who reportedly spoke at one hundred assemblies before 45,761 children and met 125 classes totaling 3,911 students at the Metropolitan and Brooklyn Institute museums. Studies in art history were sometimes combined with studio work or with courses in world history.

Appreciation through creative work, according to many art teachers, was an approach superior to picture study. As noted above, this view was promoted by Arthur Dow. Art educators like Dow did not disapprove of art history: he lectured to the children in the Horace Mann School (the "model school" at Columbia University's Teachers College) on such topics as the Parthenon, and he was listed by Columbia University as one of its art history faculty, even as he headed the art education department in the college. But Dow claimed that the ultimate goal of school art was the development of fine taste in all aesthetic choices and that this development depended on the experience of individual judgments in such exercises as those described in his book *Composition*.

After the twenties, studio work did become the main approach to art appreciation, as historicism declined and as learning through direct experience gained theoretical force. Early in the century, however, Dow, Ross, and others, whose personal collections included a variety of art forms such as textiles, ceramics, books, and metalwork, were not projecting only their personal values in education. Their idea of good taste in everything was a widespread cultural goal. The term *art* still had an eclectic reference: this was a time when great collectors bought everything a palace might hold, and the palace itself. But although costly masterpieces could represent the highest aspirations of self-culture, the life of millionaires was no useful model for public schools.

"Art in daily living," beginning around 1910, became an important slogan representing the influence of the Arts and Crafts Movement, which promoted a more approachable ideal of good taste throughout the ordinary home. For Dewey and other Progressives, a vital democratic art could not depend on old masterpieces in museums. For the beautification of the civic environment, an aesthetically responsible citizenry would be needed. ("Start with your coffee cup," said John Cotton Dana, addressing adults who aspired toward personal culture in art.) Even earlier, manual arts and other craftswork were intended as a practical aesthetic education. As more modest houses and furnishings became fashionable, high school art projects could combine mechanical drawing, illustration, and sometimes shop work, with consideration of interior decor in an affordable style. Moreover, the place of art in daily living correlated readily with much of the new field of home economics. At the same time, the concern for industrial edu-

Figure 2-11. Illustration for an article on picture study, "Some Happy Children," by Elsie May Smith. *School Arts Magazine* 12, no. 9 (May 1913). Reprinted with permission of *School Arts*.

SOAP BUBBLES
By Elizabeth Gardner Bouguereau

SUGGESTIVE QUESTIONS

Where are these girls seated, indoors or out? What building do you think is represented just behind them? Upon what are the girls seated? Is it well represented? Why?

What are these girls doing? Do they seem to be enjoying their sport? What makes you think so?

What does the eldest girl hold in her hand? What does the expression of her face say to you?

What is her younger sister doing? To what are her eyes directed? What does the expression on her face say to you?

What is the sister doing whose back is toward us? What look do you see in her face? How has the artist shown her intense interest in what she is doing?

Do you think these are attractive looking girls? What makes them so?

Do you think the girls' clothing is well painted? Do you think the figures are well grouped? Why?

What do you see in the window? Do you think this reflection is well represented? Why? Why did the artist make use of such a reflection?

What is the center of interest? How is it made of chief attraction to the eye?

cation brought renewed attention to design in manufacture. As a result of these factors, talks on "art appreciation for the masses" were addressed to art teachers with little reference to the fine arts at the same time when picture study was at its peak.

Research

Before World War I, American and European researchers had developed a considerable body of knowledge about children as artists; several of those early studies were still cited decades later. Children's

art provided evidence of their developmental patterns: thus, there were investigations of their interests in subject matter, their liking for various art activities, their perception and visual memory, their color preferences, and the growth of their vocabulary. There were studies of giftedness in art related to various aptitudes. There were efforts to correlate ability in art with achievement in other school subjects, with measures of intelligence, and with interests in parts of the body. In relation to such studies, the sexes were compared. Other research topics included the comparison of children's art to "primitive" art, the nature of mental operations involved in drawing, and the drawings of the insane.

In the United States, most of this research was done before 1900, during the first enthusiasm of the Child Study Movement. Most of the researchers, who were not art educators, went on to other educational interests. American art teachers were not prepared as researchers; they usually came into education through programs in art or "normal art" and advanced degrees were uncommon. However, the more alert art educators were acquainted with the main findings of existing research, and teaching practices were influenced to some extent.

The focus of much educational research in the early 1900s was influenced by the call for standardization and efficiency. Art education did not develop such research, though the need for it was pointed out beginning in 1910 by Walter Sargent, a professor at the University of Chicago. All the claims for the value of school art lacked proof, he said; teachers could give no convincing answers to questions about the benefits of various elements of the curriculum, the methods that would produce intended results, or the standards of achievement appropriate to each grade. These were only the most general kinds of criticisms that might have challenged researchers in art education. Sargent suggested many others with more precision, and he did subsequently promote a collaborative effort to discover the best methods of developing representational skills in children.

The one major prewar research effort that aimed at standardization was conducted by the psychologist Edward L. Thorndike, who developed a scale to measure achievement in drawing. He expected such measurements to be useful for specifying individual improvement, for defining expected group progress, or for cross-cultural comparisons. The scale had definite limitations: it consisted of fifteen selected drawings, all but one in simple line, which were ranked for progressive superiority by a large number of artists, art teachers, and graduate students. Moreover, the scale was concerned only with accuracy of representation. Nevertheless, Thorndike claimed assurance of the validity and utility of the scale and predicted the

development of other scales to measure different qualities in drawings of other types.[10] A number of such research efforts were undertaken in the following decades, but the general condition described by Sargent was not resolved: even when useful research could be cited, art teachers generally still felt unable to show "scientific" proof of the benefits of their instruction or the efficacy of particular methods.

SUMMARY

At the start of the new century, industrial expansion increased the rate of immigration. Pressed again for practicality, the schools taught manual arts and created the field of domestic science, or home economics. The triumphs of the assembly line popularized the idea of efficiency: standardized learning was to be the measurable productivity of the classroom. Yet most youngsters would not finish high school: many, if not the majority, would go to work after the eighth grade.

The Gay Nineties continued into ragtime. With new freedoms, new technology, and the support of the sciences, the younger generation rejected Victorian strictures of social behavior. Aesthetic sensitivity was part of its liberation. Freud was not yet a popular figure, but he spoke at Clark University. The "new education" of the 1880s was becoming "progressive" education.

Art educators were stimulated by three international conferences—Paris in 1900, London in 1908, and Dresden in 1912. At home, the drawing and design of the nineties continued in a curriculum expanded by color in more varied media. The *Applied Arts Book* became the *School Arts Magazine*, offering yearlong curricula for each grade. The Prang Company published full-color hard-bound texts for each of the first seven grades and another for high school. The greatest excitement was stirred by Arthur Dow's new theory and method: his students at Teachers College, Columbia University, came from all over the country and graduated to important positions to teach art structure and composition and to promote the Arts and Crafts aesthetic.

Dow believed that exercising judgment in two-dimensional composition would develop fine taste in all aesthetic decisions—appreciation through making art. "Picture study" enabled unprepared classroom teachers to promote a kind of art appreciation that combined story telling, commonplace opinion, and moral inculcation. Art museums developed educational programs in cooperation with schools.

10. Edward L. Thorndike, "The Measurement of Achievement in Drawing," *Teachers College Record* 14 (November 1913): 345–82.

Professional organizations of teachers of art and manual art merged because their teachings and job titles were often indistinguishable. The integrity of both subjects, however, was threatened by a new curriculum concept, *industrial education*.

The research developed in the Child Study Movement was not continued by art educators. The psychologist Thorndike published an elaborate scale of quality of children's drawings. One art educator, Walter Sargent, did study the methodology of drawing instruction for young children, and he urged others to take up research to provide proof of effective teaching to meet the national demand for efficiency.

FURTHER READINGS

Bailey, Henry Turner. *Art Education*. Boston, 1914.

Batchelder, Ernest A. *The Principles of Design*. Chicago, 1904. An early representation of Ross's theories.

Daniels, Fred H. *The Teaching of Ornament*. New York, 1900. An excellent representation of turn-of-the-century practice.

Dow, Arthur W., "Training in the Theory and Practice of Teaching Art." *Teachers College Bulletin* 10 (May 1908): 49–50.

Farnum, Royal Bailey. "Present Status of Drawing in the Elementary and Secondary Schools of the United States." *Bureau of Education Bulletin*, no. 13 (1914). Farnum gives detailed information, with numerous photographs of student work.

Hall, Stanley, G. *Educational Problems*. New York, 1911. In volume 2, Hall gives a long listing and discussion of research in children's art to that time.

Haney, James Parton, ed. *Art Education in the Public Schools of the United States*. New York, 1908. Prepared for the Third International Congress for the Development of Drawing and Art Teaching, London, 1908, this book gives the most comprehensive description of practice in this country at the time.

Moffatt, Frederick C. *Arthur Wesley Dow (1867–1922)*. Washington, D.C., 1977. The best biography.

Sargent, Walter. *Fine and Industrial Arts in Elementary Schools*. Boston, 1912.

Sargent, Walter, and Elizabeth E. Miller. *How Children Learn to Draw*. Boston, 1916.

⊰ 1916-1929 ⊱

The twentieth century, it has been said, entered the United States in the years between World War I and the Great Depression. The demise of the Victorian code of behavior that began in prewar ragtime was completed in the twenties: modern youth was "liberated." Nineteenth-century aesthetics and popular taste likewise were left behind. Post-Impressionism and early twentieth-century art began to come into some schools because progressive education prized creative self-expression. Art teachers were equally influenced by more general educational issues: the demand to equip students for daily adult responsibilities; an industrial education curriculum to support the nation's productive power; and the increasing popularity of "activity learning," which engaged children in correlated art projects. By the end of the decade, "creativity" was the most honored word in art education.

SOCIAL AND CULTURAL CONDITIONS

Social Factors

Europe was battered and exhausted. Its empires were broken; its seventeen prewar nations had become twenty-six. The idealism represented by Wilson's proposals for the peace treaty were overpowered by traditional national contentions, and the United States itself stayed out of the League of Nations. The very nature of government was in doubt: World War I had been a war "to make the world safe for democracy," but collectivism, with its promise of dynamic efficiency, challenged the momentum toward individuality. The public mood mixed idealism and disillusion: internationalism and isolation, technocratic materialism and pop psychology, public optimism and private anxiety.

The United States emerged as the dominant power, the leading industrial producer. In a decade of Republican presidencies, *laissez-faire* policies favored business interests; Harding's campaign slogan in 1920 was "back to normalcy." After the brief depression of 1921, the 1920s were an affluent decade: real per capita income rose by almost one-third from 1919 to 1929. Assembly line efficiency increased even more impressively. Technocrats rode high, while unionism was quiescent. Prewar social progressivism waned, apart from the granting of the vote to women and the enactment of prohibition.

Yet there were many tensions. Agriculture as well as the mining and textile industries were exceptions to the general prosperity. In a population of unprecedented ethnic diversity, farm families were outnumbered for the first time in 1920 by city dwellers, many of them African-Americans migrating from the South. Racial clashes occurred in several cities in 1919. The Ku Klux Klan reemerged violently, expanded sufficiently to influence elections, and accentuated social animosities. Bombs, fear of Bolsheviks, and a government-promoted "Red scare" contributed to general prejudices against the foreign born and a drastic reduction in immigration. In the schools, citizenship education seemed urgent.

New products and aggressive merchandizing changed daily living. The family car could be more important than the bathtub: nine million cars in 1920 increased to more than twenty-six million in 1929. The first radio station, KDKA–Pittsburgh, began in 1920; two years later, New Yorkers heard daily newscasts. Auto dealers developed installment buying; by 1925, two-thirds of the new cars sold each year were bought on credit, immediate gratification replacing an old puritan ethic. By the end of the decade, the normal patterns of American life were determined by mass processes in manufacturing, merchandising, communication, and consumption.

Intellectual Currents

The public seemed eager for knowledge: several new encyclopedias were published. Authors of the stature of H. G. Wells and Bertrand Russell wrote for the general reader about world history and the newer sciences of the atom and bacteriology. The number of substantial new historical studies of American pioneering, politics, thought, and social trends suggests the wish for a national identity more distinctly sepa-

rate from Europe. American educators were aware of internationally important advances in science, mathematics, logic, linguistics, and the social sciences. They saw that the expansion of knowledge and intellectual disciplines would require the revision of subject matter, the development of a flexible, experimental intelligence, and an emphasis on independent problem solving.

At the same time, among less urbane elements of the diverse population, Darwinism was still anathema. Religious fundamentalists in many states promoted legislation banning the teaching of evolution in schools. The outcome of the Scopes trial in Tennessee, whatever its notoriety, showed how profound was the resistance to science and how remote the possibility of a national curriculum.[1]

Psychology on the professional level saw the emergence of gestalt theory and the further development of behaviorism. The processes of learning increasingly were conceived as functions of the whole organism. Woodworth's "dynamic psychology" emphasized basic drives rather than specific instincts waiting to be triggered or behaviors waiting to be reinforced; any purposeful activity, including learning, would be rewarding in itself, if it were important to the individual. "Equilibrium," "adjustment," and "interest" became key terms in learning theory.

Such psychologies reflected increased scientific interest in the relationship of humans to their environment and a continued effort to broaden the scientific base of educational theory. Studies in animal ecology and herd behavior became numerous after 1910 and were cited by some educators in the twenties. Woodworth credited the physiologist Charles Sherrington for the basis of his theory. William Heard Kilpatrick, a leading exponent of Deweyian thought, in his own work cited J. B. S. Haldane, who studied organisms and environment as a unity.

On the popular level, while psychoanalytic terminology became fashionable, the practical problems of the normal adult gained new attention in a variety of books explaining human behavior. Educators' concerns for mental hygiene and social adjustment reflected a general public concern.

The **ideas** shared among the younger intelligentsia, according to one of them, were such as these:

■ A new generation of children, their innocence and purity preserved by a new education, might build a better world.

■ Creative self-expression and a life of beauty constitute the life purpose of every person.

■ Paganism represents the natural beauty of body and love.

■ Life is to be lived in full intensity at each moment.

■ Every law, rule, or convention that opposed these goals should be rejected.

■ Women should be treated as equal to men.

■ Psychological maladjustment is the common result of modern repressions; adjustment can be achieved individually through a variety of treatments and disciplines.[2]

These ideas, according to critic Malcolm Cowley, spread from New York's Greenwich Village through the country in the 1920s. They usefully summarize the climate that nurtured the development of creative self-expression as a major goal of art education.

Culture and the Arts

The 1920s gained an aura, a mythos, as an especially significant decade: they were the "roaring twenties"; the "jazz age"; the decade of the "flaming youth," the "flapper," the "speakeasy," and the "lost generation." In many respects, these terms represent the renewal of the prewar ragtime era. Equally evident, however, were the influences of expanding entertainment and communications industries, relatively unprecedented affluence and mobility, the predominance of the city, and an attitude of moral independence.

Bobbed hair in 1919 was a sign of radicalism; it was merely a fad in 1921, when skirts reached the knees. Rouge and lipstick were immoral in 1920 until advertisers turned from the provision of real needs to the creation of desire and the "engineering of consent." Coed smoking became commonplace, and the enclosed car became an instrument of romance. Nightclubs were new around 1922. Sports became big business.

Books represented concerns of the period that influenced education, however indirectly. The war novels that affected Americans most deeply, like Hemingway's *A Farewell to Arms* and *All Quiet on the Western Front* by Remarque, a German, did not glamorize; they intensified the wish to build a new morali-

1. In 1925, J. T. Scopes, a public school teacher in Tennessee, was tried in court on a charge of teaching Darwinian evolution, a violation of state law. His conviction was reversed by a higher court, but the trial, notorious nationally at the time, has remained as a landmark in the relations between religion, science, and democratic government.

2. These ideas have been paraphrased from Malcolm Cowley, *Exile's Return* (New York, 1934), 70–71.

ty. Disillusion among the younger generation was the domain of F. Scott Fitzgerald in *This Side of Paradise*, *The Beautiful and the Damned*, and *The Great Gatsby*. Edna Ferber wrote about the new American woman. Sinclair Lewis pilloried small-town life, evangelist religion, and middle-class materialism. John Dos Passos's *Manhattan Trilogy* (1925) probed the flaws of capitalism. In Theodore Dreiser's *An American Tragedy* (1925), a poor Midwestern youth, lured by the wealth and high life of the big city, ends as a murderer sentenced to death. But many books were also published advising of keys to success. A best-seller for two years was Bruce Barton's *The Man Nobody Knows*, which presented Jesus as a supreme executive and advertiser, "the most popular dinner guest in Jerusalem," and "the founder of modern business" through his dedication to service.

Sex was a favored subject at all levels of literature, often as a sharing of the problems of the new freedom. At least three English authors had an enduring impact: Havelock Ellis's *The Dance of Life* (anthropology showing human sexuality as natural); Hall's *The Well of Loneliness* (lesbianism); and D. H. Lawrence's *Lady Chatterlee's Lover* (the man of nature releasing the cultivated woman).

At the end of the decade, Waldo Frank, one-time husband of Margaret Naumburg, saw America as a jungle, with man at the mercy of machines and economic forces. Wildly pluralistic and uncontrolled, America, according to Frank, was built out of the remnants of Europe and had no organic wholeness of its own. She was rich and pleasure seeking, but uncomfortable. Her current arts still lacked conviction: "The enormous energy of American life does not enfuse them, and the American traditions do not inform them."[3]

Music, nevertheless, provided genuine American expression. As African-Americans came north to the big cities, jazz became an international enthusiasm. It grew sophisticated. (Indeed, most popular songs, that before the war were simple enough for the amateur to master at home, were now written for professional performance in Broadway shows.) Men like Fletcher Henderson and Duke Ellington led larger night-club bands using the complex harmonies of Debussy and Ravel; Stravinsky and others took up the syncopations of jazz. Gershwin's *Rhapsody in Blue*, introduced by Paul Whiteman in 1924, represented the entry of jazz and show music into the concert hall.

Aaron Copland worked deliberately toward an American style by joining jazz and folk material with Parisian modernism. Others, like Varese, Sessions,

and Cowell, extended the possibilities of music through individual styles. While the next generation of American composers studied in Paris, contemporary music was promoted in concerts organized by Copland and Roger Sessions and through the League of Composers and other groups.

Dance was so new to American audiences in 1910, when Pavlova brought her company for its first American tour, that a promotor could claim that ballet was an art unknown in the United States. But beginning in 1916, Americans could see the foremost contemporary Parisian ballet and the greatest male dancer, Nijinsky, in the tours of Diaghelev's company. Adolph Bolm's Ballet Intime toured the country after 1917; Fokine founded a ballet school in 1921 and a company in the next year; by 1928, a festival of recent ballets was presented in Washington, with Bolm and Stravinsky collaborating in a new work commissioned by Elizabeth Sprague Coolidge.

The 1920s also saw the development of modern dance in America. Martha Graham, Doris Humphrey, and Charles Weidman emerged from the Denishawn company to build more abstract, personal styles. A more direct social commentary was made by Helen Tamiris in her *Negro Sprituals*, *Revolutionary March*, and *Dance of the City*. In popular ballroom dancing, the "dance craze" of the ragtime era quieted somewhat until the charleston became popular in 1926. The "black-bottom" was considered too vulgar to last, but the fox-trot and waltz, taught systematically by Arthur Murray, ensured the respectability of ballroom dancing. All the contemporary dance styles were brought together in Broadway musicals.

Film transformed popular entertainment. Vaudeville and road-show theater faded quickly, no match for the cinematic combination of realism and escape and the fantastic luxury of the great "movie palaces." In one midwestern city in 1923, over three hundred showings were available every week; in one month the box office sold tickets to four and one-half times the total population.[4] After the first big success with sound (Al Jolson in *The Jazz Singer* in 1927), movie attendance nearly doubled. Adventure, romance, superdramas, westerns, comedies, and especially subjects of contemporary sex brought a new level of worldliness and sophistication and new models of dress, behavior, and morals.

Theatre on Broadway, of course, did not die. In a generally light-hearted decade of comedies, revivals, and a few war plays, the most significant contemporary expressions were Eugene O'Neill's studies of primitive drives, dark obsessions, decadence, and vio-

3. Waldo Frank, *The Rediscovery of America* (New York, 1929), pp. 126–27.

4. Robert S. Lynd and Helen Merrell Lynd, *Middletown* (New York, 1929), 263.

lence—the psychology of the irrational, the id. Musical theatre was perhaps more typical of the 1920s. The operetta gave way to the review and the musical play or comedy—old-world romance replaced by modern girls, catchy hit tunes, current lyrics, and jazzy dancing.

THE VISUAL ARTS

Modernism in painting and sculpture was not readily appreciated by the general public. Post-Impressionist art, exhibited at the Metropolitan Museum of Art in 1921, was called "degenerate" and was linked to Bolshevist propaganda in an organized protest. German Expressionism was shown in New York as early as 1923, though it had little if any recognition in school art for years to come. Surrealism had little impact in the United States before the thirties.

Nevertheless, from the time of the Armory Show in 1913 until the early 1920s, there was a considerable vogue, at least in art circles in New York, for Cubism and other elements of early twentieth-century modernism. By 1915, three leading Parisians, Duchamp, Picabia, and Gleize, were active in New York. In 1916, the Forum Show presented the abstract work of seventeen Americans returned from Paris, and Futurism arrived in San Francisco at the Panama Pacific exhibition. Duchamp's famous urinal, signed "R. Mutt," was rejected by the 1917 exhibition of the Society of American Artists—the most noted manifestation of a small flurry of Dada activity. New Yorkers could read criticism of abstraction and view such work in a few galleries. The Société Anonyme, founded in 1920 by Katherine Drier, Duchamp, and Man Ray, exhibited many of the leading European modernists, including Klee, Kandinsky, Léger, Archipenko, Ernst, Miró, Malevich, and Schwitters.

By that time, however, most of the first generation of American Cubists had returned to more traditionally representational styles. Some of them had a stronger urge to do something purely American. It was said that Americans were not ready for a radically changed worldview or that they had compromised by simply presenting the usual subjects in a Cubist style or by attempting to combine the best of the old and new. The first wave of modernism ebbed quickly. The *Seven Arts*, a magazine founded in 1916 by Waldo Frank and others, saw in the new art an expression of America's greatness in a renascent culture; it lasted less than a year. Alfred Stieglitz's magazine *291*, founded in 1915 with the help of Francis Picabia (soon a leader of Dada), also was published for only a year. *New York Dada*, published in 1921 by Duchamp and Man Ray, existed only in a single issue.

Regionalism began to develop in the 1920s, most durably in the murals of Thomas Hart Benton.

Painters like Hopper and Burchfield followed Sloan and others of the "Eight," matching the gloomy cast of naturalist writers. The "Precisionists"—Sheeler, Shamburg, Demuth, Spencer, and others—combined photographic clarity and Purist simplification with abstract compositional values to give a modern interpretation of such American forms as barns, factories, and grain elevators.

Printmaking gained popularity in the 1920s. The etchings of Whistler and Pennell already were collected, but a particularly modern expressivity was found in block printing and lithography. At Teachers College, Columbia University, art education students were given a course in the history of prints, and a young instructor, Arthur Young, learned from commercial printers the techniques of printing from the stone.

Architecture and industrial design, including graphic and interior design, brought "modern style" to popularity with the general public: new products, new life-styles, new looks. From the Arts and Crafts Movement through the Viennese Secession, the Werkstatte, the Werkbund, and after World War I in the De Stijl group and the Bauhaus, modern design showed a spirit of social meliorism. The designer, a concerned rationality governing the limitless new technology, would create a sane, hygienic, exhilarating environment. The skyscraper lost its Gothic remnants: "ornament is crime," said Adolf Loos. In the new world of design, there was more than a hint of the statistician, the social engineer, the efficiency expert. The postwar decade was a time of dream cities, of precision and pure form, of functionalism, of Le Corbusier's "machine for living," of the beginning of the "International Style." But not only "dream" cities: a number of planned communities were developed in the United States and elsewhere so that the promise of planning for better living had public interest.

Luxurious craftsmanship had its main event in the 1925 Exposition Internationale des Arts Décoratifs et Industriels Modernes. But even at its most elegant, the modern style could be filtered to American department stores in mass manufacture, with its imagery ubiquitous in advertising graphics. Modern design was popular. The intuitions of Cubists and nonobjective painters and sculptors may have been too difficult for the general public to comprehend, or too European for the American artist, but the conception of the modern as stylized in manufacture was tangible, exciting, and inexpensive.

In the United States, however, there was no school to produce industrial designers until the end of the decade. Nevertheless, the field was established as a specialization during the 1920s, led by men who generally were either architects or designers in theatre, graphics, or fashion.

Museums multiplied: sixty were founded between 1921 and 1930. Modernism had its champions. The Phillips Memorial Gallery in Washington, founded in 1918, was the nation's first public gallery devoted to contemporary art. Gertrude Vanderbilt Whitney organized the "Friends of the Young Artists" in 1915; three years later, it became the "Whitney Studio Club," which gave exhibitions for its artist members and formed the basis of the Whitney Museum of American Art, which opened in 1931. The most important addition was the Museum of Modern Art in New York, which opened in 1929.

Museums returned to their earlier concern for the design of industrial products. The annual conference of the American Association of Museums in 1917, titled "The Producer and the Museum," stimulated, for example, a series of exhibitions by the Metropolitan Museum under a full-time curator. They were intended to have a strong public effect: in 1929, the eleventh of these, titled "The Architect and the Industrial Arts: An Exhibition of Contemporary American Design," involved the collaboration of one hundred fifty manufacturers, designers, and craftsmen. In Newark, John Cotton Dana presented an exhibit of household items costing no more than ten cents to show that good taste in the home was not dependent on money.

Museums also exhibited children's art and expanded their educational programs. Gallery talks, loan programs, and collaborations with schools were common. The Metropolitan and other museums developed programs for department store buyers and sales personnel to acquaint them with trends in modern design—assisted by faculty in art education selected for such expertise. Lectures were provided for the deaf who could read lips and for the blind with objects that could be handled. At least ten films were produced by the Metropolitan and rented to schools throughout the country.

Aesthetic theories recognizing twentieth-century art and culture began to reach public education during the 1920s. Intuitionist theories, particularly Bergson's, and the writings of Lipps and Vernon Lee on empathy in the response to art evidently fitted with the art teacher's interest in individual expression and creativity. Clive Bell's provocative insistence on the primacy of aesthetic values in art supported the deemphasis of accurate drawing, the move toward formal principles, and probably the growing recognition that some kind of aesthetic education was a responsibility of the school.

The changes reflected in the arts and literature were described in more conservative terms by educators through the 1920s. Schools, they said, had to change accordingly. Americans would have to learn that nations were interdependent. They would have to be prepared to live by the machine rather than by hand labor. Biological sciences had developed new awareness of the problems of health, and the social sciences explored the tensions between individuality and the increasing massiveness of society. Rapid transportation and the new media of communication might extend personal freedoms, but they also could promote uniformity of thought and attitude so that intelligent independent judgment would become both a possibility and a necessity. This need for "liberated intelligence" was important to curriculum planners, and it became a feature of the rationale for art education.

CONDITIONS IN EDUCATION

The decade of the 1920s in American schools was marked by two major features: the reconstruction of the curriculum and the powerful impetus of the Progressive Education Movement.

As World War I ended, American educators turned from their brief concern with such topics as patriotism, defense, and food production to more general problems: citizenship and moral education, vocational programs, the "new internationalism," and the rebuilding of civilization.

The war had revealed a shocking degree of illiteracy among draftees; teachers seemed inadequately educated; the nation had no broad system or standards for schools. Buses could begin to reduce rural isolation, but many schools were too small to support the diversified curriculum that the times demanded. Through the decade, the National Education Association formed committees responsible for character education, thrift, measures and standards, relations with museums and the movie industry, audiovisual instruction, and varieties of specialized curricula. As early as 1922, thirty-four cities were reported to be using "pedagogical films" in classrooms and assembly halls. By 1926, educational radio programs were offered, complete with syllabi. The rapid growth of junior high schools and junior colleges added to the problems of curriculum revision. The campaign to strengthen federal organization and support of education was constant and inadequate. Early in the decade, Red scares and labor strikes were reflected in educational emphasis on Americanism and democracy. By 1929, world peace and Mussolini had become conference agenda concerns.

Changing conceptions of purpose and method in American education in the 1920s guided schools through midcentury. The basic convictions underlying these changes are well represented by two documents.

"Seven Cardinal Principles" were promulgated in 1918 by the National Education Association's Commission on Reorganization of Secondary Education. In 1893, a National Education Association

Committee of Ten reaffirmed a high school curriculum based upon college admission requirements. But since then, the high school population had grown: child labor laws were more stringent; the Smith-Hughes Act in 1917 had funded vocational education; and the expectation of a high school education grew among employers and work force alike. A new definition of secondary education was needed. Its main objectives, according to the commission, were to meet seven common basic needs of adult living. These needs were stated, and became widely known, as the Seven Cardinal Principles: good health, effective citizenship, worthy home membership, ethical character, an adequate vocation, worthy use of leisure time, and "command of the fundamental processes" (i.e., basic ability in the three R's).

The **Progressive Education Association** avowed principles that had begun with the "new education" before the turn of the century:

■ "Freedom to develop naturally," under self-governance, and with full opportunity for initiative and self-expression.

■ "Interest, the motive of all work," promoted through experience, application of learnings, and correlation of subject matter.

■ "The teacher a guide, not a taskmaster," encouraging use of all the senses, acting as a resource person, and guiding logical conclusion and expression.

■ "Scientific study of pupil development," including subjective reports, to show social, physical, emotional, and moral growth as well as academic advancement, recorded to guide all phases of development as well as teaching of subject matter.

■ "Greater attention to all that affects the child's physical development," with attention to health and the school environment.

■ "Co-operation between school and home to meet the needs of child life," the better to provide for all natural interests and activities.

■ "The progressive school a leader in educational movements," a laboratory for combining new ideas with the best of the past.[5]

The Progressive Education Association was founded in 1919. John Dewey was the acknowledged conceptual guide, though he questioned the extent of

5. *Progressive Education Quarterly* 3, no. 2 (April–June 1926).

its "child-centeredness" and the subordination of subject matter of which progressive schools were accused. Most leaders of the Progressive Education Association were representative of small private schools and university education departments. But "progressive" models were found also among city systems. In Dalton, Massachusetts, Helen Parkhurst developed a system of "contracts," through which elementary pupils undertook specific studies. Carleton Washburn, the superintendent of schools in Winnetka, Illinois, promoted units of work for each grade so that individualized plans of instruction could be fitted to each student's abilities—a forerunner of programmed instruction. Teachers College, Columbia University, collaborated with the New York City system at the experimental Lincoln School, where the poet Hughes Mearns and others liberally encouraged creativity in relating literature and the arts. Indeed, emphasis on individual expression through the arts was a hallmark of progressive schools.

Educational research following World War I was especially concerned with the development of tests and measurements that could be standardized for age or school year to assess both general intelligence and special abilities. Where "progressive" educators saw a means of individualizing instruction, others saw possibilities of economy, efficiency, and/or national standards, as befitted a "scientific education" in the era of technocracy. Critics of the latter view feared that standards and testing would lead inevitably to a national system, with a single curriculum in which the traditional state and local control would be surrendered.

Curriculum theory developed markedly in the 1920s. An unprecedented flow of books and articles grappled with the Seven Cardinal Principles; the tenets of the Progressives; the development of stimulus-response theory and holistic psychologies of learning; "scientific" methods; the concern for industrial, vocational, and moral education; and the spread of the junior high school. All of these implied changes of content, organization, and method.

The "scientific" approach to the revision of subject matter required the identification of the tasks of adulthood, just as efficiency experts in industry measured every movement on the assembly line. But sociology revealed a variety of adult life patterns among the many distinct segments of the general population; for each of these, according to theorists, the curriculum should provide specialized content. Necessary learnings were tabulated; bankers, for example, advised on the learnings necessary for effective adulthood at the bank. Psychologists developed lists of the most commonly useful words. In the extreme, the adult activities represented in the Seven Cardinal Principles were claimed to constitute the sole source

for learning objectives in the schools; the study of Latin, for example, could hardly be defended. But the principles of uniformity and diversity clashed: "scientific education" also required the recognition of individual differences, which implied greater variation of subject matter.

The **organization and method of instruction** were to be guided by further theories. Dewey's pragmatic philosophy, together with his conception of learning as the thoughtful reconstruction of experience, recommended an experimental mode of learning that fitted well with the growing conviction that "learning by doing" answered best both to psychology and to the needs of adult living. Woodworth's dynamic, organismic psychology was also evident in the ideas of purposiveness, wholeheartedness, and learning as growth. Such theories intensified the interest in originality and creativity and implied the need for individual freedom in the curriculum. By the end of the decade, the "activity curriculum" was popular, and a curriculum was seen as an organization of "learning experiences."

In contrast, "scientific education," behaviorism, and practicality called for specific objectives. Specificity was implied further by Thorndike's advice that learnings would transfer to other contexts only to the extent of common elements. Yet the learner's need for connectedness—integration—called for the correlation rather than the separation of school subjects. At the same time, the "law of interest" argued that learning would be most effective where the curriculum was based upon personal experience. "Motivation," as one syllabus said, was the "new note" in education.

These diverse implications from educational theory were in some degree accommodated through **curriculum units**, which became popular as a way of organizing a series of lessons that might bring several subjects to bear upon a central problem. The **project method** went further, developing such units around problems or products that were supposed to incorporate the personal goals of individual students and thus maximize personal motivation and development (Thorndike's "law of readiness") as well as reward (his "law of effect"). Kilpatrick, the leading theorist of the project method, identified four types of projects: making or producing; enjoying (listening, seeing, appreciating); problem solving; and skill gaining. The test of a good project was the student's own purposing and its evaluation by classmates for social learning.[6] Any of the four types of projects could involve the arts.

Late in the 1920s, the principles of Darwinism, the concern for holistic individual development

("growth"), and the increasing interest in personality and psychotherapy came together with an emphasis on societal goals of education. The learning experience was seen as an interaction with an environment drawn from life situations, resulting in the acquisition of new adjustive behaviors. The entire curriculum thus could be construed as a collection of desirable adjustive techniques in all domains of life—physical, social, familial, economic, or spiritual.

But within this generality, a major issue appeared, one which has persisted through the following decades. Those who gave priority to the individual, especially Progressives influenced by psychoanalytic theory, saw adjustment as a resolution of internal forces in the development of a balanced personality. From another viewpoint, those who gave priority to the societal purposes of education appeared to think of adjustment as a constraint on the most common patterns and manners of adult living—the opposite of individuality. For still another group, these curriculum theories of the 1920s posed a radical threat to the status of the traditional subjects as distinct categories of knowledge worth acquiring in a well-rounded education. Curriculum planning thus came to be a process of balancing three main concerns: for the society, for the individual, and for the subject mattter.

ART EDUCATION

Introduction

From the viewpoint of subsequent directions, probably the most important development in American art education in the 1920s was the gradually increased emphasis on creativity and self-expression, especially as a feature of the Progressive Education Movement. Less dramatic, but probably more pervasive, was the continued shift in curriculum planning, from independent lessons to units that promoted correlation and more or less incorporated the project method. At that time, however, many art teachers would have said that the most notable new interest was the contribution of art to industrial education and to the appreciation of beauty in daily life. In all of these tendencies, of course, art teachers were responding to external conditions in the culture, in the world of art, and in education generally.

The Status of Art Education

Certainly conditions were favorable. School art was supported by educational theory. There was evidence of growing public recognition of the educational values and the cultural and industrial importance of art and design. In major universities between 1920 and 1930, schools or departments of art and architecture became common, and enrollments increased fivefold; registrations in independent art schools

6. William Heard Kilpatrick, "The Project Method," *Teachers College Record* 19 (September 1918): 319–35. Kilpatrick acknowledges the earlier work of Dewey and Charles McMurry.

increased by 50 percent.[7] In big city high schools, at least, the number of students taking art courses increased much more than did total enrollment. In the burgeoning junior high schools, art was commonly required for at least one year. The number of art teachers and the expenditures for art classes increased accordingly. Through the 1920s, leaders in the field claimed that art education had reached a new level of maturity, that it was finally emerging from its experimental beginnings.

Even so, its status as a subject was still uncertain. With the emphasis on learnings useful in daily life and the prestige of vocational education as the recipient of federal monies, art was often classified as one of the "practical arts," and in some cases, it was even identified with industrial arts. In 1919, it was reported that in twenty midwestern states, more than half of the secondary schools did not conduct courses in art, even though big city high schools might offer four years of art electives. In most elementary schools, art instruction was conducted by the classroom teacher, with whatever help an art supervisor provided. Moreover, one teacher was often responsible for both fine and industrial arts, extending the problem of capability.

Materials and equipment continued to improve. The growing school population and the new junior high schools in particular required new construction. There would be special facilities for industrial arts, and art could claim its share. Early in the twenties, reproductions in full color became available for picture study. **Audiovisual** instruction gained impetus: the Eastman Kodak Company in 1926 announced a two-year experiment in educational film, with the "fine and practical arts" as one of five subject areas involved.

Professional organizations reflected the ambiguous position of art teachers. In the National Education Association, they were placed for several years in the Department of Vocational and Practical Arts. But their subject had little if any place in the departmental convention program after 1920. By 1924, it was simply the Department of Vocational Education, and art teachers had no departmental home in the National Education Association until 1933.

Regional associations provided art teachers with their main professional affiliations. In 1919, the Western Drawing and Manual Training Association became the Western Arts Association. Yet, in the early twenties, the Eastern Arts Association, which had undergone a similar change four years earlier, had nine divisions embracing manual arts, industrial arts,

household arts and domestic science, printing, and school gardens. The identity of art teachers apparently was clearer by 1925, when the Pacific Arts Association held its first convention.

In 1925, the Western, Eastern, and Pacific arts associations joined with the American Federation of Arts, the American Institute of Architects, the Association of Art Museum Directors, and the College Art Association to form the Federated Council on Art Education. This was a delegate body that was expected to fulfill the functions of a European ministry of fine arts, without the regulative hand of government. Its main achievement, however, was a set of committee reports on art instruction at various levels and on the terminology of art: it was not effective otherwise in the strengthening of national policies favorable to school art.

International conferences were not resumed after the war until 1925, when the fifth congress was rather hastily put together in connection with the great exposition of decorative arts in Paris. Only one hundred fifty attended (including two Americans), representing twenty-three nations. But the sixth congress, in Prague in 1928, was large and well planned, and it demonstrated the enthusiasm of art teachers in the United States. Approximately one thousand of them attended, and they could compare the work of American children with exhibits of school art from twenty-six other countries.

Publications

The belief that art education had reached a new level of maturity by the end of the 1920s was borne out by the number and quality of books published through the decade that were directly concerned with school art. Several of these, written by art teachers or supervisors, dealt in detail with problems of purpose, curriculum planning, the newer psychologies, and classroom method. Neither of two similar efforts before the war, by Henry Turner Bailey and Walter Sargent, could match the treatments of elementary art education by Belle Boas, Margaret Mathias, and Leon Winslow or the first two really comprehensive texts for preparing art teachers—Winslow's *Organization and Teaching of Art*[8] and Whitford's *Introduction to Art Education.*[9]

An important book edited by John Dewey resulted from his intense study of art and aesthetics in association with the Barnes Foundation. *Art and Education* (1927) includes three essays by Dewey, another by Thomas Munro, an influential aesthetician and direc-

7. Frederick P. Keppel and R. L. Duffus, *The Arts in American Life* (New York, 1933), 39–47.

8. Leon Loyal Winslow, *Organization and Teaching of Art* (Baltimore, 1925).

9. William G. Whitford, *An Introduction to Art Education* (New York, 1929).

tor of the Cleveland Museum of Art, and others by recognized authorities on art.

Many new books were offered on picture study and appreciation. Three of these were highly successful because they promoted the extension of appreciation beyond the fine arts. *Essentials of Design*, by De Garmo and Winslow, was a text for schools and the public that intended to develop an understanding of the principles basic to good taste in industrial design, house decoration, and clothing.[10] *Art in Every Day Life*—a more detailed text directed toward "students of art, of home economics, and of salesmanship"—was written by Harriet and Vetta Goldstein, two art professors lodged, significantly enough, in a university department of home economics.[11] George Cox wrote *Art for Amateurs and Students* to demonstrate the continuing validity of Dow's "art structure" for achieving an appreciation of architecture, sculpture, painting, and the "minor arts," including examples of the most current styles.[12]

Useful newsletters and guides for classroom activities, some of them bound in volumes or compiled in portfolios, were distributed by manufacturers of school art supplies. Many art teachers, still unprepared for the increasing variety of tools and media and constantly looking for new projects, followed these instructions for years—the beginning of a long line of how-to-do-it handbooks.

Soft-bound 8½-by-11-inch graded workbooks, introduced in graded series around 1909, remained popular through the 1920s. Beginning about 1915, their early emphasis on manual arts was reconstrued as "industrial arts." Many of the art activities, however, were essentially unchanged, with drawing further subordinated to the design of decorations for useful products. The more important development was the addition of lessons in the appreciation of design in clothing, architecture, interiors, commercial art, and industrial products, in keeping with the broadened concept of art in schools in the 1920s.

The **School Arts Magazine**, under the editorship of Pedro de Lemos beginning in 1919, showed a different sort of maturity—partly in the loss of the tone of excitement that marked the prewar years, partly in a kind of conservatism. De Lemos was not a specialist in school art (he had been a museum director), and he represented the generation of enthusiasm for the Arts and Crafts Movement. He was not in sympathy with many of the directions of public schooling in the

1920s. Art teaching had become too complicated, he said, too much burdened by pedagogical theory. Good results would come only through methods developed individually by teachers whose main strength was in the knowledge of the subject matter.

De Lemos's attitude is significant because it has been common since that time not only among the public and artists but also among art teachers. The magazine, accordingly, showed little concern for problems of educational theory or policy or for professional developments. Readers evidently were satisfied with its emphasis on elementary classroom techniques and on crafts and decorative design rather than expressive drawing and painting and with its historical examples from the old world and a marked avoidance of twentieth-century art and design.

De Lemos, it should be added, was a splendid champion of native American art and culture, and the magazine provided excellently illustrated articles on the subject. His how-to-do-it books, *Applied Art* and *The Art Teacher*, were perhaps the most favored classroom aid through the twenties and thirties. He also developed a number of "folios" as aids for teachers. The subjects of these sets of illustrations provide an indication of the main concerns in the typical art class of the time.

Purposes and Issues

Many of the leaders of art education in the 1920s had reached maturity in the years when prewar progressivism and the credo of the Arts and Crafts Movement gave to school art a social mission. For them, art was to be concerned less with museum masterpieces than with the aesthetics of daily life and the vital expressions of common people.

Furthermore, the climate of thought manifested in the National Education Association's Seven Cardinal Principles (1918) influenced art education no less than the general school curriculum. Thus, through the 1920s, purposes were conceived most often in terms of common adult responsibilities. In the broadest phrasings, the goal of school art was the development of the appreciation of beauty through an understanding of the fundamental principles of design and the ability to use those principles to enhance the aesthetic quality of all elements of daily life. Thus, categorizing the cardinal principles, the purposes of art in the classroom could be grouped under such headings as "social, vocational, and leisure" or "home, community, and industrial." From that beginning, an art educator could follow the current "scientific" approach, by stating as a purpose the appropriate competence in any number of categories of the uses of art.

The specific identification of such competencies as purposes was advantageous in the efforts to estab-

10. Charles De Garmo and Leon Loyal Winslow, *Essentials of Design* (New York, 1924).

11. Harriet Goldstein and Vetta Goldstein, *Art in Every Day Life* (New York, 1927).

12. George J. Cox, *Art for Amateurs and Students* (Garden City, 1926).

Figure 3-1. The art curriculum represented in teaching resources. *School Arts Magazine* 27, no. 6 (February 1928), xix. Reprinted with permission of *School Arts*.

Here's help for you arranged in handy Portfolio form
(loose sheets 7 x 10 in. enclosed in folder cover) containing the pick of the best material published in The School Arts Magazine.

PORTFOLIO OR PACKET	Postpaid
752 *Animals in Pencil, 8 plates, 7 x 10 in. *New Portfolio*	.75
753 *Art of Lettering, 12 plates, 7 x 10 in.	.75
754 *Bird in Art, 16 plates, 7 x 10 in.	.75
755 *Birds in Pencil, 8 plates, 7 x 10 in. *New Portfolio*	.75
Busy Bee Packets for Grade Work, 16 plates in each, 7 x 10 in.	
501 *Animal and Toy Drawing	.50
503 *Christmas	.50
504 *Easter	.50
505 *Flowers and Springtime	.50
509 *Halloween	.50
510 *Paper Work	.50
511 *Thanksgiving	.50
512 *Washington and Lincoln	.50
151 *Cement Craft—Simplified, 24 plates, 7 x 10 in.	1.50
101 *Costume Design, American, Colonial to 1924, 12 plates	1.00
102 *Costume Design, History of, Egyptian to 1840, 24 plates	1.00
756 *Decorative Tree Drawing, 12 plates, 7 x 10 in.	.75
105 *Figure Drawing—Simplified, 20 plates, 7 x 10 in. *New Portfolio*	1.00
757 *Gift Card Designing, 16 plates, 7 x 10 in.	.75
351 *Human Proportion Packet, 8 plates, 7 x 10 in.	.35
152 *Indian Decorative Design, 28 plates, 7 x 10 in. *New Portfolio*	1.50
758 *Object Drawing, 12 plates, 7 x 10 in.	.75
155 *Oriental Decorative Design, 28 plates. *New Portfolio*	1.50
759 *Pen and Ink Drawing, No. 1, for beginners, 10 plates	.75
760 *Plant Form in Design, 16 plates, 7 x 10 in.	.75
153 *Poster—School Posters, 24 plates, 7 x 10 in.	1.50
104 *Poster Panels, 16 plates in color. *New Portfolio*	1.00
103 *Poster Work, 24 plates, 7 x 10 in.	1.00
761 *Principles of Beauty in Industrial Design, 8 plates, 7 x 10 in.	.75
352 *School Arts Alphabet Sheets, packet of 15 copies	.35
762 *Still Life Drawing, 12 plates, 7 x 10 in.	.75
763 *Tree in Art, 16 plates, 7 x 10 in.	.75
BOOKS	
AA Applied Art, Lemos	6.00
BB Bookbinding for Beginners, Bean	2.50
FOD The Flush of Dawn, Bailey	1.00
CC Color Cement Handicraft, Lemos and Lemos	5.00
PFA Photography and Fine Arts, Bailey	2.50
SYS Symbolism for Artists, Bailey and Pool	5.00

THE SCHOOL ARTS MAGAZINE, 44 Portland St., Worcester Mass. Feb. 1928

*Items marked with * may also be obtained on this handy coupon from Practical Drawing Co., Dallas, Texas, Practical Drawing Co., 1512 Wabash Ave., Chicago, and Eau Claire Book & Stationery Co., Eau Claire, Wisconsin.

Please send me the following (use numbers) ..

..

I am enclosing $ *Name* ..

or (*Send bill to Board of Education at*) *Address* ..

lish short-term objectives and standards so that the possibility of systematic evaluation of art teaching could be demonstrated. In such statements, an art educator also could explain the contribution of art toward more diffuse, long-range goals, such as character building, thrift, or good citizenship. The ability to think through and state clearly the role of art with-

in the mission of public education seems to have provided much of the basis for the feeling of maturity in the field.

A second line of purpose could be termed pedagogic. Especially in the elementary grades, art could serve the entire curriculum while meeting the demands of educational psychology. Art engaged the

individual abilities and interests; it was a language for the expression of ideas and the showing of learnings; and it was an *activity* in the decade when the "activity curriculum" had growing popularity.

Concerns for internalized attitudes, organismic growth, individual personality, or cultural enrichment fitted less easily with industrial emphasis and educational technology. Though art teachers had such concerns, they were not priorities in the thinking influenced by the Seven Cardinal Principles. Furthermore, as a new trend, the importance of industrial education through art seems to have dominated early in the decade. But by 1925, attention to self-expression and creativity increased, and at the end of the decade, these and other values associated with the Progressive Education Movement were given much more explicit recognition.

The Art Curriculum

The changes in education that affected art teaching did not diminish the diversity that had been typical in the United States, but leading art educators did adopt the thinking that brought about significant developments in curriculum planning in the 1920s. Despite the differences from city to city, a few generalizations are possible.

Before World War I, many art plans simply linked holidays or seasonal interests to media, activities, or products through which particular skills were to be taught. To the postwar educator, other more important considerations existed: the needs and the active interest of the student; attitudes and organic growth as well as knowledge and skill; and the "laws of learning" stated by educational psychologists such as Thorndike. All of these factors had their developmental aspect. Needs, furthermore, could be distinguished as either "deferred" (adult needs) or "immediate" (relating to school and community affairs as well as the planned progress of learning). As the complexity of these concerns led general curriculum theorists to the coordination of single lessons into units and to the project method, some art teachers could feel reinforced in a way of working that they had already developed before World War I. By the mid-1920s it was said that unit planning and the project method were inevitable in art classes.

The format of a theoretically adequate curriculum plan changed accordingly. Ideally, the design of any unit might state a need, a medium or activity, and the objectives in knowledge, skills, attitudes, or habit. Evaluation was wanted, but it was already apparent that, whereas skills could be observed, the proof of learnings of attitudes and habits was difficult. For example, the "tests for art ability" offered in Prang's 1925 edition of the *Industrial Art Text Books* were limited to tasks with art media. The word *ability* came

into wide use to specify a learning that could be directly observed (including evidence of appreciation: "ability to choose"). But words like *habit, desire,* and *civic pride* (learnings difficult to test) also were written into lists of "specific" objectives.

Such specificity in the planning of a unit implied that each lesson should be designed with equal clarity, stating its particular designations of knowledge to be imparted, activities to be completed, and various types of objectives to be achieved. The older Herbartian lesson plan was recommended. By the late 1920s, some art teachers were participating in experiments with printed unit plans that could be used by children independently of the teacher.

The 1920s thus was the first period in which ordinary art teachers could be expected to engage in theorizing, in the analysis of their teaching, and in the design of curricula in some systematic way. Some leaders in the field said that such activity should promote desirable standardization across the country.

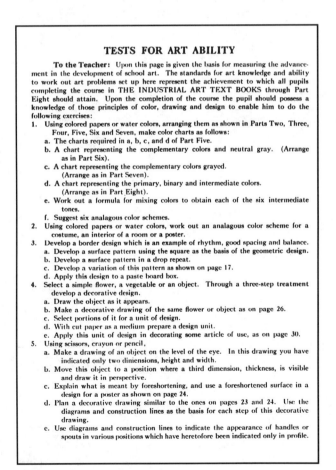

Figure 3-2. The demand for evaluation, as met in a workbook. Bonnie E. Snow and Hugo B. Froelich, *Industrial Art Text Books*, pt. 8, rev. ed. (Chicago, 1925), 72.

But local differences prevailed: in 1929, William Whitford at the University of Chicago complained that "some cities stress the industrial side, some the aesthetic, some the household, some the civic, some the historical, some the purely appreciational." And he might have added still other dominant curriculum concerns: for self-expression, for correlation, or, in some of the more progressive schools, for the interrelating of the arts.

The Elementary Art Curriculum

The development of junior high schools and the further spread of kindergartens in the 1920s established the elementary school grades (K-6) that remained typical until the introduction of "middle schools." It was already understood that children's interests and abilities in art changed by the fourth grade and that the younger children were not ready for direct instruction in such matters as the principles of design. The elementary art curriculum thus took on somewhat distinct primary and upper elementary segments: Mathias's *Beginnings of Art in the Public*

Schools (1924) was the first well-known book for teachers in the primary grades.[13]

In schools that were relatively unaffected by the emphasis on industrial education, classroom activities might seem to have continued from prewar trends. The new approach to curriculum planning, however, did not simply divide the school year into periods for a given set of media and activities. Ideally, at least, activities would be chosen to satisfy the anticipated developmental needs and interests of the children and, at the same time, to carry forward appropriate learnings in art. Correlation with other school subjects, as Parker had said decades earlier, could provide many opportunities in any media for engaging the child's immediate interests. School and community affairs brought further possibilities for teaching art as a vital interest in daily life. Manual arts fitted into the practical work in design, especially within the project method. In such programs, at least under compe-

13. Margaret Mathias, *The Beginnings of Art in the Public Schools* (New York, 1924). More precisely, the book concerns art in kindergartens and grades one and two.

Figure 3-3. Curriculum planning for specific objectives. Margaret E. Mathias, *Art in the Elementary School* (New York, 1929), 170–71.

FIFTH GRADE			
ART ACTIVITIES ARISING FROM SCHOOL INTERESTS	KNOWLEDGES GAINED IN ART SUBJECT MATTER	HABITS AND SKILLS ACQUIRED	GROWTH IN APPRECIATION
Making of posters advertising school play.	How to plan spacing by means of simple rectangles and then add details. How to use "unit" to cut letters. Subordination and emphasis as gained by size, placing, and color. Enclosing margin should be greater than intermargins. Rhythm as applied to lines and masses in order "to fit" space.	Spacing for adequacy and beauty. Cutting and spacing letters. Discriminating between important and unimportant; emphasizing the important and subordinating the unimportant.	Appreciation of good spacing wherever it occurs. Appreciation of careful workmanship. Appreciation of unity as essential to adequacy and beauty. Enjoyment of applications of rhythm of line and mass.
Making a sand-table of a southern plantation.	How to show correct dimensions on a plan.	Making a plan and working from a plan.	Appreciation of "Head-work should always precede hand-work."
Drawings in crayon showing colonial utensils.	Principles of circular perspective. Knowledge of craftsmen of colonial days and why their products are enjoyed to-day.	Locating main essentials and getting good proportion before adding details. Drawing ellipses. Showing light and dark sides of objects.	Appreciation of adequacy and beauty in colonial implements. Satisfaction in drawing.
Drawings to illustrate study of the United States.	In addition to knowledges of placing already learned—placing objects that are above eye-level lower on paper to show distance.	Additional skill in showing distance. Using drawing readily to clarify statements.	Appreciation of possibilities of drawing as means of expression. Enjoyment of paintings about the United States.

tent art teachers, art remained as the underlying subject matter: drawing, painting, printing, lettering; the crafts media treated as art; the principles of design or art structure and color taught somewhat directly in the upper grades; and appreciation given further separate attention through picture study and possible museum trips.

This kind of program was described by Mathias, as director of art in the Cleveland schools in the 1920s, and by Belle Boas, the head art teacher at the Horace Mann School, the model school of Teachers College, Columbia University. In their teaching, "art structure" was important as the basis for individual expression and aesthetic judgment, for Mathias and Boas were strongly influenced by Arthur Dow. Boas noted, incidentally, that whereas a large city system would require a rather rigid curriculum to be followed by classroom teachers, a specialist art teacher could plan with much more flexibility.

Industrial education created a sharp contrast to such programs. A representative industrial arts curriculum was developed in the New York state department of education, where Leon Winslow was "specialist in drawing and industrial training." In such a curriculum, he said:

> most of the drawing, art, and construction work done in schools will fall to the new subject of industrial arts not because it is a *manual* subject but because it is an *industrial* subject. . . . As phases of school life, drawing and manual training are at the disposal of all school studies, but the time has gone by when either drawing or manual training should be regarded as an elementary school subject.[14]

In Winslow's plan, twelve major industries were studied "from the viewpoint of general education," with major attention given to the history and the manufacturing processes and to the influence of the industry on the life of the people. As part of the study of the pottery industry, for example, children in upper elementary grades made pots by coiling and slipcasting, and a painting of a potter was the subject of picture study. Appreciation was promoted further through illustrated discussions of good decoration and appropriate form as related to function. The art curriculum was not alone in this subordination to industrial education; the same relationship was shared by the other school subjects.

Winslow took this program to Baltimore, as its director of art education, but the curriculum he recommended in 1928 showed a change in the concept of

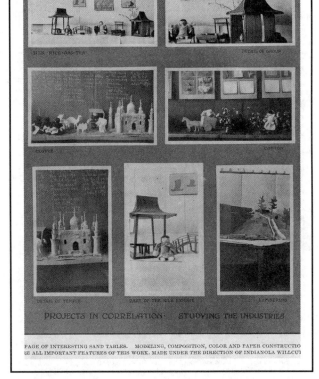

Figure 3-4. Industrial education in elementary grades. *School Arts Magazine* 21, no. 7 (March 1922): 429. Reprinted with permission of *School Arts*.

general education about industry.[15] The topics in this later plan were not the industries themselves but rather the fulfilling of generic needs for food, clothing, shelter, tools and machines, records, and light and power. In effect, the curriculum had moved from organization by subject matter (each industry) to organization around centers of community life considered to be at the level of the child's experience and interest. These central topics were rather easily approached through picture study. It appears also that the effort to approximate industrial processes promoted a further diversity in the materials experienced by children in elementary art classes, including cement, plaster, glass, wood, and metal. In Winslow's view, this plan would strengthen school art by making it more purposeful, and indeed he claimed that only through such individual purposing could school art be genuinely expressive—an instance of the ambiguity of "expression."

14. Leon Loyal Winslow, *Elementary Industrial Arts* (New York, 1922), p. vi.

15. Leon Loyal Winslow, *Organization and Teaching of Art*, 2d ed. (Baltimore, 1928).

ORGANIZATION CHART FOR THIRTY PROJECTS IN INDUSTRIAL ARTS IN THE ELEMENTARY SCHOOL

Products	Grades	Topics		Utilities
A. B. C. Book	1 & 2	Printed matter, books	1	Records
Paper box	3	Paper	2	
Drawing of flower or landscape	4	Painting (picture study)	3	
Portfolio	5	Illustrations	4	
Modeling	6	Sculpture	5	
Sand table work	1 & 2	Clothing materials, wool	6	Clothing
Gingham holder	3	Cotton	7	
Rug design	4	Linen	8	
Cloth covered box	5	Silk	9	
Padback	6	Leather	10	
Play house	1 & 2	Temporary dwellings, modern houses	11	Shelter
Drawing of building	3	Public buildings	12	
Collecting illustrations	4	Furniture	13	
Stencil	5	Household textiles	14	
Wall arrangements	6	Interior arrangements	15	
Drawings of toys	1 & 2	Toys, earthenware	16	Utensils
Pottery design	3	Chinaware	17	
Chart	4	Glass	18	
Sconce	5	Ironware	19	
Design for silverware	6	Silverware	20	
Clay modeling	1 & 2	Tools, beasts of burden, the air	21	Mechanics[1]
Making bricks	3	Pressing, water, steam	22	
Map of lumber camp	4	Holding and cutting	23	
Diagram of oil well	5	Measuring, oil, gasoline	24	
Drawing of vehicle	6	Vehicles, electricity	25	
Illustrative drawing	1 & 2	Vegetables and fruits, bread and cereals	26	Food
Drawing of press	3	Beverages and sugars	27	
Poster	4	Milk and eggs	28	
Chart	5	Meat and by-products	29	
Booklet	6	Fish and by-products	30	

[1] The two utilities, tools and machines, and light, heat and power have been combined in this organization outline under the more general term *mechanics*.

Figure 3-5. Industrial education for six areas of daily needs. Leon Loyal Winslow, *Organization and Teaching of Art*, rev. ed. (Baltimore, 1928), 30.

Between these two quite different models, in varied mixtures, was the whole range of local elementary art curricula. This middle ground was well represented by William Whitford, who used the Laboratory School at the University of Chicago to develop curriculum recommendations that brought together all the divergent emphases that he had noted. Like Mathias and Boas, he gave major importance to beauty, expression, and art structure. But as with Winslow, these were directed toward practical ends that echoed the Seven Cardinal Principles: the art needs for good citizenship in relation to industry, community, and the home. In the primary grades, the project method dominated. The curriculum for upper elementary grades was organized around such yearlong topics as transportation and industry, history and patriotism, peoples of other lands, and beauty in the environment. These studies, of course, were to be correlated with the general curriculum. The subject matter of art was classified as "drawing (the graphic experience), design (the ornamental experience), construction (the motor-constructive experience), and appreciation (the visual-mental-enjoyment experience)."[16] Studies for appreciation included painting, sculpture, architecture, and industrial products as well as the home, school, and community. The desired outcomes of instruction were itemized under four headings: fruitful knowledge; attitudes, interests, and appreciations; mental techniques; and right habits and skills. Probably no contemporary elementary art curriculum was more comprehensive than Whitford's model.

The Secondary Art Curriculum

The development of the secondary school system brought further expansion and diversification of the art program. As early as 1916 it was reported that, in place of nine courses that had been commonly offered, there were as many as twenty-six. In the 1920s, courses were reconceived, as both the "6-2-4" and the "6-3-3" plans became common, with grade nine located in either the senior or in the junior high school. Such school systems soon established the pattern for art that remained the rule: art would be required in the junior high school, often in both grades seven and eight, and elective in the senior high years.

As students entered each level of secondary school with unequal preparation from dissimilar lower schools, the problem of "articulation" stimulated cooperative curriculum planning throughout a school district. This occurred in art as in other subjects and also prompted moves to require a general art course in the first year of senior high school.[17] But against the urge for standardization was the growing need for differentiation between general studies, the college entrance academic program, and the several possible vocational curricula. Art educators saw the need to provide different opportunities and standards to meet the needs of both the ordinary pupil and those with special talent who might be guided into art careers.

These divergent purposes contributed to the persistent problem of securing high school credits and college admission credits for art courses. The agreement on a standard curriculum, reached in 1909 with the North Central Association of Colleges and Secondary Schools, had not led to general acceptance.

16. William Garrison Whitford and Jessie Mabel Todd, "Art for the Intermediate Grades," *Classroom Teacher* 3 (Chicago, 1927): 7. Whitford's *Introduction to Art Education* (Chicago, 1929) was the most comprehensive text of the decade.

17. In 1928, the Committee on Standards for Use in the Reorganization of Secondary School Curricula of the North Central Association recommended a general art course "as a major subject" for "the development of a practical understanding and appreciation of art in its direct relation to the immediate and deferred life interest of the pupil."

(There was, of course, no such actual standardization.) Art educators considered this situation a major obstacle to the improvement of art education in senior high schools.

The **junior high school** years were seen as the time for exploring vocational possibilities. Programs for "trying out" whichever occupations could be sampled in school put further emphasis on individual effort and reduced formal instruction. Work in the crafts was encouraged. In the required general art courses and in work in crafts and design, history gave way to the application of art principles in daily life. In Denver, for example, where the elementary curriculum was based on industrial studies, seventh grade art focussed on art needs in the home, with a six-week course in clay modeling and pottery. The eighth-year work related to art needs in the city, with bookbinding as the crafts course. The ninth year provided a variety of elective courses in metal, drawing, commercial art, and art in the school and community. Across the country, mechanical drawing and typography were often taught as art. For such specialized studies, much of course depended on the local ability to provide appropriate equipment.

Senior high school art courses, by the end of World War I, could be classified as (1) general (appreciation and work in media); (2) survey courses (illustrated lectures, readings, and museum visits); and (3) courses in design and drawing (usually directed toward industrial and household arts). However, as noted above, many senior high schools had no art program.

In the general education program, the common goal for senior high school art was defined by compliance with the Seven Cardinal Principles: good taste for the homemaker and citizen who would face the need for worthy use of leisure in the new technocratic society. Courses in appreciation, where they were offered, continued to deal with art in industry, home, and community, possibly using historical studies. But "the production of art quality" in drawing, painting, sculpture, and crafts increasingly was considered appropriate for the academic student of average ability as well as an effective if not superior approach to appreciation.

The provision of federal funds for shop work in 1917 tended to separate art from industrial education. But, at the same time, the newly recognized need for designers and "commercial" artists gave the art program its share of the vocational responsibility. As the junior high school required a general course for appreciation of art in daily living and also undertook the identification of the talented, the senior high art curriculum developed, in effect, advanced opportunities along the same two tracks—the cultural and the vocational— but with apparent emphasis on the latter.

NAME OF COURSE	NUMBER OF TIMES COURSE WAS GIVEN
1. Applied design	13
2. Art for extra curricular activities	1
3. Architectural drawing	16
4. Art appreciation	4
5. Cam and gear drawing	2
6. Cartoon drawing	1
7. Ceramics	1
8. Charcoal	5
9. Color	1
10. Commercial design	33
11. Craft design	6
12. Costume illustration	4
13. Costume design	16
14. Decorative design	1
15. Design	35
16. Development drawing	1
17. Drafting	3
18. Figure drawing	2
19. History of art	5
20. Home decoration	1
21. Home planning	2
22. Household arts design	1
23. Interior decoration	1
24. Lettering	1
25. Machine drawing	10
26. Mechanical drawing	93
27. Nature drawing	1
28. Metal craft design	2
29. Oil painting	3
30. Pen and ink drawing	3
31. Perspective	1
32. Pictorial photography	1
33. Poster design	5
34. Representation	40
35. Shop sketching	1
36. Typography	3
37. Technical drawing	3
38. Water color painting	4
Total	326

Figure 3-6. The increase in elective art courses illustrated by thirty-eight "advanced courses" offered in 153 high schools and academies in New York State in 1922–23. Leon Loyal Winslow, *Organization and Teaching of Art*, rev. ed. (Baltimore, 1928), 83.

In large cities, where specialized technical high schools were feasible, a three-year program in industrial or commercial art could prepare students effectively for employment as designers in clothing, textile, advertising, or printing trades. The ordinary high schools in New York City provided a three-year commercial course; a more general three-year art major in drawing, color, and design; and a set of advanced electives in the history of art and various specializations in design.

These curriculum patterns for junior and senior high schools, indicated here even so briefly, appear to have established the placement of required and elective courses in secondary art education that has been commonly found since the 1920s.

The Contents of the Art Curriculum

Drawing and Painting

Drawing, especially in elementary grades, changed so much that some writers in the 1920s ridiculed the purposes and practices that had been usual at the turn of the century. The distinct types of drawing instruction that had been the basis of curriculum planning were absorbed into more complex projects. Competence in accurate representation was no longer the main objective. Even before the war, Bailey wrote that the quality of drawing suffered because the diversification of art activities took too much of the time dedicated to art lessons. After the war, advocates of industrial education said that drawing should be devoted to the training of observation and to the comunication of laws, facts, and processes. But such abilities were not to be promoted by the old exercises. Although illustrative drawing was wanted in many correlated projects, these could not wait for gradual development of skill through systematic instruction. Moreover, creativity, originality, free expression, and Dow's emphasis on composition had become more important: a critic of these values said that the aim for artistry had become confused with the aim for competent drawing.

Media made a difference. Academic drawing had been studied in black and white, with one or two values of gray shading—in pencil and, later, in pen and ink. But now color was more important than accuracy, and favored media—crayon, opaque tempera paint (which gradually replaced transparent watercolor) and cut paper—were not suited to precision. In one workbook, for example, the lesson in "object drawing" provided the outline of a taxicab to be filled in with colored papers. Two new "media" appeared toward the end of the decade, neither of which featured accurate representation: "paper mosaic" and finger painting.

Pedagogical theory changed ideas of what to teach and when. Mathias described three stages of development in childhood drawing. No direct instruction would be appropriate, she said, in the early "manipulative" stage, when the child should be free to discover and experiment. In the subsequent "symbolic" stage, the child's skill was adequate to private intentions and meanings so that systematic teaching would be unnecessary and obstructive. Only in the late third or fourth grade, in entering the "realistic" stage, would the child gradually develop a desire for recognizable imagery and the ability to benefit by instruction: at that time, the teacher might give help in color, in proportion, and in representation of distance.

Apart from developmental considerations, Deweyian theory held that techniques would be learned best when the child felt the need. The project method, including correlational activities, was sup-

Figure 3-7. Dow's *notan* and space-cutting in a more modern urban style. Eleventh-grade lino-cuts. Belle Boas, *Art in the School* (Garden City, N.Y., 1924), 63.

posed to guarantee that personal interest. But then the technique would be specific to the need. Individual guidance, rather than class practice on basic typical forms, would be the rule, and children might be better off using the pictorial reference file since the objects in correlational illustration would not likely be found in the classroom.

Of course, children did draw, and they may have gained a broader competence and a more useful attitude because the subjects needed for correlation or applied design were far more varied than the older sets of type forms, still-life objects, and simplistic landscapes. Teachers continued to show the use of simple devices like stick figures, silhouettes, and underlying geometry for "blocking in." Memory drawing, blackboard dictation, and workbooks still were common. Certainly some curricula emphasized factual observation and the rendering of appearances as well as imaginative drawing, just as they had done years before. But in the exhibits of children's art in Prague in 1928 at the international congress, the American work was again admired for its freshness and spontaneity rather than its skillful representation.

Figure 3-8. A scale for diagnostic evaluation of the understanding of the principles of distance to guide differentiated instruction. Margaret E. Mathias, *Art in the Elementary School* (New York, 1929), 27.

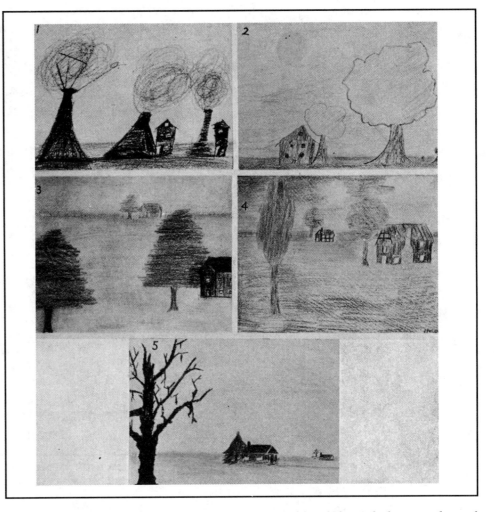

Test drawings showing different levels in application of principles.
No. 1 – 4 points. Objects are not smaller to show distance.
No. 2 – 5 points. Objects are smaller to show distance but are not placed higher on paper.
No. 3 – 6 points. Objects are placed higher on paper but tops of objects which are above eye level are not placed lower to show distance.
No. 4 – 7 points. Objects which are above eye level are placed lower on paper but eye level does not cut similar objects in same proportion.
No. 5 – 8 points. Drawing shows application of all principles discussed.

Secondary school electives in drawing, which were designed mainly to develop special talents, were more likely to imitate the programs of professional schools. Thus, teaching could be modeled after the traditional studio. The common array of electives might include figure drawing, landscape, watercolor painting, charcoal drawing, and illustration in the various fields of design as well as mechanical drawing.

Design

Much of the work in design during the 1920s differed little from prewar activities. In the more up-to-date classes, however, important changes in the rationale, the teacher's approach, and the style were underway. Design was conceived as a basic human activity, a fundamental element of the race heritage, so that learning about design brought art together with industrial education and social studies. With design construed as a mode of problem solving, its history was no longer restricted to a few great styles of ornament or decoration. Instead, the history of design was found primarily in the forms to meet uni-

versal human needs like shelter, clothing, tools, and transportation. This conception fitted smoothly with the emphasis on practical purposes of art in daily life.

Furthermore, and especially in the elementary grades, design was presented as "orderly arrangement." Nature was still the great source of forms and motifs, but universal order also was to be seen in the "eternal workings of nature," in the rhythms of tides, seasons, night and day. In the newer conception, "arrangement" was not restricted to flat shapes on a single plane but was extended to furniture, gardens, and community planning—indeed, to any three-dimensional situation.

Harmony, rhythm, and balance—the principles set forth by Ross and by Dow in his "art structure"—were still employed in the teaching at all levels, though these were not taught directly in the primary grades. But design was not to be studied abstractly through exercises: it was to be applied in the development of useful products. Accordingly, the criteria of function in form and material became increasingly important, beginning as early as 1912–13.

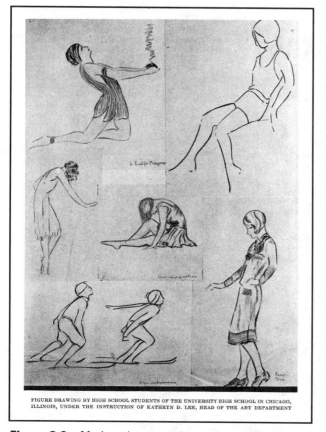

FIGURE DRAWING BY HIGH SCHOOL STUDENTS OF THE UNIVERSITY HIGH SCHOOL IN CHICAGO,
ILLINOIS, UNDER THE INSTRUCTION OF KATHRYN D. LEE, HEAD OF THE ART DEPARTMENT

Figure 3-9. Modern dance, modern styles, modern sports at the end of the twenties, by students of Kathryn D. Lee. *School Arts Magazine* 29, no. 5 (January 1930): 285. Reprinted with permission of *School Arts*.

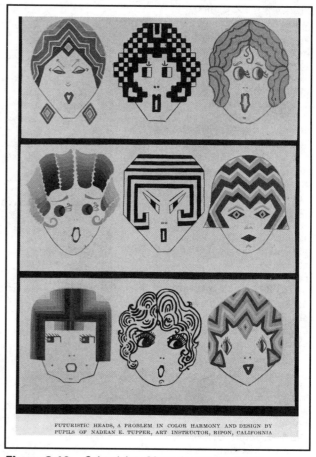

FUTURISTIC HEADS, A PROBLEM IN COLOR HARMONY AND DESIGN BY
PUPILS OF NADEAN E. TUPPER, ART INSTRUCTOR, RIPON, CALIFORNIA

Figure 3-10. *School Arts Magazine* 28, no. 10 (June 1929): 591. Reprinted with permission of S*chool Arts*.

In the organization of the curriculum, where time formerly had been allocated to particular activities or principles, the professional fields of design now provided the categories of subject matter. Whether in specialized high school electives, in the required general art elective in the junior high school, or in the correlated units of the elementary grades, the curriculum plan referred to graphic design, interior design, clothing design, and so on. As a corollary, the professional designer became as much a model as the fine artist. Thus, the fourth grader, following a workbook by cutting colored papers to fill in a line drawing of a room elevation with fireplace and furnishings, was told "You too are a designer."

As to style, many of the workbooks and texts illustrated contemporary, or "modern," forms—typography, cars, monoplanes, skyscrapers, home furnishings, clothes, and stage settings—though not usually the most advanced. The color and motifs of Art Deco entered as the decade progressed. Good taste, Cox said, meant sensitivity to art structure in any period. The aesthetic of machine manufacture, De Garmo and

Winslow explained, should replace the older emphasis on intricate ornament that was handcrafted for the aristocracy.

Nevertheless, **decoration**, usually in patterns of repeated units, continued as a standard activity at all grade levels. Motifs still were developed from nature but also from an increasing variety of other sources of interest to children: stories, sports, new products, and abstract shapes. Such decorations were no longer likely to be left as mere exercises but instead were applied to products, with emphasis (ideally) on relations to materials, form, and function.

Crafts were increasingly construed as design activity, and the term *manual arts* was outmoded. Leather, metal, wood, cement, and clay were common materials. Weaving of headbands or rugs for the dollhouse began on simple cardboard looms, with references to the work of native Americans or the traditions of Peru or other distant lands. Needlework, appliqué, batik, tie-dye, stenciling, and block prints decorated textile products, and these too were to be illustrated by examples from other cultures—another

Figure 3-11. *School Arts Magazine* 21, no. 9 (May 1922): 518. Reprinted with permission of *School Arts*.

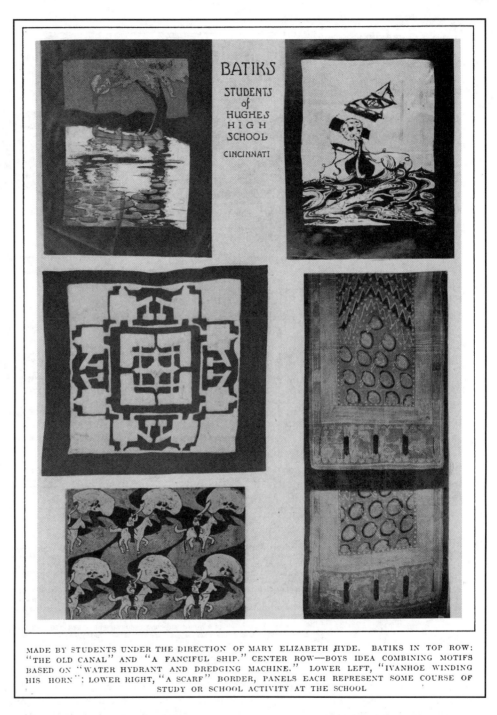

MADE BY STUDENTS UNDER THE DIRECTION OF MARY ELIZABETH HYDE. BATIKS IN TOP ROW: "THE OLD CANAL" AND "A FANCIFUL SHIP." CENTER ROW—BOYS IDEA COMBINING MOTIFS BASED ON "WATER HYDRANT AND DREDGING MACHINE." LOWER LEFT, "IVANHOE WINDING HIS HORN"; LOWER RIGHT, "A SCARF" BORDER, PANELS EACH REPRESENT SOME COURSE OF STUDY OR SCHOOL ACTIVITY AT THE SCHOOL

element in the heritage of Dow and Ross. Where industrial education was important, the crafts could be associated with processes of manufacture.

Construction, though possibly less important than in prewar years, supplied other products for decoration and provided an introduction to patterns and working drawings. Starting in the first grade with folded paper, children made boxes, bookends, lamp shades, waste containers, and other useful devices for the home. Dollhouses were popular—second graders could make them from wood—and the furnishings involved not only construction work but practice in arrangement.

Construction also was employed in correlation with other studies. At the sand table in elementary classes, cardboard, plasticine, wood, and found mate-

Figure 3-12. Design for citizenship: a page from a student workbook. G. W. Ware and Lida Hooe, *Practical Drawing, Modern Arts Course, Book Eight*, rev. ed. (Dallas, 1919), 20.

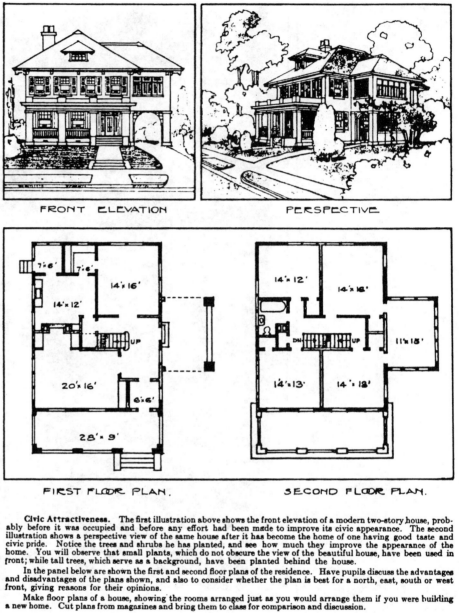

FRONT ELEVATION PERSPECTIVE

FIRST FLOOR PLAN. SECOND FLOOR PLAN.

Civic Attractiveness. The first illustration above shows the front elevation of a modern two-story house, probably before it was occupied and before any effort had been made to improve its civic appearance. The second illustration shows a perspective view of the same house after it has become the home of one having good taste and civic pride. Notice the trees and shrubs he has planted, and see how much they improve the appearance of the home. You will observe that small plants, which do not obscure the view of the beautiful house, have been used in front; while tall trees, which serve as a background, have been planted behind the house.

In the panel below are shown the first and second floor plans of the residence. Have pupils discuss the advantages and disadvantages of the plans shown, and also to consider whether the plan is best for a north, east, south or west front, giving reasons for their opinions.

Make floor plans of a house, showing the rooms arranged just as you would arrange them if you were building a new home. Cut plans from magazines and bring them to class for comparison and discussion.

rials were formed into model castles, villages, landscapes, and many ingenious forms of shelter devised throughout the "race history."

Civic art, or community design, was important wherever practicality and the Seven Cardinal Principles guided the curriculum. Projects could begin at the sand table, in the school grounds, in the gardens or plantings at home, or in the community itself. Color schemes for the exterior of a house or a family garden and plantings were also approached as civic art, beginning with crayon coloring of outline drawings in elementary grade workbooks. For secondary schools, an excellent example of the art teacher's aspirations is Minna Beck's *Better Citizenship Through Art Training* (1921), dedicated to Arthur Dow, which applies the elements and principles of art to city planning, garden cities, landscape gardening, architecture, house decoration, and costume design.[18] (The term *garden cities* referred com-

18. Minna McLeod Beck, *Better Citizenship Through Art Training* (Chicago, 1921).

monly to a number of planned communities developed during the 1920s.)

Interior design likewise could begin in the first grade, with the dollhouse and with outline drawings of the furnishings along one wall to be colored in crayon. The same activity, with increasingly specific consideration of theories of design, continued into high school elective classes. By that time, interior perspectives were developed in watercolor, and ideas for style were informed by historical and modern examples. To relate the study more closely to children's interests, projects could be directed toward the improvement of a work space, a clubhouse, the school building, or one's own home.

Clothing design in the elementary grades, beyond discussion of the children's own attire, was taught mainly through paper dolls, which could be dressed in costumes appropriate to any correlated study. But actual costumes, some of crepe paper, could be created and worn in pageants and plays as well as correlation activities. In the upper grades, figure drawing and principles of design could be linked to the students' personal interests: fashionable cuts and silhouettes; color relationships; effects of stripes and other patterns; properties of various materials; and costs of garments and accessories. Noticeable during the decade was a shift in illustrations, from contemporary adults to children and youth, and to styles in history, with some attention to specialized functions of clothing.

Especially for young women, clothing design offered one of the best introductions to modernity in design. Secondary courses in clothing could be specialized in cooperation with vocational programs or domestic arts curricula. In such collaborations as well as in the required general arts courses, art teachers made their special contribution by emphasizing individual imagination and personality, along with aesthetic and psychological effects.

Stage design became important in art classes, especially because plays, pageants, and festivals could be linked both to civic art and to correlated studies. Costumes and scenery were not merely drawings on paper: they were three-dimensional realities in an actual event. Of course, not everyone always could do the real thing. But a group could work together on a quite complete model for a five-foot stage; a small group could present a skit in class; or individuals could make model stages and show their own ideas for setting and costume. Puppetry became a popular art activity because the actual show could be produced in class. Moreover, such activities applied a number of skills—sewing, construction, working drawings, modeling, representational techniques, and lighting, in some instances.

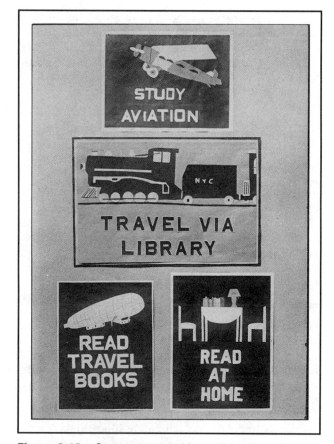

Figure 3-13. Contemporary subjects and style in elementary school posters in 1929, by students of William V. Winslow. *School Arts Magazine* 29, no. 9 (May 1930): 513. Reprinted with permission of *School Arts.*

Graphic design was an essential at all levels for correlation, for expression of school and community interests, for vocational and industrial objectives, and as a form of civic art. Posters and advertisements exemplified modernity in their subjects, their graphic style, and the informality of their communication. Children were less troubled by imitation of old hand scripts as the popularity of new sans serif typefaces legitimized simple block letters. Cut paper gave clean, flat color. Block printing in wood or linoleum flourished as art applied in useful design. Bookbinding began in the primary grades with lacing a few folded sheets, and progressed in upper grades to sewn signatures and cloth-faced coverboards—a craft that joined literature, illustration, printing, lettering, and layout. High school classes worked in advertising art, which could extend to actual window displays in the community.

Color still was taught by wheel and other charts, but changes were evident. Exercises were replaced by the application of color in all media and forms of design. The nomenclature of standard "schemes"

became less urgent as the culture moved away from laws of good taste and teachers began to value personal expression. In the 1920s, whether in paintings, cars, magazines, or home furnishings, color was to be crisp and lively. Art teachers spoke of the move away from the "gray" colors of the Dow era: here was another instance of the affinity of modern art to childhood.

Appreciation

Since most adults would not meet their daily needs by making art, the appreciation of art was the main goal of art education in the 1920s. "Art," of course, was redefined to include all the aesthetic choices of ordinary life. Given the current pedagogy of "learning by doing" and the simple fact that class time was mostly spent in work with media, it followed that appreciation was to be developed as much through making art as through historical and theoretical knowledge. Both ways of understanding were to be based upon the principles and elements of design. The exercise of such understanding in the home and community was important to the ideals of good citizenship. Some educators implied that old masterpieces were somehow undemocratic: the art of a vital, future-oriented culture was not to be stored in museums. Furthermore, as personal expression and creativity gained importance through the decade, the study of professional art began to appear as an inhibiting imposition of adult concepts and standards. Thus, the 1920s saw the extension of ideas relating to art appreciation that had been developing since the turn of the century.

Twentieth-century innovations in the fine arts were less readily welcome in schools than were the expressions of modernity encountered by the public in commerce and industry. Influential writers in art education spoke of Cubist and Expressionist art as "undisciplined egotism," and "humbug," whereas the unornamented products of new manufacture were praised as functional and modern in spirit. But even in painting and sculpture, a contemporary aesthetic began to influence art education: Belle Boas referred to Bell, Fry, and Havelock Ellis; George Cox included Marin, O'Keefe, Dove, and Archipenko among his illustrations of art structure; and students at Teachers College, Columbia University, sold textile designs in the Bauhaus style.

Picture study began to lose popularity in the late twenties as the scope of appreciation widened. Until then, lists of pictures to be studied in each elementary grade were published in several states. By the early 1920s, miniature full-color reproductions became available. Several guides for teachers were published, and new sets of illustrated readers were written for children, with vocabularies recommended for each grade. On the conservative side, the older story telling

and moralizing continued. The content and style of approved pictures remained entirely conventional: though children saw more depictions of ordinary contemporary life, painters like Van Gogh, Gauguin, Cezanne, Matisse, and Picasso were not to be represented in picture study.

But the graded readers did direct added attention to the organization of the picture and the qualities of line and color. The more important texts on art education showed how to lead children to consider the pictures as an artist might have done, looking at composition and technique and analyzing the means of expression, with the intention of relating these learnings to classwork in drawing or painting. Winslow indicated criteria by which children could begin to form their own evaluations of a picture. By the end of the decade, this kind of teaching was sufficiently developed to enable two supervisors of large city art programs to write an exemplary guide for teachers, even as the general enthusiasm for picture study faded.[19]

In the broader approach, art appreciation developed more varied content and methods of teaching than can be detailed here. One of the common student workbooks, for example, showed not only paintings but also sculpture, buildings, interiors, textiles, landscapes, flower arrangements, a fern, and a peacock to illustrate the elements and principles of design—using Denman Ross's construct: balance, rhythm, and harmony.[20] Curriculum units included field trips, small group research, "living pictures," notebooks, essays, and guest discussions.

The general art course for secondary students could devote much of the year's activities to study of elements and principles of design in many forms of art and design. New York City high schools announced a full-year course devoted entirely to a broadly defined "art appreciation," conducted not by work in the media but by illustrated lectures, notebooks, and recitations.

Correlation, it was claimed, promoted appreciation by using pictures as illustrations of subjects from history, literature, industrial processes, or household arts. Among the more surprising relationships, one educator recommended the study of Greek sculpture for the appreciation of good posture, a Monet to build a positive attitude toward sunshine, and Dutch still-life paintings to spark interest in nutrition.[21] Moreover, all the making of art for correlation could

19. Walter Klar and Theodore M. Dilloway, *The Appreciation of Pictures* (New York, 1930).

20. James C. Boudreau and Harriet M. Cantrall, *Art in Daily Activities* (Chicago, 1929).

21. Lois Coffey Mossman, "Project Method in Practical Arts," *Teachers College Record* 22 (September 1921): 327.

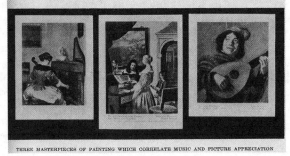

Correlating Music and Picture Study

JESSIE TODD
Department of Art Education, University of Chicago, Chicago, Illinois

WE have so much art to teach in the elementary school that we have to make the most of our opportunities to teach some appreciation. Several companies have done a fine piece of work in putting on the market some lovely little color prints cheap enough to be bought by each child.

The children in the fifth grade bought these three prints. They were interested in the pictures because they studied musical instruments in music. Moreover, the class was studying Holland and these paintings by Dutch masters offered another correlative opportunity.

HOME INDUSTRIES IN ART

The following lists compiled by Beula M. Wadsworth refer to small color prints used by her in a postcard projecting lantern for lecture work with children, and illustrate correlation of picture study with other subjects:

1. TEXTILE WORK
 a. The Sewing School—Artz (German)
 b. The Knitting Lesson—Millet (French)
 c. The Spinner—Maes (Dutch)
 d. La Fileuse—Moreau (French sculpture)
 e. The Washerwoman—Daumier (French)

2. FOOD PREPARATION
 a. Young Girl Peeling Apples—Maes (Dutch)
 b. The House Wife—J. Bail (French)
 c. The Cook—Ver Meer (Dutch)
 d. Russian Winter—Grabar (Russian)
 e. The Water Carrier—Goya (Spanish)

3. FARMYARD ACTIVITIES
 a. Feeding Hens—Millet (French)
 b. Going to Market—Troyon (French)
 c. The Belated Kid—Hunt (American)
 d. Herd in the Sunlight—Claus (Belgium)
 e. Bringing Home the New Born Calf—Millet (French)
 f. Shoeing the Bay Mare—Landseer (English)

4. FARM WORK
 a. Oxen Plowing—Bonheur (French)
 b. The Sower—Millet (French)

THREE MASTERPIECES OF PAINTING WHICH CORRELATE MUSIC AND PICTURE APPRECIATION

Figure 3-14. Picture study correlated with music for fifth-grade study of Holland and home industries. *School Arts Magazine* 28, no. 9 (May 1929): 561. Reprinted with permission of *School Arts*.

be construed as learning to appreciate the pervasive importance of art in human affairs.

Plays and pageants, of course, brought together all the arts, and such correlation was not new in the 1920s. But innovative efforts were made to relate the arts in more formal instruction. Music was readily approached in picture study. Winslow wrote of the stimulus to all the senses in the appreciation of paintings. In Pasadena and Los Angeles after 1923, all high school students reportedly were required to take courses in the appreciation of music and art. The University of Wisconsin began a summer school of creative arts in 1928. As abstraction entered the art class, students used paint to interpret music in line, shape, and color. One elementary school project in "aesthetic appreciation" included gallery visits and children's concerts, along with writing about music, musicians, art, and artists. Certain progressive schools went further in emphasizing creativity in all the arts.

Progressivism in Art Education

The foregoing description of the art curriculum in the 1920s represents especially the mainstream of developments in public schools. But much of the impetus toward the activity curriculum, the project method, correlation, and individuation came from private schools, which had smaller classes and greater freedom to experiment.

The principles of progressive education were closely related to the liberal ideas of the 1920s that Malcolm Cowley attributed to artists and intellectuals of New York's Greenwich Village. Among them was Margaret Naumburg, founder of the Walden School, who later was a leader in the development of art therapy. Others among them were the chief patrons of Carolyn Pratt's City and Country School, where play was the basis of learning activity and where the sculptor William Zorach taught art. Another associated progressivist was Harold Rugg, who began at the experimental Lincoln School (connected to Teachers College, Columbia) as an educational statistician and became a leading proponent of creativity in the arts.

In Rugg's view, true creativity entered education only as practicing artists began to teach, particularly in private schools. Though creativity had been advanced as an objective earlier in the century, he said, and some teachers had mistakenly granted students complete freedom in art activities, it was only the real artist who understood how the creative process required that freedom be joined with discipline, experiment with control. Of course, Dow, Ross, Sargent, and other earlier educators had been artists, but they were products of nineteenth-century academic teaching. Since their day, ideas of creativity in art had changed, and private schools were free to welcome those new ideas.

The Progressive Movement had its counterpart in Europe. Indeed, the most famous "artist-teacher" of the first quarter-century was the Viennese Franz Cizek. His "juvenile art classes" began in 1897, with the encouragement of associates among the Secessionist group. Americans saw the work of his students at the London Congress in 1908, though their favorable reports aroused no special interest. But by late 1923, when his students' work was shown at the Metropolitan Museum, progressive educators were ready to praise him as a model of creative teaching. Though his methods have been disputed, he was acclaimed as a teacher who treated children as artists, promoted independence and imagination in a variety of media, encouraged them to learn from each other, and "took the lid off where others clamped it down."[22]

22. Peter Smith, "Franz Cizek: Problems of Interpretation," in *The History of Education: Proceedings from the Penn State Conference*, ed. Brent Wilson and Harlan Hoffa (State College, Pa., 1985). A critical review of reports on Cizek's teaching.

Figure 3-15. Flames, by a thirteen-year-old student at Margaret Naumburg's Walden School. Florence Cane, "Art in the Life of the Child," *Progressive Education* 3, no. 2 (April–June 1926): 160. (Original in color.)

In the United States, one of the most noted of the artist-teachers in progressive private schools was Florence Cane, who taught in her sister Margaret's Walden School. Both had gone through psychoanalysis, and their ideas of art education were based largely on the theories of Freud and Jung. Thus, art was to be a medium for the integration of the individual personality through expression of innermost feelings and visions, bringing egocentric drives into constructive social relations. Art permeated the curriculum. For the younger child, there was little teaching, beyond care of the materials. But after age ten or so, as the child grew self-critical, Cane tried to guide each individual to find a personal center, distinguishing the needs of the introvert from those of the extravert, working toward a fruitful mixture of spontaneity and self-discipline, of play and work.[23]

Examples of artwork from progressive schools

show many projections of personal feelings and emotions. Expressions of "paganism" were common; this was a time when the natural innocence and nudity of childhood were much recommended to mothers. Even in correlated illustrations, one finds unusual freedom of imagination and execution. What was modern was relatively unforced; there was no apparent tendency, at least in the twenties, to impose imitations of Cubism, Futurism, or "modern" shapes.

The issue of balance of freedom and control became central to criticisms of progressive schools, where the vitality of the arts was a salient achievement. John Dewey, by then regarded as the elder statesman of the movement, argued that too much freedom promoted an excessive egocentricity, an impudent disregard for regulation, while society required order and collaboration. Margaret Naumburg, once a favored student of Dewey, wrote that his was a "herd philosophy," typical of an older generation, of an earlier and more political progressivism. For her, society was becoming too technocratic, too massive, too oppressive. Dewey's education, she wrote, gave too little place for feelings and imagination: her goal for an independent citizenry was the emotional maturity requisite to a liberal social order. Within that rationale, art would serve society through the development of such maturity: art would be educational as a medium of symbolic, sublimating, personal expression.

This dispute, between two of its major proponents, placed school art in the context of a fundamental and perennial educational issue, which in turn reflected broader social problems that had been developing through the decade. It became most explicit in 1930, just when totalitarian regimes abroad and the economic crisis at home began to cause enduring changes in American life.[24] Through the next decade, individual creativity, of the kind attributed to progressive schools, began to dominate American art education.

Research

In the United States, the first phase of research in child art, which came in the Child Study Movement after 1880, had been concerned mainly with patterns of human development. Similar research continued in Europe.[25] By the early twenties, there was general agreement that children's drawing progresses through

23. Florence Cane, "Art in the Life of the Child," *Progressive Education* 3 (April–June 1926): 155–62.

24. The *New Republic* published a series of articles on progressive education in 1930, including Naumburg's "The Crux of Progressive Education" (June 25, 145–46) and Dewey's "How Much Freedom in the New Schools" (July 9, 204–06).

25. A review of American and European research precedes the report of a study of 31,239 drawings by American children, in *Children's Drawings: A Study of Interests and Abilities, Data Collected by the Child Study Committee of the International Kindergarten Union* (Baltimore, 1924). The copy kindly shown me by John Michael is complete with a packet of scales, examples, and tables.

certain stages, a recognition that development was continuous rather than segmented. Generalizations regarding the stages of development observed in children's drawing consisted of the following:

■ **A scribble stage** (ages two to three) progressing toward the beginnings of named representation.

■ **A symbolic stage** (four to six) in which drawings are controlled more by the conception of objects than by their usual appearance.

■ **Beginning realism** (seven to nine or ten) with more reference to fact and detail.

■ **Visual realism** (ten to eleven, or so) showing concern for accuracy and technique and a resulting loss of confidence and spontaneity.

■ **Repression** (eleven to fourteen) and further self-criticism, with a tendency to discontinue art activity.

■ **Artistic revival**, in some adolescents, with active interest in chosen subjects and technique and deliberate aesthetic purpose.[26]

Such developmental patterning was useful as several psychologists after World War I followed Thorndike's lead in developing tests and measurements for art as for other subjects. Apart from the practical necessity stated earlier by Sargent (the need to demonstrate the efficacy of a scientific methodology in teaching art), there were deeper theoretical interests. Psychologists disputed the existence and definition of any general intelligence in relation to such special abilities as art. Thus, the nature and genesis of talent in art required investigation. To develop separate standardized tests for drawing and appreciation, it was necessary to further analyze the complexity of knowledge, skill, and production in art. All such efforts required the development of research methodology.

Much of such research involved the development of scales by which the quality of children's drawings could be judged and quantified. Thus, techniques were needed to ensure the reliability and validity of the scales. Studies of art appreciation involved the selection or creation of sets of objects to be judged in preference tasks. Both types of research entailed problems of qualitative distinctions, reliability of judges,

and adequacy of samples as well as basic questions in aesthetics.

Most of the published tests were quite readily criticized on technical grounds, but researchers tentatively answered one large question: the intelligence measured by IQ tests did not correlate generally with drawing ability, although outstanding success in art seemed to require high intelligence. (Related to this question was Goodenough's *Draw-a-Man Test*, published in 1926, which does not attempt to test art quality but is still used to assess children's intellectual development by the factual perception evident in their drawings.) Toward the end of the decade N. C. Meier laid the foundation for an extensive campaign of researches in the early thirties, beginning with the premise that art talent could be identified with "aesthetic judgment," which could be tested through perception of balance, unity, rhythm, and other principles known in the 1920s as "art structure."

Thorndike himself pointed to another set of problems in art education research in 1923 when he published a revision of his 1913 "Scale for General Merit of Children's Drawings." "Regardless of what system of training in drawing the school has used," he reported, the quality and style of original drawings at any grade level showed a wide range of ability and little effect of the teaching method.[27] At issue were the values to be established as criteria—still mainly cognitive at the time—and the difficulties of controlling for the complexity of factors in comparative tests of teaching methods.

A few art educators began to acquire research techniques for practical purposes in this same period. In 1919, Whitford published a test of both appreciation and drawing abilities. In 1921, he outlined a curriculum based on opinions of fellow art educators: his survey asked which art learnings prepared pupils best for their needs in art in daily life. (He reported a 95.1 percent level of agreement that learning about the "elements and principles of art" was of unquestioned value, whereas "design" was valued above drawing, painting, construction, modeling, or history of art.) His colleague Jessie Todd, in an effort to improve picture study, analyzed 6,692 written comments by children on artists they had studied and found that children remembered facts about artists but said very little about any particular pictures. Whitford also led a substantial survey to establish professional definitions of terminology in art.[28]

With the development of graduate studies in education, the U.S. Office of Education initiated annual

26. The names of these stages follow the paraphrase of Sir Cyril Burt (1921) given in Dale Harris, *Children's Drawings as Measures of Intellectual Maturity* (New York, 1963), 17–18. The descriptions are modified somewhat to represent a broader range of opinion.

27. Edward L. Thorndike, "A Scale for General Merit of Children's Drawings," *Teachers College Bulletin*, 15th ser., no. 6 (December 1923): 3.

28. Federated Council on Art Education, *Report of the Committee on Terminology* (Boston, 1929).

Figure 3-16. Whitford's findings assessing the value of art as a school subject in preparing for the daily needs of adult life. William G. Whitford, *An Introduction to Art Education* (New York, 1929), 92–3.

SHOWING THE JUDGMENT OF FIFTY TEACHERS OF ART IN RESPECT TO RELATIVE VALUES OF ART TRAINING GIVEN IN THE SCHOOL

Put a check mark in the columns where the training furnished by drawing, painting, design, construction, modeling and history of art, meet *without question the demands* of art in the home, city, or town environment, for self-expression, the industries and the various other items at the top of the table.

PART I

Does the Training Afforded by These *Subjects* Meet the Demands of the Ordinary Pupil in These Capacities? →	1. Home-clothing	2. City or Town Environment	3. Expression	4. Industrial	5. Commercial	6. Publishing	7. Fine Arts	8. Cultural
Drawing	52	44	90	50	68	58	92	92
Painting	66	52	86	42	68	48	92	90
Design	100	64	88	90	94	88	78	90
Construction	82	30	78	86	56	42	62	74
Modeling	44	82	86	50	36	12	90	92
History of Art	62	66	50	40	36	32	86	94

PART II

Follow the same procedure for line, form, tone, color, texture, and composition.

Does a Proper Knowledge of these *Subjects* Provide Valuable Training for These Activities? →	1. Home-clothing	2. City or Town Environment	3. Expression	4. Industrial	5. Commercial	6. Publishing	7. Fine Arts	8. Cultural
Line	100	94	98	100	98	96	100	100
Form	96	100	98	100	96	90	100	98
Tone	96	88	90	88	92	92	96	92
Color	100	98	100	100	100	96	100	100
Texture	96	80	84	94	90	82	90	88
Composition	96	94	98	90	96	98	100	98

EXPLANATION OF TERMS USED.—(1) *Home and Clothing* (Decorating—Furnishing—selecting—making, etc.) (2) *City or Town Environment* (City beautiful—streets, parks, museums, buildings, monuments, etc.) (3) *As a Means of Expression* (4) *Industries* (Manufacturing—Producing) (5) *Commercial* (Buying, selling, arrangement, displays, advertising, etc.) (6) *Publishing* (Book, magazine and newspaper illustrating and designing) (7) *Fine Arts* (Production of fine arts—Painting, Sculpture, Arcitecture) (8) *Cultural* (Appreciation of Fine Arts).

reports on thesis research. In art education, the number of master's-level theses increased rapidly, from seven reported for 1927 to twenty-five for 1929–30. For these students, practicality was important: the most frequent topics concerned curriculum, classroom methods, and testing and measurement, in that order. As students also practiced the design of tests as part of their classwork, it appears that research first began to be a common concern in art education during the late 1920s.

Nevertheless, art teachers distrusted tests, partly because they seemed more concerned with accuracy and standards than with art quality, and more generally because testing represented an attitude antithetical to personal expression and originality. Sallie Tanahill, of Teachers College, Columbia University, concluded that progress would require psychologists and art educators to work together.

SUMMARY

In 1917, the long transformation of manual training was completed by the provision of regular federal funding for industrial education. In 1918, the National Education Association's *Cardinal Principles of Secondary Education* finally established the common ground for a useful education for every pupil by defining the preparation for normal daily responsibilities of adulthood in the democracy. Thus, the mainstream curriculum planning emphasized practical, observable objectives, with differentiation of educational opportunities as an obvious requisite. At the same time, the "new education," begun in the 1880s and carried forward under the banner of the Progressive Education Association, represented intellectual currents and the broad cultural trend toward individualism, hence, the recognition of student differences and the concern for independence in thought, behavior, and personal expression.

The responsive programs and leaders in art education moved with both of these forces. Most of the adult needs of art in daily life were related to the growing professions of industrial and commercial design, which also provided a model for industrial education. The designer was the exemplar of productive problem-solving thought and discipline. Design activities fitted easily into the project method and the correlated curriculum. But as educators pondered the unpredictability of the future and as Expressionism and Freudianism pervaded the modern attitude, the fine arts promised the nurture of originality, creativity, and emotional expression. For the first time, the fine arts began to be treated as a group of activities essential to healthy personal development.

The idea of creativity grew throughout education. Each new learning could be seen as creative in the sense of growth, enlarging the repertoire of adjustive behavior. Kilpatrick said that even the decision to cross the street in modern traffic was a creative act. In 1931, George Cox observed that "creativity" had become a shibboleth in art education, as though it could be manifested in no other human activity.[29] And, looking ahead, Cox already had suggested that, with all the developments of theory and practice in art education in the 1920s, a whole decade "might be profitably spent in consolidating the recent gains."[30]

Progressive education, however, was never a uniform movement across the country. What was new in the twenties may not have reached many school systems for another decade, whereas the enthusiasm for industrial education, for example, simply faded away.

FURTHER READINGS

Boas, Belle. *Art in the School*. New York, 1924.

Cane, Florence. *The Artist in Each of Us*. New York, 1951. A retrospective statement of Cane's beliefs and practice.

Clark, Gilbert. "Early Inquiry, Research, and Testing of Children's Art Abilities." In *The History of Art Education*, edited by Brent Wilson and Harlan Hoffa. National Art Education Association: 1985.

Cremin, Lawrence. *The Transformation of the School*. New York, 1962. The standard history of the Progressive Education Movement.

Dewey, John, ed. *Art and Education*. Merion, Pa., 1929. Contains three articles by Dewey representative of his thinking about art under the influence of Albert Barnes.

Farnum, Royal Bailey. *Art Education*. Department of the Interior, Office of Education, Bulletin 1931, No. 20, Vol. 1, Chap. 8. Washington, D.C.: Government Printing Office, 1931.

Mathias, Margaret E. *Art in the Elementary School*. New York, 1929.

Mearns, Hughes. *Creative Youth*. Garden City, N.Y., 1925. An exemplary statement on creativity in the arts in progressive education.

Naumburg, Margaret. *The Child and the World*. New York, 1928. Her major statement on progressive education.

Progressive Education 3 (April–June 1926). An issue devoted to art education, with many illustrations of children's art. The articles were reprinted in Hartman, Gertrude, and Ann Shumaker. *Creative Expression*. New York, 1932.

Rugg, Harold, and Ann Shumaker. *The Child-Centered School*. Yonkers, 1928.

Whitford, William G. *An Introduction to Art Education*. New York, 1929. A systematic approach with special concern for learnings useful in daily living and including forty-seven pages devoted to methods of evaluation.

Winslow, Leon Loyal. *Organization and Teaching of Art*. 2d ed. New York, 1928. Valuable for detailed outlines of curriculum plans and course content, with special interest in the contribution of art to industrial education.

29. George J. Cox, "Art Teacher Training for the Changing Curriculum," *Teachers College Record* 33 (October 1931): 54.

30. George J. Cox, "Modern Trends in Art Education," *Teachers College Record* 31 (March, 1930): 520.

~§ 1930-1945 §~

uring the decade of the Great Depression, art in the schools continued the trends of the late 1920s but with a special spirit. Many art teachers shared the sense of educational mission in meeting national and world crises; many were stimulated by the dedication of leading artists to social issues and by federal programs that made art seem a vital force. The typical current concerns in the art curriculum were the values of art in community life, integration with other subjects, and the idea of the child as a natural artist.

SOCIAL AND CULTURAL CONDITIONS

Social Factors

In the depths of the Depression, around 1933, unemployment spread beyond one-fourth of the work force; farm income fell by 40 percent while drought drove farmers from the "dust bowl"; banks were closed nationwide to avoid further failures; protesting World War I veterans were dispersed from Washington by the army; and the school year in some areas was reduced to as little as two months. As late as 1937, when conditions were somewhat improved, President Roosevelt declared that "one third of the nation" was "ill-fed, ill-housed, and ill-clad." While the Depression persisted, the hope for peace dwindled: Congress passed neutrality acts in 1935, 1936, and 1937, but by that time, Hitler and Mussolini had begun their expansions and had announced their Axis, and the Japanese were in China.

The response of the American people through those difficult years has been described under such themes as these:

■ **Nationalism:** The avoidance of foreign commitments; the expressions of traditions, of unity toward economic recovery, and of patriotism, particularly as the threat of war increased; the appeal of the America First Committee, with the aviator-hero Lindbergh as its spokesman.

■ **Regionalism:** A comforting conception of the vast federation; an approach to planning of public works; a grass roots reassessment of heritage; finally, local mutuality and collaboration.

■ **Pluralism:** The valuing of people themselves, the ultimate resource in depression; an assertion and acceptance of the cultural needs and contributions of ethnic, regional, and socioeconomic groups.

■ **Federalist Liberalism:** A resurgence of pre–World War I progressivism, supporting Roosevelt's New Deal—the Works Progress Administration, Civilian Conservation Corps, Tennessee Valley Authority, Federal Deposit Insurance Corporation, agricultural subsidies, rural electrification, and so on. Although some of Roosevelt's programs were short-lived, if not outright failures, an enduring expectation of government action to meet national problems had emerged.

■ **Unionism:** The formation of the egalitarian industrywide power of the Congress of Industrial Organizations (CIO) as opposed to the select trade specialization of the American Federation of Labor (AFL).

■ **Criticism:** Populist distrust of big business and metropolitan culture, fed by such demagogues as Huey Long, Father Coughlin, and F. G. Townsend, with their schemes to redistribute wealth; among wealthy conservatives, like the American Liberty League, opposition to the New Deal as "socialism"; on the left, the traditions of nineteenth-century utopian socialism or anarchism, enlivened by the pros and cons of the Soviet model and the recognition of fascist threats; at the extremes, dogmatic Marxism (Leninist or Trotskyite) and militant white supremicists and "bund" groups.

Every position, of course, had its contrary—world federalism, resistance to federal programs, the Committee to Defend America by Aiding the Allies. Amid the general social disruption were certain healthy reactions. Depression was a leveler: anyone might be jobless, on the dole or the bread line. Sympathies, mutualities, and local values were important; neighborhoods came together. The experimental,

pragmatic activism in Washington was matched by the ingenuities, however desperate, of families and towns across the country. Community spirit was strong, and it was reflected in art education.

Technology and manufacture advanced despite the Depression, with the beginnings of radar, television, and jet propulsion. Products multiplied—new appliances, toothpastes, clothing styles, toys and games. Cars were streamlined, air transport increased, and trains reached their peak of transcontinental glamour. Two world's fairs exhibited the technological future; the second of them, in 1939, could be shown on television.

Adding to indigenous influences on the culture, beginning in the 1930s, was the influx of intellectuals, scientists, and artists escaping war and Hitler's antisemitism. In the visual arts, these included Gropius, Breuer, Mies van der Rohe, Moholy-Nagy, Joseph and Annie Albers, Mondrian, Ozenfant, Léger, and many others. The most directly influential on school art were Viktor Lowenfeld and Henry Schaefer-Simmern.[1]

Intellectual Currents

Given the continuing technological innovations, the evident futility of World War I, and the political upheavals and economic failures, much talk of a new social order was engendered. Although history could seem irrelevant, a number of studies reexamined the American past with an eye to fundamental values or social and economic determinants. Marxian analysis offered a guiding principle: the collective as the ultimate goal. Dictatorships were closely watched for assessment of centralized planning and social engineering. As early as 1930, educators saw that the benefits of radio, film, and the coming television ("radio movies") were threatened by the development of propaganda: the truth could be whatever the state decreed.

For the public, science was further unsettling. Indeterminacy and relativity were formal principles in the new physics. Newspapers reported that space was curved, that the universe was expanding, that there might be innumerable dimensions, that only five people in the world understood Einstein's theories. Anthropologists, like Boas, Mead, and Benedict, disturbed the public in other ways. They had found no universal human laws; instead they had seen that mores, customs—the whole culture and social order—were relative and contextual.

Educators already had said in the 1920s that schools would have to prepare children for an unpredictable future by helping them to develop investigative,

experimental, pragmatic, problem-solving minds. In the 1930s, intellectual currents reinforced that outlook.

Culture and the Arts

One view of American society in the 1930s focuses on the increasing conformity of communication and production—and possibly of thought and behavior. With the development of newspaper chains, syndicated news services, and radio networks, the same reports, opinions, and advertisements were spread across the nation. The *Reader's Digest*, the Book-of-the-Month Club, and a handful of monthly magazines became enormously popular. The slick weeklies—*Time, Life,* and their competitors—delivered quick surveys and powerful images: worldwide coverage with something of interest for everybody. Advertisers shifted from literary persuasion to slogans and imagery as models of what everyone should be and do and pushed media editors to please the largest possible consumer segment.

In a time of anxiety and despair, of protest and criticism, there was need for escape in cheap entertainment—in cheerful songs, comedy, radio "soap operas," film fantasies, and dancing to big bands or juke boxes. But new national broadcasts of symphony and opera, small-town subscription series of world famous lecturers and musicians, and revivals of Shakespeare also attracted audiences. "Mid-cult" expanded, but "high" culture was not dead.

Federal arts programs, beginning late in 1933, created jobs for unemployed writers, musicians, artists, and actors and thus stimulated art activities in communities throughout the nation. In every art form, the most popular efforts were based upon the history, folklore, or patterns of life in the region or locality. Many artists were enthused by the sense of being wanted, of contributing directly to the public. Though programs for each of the arts were separately administered, collaboration in their productions provided further stimulus. None of the administrative units was free from problems of censorship and bureaucracy, nor did they all survive equally—and, of course, all federal relief programs ended with World War II. The arts projects provided energizing opportunities for creative people; they left their own kind of legacy of public works; and they established a precedent for future governmental support.

Literature was intensely engaged in the issues of the day. Many of the most important writers joined in manifestos issued on the right and the left. The American Writers' Congress was formed in 1935 as a political pressure group. The "proletarian novel," with content and style to enlist workers' sympathies, was acclaimed a weapon in the class struggle.

The books cited most often as representing the 1930s were not simply ideological, yet they were sym-

1. Henry Schaefer-Simmern, *The Unfolding of Artistic Activity* (Berkeley, 1948).

pathetic to common Americans and realistic in protesting their hardships. Like many contemporary photographers and painters, writers shared the urge to rediscover the whole of the country in all its diversity and the individuality within the mass of ordinary people. Outstanding among such works were Dos Passos's quasidocumentary trilogy *USA*, Farrell's *Studs Lonigan* trilogy (the decline of middle-class life in Chicago); and Steinbeck's *Grapes of Wrath* ("Okies" migrating from the dust bowl). Sinclair Lewis moved from satire toward more supportive treatments of small-town society; his best-known book of the decade was *It Can't Happen Here*, a warning against the possibilities of dictatorship. Richard Wright's *Native Son* was a powerful indictment of the injustices suffered by African-Americans.

Less topical protest and more regionalist humanism, however grotesque, could be found in Caldwell's *God's Little Acre* and *Tobacco Road*, and in Faulkner's stories of the residue of plantation culture in Mississippi. Thomas Wolfe's autobiographical novels contrasted the metropolitan literary world with his lower middle-class upbringing in North Carolina—a boyhood relived with love and pain in a compound of romantic naturalism. Carl Sandburg, a Chicago poet who extolled the ordinary life in *The People, Yes*, sang the folk tradition above his own guitar, wrote the four-volume *Abe Lincoln in Illinois*, and finally raised goats in North Carolina. Robert Frost became the best-known poet of rural New England, whereas Edgar Lee Masters placed his *Poems of the People* in the Midwest.

At the end of the decade, a new generation of war novels was marked by Hemingway's *For Whom the Bell Tolls*, which told of the young Americans already in battle as volunteers in the loyalist brigades in Spain.

Theatre was equally engaged. Major playwrights built Broadway successes around urgent concerns: politics, union activity, migrant labor, Nazism, the hopes for peace, and the coming of war. Leftist *agit-prop* drama competed with celebrations of the American tradition.

Across the country, touring shows were curtailed by the Depression and the popularity of film. But regional theatre, amateur community companies, and drama in schools and colleges increased as never before. Philanthropic funds assisted. The Rockefeller Foundation, in particular, supported regional training centers for drama at universities and funded the National Theater Conference, which represented thousands of social and educational groups.

Music during the Depression offered American composers a patriotic mission—to create a national style, simple and sincere, that would lift the public spirit. Such music, many believed, needed native materials: the decade was rich with folk song symphonies, country dance sets, hymning suites, and ballads. In choral works, ballets, and operas, American themes abounded. To be useful, music for the people had to be tuneful and uncomplicated, so dissonance and more advanced techniques were set aside by many composers.

Some of the major musical talents, however, followed their own paths, assimilating the music of other cultures, inventing new systems of rhythm and tonality, composing with extreme complexity, and feeling no less American.

At one extreme of social consciousness, on the radical left, music was propaganda. Important young composers sometimes participated in the events of the Composer's Collective, which called for a "proletarian" music and published albums, mostly imported, of "mass songs" and workers' marches. The collective ended in 1936, when its Marxist theoreticians turned from such "cultivated" music to the presumed authenticity (and the obvious popularity) of folk song. The idea of proletarian music dwindled, and the potential of music as propaganda was given over to national loyalty.

Through the years of the Depression, despite severe unemployment, many American musicians gained in the diversity of their abilities and their sources of income. These possibilities included the popular swing bands, the new style of Broadway musical, the growth of American ballet, and the developments in the mass media—music in the movies, the record industry, and the radio networks, all with their own staffs of composers and instrumentalists. In schools, this was the first great decade of instrumental music. Soloists, chamber groups, bands, and orchestras rehearsed during the school day, earned academic credit, and competed statewide and nationally, with leading professionals paid as judges.

Dance had become "the most active and the most serious of American arts" by the mid-thirties, according to an eminent critic.[2] He estimated that the number of dance events had multiplied sixfold in the past decade. Ballet gained popularity. At Radio City Music Hall, the ballet company as well as the Rockettes danced in about thirty shows weekly. Although the traditional repertoire was toured by "Ballet Russe" companies, American choreographers created for companies of American dancers in several cities. The School of the American Ballet opened in 1934 in Isadora Duncan's former studio, with George Balanchine as teacher and artistic director. Martha

2. John Martin, "Dancing," in *Art in American Life and Education*, Fortieth Yearbook of the National Society for the Study of Education (Bloomington, Ill., 1941), 176. The article is excerpted from Martin's *America Dancing* (New York, 1936).

Graham, Ted Shawn, Helen Tamiris and others took "modern dance" on the road across the country.

Like the other arts, dance had begun to bring together the full range of "classical," "modern," "folk," and popular technique and expression: Balanchine, de Mille, and other choreographers worked with equal fluency in film, musical theater, and ballet. As in music and literature, the development of an American style was aided by American material. Among the ballets were *Rodeo, Frankie and Johnny, Barn Dance, Ladies Better Dresses, Prairie,* and *Juke Box.* Among "modern" companies, current concerns were evident in such titles as *Strike, Stock Exchange, Lynch Town, American Provincial,* and *Cycle of Unrest.*

Colleges began to offer degrees in dance and courses in dance appreciation. Churches, clubs, and labor groups, such as the International Ladies Garment Workers Union and the New Dance League, provided public classes. Ballroom dancing was never more glamorous. Big swing bands, made famous by radio and juke box, toured regional dance pavilions. The younger generation copied Harlem's virtuoso amateurs in the lindy hop and the shag. Their parents continued to fox-trot and waltz.

Radio and film had their greatest cultural impact in the thirties. With sound and color, movies had new possibilities; a majority of Americans attended at least once a week. One-third of the population— adults and children—owned at least one radio.[3] Newsreels, "globe-trotting" reporters, and celebrated commentators brought the world's anxieties to this unprecedented audience. Current events became a part of popular entertainment.

Comedy, however, was preferred most; on radio, music was second, followed by daytime "soap operas," the evening's family serials, detective thrillers, and major sports events. Film, for the most part, offered cowboys, gangsters, young lovers, and a few monsters. But more serious interpretations from literature and theatre were also portrayed in film, some of them concerned with current issues, and certain masterpieces of film became art.

Hollywood musicals featured Fred Astaire and other dance stars in technicolor; Busby Berkeley blended the synchronized limbs of innumerable chorus girls with fantasies of scenery in *Art Deco* styling to produce the first abstract art welcomed (though perhaps unrecognized) by the general public. Animation, especially in Walt Disney's full-length features, was even more obviously art. Film merged the arts: with sophisticated scenery, color photography, and music by noted composers, movies could approach the status of grand opera. Disney's *Fantasia,* projecting the relatedness of the arts, enthused some

artists no less than the lay public, whereas critics called it banal.

Educational programming was developed both more and less formally in short-film subjects, network series, agricultural broadcasts, and documentaries, some of which—like Pare Lorentz's *The River* and *The Plow That Broke the Plains*—were appreciated as high art. A radio program, "The Human Side of Art," was broadcast from Detroit in 1935; its author later became "Associate in Radio" at the Metropolitan Museum of Art. Through the war, of course, both film and radio served the purposes of propaganda.

Whatever the content, the immediacy of voice and image in mass media presented a sense of sharp reality. Current events entered the school curricula; teachers engaged in social and patriotic causes; and children brought fact and fiction from the media into their classroom art.

THE VISUAL ARTS

As in the other arts from the mid-twenties through the thirties, painting and drawing in the United States were dominated by the effort to develop a distinctive national style. Conservative critics, scorning European "isms," hailed a new movement that could be understood and loved by the average citizen— the art of the American Scene.

The "scene" was city, small town, or farm and the buildings, people, and activities typical of those locales. The subject was ordinary folks going about their lives: the heroic dimension of the commonplace. Apart from subject matter, however, no shared aesthetic problems, no preferred palette, no basic compositional schema—in short, no uniform style—was sought. Individuality was found in the handling of a particular domain of local color and human interest: leaders like Thomas Hart Benton and Grant Wood applied distinctly different artistic traditions to equally different ideas about native cultures. Such painting was warmly appreciated: artists working in every region gained national reputations.

Like the Ash Can group of the Progressive era, this was an art concerned with common existence, responsive to a spirit of reform. And though the typical American Scene painting might seem politically neutral, some were, in fact, bitter criticisms of American life. Social Realism found fit subjects for protest in bread lines, slums, idle factories, drought-stricken farms, and politicians. The Artists' Congress, formed in 1936 to express opposition to fascism, war, and the economic depression, had as many as six hundred members.

Abstraction, abandoned by many of the promising young talents around 1920, progressed very slowly in the thirties. The art exhibitions at the world's fair in Chicago in 1933–34 included a gallery of about thirty

3. Russel Nye, *The Unembarrassed Muse* (New York, 1970), 393.

imported examples of Cubism, Constructivism, and Surrealism. The Whitney Museum and the Museum of Modern Art (MOMA) held exhibitions of abstract art in 1935 and 1936, and the Solomon Guggenheim collection, featuring Kandinsky and Rudolph Bauer, was open to the public after 1937. The organization of the American Abstract Artists, also in 1937, led to annual exhibitions. However, abstraction had lost the appeal of novelty, and it was criticised as "art for art's sake," which fitted poorly with the social consciousness and the spirit of grassroots nationalism in the thirties.

Surrealism, the only new style to have emerged between the wars, was exhibited at the Museum of Modern Art in 1936; some of the works were sufficiently varied and important to be continually shown in its permanent collection. The public, however, knew Surrealism mainly through reproductions of Dali's meticulously rendered oddities. For artists, Surrealism's power lay in its deeper interest in the basic idea of the subconscious as the source of "automatic," uncontrived imagery that might not necessarily be representational. Surrealism, thus, could make possible an abstraction informed with deep meaning and liberated from any preestablished structure. These ideas came together in America in the early forties with the influx of European artists, and New York became the center of advanced art from which Abstract Expressionism was to emerge after the War.

Murals, as the monumental civic form of American Scene painting, were never so important as during the Depression. Notable examples followed the stock market crash: Benton's panels on contemporary America at the New School for Social Research in New York; Boardman Robinson's history of commerce at Kaufmann's department store in Pittsburgh; Winold Reiss's celebrations of local history and industry in Cincinnati's Union Terminal. Orozco and Rivera, two of the Mexican muralists acclaimed through the twenties for their nationalist use of indigenous imagery, executed commissions in the United States in the early thirties. (Their Marxian interpretations also stimulated lessons in public opposition.) Reginald Marsh painted the daily business of the New York harbor—sailors, stevedores, a glamorous celebrity meeting the press on shipboard—on the walls of the U.S. Customs House. Artists and public, thus, were receptive to murals as a major medium for governmental support and alert to the possibilities of censorship.

Printmaking flourished in the thirties. The graphic arts divisions of the Federal Art Project, while providing modest incomes, helped artists to learn new techniques, especially in lithography and silk screen, and produced a great many prints and posters. Print media were appropriate for the details of the American scene or the direct vigor of social protest. (Among the touring exhibits of prints, two were formed by the Artists' Congress, titled *America Today* and *Against War and Fascism*.) In style, printmaking in the thirties was generally conservative. Moreover, the Society of American Etchers represented a certain bias against other printmaking media, which were associated with commercial reproduction.

At the close of the decade, changes began. To counter a purist prejudice against color in fine graphics, the American Color Print Society was formed in 1939. A silk-screen print won an important prize in 1940. The Silk Screen Group, later the National Serigraphic Society, was formed to present exhibitions. And most important, Stanley William Hayter, leader of the famed Atelier 17 in Paris, came to New York and set up the Atelier under the auspices of the New School for Social Research.

Atelier 17 was a workshop for intaglio. Hayter considered himself a Surrealist; his own work was largely abstract; and his teaching method was one of shared discovery, combining all the intaglio techniques with much attention to color. As early as 1944, the group's work was given an influential exhibition by the Museum of Modern Art, titled *New Directions in Gravure*—a body of innovative graphic imagery produced by experimental freedom in the service of a wide range of modern styles. For postwar printmaking, this show helped to create a new threshold of possibilities.

Sculpture had employment at two world's fairs (Chicago, 1934, and New York, 1939) and at the San Francisco Palace of Fine Arts; either a fully traditional representation or a modernistic stylization could meet public expectations. Just as in painting, capable compromises with Cubism were evident in sculpture. Older cultures offered possibilities for monumental simplicity. Brancusi, Arp, and Naum Gabo were known here, and Archipenko lived in New York, but only a few American sculptors worked in abstraction before the forties.

Crafts gained status during the Depression. Considered as folk art, the crafts expressed a common urge for practical beautification and a renewed admiration of self-reliance, skill, and individual judgment. Most significantly, the crafts represented traditional regional cultures in areas like New England, Appalachia, and the Southwest.

Supporting the crafts as home industries, state legislatures promoted organizations of craft workers with cooperative sales outlets. As a form of social work, the Russell Sage Foundation conducted and published an extensive survey of American crafts. The Southern Highlands Handicraft Guild, for example, included twenty-eight centers of crafts production and maintained a display room in Rockefeller Center.

The leisure time projected through technology had come instead through unemployment. People wanted to make things. Many new crafts schools, neighborhood centers, camps, and other institutions provided facilities and instruction. Between 1939 and 1942, a series of organizational moves led by Aileen O. Webb brought together local and regional crafts groups to form the American Craftsmen's Cooperative Council. The council worked quickly: a center for crafts, America House, was established in New York City; the American Craftsmen's Educational Council was chartered in 1943; a mimeographed periodical, *Craft Horizons*, began publication; and the School for American Craftsmen opened in 1944 in relation with Dartmouth College student workshops. Through these first steps, the American Craftsmen's Educational Council was prepared to act as a central force in the postwar resurgence of crafts.

Architecture was an influential expression of modernism during the Depression. The Museum of Modern Art's (1932) International Exhibition of Modern Architecture toured in parts to thirty cities through the following six years. Unlike painting, most of the major architectural achievements were not concerned with traditional or regional idioms; architects, like other designers, were more interested in technology, styling, and the shape of the future. Among skyscrapers, an early approach to the International Style was Raymond Hood's McGraw-Hill building (1931)—a shiny tower of rectangular solids with nonsupporting "curtain" walls hung on a steel frame and integral color replacing ornament. Rockefeller Center (Radio City) in New York was a step toward the "dream cities" sketched in the twenties—a cluster of towers, uniform in style but varying in dimension, with subsurface shopping malls and pedestrian walkways protected from traffic. Frank Lloyd Wright's research tower for S. C. Johnson and Son was a technological beauty of glass walls hung around a concrete core, but he returned to the forms and textures of the environment at Taliesin West in Arizona and also in the Kaufmann house, *Falling Waters*, cantilevered among the ledges of western Pennsylvania.

Civic architecture, with trimmings in the streamlined neoclassicism of Art Deco, looked much the same wherever an optimistic modernity was wanted in the Western world, whether the nation was democratic or totalitarian. In the United States, the streamlined look multiplied in movie theaters, resort hotels, and the standardized corner gas station. Futuristic visions were made commonplace by such diverse media as the 1939 world's fair in New York and the comic strip *Flash Gordon*.

At the Chicago Century of Progress Exposition in 1933, model homes promised a safe, hygienic, and prefabricated future, achieved with steel frames, glass bricks, synthetic stone, panels glazed in ceramics, and air conditioning. Federal support for construction of several new planned towns provided another kind of model for healthful living. It was such residential design, along with the skyscraper, that constituted the main contribution to the study of architecture in schools in the thirties.

Industrial design gave the public its most common imagery of the machine age. Firms headed by such famous designers as Normal Bel Geddes, Raymond Loewy, and Walter Dorwin Teague applied the aesthetics of technology to every product the consumer might want and to the factories that made them. On the grandest scale, designers, architects, and engineers worked together, shaping highways, bridges, and power dams that changed the American sense of landscape.

Museums continued to develop their collections and educational programs: public lectures, classes for children on Saturdays or released school time, shows of children's art, and loan exhibitions were common. Free classes in practical arts for the unemployed were a trend among museums even before the start of federal projects. The Metropolitan Museum offered instruction in practical design for department store employees.

The Whitney Museum of American Art and the Museum of Modern Art, founded in 1929 and 1930, respectively, were quickly influential owing to their special purposes: the Museum of Modern Art's early exhibits included international architecture, machine art, organic design, and the architecture of the Tennessee Valley Authority. The Solomon R. Guggenheim Foundation, as noted earlier, opened its collection of nonobjective art in a Manhattan townhouse. The inauguration of the National Gallery in 1941 enhanced the status of art in the capitol city.

By this time, major museums were administered by a younger generation, most of whom were American-trained and ready to participate actively in the cultural efforts of the community. When the General Education Board of the Rockefeller Institute surveyed fifty-four museums, the majority expressed interest in collaboration to improve art education in secondary schools. In 1937, the board provided a five-year grant through which the Museum of Modern Art established its Department of Art Education. In 1939, five museums were funded by the board for a three-year project. Working with one or two schools or with the entire local secondary curriculum, each museum had time and money to carry out its own plan.[4] Thus,

4. The five museums were the Cleveland Museum of Art; the Albright Art Gallery, Buffalo; the Milwaukee Art Institute; the Chicago Art Institute; and the Museum of Modern Art, New York. See Lydia Powell, *The Art Museum Comes to the School* (New York, 1944).

the project brought together experiences based on different conceptions of educational purpose and content. Time and money for experimenting with diverse activities were available: lectures, instructional resources, in-service courses for teachers, and classes and exhibits in schools or museum galleries. The momentum was not limited to this one set of projects: the Carnegie Corporation also funded educational efforts in several art museums, but war began before their full benefits could be realized.

Final reports of the General Education Board's projects described frequent difficulties in museum education: inflexible school schedules; college entrance curricula that permitted few art electives; and boards of trustees who considered museums primarily as repositories of art objects. The diversified art curriculum of the thirties was evident in the subjects of exhibits, including correlational topics, crafts, commercial art, interior decoration, peasant costumes, printmaking, maps, and the art of a variety of periods and cultures. In Cleveland, incidentally, the students' favorite among eighteen exibits concerned the process of making animated cartoons.

Books on art for the general public had two main topics in the thirties: modern art and the resurgence of Realism. Even while the Museum of Modern Art conducted its first decade of exhibition and publication, certain writers agreed that the modern movement already was history. Books by Martha and Stuart Cheney passed to the public a balanced consensus of description and assessment of early twentieth-century art and design. But a different body of opinion was represented by Thomas Craven in 1934.[5] In his view, the modernism of the School of Paris was spawned in bohemian decadence that could not have produced great art. According to Craven, the modern movement was simply a succession of interesting technical experiments that achieved a needed revolt against "mechanical imitation" at the expense of content. Great art was essentially the expression of personal experience in a particular culture; "localism," therefore, was one of its marks, and the best hope for the future was the development of the then current American Scene painting. This opinion remained strong through the decade: Peyton Boswell, Jr., introduced a collection of paintings commissioned by *Life* magazine with the statement that "America today is developing a school of painting which promises to be the most important movement in the world of art since the days of the Italian Renaissance."[6] (*Life*, incidentally, was said by the director of the Corcoran Gallery to have become the "most significant single force in the appeciation of art in America."[7])

Several important books marked the growing importance of industrial design. Leading designers described the field to the consuming public; they were joined by the Cheneys in projecting the benefits of a rationally designed environment. Herbert Read and Lewis Mumford, however, warned that functionalism alone would not satisfy deeper human needs: the joining of art and machine would require a new aesthetic, a profound change in social values, and therefore a radically revised education.

In **aesthetics**, Dewey's *Art as Experience* (1934) was the most important achievement of the time. Because of its importance to art education and because Dewey brought together ideas that represented a broad change in conceptions of art, it seems worthwhile to attempt a brief characterization of some of the principles that have influenced the teaching of art since its publication:

■ Aesthetic experiences have always been a normal part of daily existence. Art and artists once were integrated in communal life, but specialization and technology have made made them increasingly remote. Dewey's book intensified the challenge to education of reintegrating art with common experience.

■ Experience, both as doing and undergoing, is the continuous interaction between self and environment. In this interaction, the whole organism is unified; there is no separation of mind from body, of perception from cognition. Art provides this unifying experience, with doing and undergoing essential to both the making and the appreciative response.

■ The art-making process begins in "impulsion," proceeds as an interaction through the forming of a medium, entails critical perception as well as action, and requires intelligence equal to that required in science. For the teacher, therefore, variety of media is a pedagogical necessity, and art making is neither busy work nor daydreaming.

■ Expression is achieved through fusion of the plastic elements into form as a significant organization of energies. These elements—lines, shapes, colors and so on—develop significance throughout our experience, and expressive form amounts to a reconstruction of experience.

■ The appreciative response requires an active perception, not merely absorbed contemplation, a doing as well as an undergoing. The aesthetic work of art, so perceived, is unique for each individual and for any person at each response is a product of all prior experience. Art appreciation is thus a creative experience, and standardized verbal appreciations are inadequate. Furthermore, the experience of making art is needed

5. Thomas Craven, *Modern Art* (New York, 1934).

6. Peyton Boswell, Jr., *Modern American Painting* (New York, 1940).

7. Boswell, Jr., *Modern American Painting*, "Foreword."

for appreciation; Dewey thus reinforced the contention that appreciation was best taught through studio activities.

Federal art programs were administered under several agencies during the thirties, mainly but not solely to support artists as unemployed workers. The Farm Security Administration brought several of the nation's leading photographers into a campaign to document life in rural America. The Treasury Department set up a Fine Arts Section primarily to create murals and sculpture for public buildings, with quality control achieved through jury selection and anonymous open competitions. The section also sponsored thousands of easel paintings, circulated art to schools and libraries, collaborated in setting up a National Art Week in 1940, and extended art programs to the Civilian Conservation Corps.

The largest program was the Federal Art Project within the Works Progress Administration, which employed some five thousand artists in its peak years. Terminated in 1943, the Federal Art Project produced more than one hundred thousand paintings, twenty-five hundred murals, eighteen thousand sculptures, two hundred thousand prints, and about two million posters. The program for community service established federal art galleries, travelling exhibits, and community art centers with classes for children and adults. In its section for research, the Index of American Design sent hundreds of artists across the country to make as many as twenty thousand accurate drawings and watercolors of all kinds of traditional handcrafts.

These projects and the enormous number of works that they distributed served one other purpose—to promote the dispersion of artists and art from the few metropolitan centers into communities throughout the nation. The democratization of art developed in other ways. Department stores began to house art galleries. Chambers of commerce organized annual "art weeks." For a while, artists could feel they had a functional position in society, and there was reason to hope that the ordinary citizen would come to appreciate contemporary American art. In at least some schools, art programs benefitted through such stimulation of public interest.

CONDITIONS IN EDUCATION

World concerns in the early thirties entered the American classroom through programs in international education, with art as one of their vehicles. These efforts continued under such rubrics as global friendship, world citizenship, and peace studies, until war became imminent. As the development of dictatorships abroad coincided with economic depression at home, leading educators spoke of the end of an age

of individualism and laissez-faire economics, of the growing spirit of collectivism, of the spread of a "philosophy of statism" with government responsible for personal welfare. In the building of a new social order, some said schools should become an agency for change: implied indoctrination and propaganda became a hot issue.[8] As war approached, however, criticism gave way to patriotism, the "safeguarding of democracy" became the educational mission, propaganda became respectable, and posters gained importance in the art curriculum.

Financial distress had many effects. Not only was the school year shortened in many districts but state aid declined and teachers lost jobs or suffered salary cuts. Hard times did indeed tend to replace individualism with mutual assistance, and in education, the enthusiasm for a "child-centered" school lost its leading edge as the idea of the "community-centered" school gained strength. (Learning in the community context was pedagogically realistic, and community relations, with the scarcity of tax dollars, were important both in depression and in war.) On a national scale, conservative educators feared with good reason that business and government groups would be alarmed by talk of a new social order and of the duty of teachers to ally themselves with workers; especially as war approached, loyalty oaths and other threats to academic freedom became an issue.

Education in the thirties exhibited the usual interaction between current socioeconomic conditions and the distinct momentum of professional theory, which, in turn, reflected more profound cultural forces. The basic assumptions underlying the National Education Association's Seven Cardinal Principles of 1918 remained quite intact in a report of the Association's Educational Policies Commission issued in 1938, which set forth forty-three objectives subsumed under four categories: self-realization, human relationships, economic efficiency, and civic responsibility. Progressive theory continued to emphasize the wholeness of the learner, the learning process as a creative organic response to the changing environment, and the school as integral to social life.

The progressivists and the movement for social reconstruction had their strongest opposition from *essentialists*—conservatives who insisted that schools should teach what most adults needed most often and urgently and should emphasize the basic subjects and established methods. The development of social studies as a new, comprehensive subject provided one kind of resolution since it combined contemporary realism with preparation for citizenship. A third body

8. The major document of these proposals was George S. Counts, *Dare the Schools Build a New Social Order?* (1932; reprint, New York: Arno Press, 1969).

of curriculum theory, *perennialism*, called for reemphasis on the classical humanist tradition in general studies, especially in colleges and adult education.

Through the years of unemployment into the shortage of workers for defense production, a related school problem was the tension between vocational training and the education of the "whole person." Unemployment created doubts about specialized vocational education and also intensified the idea that the future workweek would be much reduced. Yet it seemed that work alone did not constitute the whole of a person's life despite the importance of work to one's identity, and work seemed unrelated to culture. Thus, much talk ensued of the "enhancement of leisure" and the "enrichment of adult living," with important implications for art education.

In practice, curriculum planning continued the developments of the twenties. The activity program and the project method were favored by Progressive educators, with special emphasis on experiences relating to daily life in the community. "Integration" was a key term: integrate the curriculum to integrate the child; integrate the child with the community; integrate the nation. Because the curriculum units of the late twenties threatened to become rigid and separate, the idea of an established curriculum design was supplanted by the concept of an ongoing development process that would bring subjects together.

By the end of the decade, this concept had matured in secondary education under the term "core curriculum." A large block of time was gained by bringing together the subjects considered most useful for all students, with social studies, literature, or science serving often as the unifying center of the "core." The schedule thus provided flexibility for units and projects, for field studies as well as widely varying in-school activities, for one "core teacher" assisted by subject specialists. Ideally, in this general education plan, an active learning experience would integrate student interests, community life, and commonly needed knowledge, abilities, and attitudes. Although the majority of schools actually retained the usual organization of separate subjects, the ideas of correlation, integration, and the "socialized curriculum" dominated educational thinking, with especially forceful implications for the arts.

As concepts of the learner and the curriculum grew more complex, a reaction against the idea of education as a science developed. Influential critics, like Harold Rugg and William H. Kilpatrick, said that emphasis on measurement and statistics directed attention only to observable segments of people and their behavior while ignoring the immeasurable, organic whole. Human nature was not mechanistic, they insisted: education concerned values, purposes, the total personality. In particular, Rugg noted that

"scientific education" had shown little interest in creative expression and appreciative awareness.[9] Intelligence testing already had come under similar criticism.

The new high school curriculum of the thirties, including art education, was reinforced by a large-scale experiment conducted by the Progressive Education Association, known as the "Eight Year Study" (1933–41). Three hundred colleges and thirty high schools participated. Graduates of these schools were evaluated for college admission on a broad base of personal data, and, most important, no specified high school courses were required. Released from the standard college entrance requirements, the schools used a variety of curricula, and students were unusually free to elect courses in art. An extraordinarily extensive evaluation process showed that students from less conventional programs achieved more complete success in college, both in academics and in extracurricular activities, than did those prepared by the usually required college entrance coursework. In regard to art education, the study thus indicated that as high school art courses had gained in popularity, they also contributed to success in college.

ART EDUCATION

Introduction

The leading ideas in American art education in the thirties already have been suggested: emphasis on the common uses of art in the home and community; the creative artist as a model for a more open plan of art activities, rather than the stipulated graded series of lessons; the correlation of art with other subjects, especially in the new core curricula; and the appreciation of art through work in various media. This was a period when school art was much influenced by conditions in society and in the world of professional art and by consolidation of the progressivist educational theories and methods introduced in the twenties.

The Status of Art Education

Data on art enrollments are scarce, but certainly the extent and quality of art programs varied greatly. Art instruction was well provided in many cities and nonexistent elsewhere, especially in rural areas. Even in the late thirties, about one-half of all students lived on farms or in communities with populations of fewer than twenty-five hundred; about 40 percent of high schools enrolled fewer than one hundred students. Despite the development of consolidated districts, one-room schools were at least half of the total. Small schools could not provide full teaching loads for art teachers. Many elementary classroom teachers

9. Harold Rugg, "After Three Decades of Scientific Method in Education," *Teachers College Record* 35 (November, 1934): 114–16.

responsible for art had but a year or two of education beyond high school and little or no experience in art.

From the late twenties into the early thirties, the number of high schools offering art classes had increased by nearly 50 percent.[10] But art was especially vulnerable to the shortage of funds for public schools. In early 1934, Pedro de Lemos reported to readers of *School Arts Magazine* worrysome statistics from a federal bulletin entitled *The Deepening Crisis in Education*: "In 700 typical cities 36 art departments were eliminated, 67 art departments have been reduced." In that year, 15.33 percent of high school students were enrolled in art: the percentage in 1928 had been 18.62 percent; in 1922, 14.75 percent; and in 1915, 22.87 percent.[11] "Without a doubt," warned de Lemos, "the art teachers of this country will have to clean house and arrange for more practical and inter-related art instruction for their students if art education is to survive."[12]

Adverse conditions did indeed arouse promotional energies. Through the decade and into the war years, art teachers exhorted each other to "sell art," even to develop "propaganda" for art through displays, posters, official "art weeks" featuring local speakers, public art service activities, and especially through curricula that developed activities around current community needs and interests. An art honor society could add prestige. School art clubs became common: by 1934, they were available in more than one-third of junior and senior schools. (Interestingly, the value claimed most often for the art club was its contribution to the curriculum; vocational training was least often cited.)[13]

These efforts were aided by certain favorable conditions. Public appreciation of the arts was stimulated by the media, by museum activities, by civic groups, and especially by federal projects. School curricula favored art as a subject that promoted correlations, that offered immediate value related to current student interests, and that provided means of participation in social and civic affairs. The Eight-Year Study allowed at least some students to break the barrier against art electives in college entrance programs. A high school specializing in music and art was launched in New York City in 1936. By the end of the decade, some art educators could say that the ground lost during the Depression had been regained.

Professional organizations likewise were spurred by adversity; for the whole population, it was a period of intense group effort and political activism. Important to art education were two lines of momentum that were interrupted only by the approach of war.

The first of these two developments aimed toward a national organization dedicated solely to public art education. In 1933, the National Education Association reestablished its Department of Art Education. Four regional art education associations—Eastern, Western, Southeastern, and Pacific—continued their annual conventions, with standing committees and at least one junior division for art education students in college. Indeed, though membership decreased at the depth of the Depression, Eastern Arts Association had grown to enroll fifteen hundred members at its 1937 convention. State and local organizations promoted public appreciation for art programs, bolstered teacher morale, and rallied budgetary support. This diversity, however, lacked concerted force.

A short-lived **National Association for Art Education** was formed late in 1935 as an outgrowth of the Federated Council on Art Education.[14] The National Association for Art Education was initiated mainly by Royal B. Farnum, a leader in public school art, who aimed to unify support for the entire field of art education.[15] Art teachers concerned with the education of children might thus have been affiliated with two larger organizations: one "all art"; the other "all K-12 education." Leaders of the National Education Association Department of Art, however, resisted subordination to the National Association for Art Education, thereby causing its demise in 1938. In the next few years, the National Education Association group, which formed mainly around convention activities, proved inadequate to the need for continuous national leadership. Thus the National Association for Art Education episode constituted a first step toward the formation of the National Art Education Association in 1947.

The influential **National Committee on Art Education** was formed in 1942 under the auspices of the Department of Art Education at the Museum of Modern Art, which was headed by Victor D'Amico. Convinced that current ideas and problems in art

10. *Art Digest* 12, no. 1, (October 1937): 27, citing *School Life*, official organ of the Office of Education, October 1937.

11. Department of the Interior, U.S. Office of Education, *Biennial Survey of Education in the United States, 1935–1938* (Washington, 1942): 24–28.

12. Pedro J. de Lemos, "Art and Enthusiasm in New Russia," *School Arts Magazine* 33, no. 6 (February 1934): 322. His source: Department of the Interior, U.S. Office of Education, *The Deepening Crisis in Education*, Leaflet 44 (Washington, D.C., 1933).

13. Maris M. Profitt, *High School Clubs*, Department of the Interior, U.S. Office of Education, Bulletin 1934, no. 18 (Washington, D.C., 1934).

14. For an account of these two organizations, see Robert J. Saunders, "First Steps: The FCAE and the NAAE: A Brief History," *Art Education* 31, no. 7 (November 1978): 18–22.

15. Royal Bailey Farnum was then education director at the Rhode Island School of Design. He had been state specialist in drawing and handwork in New York, and president of the Massachusetts Normal Art School and state director of art education for Massachusetts. He authored biennial reports on education for the U.S. Bureau (later, Office) of Education in 1914, 1923, 1925, and 1931.

played too small a part in educational thinking, the committee gave strong impetus to the concept of the "artist-teacher." The membership of artists and art educators (mainly at the college level) and professionals in several fields of art was not large as a national organization, but their annual conferences were widely significant because of the prestige of the participants and their concentration on immediate relationships between art and education. The national committee was dissolved in 1965, to be succeeded by the Institute for the Study of Art Education.

A second campaign brought together a broader range of professional arts organizations in an effort to establish a federal office for support of all the arts, independent of temporary relief projects. From late 1936 into the congressional session of Spring 1938, a number of legislative proposals were debated, not without resistance among supporters of the arts who feared bureaucratic constraints. These proposals included a federal bureau of arts, a division of creative arts within the U.S. Office of Education, and an executive department of science, art, and literature, with cabinet status. Though none of these recommendations was enacted, they confirmed the heightened public interest in the arts in the thirties; the lag of nearly three more decades before the establishment of federal agencies for the support of the arts, humanities, and science represents the usually slow process of coalescent change in culture, education, and democratic action.

International conferences continued, though the scheduled four-year series (determined at Prague in 1928) could not be maintained. The Vienna Art Congress, scheduled for 1932, was cancelled because of economic conditions, and a more limited conference was developed rather hastily in connection with an international exposition in Brussels in 1935. The Eighth International Congress for Drawing and Art Applied to Industry, the last before the war, met at the Sorbonne in Paris in 1937. Its main topic was "the art culture of the nation"; American leaders enroute to the congress emphasized the two major themes in school art at home in the thirties: free expression and the appreciation of beauty in the environment and in daily life.

International cooperation grew in other relationships. As a result of work shown in England at a conference of the New Education Fellowship, the Progressive Education Association developed an exhibition, "Children's Art from Five Continents," that circulated in the United States. The continuity of belief in the contributions of child art to international relations would be demonstrated by the rapid postwar development of worldwide organizations.

Professional preparation in art education still varied greatly through the thirties, whereas the requirements for certification continued to increase in all subject areas. Early in the century, most art teachers were products of art schools; by 1940, most were graduates of teachers colleges or universities, where programs included educational foundations courses, special methods in art education, and practice teaching. Supervisors of art could be expected to have completed some graduate study, but there was no general agreement on the requirements for a master's degree in art education. A doctoral degree was rare among art educators.

The needs for competence as an art teacher had changed. The older graded course of study had given way to the activity program and the integrated curriculum, which required broader knowledge in the liberal arts. Projects that engaged art with other subjects challenged the art teacher to apply an ever-expanding range of media to the world's traditional forms and to invent new uses: flexibility and ingenuity were esential. To promote individual creative expression, the art teacher needed an understanding of educational psychology, a nurturing personality, and experience with individual patterns of development in art in a variety of youngsters. At the same time, much was new in the world of professional art and design. Concerns grew that the teacher's own capability in creative work would suffer. There also was recognition that the professional responsibility of the art teacher included public relations if not outright salesmanship.

Most art teaching, however, took place in the elementary schools and was conducted by classroom teachers who had taken no art studies in high school and little or none in college. Where there was no art supervisor or visiting art teacher, elementary art education depended often on patterns, outdated workbooks, and "how-to-do-its."

The Owatonna Project was the outstanding example of concern for the community in art education during the prewar decade. Owatonna was chosen as a typical midwestern town where the full potential of art education for the enhancement of daily life could be tested. From 1933 through 1938, the Carnegie Foundation for the Advancement of Teaching funded the University of Minnesota in developing a program that incorporated most of the best current educational thought.

The Owatonna art curriculum was based on existing community needs, unit planning, and the project method, with appropriate correlations with other subjects. The program for adults included studio work, lectures, and projects in homes and throughout the town. The art staff was uncommonly competent in applied design, including interiors and landscape: acting not simply as instructors, they served increasingly as consultants and coordinators. National leaders in professional design fields were brought to Owatonna.

The best available instructional aids enriched the program. A small number of influential books were published. Staff members earned national prominence. Three of them collaborated on a college text based upon an introductory course at the university that, like the entire project at Owatonna, approached the appreciation of art as a response to common needs in the home, community, religion, industry, and commerce.[16]

The Owatonna Project attracted international attention: it was the first great funded curriculum experiment in art education. Its impact was probably much diminished by the war. But it finally taught hard lessons. First, as one of its leaders, Edwin Ziegfeld, noted subsequently, educational needs change continuously: twenty years later the crucial problems were not in small towns but in big cities. Second, as other ambitious efforts have shown since, splendid programs built through short-term funding will not endure without continued superior support. Nevertheless, residents who had been involved in the project asserted that its influence was still evident in 1975.[17]

Publications

The writings of the thirties in art education, read again decades later, reinforce the sense of stimulus of the Depression, sustaining the momentum of changes begun in the late twenties. Creative expression was a primary theme. Principles of design and skill in drawing were no longer topics for texts concerned with school art, though substantial books on these subjects were published. Picture study likewise disappeared from lists of new titles; the activity remained in some classrooms, but the newer title words, *art appreciation*, referred to much expanded purpose, scope, and method.[18] Only a few new graded workbooks were published, indicating decline in a kind of instruction that had been popular since about 1907, indeed since the precursors to industrial drawing.

As budget cuts threatened classes, the support of school administrators was crucial. They were offered a still useful lesson on changes and needs in art education by Sallie Tannahill, a veteran professor at Teachers College, Columbia University.[19] Baltimore's director of art education joined with two state directors to write the best book of its time on the organization and administration of school art programs.[20]

Contemporary trends were evident in several of the new titles published as the Depression eased: Winslow's *Integrated School Art Program*,[21] Natalie Cole's *Arts in the Classroom*[22] (children's expression in all the arts together), and Victor D'Amico's *Creative Teaching in Art*[23] (the artist as model, the child an innate artist). In *Our Changing Art Education*,[24] Felix Payant emphasized social change, individual expression, and the vital role of the art teacher as a sympathetic leader. In *The New Art Education*,[25] Ralph Pearson explained the relevance of the full range of current art, including nonobjective painting, abstraction, Social Realism, propaganda, and the teachings of the Bauhaus. A series of annuals, titled *Art Today*, begun in 1935 by departmental faculty at Teachers College, Columbia University, carried articles by leading art educators and showed current styles in students' creative work.

The intense interest in creativity was international. Wilhelm Viola described the work of Franz Cizek in Vienna in *Child Art*.[26] Helga Eng's *Psychology of Children's Drawings* was translated from the German.[27] Viktor Lowenfeld, a recent refugee from Vienna by way of England, reported experimental work that would become profoundly influential in *The Nature of Creative Activity*.[28] Herbert Read, in England, developed a comprehensive theoretical ground for placing the arts at the center of education, with the individuality of the child's expression in art as a fundamental element of the theory.[29]

The general educational value of art in secondary schools was considered in the report of a committee set up by a commission of the Progressive Education Association. The committee on art education, chaired by Victor D'Amico, included several other leading progressive art educators, among them Belle Boas, Rosabelle MacDonald, and Thomas Munro. In book form, their report served as the "bible" in the early 1940s at Ohio State, in the recollection of one student.[30]

16. Ray Faulkner, Edwin Ziegfeld, and Gerald Hill, *Art Today* (New York, 1941).

17. Elizabeth Michalowski, "An Inquiry into the Long-Range Effects of Intensive Art Stimulation on a Selected Group of Individuals. The Owatonna Art Education Project in Retrospect" Ed.D. diss., Columbia University, 1978).

18. M. Rose Collins and Olive L. Riley, *Art Appreciation for Junior and Senior High Schools* (New York, 1931).

19. Sallie B. Tannahill, *Fine Arts for School Administrators* (New York, 1932).

20. Walter H. Klar, Leon L. Winslow, and C. Valentine Kirby, *Art Education in Principle and Practice* (Springfield, Mass., 1933).

21. Leon Loyal Winslow, *The Integrated School Art Program* (New York, 1939).

22. Natalie Robinson Cole, *The Arts in the Classroom* (New York, 1940).

23. Victor D'Amico, *Creative Teaching in Art* (Scranton, Pa., 1942).

24. Felix Payant, *Our Changing Art Education* (Columbus, Oh., 1935).

25. Ralph M. Pearson, *The New Art Education* (New York, 1941).

26. Wilhelm Viola, *Child Art* (London, 1942).

27. Helga Eng, *The Psychology of Children's Drawings*, trans. H. Stafford Hatfield (New York, 1931).

28. Viktor Lowenfeld, *The Nature of Creative Activity* (New York, 1939).

29. Herbert Read, *Education through Art* (London, 1943).

30. Committee on the Function of Art in General Education, *The Visual Arts in General Education* (New York, 1940). John Michael recalls the inspirational spirit of the book and the faculty at Ohio State, who were leaders in the Progressive Education Movement.

Most art classes, however, changed much more slowly. *School Arts Magazine* shows that much of the work produced through the thirties, even under widely respected teachers, might have been created a decade earlier. Some of the least-changed work filled the pages of one of the most successful books of the period, *The Art Teacher*, by de Lemos, the editor of *School Arts*. As a guide to techniques in a variety of media and forms, the book represents norms of school artwork of the time with little reflection of changes in curricula and purposes.

The most substantial account of art education in the period was compiled for the fortieth yearbook of the National Society for the Study of Education.[31] These annual topical studies were written by numerous specialists under an editor guided by a distinguished committee. This yearbook considered art instruction at all levels. The articles discussing school art were set in a context notable for the breadth of its concern for the role of art in society, from city planning, landscape design, clothing, and printing to flower arranging, theater, dance, and film, as well as sculpture, painting, printmaking, and photography. The wide scope thus implied for art as a school subject was representative of leadership opinion at the time.

Purposes and Issues

The decades between the two world wars provide instructive instances of educational response to changing external conditions. At the end of the First World War, the Seven Cardinal Principles (promulgated by the National Education Association in 1918) stated as educational purposes the common adult capabilities that were considered essential. The product would be a wholesome person, able to cope in areas of responsibility that might still seem sensibly defined. The needed capabilities could be phrased more specifically as objectives that satisfied the modern urge toward technocratic precision in design, management, and assessment. Thus, the daily utility of learnings in art could be identified as readily as in other subjects. But although adult responsibilities might be constant, conditions could quickly change the particular means of coping as well as the short-term demands upon schools. By 1940, at least two sets of factors, which might be called psychological and social, had changed the statements of educational purpose.

Already in the twenties, Progressives emphasized the wholeness of personality rather than particular knowledge and skills. Within the context of *adjustment* as adaptation to societal norms, *integration* came to imply self-reliant individuality, *adjusted* but

not thereby diminished. Creative self-expression became the mark of individuality and the proclaimed mission of art education.

The failure of the economy reinforced this sort of change. With jobs disappearing, the itemized competencies of the twenties were no longer reliable. What Kilpatrick had said then was now accepted: flexible adaptability would be needed, grounded in broader knowledge, independent thinking, and such personal qualities as openness to change and confidence in personal enterprise. Unemployment and the collapse of business and finance forced a reassessment of fundamental values and necessities. Where money was scarce, satisfaction could come through community, and the enrichment of living could come from one's own creativity and culture. In the response of the schools to these needs, the arts seemed especially valuable.

The purposes of art education still could be stated in the early thirties in terms of the love of beauty in nature and the development of good taste. But nature was less accessible in growing cities and unkind in the dust belt, whereas the concept of good taste was class-ridden, antiquarian, and expensive. The more contemporary phrasings of such purpose began to speak of the appreciation of modern design, in all its applications throughout the community, as the key to good living. Activity in the arts was recommended for the enhancement of leisure, as adult education gained momentum. A follower of Dewey could speak of *aesthetic growth*, with the arts as the ideal media of the integrative experience. The *building of character* had been claimed at the turn of the century as a value of school art; it was a value that again earned emphasis in the adversities of the Depression, with integration, adjustment, and self-reliance being seen as specific qualities of character; some began to talk of art as therapeutic. Thus *appreciation* and *creative self-expression*, subsuming the other values, became the most common terms of purpose for art education under the unusual conditions of the thirties.

Given such purposes, the resistance to tests and statistics noted above was particularly strong among supporters of the arts. This opposition included some who had hoped in the twenties that testing could help to identify talent, to promote individuation of curricula, or to verify progress in art. Talent and learning in the arts, it appeared, were too complex to be readily measured. Moreover, said critics of testing, such efforts seemed worse than futile because they created a misunderstanding of art and an atmosphere inimical to its purposes.

Another issue, the question whether schools should assume a primary responsibility for the reconstruction of society, had particular effects in art classes. For instance, this was a decade of propaganda:

31. Guy M. Whipple, ed., *Art in American Life and Education*, Fortieth Yearbook of the National Society for the Study of Education (Bloomington, Ill., 1941).

educators argued whether propaganda should be avoided, analyzed protectively, or actively used in schools. Posters were a common school product; murals, a popular group activity: what should be the position of the art teacher on propaganda? More generally, daily experience as the subject for school art was readily fitted to the popularity of American Scene painting. The idealism of adolescence could be guided toward the sympathetic, the critical, or the rebellious dimensions of social realism: what was the responsibility of the art teacher as stimulator and guide?

The relation of art to the general curriculum entailed other problems. In this decade of integrated units and "core" planning, the claim that art should pervade the curriculum was common, even among those art educators usually oriented toward professional art. But within a few years, it was equally common to say that integration was likely to exclude essential creative self-expression by reducing art to illustration, model making, and group activities. Here was the resurgence of an issue that had appeared in 1895, in the debate between Parker and Clark, when school art had first gained identity—a duality inherent in the possibilities of the subject.

Toward the end of the decade, statements of educational purpose reflected the menace of fascism and the threat of war. Indoctrination by the school now was justified; the art class could proudly make propaganda. Moreover, art was claimed to be inherently democratic. During the war, the short-term purpose of school art was to make whatever contribution it could to reduce tensions, to boost morale, to join in civic efforts. For adults, special classes were offered in blueprint reading, camouflage, and therapy. And, as the end of the war approached, school art took on a further purpose: the promotion of world understanding.

The Art Curriculum

In 1933, the U.S. Office of Education issued a report of trends in secondary art education based on analysis of courses of study in forty-two cities in twenty-two states and on visits to thirty-five schools.[32] Many if not most of these curriculum guides were issued in the late twenties: the visits provided current information. Correlation was mentioned frequently in the guides, but few of them gave practical help to develop such instruction. Units of study were just beginning to be introduced in schools: none was found in the art guides examined. Only in the most recent guides were creative expres-

sion and general appreciation given primary emphasis as goals.

Another survey, quite possibly using the same curriculum materials, was conducted in 1933 as the Owatonna Project began. It was found that

> fewer than a third of these thirty-five curricula laid any emphasis on the art of daily life. About the same number stressed the development of appreciation through creative work. In all the others the emphasis was on self-expression, on skills and techniques, and on the knowledge of art principles.[33]

Thus, it seems that most art teachers thought of their subject matter in the usual categories of the forms and media of art. But because school curricula through the decade gave increased attention to practical applications of learning, it may be useful to cite the nine areas of art in daily life that were taken as the basis for curriculum planning at Owatonna.

The first four of these were derived from the naturally expanding domains of interest in the developing child: the self, the home, the school, and the community. The remaining five areas identified forms of utilitarian art: commerce, industry, printing, religion, and recreation. These alone, however, were not fundamentally sufficient; special units were added as needed in design and color and in painting and sculpture.[34]

As curriculum planning in art developed through the thirties, the key terms became *unit* and *correlation* or *integration*. In theory, at least, the newer curricula were not to be built simply of a logical sequence of skills and knowledge. (Art, in particular, had weak claim to any such inherent structure.) Where the simple correlation of two subjects continued, the art teacher could still plan a series of specific art lessons. But wherever the school organized more complex integration or core programs, art learnings had to be fitted into projects dominated by other subject content.

Mathematics, science, literature, geography, health: every subject had a place for art. For example, a single issue of *School Arts* devoted to integration had articles about art and the "hat shop," musical instruments, folk songs, movies, the jungle, the Philippines, Australia, delinquency, and modeling a symphony orchestra. One effect of such relations to other subjects was the further expansion of the variety of media and forms of school art.

With such a range of projects, planning and writing a curriculum was complicated. In the twenties, art teachers had been encouraged to join in the effort to make schooling accountable—to show a planned relationship between objectives, content, activities, and learnings. While the flexibility required by newer integrated projects made it impractical to schedule

32. Robert S. Hilpert, "Instruction in Music and Art, Part II," Department of the Interior, U.S. Office of Education, *National Survey of Secondary Education*, Bulletin 1932, no. 17, Monograph no. 25 (Washington, D.C., 1933).

33. Edwin Ziegfeld and Mary Elinore Smith, *Art for Daily Living: The Story of the Owatonna Project* (Minneapolis, 1944), 123.

34. Ziegfield and Smith, *Art for Daily Living*, 62–63.

Figure 4-1. Diversified art activites for projects in six areas of life needs, correlated with literature through the six elementary school years. Klar, Winslow, and Kirby, *Art Education in Principle and Practice*, 116.

This chart and the seven others immediately following were developed and contributed by Miss Marguerite B. Tiffany.

ART AND LITERATURE ACTIVITIES*

	I	II	III	IV	V	VI
Type	Home life. Nursery rhymes and Mother Goose	Community. Nature Stories. Fables	Country Life. Pastoral man. Indian Stories. Eskimo Stories	Myths, hero and adventure stories	Colonial life, Explorers and pirates	International.Chinese. Japanese. African
Food	Illustrate, nursery rhymes. Fairy Tales	Illustrate, how forest friends obtain winter food. Letter labels for store	Illustrate, butter and cheese making. Make butter and cheese. Grind meal	Illustrate, banquet scenes, festivals; feats and pageants. Make a frieze	Serve a colonial meal. Study colonial recipes. Make a model colonial kitchen	Study and illustrate, the salt industry. Early local customs. Food customs in other countries
Clothing	Illustrate, clothing of Mother Goose characters. Home clothing	Dramatize stories. Construct and dress sand table characters	Indian weaving. Illustrate, Dutch, Eskimo, and Japanese clothing. Tanning a hide	Make a movie of stories read. Make costumes of mythological characters	Make costumes for a colonial play. Make a sampler. Cotton plantation	A study of rubber. Make a book of costumes. A study of rugs
Shelter	Write names of parts of a house in an illustrated booklet	Illustrate, types of buildings and people working in them	Sand table project. Model barn and farm animals	Construct a castle. Model Roman houses and theaters	Study colonial architecture. Collect pictures of historical buildings. Write stories	African and Oriental architecture and furnishings. Make models
Records	Picture books. Keep a diary. Make a newspaper for the class activities	Make a booklet of illustrated nursery rhymes. List police and fire stations	Start library. Write letters to characters in stories. Indian picture writing	Learn to use library references. Greek and Roman sculpture as records	Horn books. Picture study as a record. Write a diary representing colonial times	Illustrate, Egyptian hieroglyphics, Chinese and Japanese writing, art and carvings
Utensils	Illustrate, utensils from Mother Goose stories	Illustrate, utensils used by primitives. Early and late stone age	Illustrate, needles used by early peoples. Make a mortar and pestle, butter churn	Study and construct Greek and Roman vases	Visit a museum. Illustrate, colonial utensils. Make a collection of articles	Illustrate, Chinese, Japanese, and African utensils
Tools	Construct tools of cardboard. Saw, hammer, hatchet, etc.	Construct tools to be used in dramatizing stories	Make a booklet of garden tools. Illustrate with drawings	Illustrate, kinds of tools used in ancient and mediaeval times	Make models of boats used by explorers and pirates	Make a frieze showing the development of manufacturing

sequences of specific lessons, a careful format for unit plans could help to clarify purposeful organization and show how the desired range of learnings were promoted sometime during the year. Considerable sophistication was needed to achieve such definition within integrated curricula.

As the decade progressed, successful unit plans often were developed into packages complete with background information and visual resource materials. Yet, at the same time, the administrative demand for systematic presentations of planning seems to have been reduced by a general confidence in collaborative curricula and by growing acceptance of an essential spontaneity in creative arts experiences. Art teachers, however, began to complain that fundamental art values were often lost in correlation. Noticeably in the early forties, though correlation continued, the concept of the art teacher as curriculum expert was surmounted by the concept of the artist-teacher, a shift that continued for many years.

Insofar as generalizations may be plausible in relation to the wide variety of art teaching, it can be said again that two enthusiasms for curriculum reached their peak in the thirties: for the integration of art with other subjects and for the concern with art and design in the home and the community.

The Elementary Art Curriculum

Except in platoon schools, elementary art usually was taught by classroom teachers who ideally worked with supervising art specialists in planning the curriculum. Correlation in the elementary grades had been common for years before the thirties; it was nat-ural in classrooms where the teacher had responsibility for all subjects, knew each child, and could control the daily schedule. Nevertheless, correlated teaching was not the rule everywhere.

Typical of a more subject-centered approach at the outset of the thirties was the New York City course of study, a plan necessarily stiff in consideration of the size of the school system, which hindered cooperation between classroom teachers and art supervisors.[35] For each month, actvities were stipulated according to standard categories of classroom art: picture study, nature drawing, pictorial drawing, construction, color and design, poster making. Especially in the primary grades, most of the activities were related to seasons, holidays, and events; rather few suggestions for correlated projects were offered in the upper grades. Such curriculum content differed little from the usual teaching of the twenties.

In a smaller, more progressive school system, integrated units already encouraged flexibility, just as the instability of the outside world called for short-term plans, improvisations, and readjustments. Attitudinal learnings gained importance in planning. The old concern for good habits and attitudes, following the current of community participation and social activism of the Depression, increasingly emphasized self-reliance, together with small group responsibilities. In this newer methodology, knowledge and skills would be developed as needed in the project rather than in an analytical sequence of lessons. The teacher,

35. Board of Education, *Course of Study in Art for Elementary Schools* (New York, 1931).

Figure 4-2. State-of-the-art planning for the major funded project of the thirties. Edwin Ziegfeld and Mary Elinore Smith, *Art for Daily Living*, Owatonna Art Education Project, no. 4 (Minneapolis, 1944), 132–35.

ACTIVITIES INVOLVED IN DEVELOPING THE UNITS PUBLISHED IN *Art Units for Grades 1–3* and *Art Units for Grades 4–6*, COMPILED BY CLIFTON A. GAYNE AFTER THE CLASSIFICATION SUGGESTED BY CASWELL AND CAMPBELL

	Units for Grades 1–3										Units for Grades 4–6							
	Making a Living Room	Learning about Clothes	What the Farmer Does for Us	Beautifying the Schoolroom	Building a Store	Machines	Trees in Autumn	Making a Newspaper	American Indians	Using Art in the Home	How Communities Grow	Making a Magazine	Artists and Industry	Textiles in Everyday Life	Man Conquers Distance	Architecture in Community Life	Life in the Medieval World	Planning Homes and Gardens
ACTIVITIES PRIMARILY FOR THE PRODUCTION OF MATERIAL OBJECTS																		
Constructing playhouses, stores, etc.	X				X				X									
Constructing furniture, toys, etc.	X			X	X													
Making pottery	X								X									
Weaving and decorating textiles														X				
Making wood and soap carvings																		
Making puppets and stagecraft objects																		
Making clay models and casts	X				X						X							X
Making objects of paper and scrap material									X		X					X	X	
Making decorations							X		X	X							X	
Making miscellaneous crafts objects									X	X								
Illustrating and binding books								X	X		X	X						
Making drawings and paintings	X	X		X				X	X	X			X	X		X	X	X
ACTIVITIES PRIMARILY FOR CREATIVE EXPRESSION																		
Drawing and painting	X		X		X				X					X			X	X
Modeling, sculpture, carving																		
Planning and producing plays, puppet shows, etc.																		
Illustration	X								X			X		X			X	X
ACTIVITIES PRIMARILY FOR RECREATION																		
Playing games									X									
Having parties	X			X	X				X	X								
Listening to music																	X	X
Looking at pictures				X														
Reading stories, plays, poems				X		X		X		X							X	
Going to the theater																		
Telling and listening to stories				X		X				X							X	X
Organizing clubs																	X	X
Using art materials											X			X				X
MATERIALS USED																		
For drawing: pencil, crayon, chalk, pen and ink, brush	X	X	X	X	X	X	X	X	X	X	X	X	X	X	X	X	X	X
For painting: water-color, tempera, powder, oil, and finger paint	X		X		X	X			X				X			X	X	X
For modeling and carving: clay, plasticine, plaster of paris, soap	X		X		X						X						X	X
For the graphic processes: stencil, etching, block print, photographic equipment																		
For construction: wood, paint, cardboard, boxes, etc.	X		X	X					X	X						X	X	X
Crafts materials									X	X								X
Colored paper			X	X	X	X			X					X		X	X	X
Clippings and illustrative materials specifically related to unit	X	X	X	X	X		X	X		X		X		X	X	X	X	X

accordingly, became more a guide and organizer, less a dominant authority—a leader in motivation, group planning, and evaluation, with projects carried out by committees and teams. Younger children showed surprising ability to take on such roles.

Other changes were evident in the elementary curriculum. The nationwide popularization of the arts in the thirties has been noted above. In the schools, emphasis on creative expression within integrated unit projects brought together drama, dance, music, literature, and visual arts. Here, again, children showed spontaneous talent, and by this time it was accepted that adult conceptions and standards could not promote a superior learning. Teachers published descriptions of projects vitalized by the arts. Faculty members

of several departments at Teachers College, Columbia University, developed a group of "General Arts" courses, beginning in 1935.[36] The inherent relatedness of the arts became a frequent topic in educational discourse, and indeed one leader of the movement asserted that the proper interrelation of the arts was not with the rest of the curriculum but among themselves.

A persuasive description of integration was given in Natalie Cole's *Arts in the Classroom*, cited above. Hers was a school populated by minorities, many of them recent immigrants. For her, the arts were modes

36. Foster Wygant, "A History of the Department of Fine and Industrial Arts of Teachers College, Columbia University" (Ed.D. diss., Columbia University, 1959), 58.

Figure 4-2. *Continued*

ACTIVITIES INVOLVED IN DEVELOPING THE UNITS PUBLISHED IN *Art Units for Grades 1–3* and *Art Units for Grades 4–6*, COMPILED BY CLIFTON A. GAYNE AFTER THE CLASSIFICATION SUGGESTED BY CASWELL AND CAMPBELL

Activity	Making a Living Room	Learning about Clothes	What the Farmer Does for Us	Beautifying the Schoolroom	Building a Store	Machines	Trees in Autumn	Making a Newspaper	American Indians	Using Art in the Home	How Communities Grow	Making a Magazine	Artists and Industry	Textiles in Everyday Life	Man Conquers Distance	Architecture in Community Life	Life in the Medieval World	Planning Homes and Gardens
ACTIVITIES PRIMARILY TO SECURE INFORMATION																		
Reading		X	X		X	X	X	X	X	X	X	X	X	X	X	X	X	X
Listening to lectures																		
Conferences and interviews			X									X						
Discussions	X	X	X	X	X	X	X	X	X	X	X	X	X	X	X	X	X	X
Studying pictures, maps, charts, etc.	X	X	X			X	X	X	X		X	X	X	X	X	X	X	X
Seeing slides and movies																		
Conducting experiments												X						
Field trips and excursions			X		X	X	X						X	X	X	X		X
Making surveys					X													
Observing and recording					X	X	X	X		X	X	X	X	X			X	X
Collecting specimens		X				X	X	X	X			X	X	X	X		X	
ACTIVITIES PRIMARILY TO ORGANIZE AND PRESENT INFORMATION																		
Making charts, graphs, maps, etc.											X			X				
Making posters and advertisements				X								X						
Making booklets and scrapbooks	X	X			X	X						X	X	X				
Making illustrations, "moving pictures," etc.	X	X	X		X	X			X			X		X	X	X	X	X
Giving programs			X						X					X		X		
Organizing exhibitions, displays, and sales	X	X	X	X			X	X	X	X	X	X				X	X	X
Giving oral reports and demonstrations	X	X		X		X	X	X		X		X	X	X	X		X	X
Writing reports and articles		X						X				X	X				X	
Making plans and diagrams, working with dittoed or mimeographed sheets, etc.		X								X								X
Making friezes and murals							X	X						X				
Making models			X													X	X	X
ACTIVITIES PRIMARILY TO FACILITATE THE DEVELOPMENT OF SKILLS																		
Lettering					X	X	X	X			X	X	X	X	X			
Measuring	X				X	X		X		X	X	X	X	X	X	X		X
Modeling	X		X		X				X								X	X
Drawing objects						X										X		
Drawing figures and animals	X		X	X									X		X		X	X
Drawing landscapes																	X	X
Mechanical drawing												X			X			
Designing	X	X			X	X		X	X	X	X	X	X	X	X	X	X	X
Reading plans and blueprints												X						
Painting					X							X						
Using color	X	X	X	X	X	X	X				X	X	X	X		X	X	X
Experimenting with different media						X					X	X	X			X		X
Using crafts materials	X										X	X	X	X	X	X	X	X
Exercising discrimination	X	X			X	X		X	X		X			X		X	X	X
Evaluating art objects	X				X	X					X			X	X	X	X	X
Planning arrangements and layouts	X		X	X	X	X	X	X	X	X	X	X		X	X		X	X

of expression where language might fail and a means toward self-esteem and mutual respect where ethnic, economic, and social barriers were common. Such an aim required highly personal motivation, an earnest emotional freedom in teacher and child, and the priority of individual expression over conventional skills. Expression as an aim in visual art was matched by the individuality of free improvisational dancing. Cole's purposes and methods, in a situation that was not yet common, linked the heritage of progressivism to inner-city art education in the next few decades.

A rather different development in the late thirties and early forties, which tended away from the integrated art program, appeared in the growing reference to the artist as the model in conceiving the school art curriculum. In effect, this meant more attention to effective production in basic art media. Probably contributing to this shift were the recognition of the authenticity of child art and the understanding that learning in the arts was somehow different, together with a somewhat more general acceptance of the artist as socially useful during the years of American Scene painting and federal projects. For some, this emphasis on the child as an artist seemed simply a reassertion of the long discredited "art-for-art's-sake" position. Its proponents, however, argued that the value of art experience in developing the full potential of all children warranted an essential role in general education, just as the arts were essential to civilization.

Finally, it must be said once more that, although the trends described above were prevalent among many art programs through much of the nation, many schools remained where classroom art was poorly provided and little changed from the lower qualities of work of earlier decades.

The Secondary Art Curriculum

Art programs in junior and senior high schools generally followed the organizational patterns developed in the twenties.

The junior high school was planned for appreciation and personal exploration: these aims accordingly governed the art curriculum. The general art course commonly required in the seventh year provided the only link between elementary art and adulthood for most students. In teaching for appreciation, historical content diminished. Instead, following current ideas of motivation and practicality and the growing interest in environmental and industrial design, this general course often gave much attention to contemporary applications of art in the home and community. To promote exploration and personal expression, it was considered important to schedule experiences in a wide variety of media. Theoretically, individually planned projects were ideal, but with classes averaging as many as forty-five students, organization into small groups was a more practical solution.

Art was usually elective in grades eight and nine, providing some students with continuity into the high school program. In many schools, however, such art electives were not available or were hindered, whether by industrial arts and home economics requirements or by the specifications of college entrance programs reaching down through the senior high school. A New York state syllabus, by contrast, required art in both seventh and eighth grades and recommended close collaboration between art, industrial art, and home economics departments to ensure practicality in art.

The same syllabus expected that the two required years of art would identify three types of students:

> those with decided talent, who should be encouraged to take advanced courses in senior high school as a foundation for future work; those who are unable to draw well and have little interest in general high school work, but are interested in craft work; and those who are without special art abilities but who would find the general courses in art appreciation most valuable in helping them to appreciate the beautiful and useful things in life." [37]

37. University of the State of New York, State Education Department, *Correlated Syllabus in Art Education for the Junior High School Years* (Albany, 1936), 7.

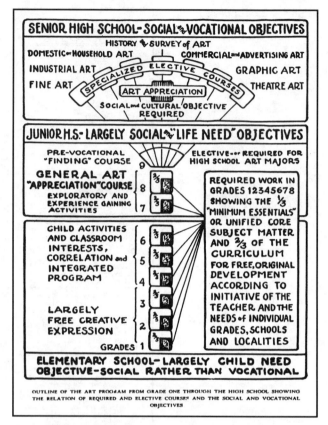

Figure 4-3. Provison for unit and core curriculum early in the thirties, with emphasis on vocational needs. (Ninth grade might be either junior or senior high school.) William G. Whitford, "Analysis of the Art Curriculum," *School Arts Magazine* 32, no. 10 (June, 1933), 585. Reprinted with permission of *School Arts.*

Senior high school art programs commonly distinguished two lines of curriculum: for the general student and for the vocationally talented. A few surveys suggest that as few as 10 to 12 percent of high school students enrolled in art. But that number was certainly higher in many cities, and some programs offered art as a major study so that a student could enroll in two or more courses in each term. The curriculum commonly began with a general course that in some schools was prerequisite to further electives; it was frequently urged that such a course should be required in all high schools.

A wide variety of art electives was found in both junior and senior high schools. The popularity of free-hand drawing continued. Photography, crafts media, and printmaking were among the electives that gained regard in the thirties, whereas some students specialized in commercial art. More often available only in the upper grades were costume design, interior decoration, fabric design, metal crafts, and stage design.

In both junior and senior high schools, progres-

Figure 4-4. Drawings from a one-room rural school, for study of transportation. *School Arts* 38, no. 7 (March 1939): 223. Reprinted with permission of *School Arts*.

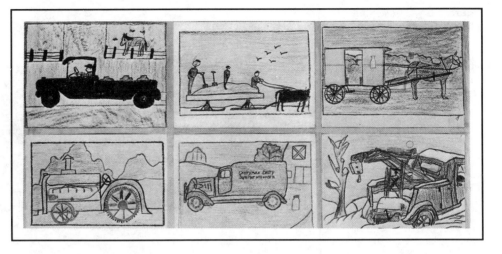

sive critics found too much instruction continuing in the manner of professional art schools. Too many teachers, they said, were not sufficiently prepared for the new methodology. Moreover, integration of studies was inherently difficult, due to the departmentalization of courses and the traditions of college entrance curricula. Even among schools included in the Eight-Year Study, integrative art courses apparently were not the rule. In some of the more progressive schools, however, art activities already were, or soon became, quite intensively joined with other subjects in unit plans, and these changes were publicized. It is also evident that the planning of art courses across the country generally did take students into a wider range of activities and media, often out in the community, and did rely much more than previously on student initiative and organization. Though some art educators disliked these changes, curricula and methodology were moving in progressivist directions.

The Contents of the Art Curriculum

Drawing and Painting

In elementary art, the trends of the twenties continued: less intention to teach for accurate representation; more promotion of free expression in response to subjects of personal interest; more concern for encouragement and guidance, less for direct instruction. Not only were children said to be natural artists but modern artists, it was claimed, were adults seeking the spontaneous freedom of children.

Drawing became a medium for mental hygiene. Expression implied the communication not merely of ideas but of the whole personality. Like dance, expressive drawing was to engage the body in swinging rhythmic movement, particularly since younger children were not yet ready for small-muscle skills. Large movement required bigger paper and tools: the small points of pen and pencil were no longer suitable.

Color was the other component of such expression. Chalks and crayons were appropriate, but the small brushes and delicate tints of the watercolor box gave way to tempera—brilliant color that was easily applied with big brushes and readily overpainted. For sheer freedom, best of all and quickly popular were the finger paints introduced by Ruth Shaw, which engaged the whole arm, invited experiment, and brought surprising results that seemed somewhat like modern nonobjective art. (Since such results were not pictures, children and teachers alike, in whatever medium, called them "designs.") Somewhere around 1940 came the first reports of an approach to abstraction that threatened to last forever: scribble over the whole paper, then fill in any of the shapes with any crayon.

Representation, however, continued as a natural form of expression for children. Some teachers began to say that, to preserve originality, children should have no instruction and see no adult art. Others, like Jessie Todd at the University of Chicago, responded that children should be helped in art expression as in any other subject; that they were surrounded by adult art anyway; that copying was not necessarily bad; and that a good teacher could give help when needed without impeding creative freedom. Moreover, when correlation called for the skills of representation, theory approved of direct instruction since the children were presumed to recognize the need. Some teachers cited laws of learning: children should learn to draw simple objects and maintain this learning by frequent use. For children to copy such drawings, the new ditto machine came into play: ditto masters designed by Jessie Todd were sold to teachers by the manufacturer.[38] Since correlation required illustration, *School*

38. Jessie Todd and Ann Van Nice Gale, *Enjoyment and Use of Art in the Elementary School* (Chicago, 1933), gives ample evidence of Todd's ability to promote individual expression through judicious teaching, despite these ditto models.

Figure 4-5. High school art of the American scene, by students of Margaret Rehnstrand. *School Arts* 42, no. 1 (September 1942): 11. Reprinted with permission of *School Arts*.

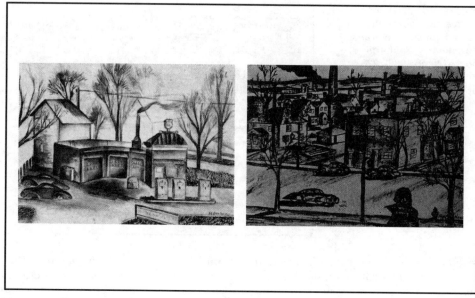

Arts published special issues with information and imagery on popular topics: reference, or copy, was needed, for how could a child be taught to represent what had never been seen? The apparent contradiction between creative individuality and such production of illustrations, especially in elementary grades, troubled many art educators.

In secondary art classes, paintings and drawings were often a part of more complex projects rather than final objects in themselves. Otherwise, still life and figure studies remained popular. Art sponsored by the Works Progress Administration, especially regionalist realism, offered suitable ideas of subject and style to fit the "socialized" curriculum. Modernist styles brought new approaches to drawing and painting. Contour drawing, as a teaching method, was introduced by Charles Martin at Teachers College, Columbia University, in 1927; by the early thirties, teachers reported success among children who had not learned to draw under "academic" methods. A few teachers experimented with "cinemagraphology," drawing from motion pictures, as an updated form of memory drawing and as an approach to sketching fast action. To achieve the stark contrasts associated with modernity, broad-tipped lettering pens were used in drawing, especially for the continued study of *notan* in composition. Spattering became popular, partly in imitation of the airbrush, which produced the sharp edges and slick gradations that characterized contemporary commercial illustration. Not only commercial work but such artists as Sheeler, Crawford, and Feininger provided models for adolescents: skyscrapers, aircraft, automobiles, spotlights, and reinforced concrete offered forms fit for "modern" stylization and were symbolic of the machine age as well.

Printmaking

Printmaking became increasingly important to artists during the Depression, partly for income, partly for direct expression on social themes, and partly because workshops could be equipped through federal funding. This renaissance was reflected in school art, where block printing with wood and linoleum had been commonplace for at least two decades. Potato printing that had decorated old Pennsylvania farmhouses was easily managed by youngsters. Children enjoyed the use of tools, the transformation of the print process, and the achievement of multiple reproductions. Teachers valued such motivation and used simple prints, especially for projects in design. In secondary classes, block prints were useful for studies in composition and for book projects.

In the thirties, some art teachers and adolescents learned the sophisticated techniques of etching and lithography, including drypoint and aquatint. These media could reproduce freehand drawing more directly, with infinite nuance of texture and value, and they also provided for experiment with plates.

Professional printmaking equipment and materials were rather expensive for most schools. Ingenuity helped: a clothes wringer from a washing machine could serve as a press. By 1937, a simple etching press was available to schools for twelve dollars. Industrial sheet plastic, cheaper than metal plates, was merchandized for drypoint. Teachers experimented with simpler substitutes: drypoint printing with celluloid scavenged from the windows of convertible cars and block printing with paraffin and with chalk-coated plates often used in cheap commercial printing. Even crayon, thickly drawn on sandpaper, could imitate the lithograph.

Figure 4-6. Two contemporary styles in the early thirties. (a) By a student of Katherine Tyler. *School Arts Magazine* 32, no. 5 (January 1933): 272. (b) By a student of Ina Ann Babb. *School Arts Magazine* 32, no. 9 (May 1933): 566. Reprinted with permission of *School Arts*.

For artists as well as school art classes the newer silk-screen process (developed since 1900) had exciting possibilities. It could be applied to many surfaces, and it more easily produced the brilliant flat colors and the bold, sharp lettering wanted in poster design. Materials were relatively inexpensive, and the technique comparatively simple.

The printmaking experience was readily adapted to correlated studies. Simply to provide for individual engagement with the subject matter, the process was likely to sustain personal interest over an extended block of time. But prints were especially useful as culminating products—in booklets, portfolios, displays, or publications—and, of course, for publicity.

Murals

Projects for walls became a major enthusiasm of art classes in the thirties, stimulated by interest in the Mexican Mural Movement, by the importance of murals in federal art projects across the country, and by their educational value. No school artwork inspired more research in correlated studies, provided a more fruitful culminating activity, or better promoted school-community relations than did murals.

For some teachers, any big artwork on a relatively flat surface could qualify as a mural. Colored paper, cloth, chalk, tempera, and oil were applied to wrapping paper, burlap, commercial paneling, and any school wall. From primary grades through the advanced art classes of high school, mural projects proceeded through a typical sequence: choice of subject; discussion and research; group selection from individual drawings; teamwork in preparing materials and surfaces; collaboration on color schemes and problems of unification; and finally enlargment and rendering according to authorship and varied talents, all on the principle that each must have a rewarding role.

According to one report, mural projects provided oportunities for "co-operation, self-expression, discussions, experimenting, self-control, execution of personal ideas, inspiration, conceptions of real beauty, acts of kindness, courtesy, consideration, and when the work is complete, a thrill of pride in their own creative art work."[39]

Photography

Although many students owned cameras and many schools sponsored camera clubs, photography was still uncommon in the art curriculum. The requisites for regular class instruction—space, equipment,

39. Maud R. Obarr, "Primary Murals," *School Arts* 38, no. 5 (January, 1939): 176–77.

Figure 4-7. A high school mural representing contemporary education, by students of Bessie Mulholland. *School Arts* 38, no. 5 (January 1939): 169. Reprinted with permission of *School Arts*.

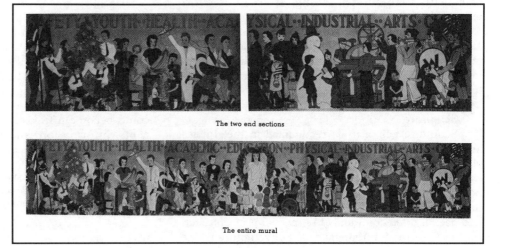

The two end sections

The entire mural

Figure 4-8. Soap sculpture, "Organizations," for a year-book divider, by a student of Bessie Mulholland. *School Arts* 37, no. 2 (October 1937): 60. Reprinted with permission of *School Arts*.

and teacher experience—were lacking, and the need or benefits were not demanding. At least one effort with pinhole cameras was reportedly not successful. Animated film, most notably Disney's *Fantasia* in 1940, was new and exciting, and a few enterprising teachers and students found ways to produce animations inexpensively. But these were pioneers in a territory that remained sparsely settled.

Sculpture

Sculpture began to be recognized in the thirties as an important element in school art. Modeling in clay and relief carving in wood were already well established; indeed, work in iron, either in bent ribbon or forged, had been popular briefly at the turn of the century. Three-dimensional experience, however, had been limited commonly to practical projects, such as those executed in manual arts. For sculpture in the

round, soap became a favored medium.[40] Papier maché was popular for many projects but was not quite sculptural, not quite a craft.

The change in the thirties resulted from influences in both education and art. Educators already recognized the general value of work with tools and resistant materials. As it became apparent that some children expressed themselves more effectively in three dimensions than in two, the principle of individuation argued for more experiences in sculpture. By then, art teachers were acquainted with early twentieth-century abstract sculpture and with the concomitant surge of interest in the sculpture of other civilizations. Freed from illusionistic realism, such exemplars at once validated the simple, imaginative expressions of which children were capable and suggested the educational possibilities of experiment with unconventional materials.

Beyond the conventional plasticine, clay, paper, soap, and wood, plaster and even cement were used, both cast and carved.[41] Students were challenged to make something out of almost anything. "Community surveys" and closet scroungings brought to class the leftovers of home life and industry: spools, feathers, boxes, scraps of whatever. Just a few years after Calder created his wire circus, teenagers made figures freely with wire, as three-dimensional studies of line.

Despite this growth of interest within schools, however, new art teachers were often inexperienced in sculpture. If they had worked with three-dimensional materials, it had more likely been within a course in general design, mainly in the study of fundamental principles. (Once in the classroom, teachers frequently approached sculpture through use of geometric solid forms.) Here was an instance of a situation that has not been rare (whether for better or worse), in which practice in the schools has varied more rapidly than the teacher-preparation curriculum.

Design

In schools during the thirties, changes in teaching design that had begun in the previous decade continued, with ever more attention to contemporary products and style. The influence of current curriculum theory was strong, particularly in its emphasis on the project method and community life.

Planning for design in the correlated curriculum could become a task of cross-referencing. What concepts, information, and media skills were developmentally appropriate at a given grade level? What

40. Procter and Gamble, the manufacturers of Ivory soap, sponsored an annual national contest in soap sculpture from 1925 to 1961, with a category for professionals and a number of foremost sculptors as judges.

41. To make plaster and concrete easier to carve, the addition of vermiculite began around 1940.

forms of design could be related to which of the major topics designated in the general curriculum for that grade? Within that form or area of design, at that age, what product could be satisfactorily imitated by the student within the limits of school equipment and organization?

Educational theory recommended the project method for motivation, practical productivity, and experience in problem solving. Experiment and discovery, moreover, were important generally in educational methodology in the thirties. Art teachers, even when nothing more novel than a decorative border or pattern was sought, tried more than ever before to find ways to avoid conventions and promote individual solutions.

The importance of products in school art reflected also the development of industrial and environmental design, the resurgence of the crafts media, and the style, variety, and technological thrill of new products themselves. Indeed, some teachers claimed that school art should be devoted entirely to design, with no attention to drawing, because design represented the forms of art in daily life.

Some enthusiasts for modern design said that the traditional principles and elements of design no longer were valid and should not be taught. Nevertheless, most teachers continued to refer to such fundamentals, though less often as the explicit content of a lesson and more usually in advice throughout the development of a project.

The concept of design, as noted above, sometimes became confused owing to growing acquaintance with abstract or nonobjective art. As an indirect approach, for example, students might be asked to freely arrange a set of regular geometric shapes, possibly overlapped. Or they might be asked to use a "finder" (a cut-out paper frame) to discover a pleasing motif within a fingerpainting, a photograph of machinery, or anything observed and to use this motif to fill an assigned space. The results might be an allover repeat pattern or a single composition: either result might be called a design. The composition might as often be called abstract or nonobjective art. But the question of relations between art and design was not limited to school art teachers. They were aware that geometric shapes and rhythmic lines were found equally in design and art, and indeed, Bauhaus theorists and others denied any such distinction.[42]

Bauhaus theory had become at least roughly familiar to many art teachers by the early forties. Moholy-Nagy, who founded the School of Design (the

Figure 4-9. Bauhaus influence: a study of texture by a sixth-grade student of Edward Anthony. *School Arts* 40, no. 6 (February 1941): 183. Reprinted with permission of *School Arts*.

"new Bauhaus") in Chicago in 1937, addressed the National Education Association art division in 1939. *School Arts* carried short articles on Bauhaus teaching applied to schools, written mostly by college instructors who had adopted the approach. Probably the most general adaptations of Bauhaus principles in K-12 schools were emphasis on experiment with materials and techniques to discover their possibilities; the use of geometric forms; and the interest in texture as one of the elements of design.

The efforts to modernize the teaching of design failed to overcome certain inherent difficulties. D'Amico, in 1942, faced these problems squarely. Children, he affirmed, were innate designers. But design had been wrongly taught. He found that children still were required to plan for the decoration of objects never made, whereas designs on paper should be made only by those who understood, through experience, the materials and processes of manufacture in their relation to form. Moreover, the drive for novel uses of materials, in supposedly practical items for the home, produced an unprecedented variety of trash—so-called craftwork that lacked either creativity or aesthetic value. School equipment and children's capabilities were too often inadequate to meet aspirations. Consequently, he said, design activity in schools should be limited to the crafts media and to real products that afforded the possibilities of experiment and qualitative control.

Architecture, **interior design**, and **community planning** continued in elementary classes as related areas of study moved with the child's expanding experience—from the home to the school, to the neighborhood, to the farm or local industry. Children drew, made murals, built models from paper, wood, and found objects, and used the sand table as local topography.

42. In reference to categories and definitions, it may be recalled that Arthur Dow titled his book, *Composition,* only because he thought that the preferred term, *design,* had taken on an unduly narrow meaning; Denman Ross used what he called principles of design as a basis for his teaching of painting.

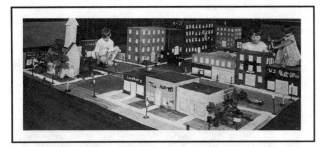

Figure 4-10. Art in study of the community, under supervison of Mary O. Pittinger. Klar, Winslow, and Kirby, *Art Education in Principle and Practice*, 199.

These topics became more exciting in secondary classes as modernistic exemplars became more familiar. The museum education project of the General Education Board (mentioned above) funded an exhibit titled "What Is Modern Architecture?" The exhibit was prepared by the Museum of Modern Art and sent to Milwaukee, where two ninth-grade students of Fred Logan wrote the script for a broadcast on the exhibit. Milwaukee classes also studied two federally funded low-cost housing projects that had been completed with much attention to landscape design. Each student planned a home for a typical project lot, beginning with assumed family interests and proceeding through floor plans and elevations, site planning, and scaled models, complete with landscaping. Students went beyond beautifying school grounds out into the community. Unit planning provided plenty of time for such extended projects: at Owatonna, an entire school year might be filled by only three units.

Figure 4-12. An "Art Deco" poster by Lois Brightman, a student of K. F. Smith. *School Arts* 33, no. 3 (November 1933): 130. Reprinted with permission of *School Arts*.

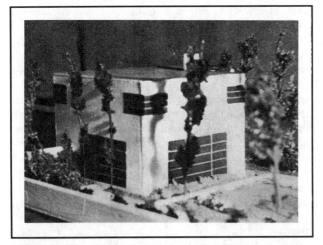

Figure 4-11. Model for a low-cost modern house, stimulated by an annual home show and federal housing developments in Milwaukee, by a ninth-grade student of Eugene J. Faber. *School Arts* 41, no. 4 (December 1941): 120. Reprinted with permission of *School Arts*.

Graphic design, at all grade levels, was so welcome in school and community projects that defenses against requests for posters became a professional problem. Art clubs helped. If demand were lacking, art classes could visit local stores and industries for subjects and slogans. Where each child made one poster, found materials could be added to two-dimensional surfaces—early instances of the influence of collage in promoting creativity in school art. Where silk screen had entered the curriculum, the reality of quantity production added incentive.

Advertising design, so much a part of modern life, could be allocated a unit or an entire elective course. In either case, it could become an adjunct to social studies and school events. Window display became a specialization for either graphic or industrial designers; a professional school of window display opened in New York, and high school artwork went into community store windows.

Late in the thirties, as part of art in daily life, **cartooning** gained approval. It was a highly motivating activity that provided individual possibilities of wit for the whole class; a talented art major headed for commercial art school often won success first with cartoons produced for a yearbook. In schools large enough to provide a more specialized vocational art curriculum, students might be introduced to basic "board skills" and techniques of illustration for reproduction—mechanical drawing, air brush, line drawings, washes in two or three values, and simple color separation. During the war years, such students also might be introduced to industrial visualizations, blueprint reading, and techniques of illustration for the production line.

Clothing design in the elementary curriculum seems to have made less use of workbooks and cutouts, but it was commonly introduced in studies of other times and places. In secondary schools, the development of separate programs in home economics gave increased opportunities for interdepartmental collaboration, but how much occurred is uncertain. A few vocational courses in fashion design were reported, complete with techniques of illustration. At all grade levels, theater arts may have provided the most common occasion for clothing design.

Theatre design became possibly the most satisfying of correlated activities in art. In many communities, historical pageants were acclaimed as regional art. Modern innovations in theatre added excitement and often encouraged simplicity. With the power of make-believe in children, a few props, a painted paper backdrop, a classroom corner, or a puppet stage could add great intensity to learning about the lives of other people. At least the more alert high school teachers were ready to lead adolescents in experiments in lighting and in abstract and symbolic alternatives to realism in scenery and costume. Secondary students could probe deeply into their special personal interests. The theatre incorporated all the arts and gave opportunities for all sorts of talent. The dramatic culmination of work that required an atmosphere of collaboration, improvisation, and real production contributed to the vitality and flexibility of school life.

Industrial design seemed important to many progressive art educators, in view of its impact on modern life. Secondary school units on art appreciation often included contemporary products during the late thirties and early forties. Students also drew designs for

Figure 4-13. Abstract design for a yearbook divider, by a student of Helen R. Snook. *School Arts* 32, no. 2 (October 1932): 96. Reprinted with permission of *School Arts*.

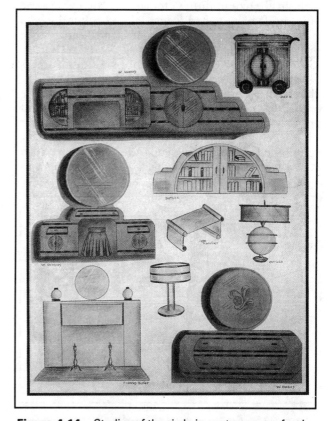

Figure 4-14. Studies of the circle in contemporary furniture design, by students of P. Webster Diehl. *School Arts* 39, no. 8 (April 1940): 269. Reprinted with permission of *School Arts*.

products. But it proved difficult to go beyond drawings into actual three-dimensional construction of model designs. Most art teachers lacked the necessary skills and equipment; these were located in the departments of industrial arts, which were largely concerned with vocational objectives rather than the quality of design. Although the separation of the two domains was frequently deplored, only a few schools succeeded in the collaboration necessary to make industrial design a substantial element in school art.

Crafts

In higher education, crafts other than ceramics were seldom offered. Nevertheless, by the late thirties, many art teachers were aware of the broad revival of public interest in crafts. For them, this was not merely the result of grass roots regionalism, federal projects, and leisure time. The idea grew that all the world's peoples had engaged authentically in all the arts, and this idea had an educational corollary—the belief that a school art curriculum for all students required a base more general than the conventionally limited fine or commercial arts.

Crafts were supported further by curriculum projects in the community: almost any town, at some point in its history, had industrial and cultural ties to the crafts. In correlated studies, the crafts often proved to be the most authentic of art activities. (*School Arts* devoted many special issues to the crafts of other countries.) Quite often free materials available in the community were suitable for work in the crafts. For some students, crafts provided the best of art activities, as, for example, in classes designated for "motor-minded" students in New York City. And for certain college-bound students, the Eight-Year Study allowed crafts electives in the unrestricted programs

that were shown in subsequent evaluation to have been associated with better success in college. In short, the crafts could be good for you.

The crafts, however, had problems of definition and self-respect. Work in fabrics, wood, metal, and clay had been common in schools since the introduction of kindergartens and manual arts. Anything a child could make that could even imitate something useful could be called handcraft. The ideals of the thirties prompted comparisons of the "old" (bad) and "new" (good) in teaching the crafts:

■ Once the interest had been mainly ornamental; now it was functional.

■ When useful objects were made, as in manual arts, the process commonly followed patterns; now the crafts process was to be exploratory.

■ Children had completed designs simply for supposed application to forms that were never made; now they designed in the material as they made the forms.

■ The main appeal had been novelty in the product or use of the material; the newer aim was truth to material, process, and function.

■ True folk art had been imitated in inauthentic materials, merely for convenience and effect; now the aim was a personal design with real materials and processes.

■ What had too often been only busywork was to be replaced by work as worthy as any art. Nor was a concept of the early thirties acceptable: the crafts were not simply "applied design." A deeper appreciation was sought in the terms "artcrafts" and "art handcrafts."[43]

These ideals accorded with the best current thinking in art and design, though the line dividing honest craft from ingenious design might be exceedingly thin. Yet, though the ideals have never been widely achieved and the faults of the "old and bad" have never been uncommon in school art, the advances in the crafts achieved during the thirties have generally endured.

Related Arts

As noted earlier, the spirit of collaboration among major artists in the production of modern masterpieces had begun to enter American education in the twenties. These efforts had been identified mainly

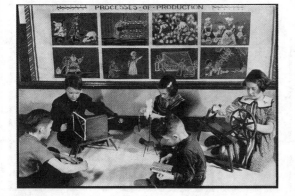

Figure 4-15. Crafts for study of "processes of production" and for "appreciation," in a Detroit school. *School Arts* 37, no. 3 (November 1937): 66. Reprinted with permission of *School Arts*.

43. These comparisons are evident in many writings, but they have been derived most particularly from Victor D'Amico, *Creative Teaching in Art* (Scranton, 1942), and Maud R. Hardman, "Crafts as Artistic Expression for the Child," *School Arts* 42, no. 9 (May 1943): 293–96.

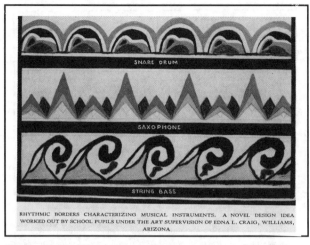

RHYTHMIC BORDERS CHARACTERIZING MUSICAL INSTRUMENTS. A NOVEL DESIGN IDEA WORKED OUT BY SCHOOL PUPILS UNDER THE ART SUPERVISION OF EDNA L. CRAIG, WILLIAMS, ARIZONA

Figure 4-16. Border designs of the relation of visual form to timbres of musical instruments, by students of Edna L. Craig. *School Arts* 32, no. 2 (October 1932): 90. Reprinted with permission of *School Arts*.

with private progressive schools. By the early thirties, however, the essential unity of the arts was stipulated in an important text used in college courses preparing art teachers.[44] As they became more familiar with the element of formalist aesthetics in all the modern arts, more teachers found that the fundamentals of design could be approached through comparisons with music, poetry, and dance. With younger children, the other arts became a frequent stimulus to creative expression, with or without representation.

Toward the end of the thirties, as art teachers

44. Klar, Winslow, and Kirby, *Art Education in Principle and Practice*, 155.

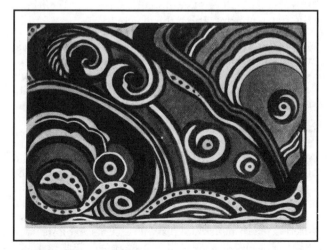

Figure 4-17. Nonobjective composition inspired by music, by a tenth-grade student of Giulia Von der Lanken. *School Arts* 41, no. 4 (December 1941): 116. Reprinted with permission of *School Arts*.

were beginning to find that integrated curricula could be disadvantageous to art, correlations among the arts themselves became a theme for conventions. One correlated (or integrated) project, based on Stravinsky's *Firebird Suite*, may provide an adequate example. Fourth graders in Covington, Kentucky, heard the story; "interpreted the mood and tempo of the music with abstract linear movements in colored chalk"; depicted scenes and characters in watercolor; made four big panels of important scenes; and finally staged a production, complete with masks, costumes, and colored lights.[45]

Appreciation

The rationale for art appreciation had never been so comprehensive as it became in the thirties. Early in the century, Arthur Dow had said that the main goal of art education was to engender the capacity for fine choices in the whole population. Dow, Dewey, John Cotton Dana, and many others had stated a corollary principle: in appreciation, it would be the art quality of objects in daily use that would matter most for the general populace. Certainly art teachers and workbooks had worked toward that goal. Nevertheless, the most specific appreciative activity, until the thirties, had been picture study, which aimed to put children at ease with masterpieces and which imparted information that was mostly a mix of biography and critical opinion.

Ideas of what was to be learned, however, had become more complex. Dewey and other philosophers and psychologists had shown that, in the appreciative response, each encounter was a creative interaction, a new experience in which the perception of the aesthetic object was altered and enriched by prior experience. Learning to appreciate, therefore, required more than historical information, more than rules of beauty, even more than knowledge of art structure. A more independent attitude and process were to be learned. Furthermore, the criteria for judgment had changed: expression became more important than beauty; formal qualities became more important than subject matter; and the aesthetics of design asked that form, material, and process be fitted to function. Finally, there were more forms and media to be appreciated; for example, the products of industrial design, community planning, and the crafts of many nations and cultures. The ultimate goal, it was said, was the extension of aesthetic appreciation to all the behaviors of living.

Ideas of method followed from such considerations and from the more general theories of learning that governed new curricula. A few principles were salient: appreciation would be learned best through

45. Mildred Matherly, "Fourth Graders Enjoy Stravinsky's 'Firebird Suite'," *School Arts* 42, no. 8 (April 1943): 288.

Figure 4-18. A plan to promote appreciation of architecture in the community. Klar, Winslow, and Kirby, *Art Education in Principle and Practice*, 137.

This chart and those on pages 143 and 148 are taken from the sixth grade Social Studies Course, Springfield, Mass., School Department.

TYPE LESSON*
Group of Buildings in Blankville
(Suggestive of the way a building may be studied)

Setting	Appearance at different times of day	Scale or Size
Would this group appear better on the top of a hill? Would it appear better if there were more space around it? Would it appear better if there were less space around it? Do the trees add to the setting? Does the group appear equally well from a distance? Do you suppose that the trees were planted after the building was completed? What would be the effect on the appearance of the group if the steps were higher and narrower? Does the group appear equally well from all sides? If not, which side is the best?	Does the group appear equally well at all times of day, as early morning, broad sunlight, twilight, and night? Is there anything peculiar about it at night? How would the group appear if it were flood lighted? Do you suppose that any building appears better with light shining on it? Have you ever seen the group in a snow-storm? in the mist? or any other unusual condition?	Would you like to see all of the buildings of equal height? Why are the buildings in the group of this size? How does the group compare with the buildings around it in size, height, simplicity, and elaborateness?

Fitness to Purpose	Elaborate or Simple	Details
Has this group any real use? Who paid for this group? Can you tell from looking at the group what each building is used for? Should one be able to tell from looking at a building what its use is? Should buildings have spires, domes, towers, or cupolas on them? Do stained glass windows have any real use? Should useful buildings be beautiful?	For what reason would you call this group elaborate? For what reason would you call this group simple? How does it compare in this respect with other buildings you know? What makes this group look as if it were meant to last a long time? Should buildings be so built as to last a long time? Will plain, simple buildings last longer than fancy, elaborate ones? Do you like to see fancy, elaborate buildings?	What parts of this group add to its beauty? What buildings have you seen that resemble the group in any way? When you compare this group with.... what is the chief difference? Are there many or few steps to the group? Are they necessary? How does the slant of the roof compare with that of your school? your home? other buildings?

creative expression in the media; discussion and research would be better than lecture; the forms found in daily life would be at least as important as masterpieces; the art of other countries and cultures should be appreciated; and individual judgment would require (1) acquaintance with commonly accepted criteria and (2) the opportunity to test those criteria independently. Finally, all through the culture, history was distrusted: the past had produced disaster, whereas science and technology had created a new world. These principles should be evident in the following particulars:

■ Picture study diminished. Students' interests and correlated subjects guided selection of examples. Rather than old masters, students preferred the color and subject matter of Matisse, Van Gogh, and Gauguin.

■ In New York City high schools, a two-year course called art appreciation was required of all students but was, in fact, a typical "general" course with enough studio production in the many common forms of art and design to provide for an exhibition at the Brooklyn Museum.

■ The world's art could be studied through studio media. Greek art could be a topic for pottery, drawing, sculpture, and architectural drawings and models. Modern French artists were the subject of a set of mural panels; another set depicted the art of nine distinct cultures, modern and ancient. A unit on Japanese prints produced drawings in ink and water-color, a booklet of lettered pages about prints, and large figure drawings in a standing screen.

■ In correlation with a social studies unit, the arts and crafts of the Congo peoples were explored through sculpture, wood carving, weaving, and metal-work—all considered in relation to principles of design and the African influence on modern art.

■ In different studies of Egypt, students developed an Egyptian museum; built a model house, with seventeen rooms and a landscaped courtyard, from an authentic plan seen in a museum visit; built a tomb (9′ x 4′ x 7′ high) and equipped it with wall paintings, a couch, a chariot, and a throne chair.

■ Radio series on art appreciation were developed in several cities and were coordinated with slides or printed reproductions in the classroom. Suggestions for preparatory and follow-up activities were distributed in advance.

■ In Buffalo, as part of the General Education Board project mentioned earlier, the Albright Museum worked with teachers in presenting exhibitions that illustrated the expanded scope of art to be appreciated. "Lithography" was concerned with the technical process. "Perspective" showed medieval, oriental, and Egyptian examples. "Design in Art" featured three-dimensional products. Other exhibits were titled "Art and the Advertising Agency," "Art in Life," and "Art in the Home."[46]

46. Powell, *The Art Museum Comes to the School*, 34.

Research

At all levels through the thirties, art educators showed more interest in research. Graduate study became more common; two dozen or more master's theses were produced annually as well as a few doctoral studies relating to art education. Professional psychologists continued to work in areas relating to art education: notably, Norman C. Meier directed graduate students at the University of Iowa in a series of studies of artistic ability that continued for as long as fifteen years. Funded projects, such as those at museums and at Owatonna, engendered surveys and constituted an informal type of curriculum study. By the end of the decade, professional organizations had formed standing committees on research, though the war interrupted their initial efforts. The work of Viktor Lowenfeld and Herbert Read demonstrated direct relations between research and the development of theory.

Lowenfeld had studied the art of the blind and near-blind in Vienna for about fifteen years. His work showed that art is not the expression only of visual perception but also of "haptic perception," defined as "the synthesis between tactile perceptions of external reality and those subjective experiences that seem to be so closely bound up with the experience of the self."[47] The relationship between expressionism in general and the evidence for two "creative types"—the visual and the haptic, corresponding roughly also to the objective and subjective—had important influence on ideas of children's art as related to the whole individual personality.

Read's *Education through Art*, grew from his analysis of a large collection of children's art. Bolstered by his many earlier writings, he developed one of the most comprehensive theoretical constructions for art education. First he strongly argued—as his title implied—that art should be at the center of humanist education. Second, his analysis brought together a variety of psychological typologies to demonstrate that children's art is the expression of the individual personality, which ought to be nurtured in education. Third, he suggested the characteristics of schools and teaching necessary for such education.

Much of the work of psychologists in the United States was concerned with talent or aptitude; interests and preferences in art; the development of abilities; and analysis of children's drawings. But the development of new tests of ability or knowledge in art had all but ceased before the war, their reliance on expert consensus criticized as invalid. The largest number of studies apparently was directed toward problems of perception, judgment, and appreciation. Few investi-

gations of creativity were undertaken. One elaborate study of the relations between the paintings, the personality, and the life experiences of individual children was conducted in a group of nursery schools. The methodology was innovative in art education in that it brought together data from daily records of teachers and paid observers; school records; psychological tests; and information about family and home conditions.[48]

Master's theses lacked the expertise and depth of professional scholarship, but they did indicate major interests among teachers in graduate study and their faculty advisers. Curriculum studies—surveys, designs, or a combination of both—were most common. These were usually rather broad in scope and often were related to a particular school locale. A few special new interests appeared in curriculum plans for the gifted or the disabled or for particular media such as photography, etching, and sculpture. Several theses aimed toward improvement of teaching methods: as might be expected, most of these involved drawing, design, or appreciation—the most common concerns of school art at the time. A few were concerned with aesthetics, supervision, and the history of art education.

Taken together, the research of the thirties shows a resurgence of interest in the psychological significance of children's art; a reduction of interest in tests and measurements; much interest in curriculum; and an increase in the small body of studies of classroom methodology. Most significantly, the research indicates that, among educators and psychologists alike, the response to art had become nearly as important as its production.

SUMMARY

Review of art education in the thirties provides many examples of the complex influence of external forces.

Economic and social conditions gave special importance to characteristics already emphasized in progressive education—to both cooperation and self-reliance, to imagination and problem solving, to experiment, to productivity, and to the contribution to community welfare. Educational methodology favored integrated units that gave students increased freedom and responsibility for their own learning, with activities that took them out into the adult world. School administrators valued curricula that built supportive community relationships. The reverence for history that had long governed education was nullified by financial and political upheavals and by new technology.

47. Lowenfeld, *The Nature of Creative Activity*, 82.

48 Rose H. Alschuler and La Berta Weiss Hattwick, *Painting and Personality*, 2 vols. (Chicago, 1947).

The response of art education was evident in the typical newer curricula. American art classes have never again been so much concerned with correlation, art in daily living, and design in community and industry. Other developments were more lasting. From the thirties into the postwar period, school art was increasingly dedicated to creative expression and its psychological correlates, although art history and picture study nearly disappeared from the classroom.

The style and media of school art followed contemporary artists, though somewhat slowly. Teachers developed counterparts of the American Scene and modernism in styling and subject matter, including abstract and nonobjective imagery. Murals, sculpture, printmaking, crafts, and theater art gained new importance during the thirties.

All of these changes were reflected in the profile of competencies expected in the art teacher. If possibly less maturity was needed in academic drawing and painting or in the fundamentals of drafting, the newer curricula required more diversity in media and style, more sophistication in psychology, and a shift in method and personality. This profile was again to become more complex in the next decades.

FURTHER READINGS

Collins, Rose, and Olive Riley. *Art Appreciation for Junior and Senior High Schools*. New York, 1931.

D'Amico, Victor. *Creative Teaching in Art*. Scranton, 1942.

Gregg, Harold. *Art for the Schools of America*. Scranton, 1941.

Dewey, John. *Art as Experience*. New York, 1934.

Faculty of Teachers College, Columbia University. Department of Fine and Industrial Arts. *Art Education Today*. 12 vols. New York, 1935–53.

Haggerty, Melvin. *Art a Way of Life*. Minneapolis, 1934. The first of a series of small books published through the Owatonna Project.

Hartman, Gertrude, and Ann Shumaker, eds. *Creative Expression: The Development of Children in Art, Music, Literature and Dramatics*. New York, 1932. The compilation of articles published in special numbers of *Progressive Education*, 1926–31.

Moholy-Nagy, Laszlo. *The New Vision*. New York, 1930. The first exposition of Bauhaus teaching familiar to many Americans; the book went through several printings.

Nicholas, Florence W., Nellie Mawhood, and Mabel B. Trilling. *Art Activities in the Modern School*. New York, 1937.

Perrine, Van Dearing. *Let the Child Draw*. New York, 1936.

Ziegfeld, Edwin, and Mary Elinore Smith. *Art for Daily Living: The Story of the Owatonna Project*. Minneapolis, 1944.

～§ 1946-1959 ❧～

The fifties may be remembered ultimately for the beginning of nuclear energy and the end of European colonization of the "third world." In the United States, it was a time when most people "had never had it so good." But it was also a decade when humans seemed ready to incinerate their planet, a time recognized as "the age of anxiety."[1]

The social concerns of American art in the thirties did not continue after the war. The dominant new style, Abstract Expressionism, was hailed as the assertion of individuality against the massive anonymity of modern life. American education, which had been challenged in the thirties to reconstruct society, was dedicated in 1950 to the nurture of the whole personality. (These had been the two goals of progressive education, or the two routes toward an ideal destination about which Dewey and Naumburg had differed.) School art had shared that dual emphasis and, in the postwar years, followed the same shift away from community engagement toward personal development.

By mid-decade, the schools were assailed for failure to teach the traditional cognitive skills and subject matter. As Cold War competition demanded rapid advance in science and technology, art education claimed a special role in the development of creativity.

SOCIAL AND CULTURAL CONDITIONS

Social Factors

The United States emerged from World War II comparatively unscathed, ready for peacetime production. Spurred by pent-up demand, ready credit, and new technology, industrial output grew and changed, notably in construction, commercial aviation, electronics, plastics, and other fields of chemistry. The consumption of energy increased by about one-third during the decade. Agricultural production also increased by one-third, albeit with fewer farmers.

Automation and computers began to change the patterns of production and employment: by 1960, white collar jobs outnumbered the blue collar work force for the first time, but by that time the assembly line was middle class.

Science produced rockets, satellites, and atomic power plants. Scientists identified DNA, found new basic elements, and discovered more nuclear particles. In medicine, more antibiotics, tranquilizers, and new surgical techniques were in use. Polio vaccinations began in 1955 and the birth control pill was introduced in 1960.

This was a decade of unprecedented growth and relocation of the population. The move to the "sunbelt" began. Unskilled families from Appalachia, the deep South, and Latin America moved to the industrial North. Businesses and middle-class families moved to the suburbs, where 83 percent of the population increase was located.

The suburban model for the up-to-date "American way of life" featured early marriage, babies, home appliances, commuting, shopping malls, recreation, and a new teenage consumer market—all promoted by television, popular magazines, and a national advertising budget that doubled during the decade. Credit cards were introduced in 1950; in the postwar period up to 1960, consumer credit increased 800 percent. More women went to work. More high school graduates, along with millions of veterans supported by the GI Bill, went to college. Community colleges and technical schools proliferated; small colleges became universities; and President Eisenhower spoke of "life-long education."

With such domestic satisfaction available to the majority, the political climate was conservative. Critics saw complacency and conformity; they called the college crowd the "silent generation." So much was good in the fifties, but all the while the problems of living with the bomb seemed worse.

As Europeans struggled with postwar problems and as their colonies became free nations, the United States emerged as the world's superpower. The role of world leadership, however, including its concomitant

1. W. H. Auden's poem *The Age of Anxiety* was taken by the choreographer Jerome Robbins as the basis for his ballet of the same title, first produced by the New York City Ballet Company in 1950.

participation in the World Bank, the International Monetary Fund, and the United Nations and its affiliates, was never entirely welcome. Soviet activities, reaching far beyond the gradual subjugation of Central Europe, seemed clearly aimed toward world communism. The U.S. policy of containment, beginning with the Marshall Plan to support European nations and extending through mutual defense pacts around the globe, led to further conflict. The Korean War dragged on from 1950 to 1954: by its end, the seeds of the war in Vietnam were already sown. Marines were sent to Lebanon; a naval force was dispatched to support King Hussein; the Central Intelligence Agency worked in Iran and in Guatemala. In Washington, Truman began loyalty probes in 1947; sensational spy trials and Senator McCarthy's fraudulent allegations convinced many of a conspiracy of spies in the federal government. Thousands of government employees were dismissed or resigned; blacklists, loyalty oaths, book burnings, and varieties of censorship heightened distrust and ruined careers. Generals and high officials were accused of "losing" China to communism. President Eisenhower himself was called a "conscious agent" of Soviet policies; his secretary of state met crises with threats of "massive retaliation" and boasted of "brinkmanship"—a poker game with atomic weaponry.

The Soviet Union had matched the United States in atomic and nuclear bomb tests. Radioactive fallout soon was shown more damaging than the bomb itself. The government issued manuals to promote construction of backyard bomb shelters, while think-tank analysts calculated the millions of civilian deaths that would be "acceptable" in the war that was assumed inevitable. The citizenry, under such pressures, could scarcely be blamed for living a good day at a time.

In socioeconomic matters, the Eisenhower administration was quiet about dissatisfactions. Despite the Supreme Court decision that in 1954 struck down "separate but equal" education for African-Americans, desegregation, in all domains of life, proceeded slowly against bitter, and often violent, opposition. Prosperity was far from equally distributed: at the end of the fifties, an estimated 30 percent or more of the population lived on or near the designated poverty level; the wealthiest fifth of the population owned 77 percent of the nation's wealth. In city streets, the youth culture centered on gang wars, kids stayed out of school to keep out of trouble, and seventh-grade girls wondered how to feed infants.

The fifties ended in discontent. There were recessions in 1957 and 1959. People organized to call for peace, to express concern for the environment, to promote a rational nuclear policy, to advance civil rights. Amid these troubles, the Russians were gaining: Krushchev threatened to "bury" the West, and the

launching of Sputnik satellites in 1957–58 shocked the United States, bringing to a head a collection of criticisms of public education that had been gathering intensity through most of the decade.

Intellectual Currents

Much of the intellectual work of the fifties as well as personal feelings and attitudes reflected nearly twenty years of upheaval, dislocation, death, and destruction that put the individual at the mercy of centrist governments and military machines. Postwar conditions seemed little different. Existentialism, however difficult its special concepts as a philosophy, became public currency because Sartre and Camus described what so many people felt—the futility of reason, the isolation of the individual, the ultimate responsibility for one's own life. The artist became the existentialist hero, the creator of something out of nothing; the child in school became an existentialist challenge.

Individuality was at issue also in social theory. Structural functionalists implied that human selfhood emerged only through the mold of social systems. C. Wright Mills claimed that democracy was in fact dominated, if not negated, by the *establishment*—a complex of power elites in government, military, industry, and finance: this term also entered the public vocabulary as the target of critical resentment. John Kenneth Galbraith argued instead that powerful interest groups, rather than a single network or establishment, were "countervailing" forces: if so, the increasing variety of activist citizen groups was an appropriate response.

But conformity—compliance with group norms—was described as the contemporary mode of the individual by William Whyte in *The Organization Man*, by Sloan Wilson in *The Man in the Grey Flannel Suit*, and by David Reisman in *The Lonely Crowd*. Daniel Bell, in *The End of Ideology*, saw the old political left disenchanted with radicalism and young intellectuals lacking any unifying new vision.

In psychology, the theories of self-realization developed by Maslow and others were of personal interest to a wide range of the public. The early educational implications of existentialism and self-actualizing psychologies, however, were radically countered by behavioral psychology and by studies of group dynamics. Among other contributions in psychology that were of most importance to education were experiments in gestalt and physiological perception; developmental theories, including a resurgence of interest in Piaget's work on cognitive development; and studies of creativity and exceptionalities. Michigan State University, for example, sponsored two interdisciplinary symposia on creativity in 1957 and 1958, to which many schools of psychology contributed.

Art education gained support indirectly through concern for the increasingly narrow specialization of education and work. In particular, C. P. Snow's *The Two Cultures and the Scientific Revolution*[2] stimulated widespread discussion of the separation of the sciences from the arts and other elements of culture. Whereas some saw the arts as a needed counterbalance to the dominance of science, others sought commonalities between the two domains.

Possibly the most pervasive intellectual change came through the interaction among several fields relating to communication and the processing of information. These fields and their concerns can be represented here only by a list of terms that came into common use in the fifties: cybernetics; binary, linear, and presentational thinking; linguistics, semantics, and semiotic and symbol systems; parameters and models. Models might be rendered mathematically or otherwise as representations of events, structures, or processes: a "thing" person was old-fashioned. Perhaps equally important was the increasing tendency to think in terms of probabilities, to conceive alternative systems or "scenarios," to approach problems through "game theory," all of which accorded with the view of life as a matter of chance in which firm expectations and plans were unrealistic. Flexibility became a criterion of mental health.

Culture and the Arts

Until the late fifties—to offer a thin generalization—literature, music, drama, and dance mainly reflected the mainstream of upper middle-class culture: eclectic in content and style, lacking the political intensity of the thirties and proceeding with formal and technical developments that had begun earlier. Only in the visual arts was there an abrupt postwar shift, with Abstract Expressionism replacing the American Scene painting of the thirties as the acclaimed new national style. During the Eisenhower years, the "beatnik" repudiation of cultural norms, not only in literature but in its total life-style, became a public fad that on a more serious level presaged the turmoil of the sixties. Before the end of the decade, discontent with the status quo was evident in radical departures in all the arts.

Television, of course, was the dominant new cultural medium and a social force of yet unmeasured dimensions. Affluent adolescents were an unprecedented market—catered to and shaped by all the popular arts.

Literature, despite predictions, was not overcome by television: book sales doubled during the fifties, partly as a result of increases in paperback editions. A few of the leading prewar writers, among them Hemingway, Faulkner, Marquand and others, continued with major successes in the fifties. Only three war novels seemed of lasting importance: *From Here to Eternity* (James Jones); *The Naked and the Dead* (Norman Mailer); and *The Young Lions* (Irwin Shaw). The social criticism typical of the thirties was no longer a common subject. The newer fiction most characteristic of the fifties was concerned with the absurdities of life, the forces of compromise and corruption, and the corresponding frustrations and dislocations of the individual.

The university provided several authors with a model of the institutionalized trials of idealism and decency. Adolescent disgust with the adult world was Salinger's theme in *The Catcher in the Rye*. Absurdities, disengagements, and chance were themes common among such writers as Barth, Styron, Bellow, Roth, Updike, and Algren. Convolutions of madness were crafted by Nabakov in *Lolita* and *Pale Fire*. The life of hallucination and addiction became a frequent topic, represented by King in *Junkie* and by Burroughs in *Naked Lunch*. Kerouac's *On the Road* was the major beatnik document: the attention given in 1957 to this story of alienation, of "dropping out," was symptomatic of a general malaise.

Much of the poetry of the fifties has been described as confessional and self-revealing. The direct exposure of inner life was characteristic of such major figures as Theodore Roethke, Randall Jarrell, Delmore Schwartz, Karl Shapiro, Robert Lowell, John Berryman, and Sylvia Plath. An increasing interest in Eastern philosophies, accepting the human self as a natural element in the universe, was represented by a number of leading poets. Especially relevant to art education because of their close associations with Abstract Expressionist painters and their critical writings on art were the "New York poets"—notably John Ashbery, Frank O'Hara, Kenneth Koch, and Edwin Denby. At the center of a resurgence of poetry in San Francisco were Kenneth Rexroth and Lawrence Ferlinghetti, who represented an erudite element in the culture of the Beats. The most publicized of Beat poets, Allen Ginsberg, best represents the links of that group to the protest movements of the sixties and the continuing recourse to Eastern thought and meditative practices.

Theatre, the dominant Broadway theatre in particular, suffered in the postwar years. Because of rising costs, productions were fewer, ticket prices higher, and artistic risks less affordable. According to one critic, the audience wanted their drama mixed with comedy—a poor recipe for art.

It was not a time for issues and ideologies: two older urbane French writers, Anouilh and Giraudoux, were popular, but Sartre and Camus were not. Up

2. C. P. Snow, *The Two Cultures and the Scientific Revolution* (Cambridge, 1959).

through the late fifties, only about about a half-dozen of theatrical critical successes were war plays; somewhat fewer were concerned with communism and spies. The three most important new American playwrights, however, did deal with current concerns: Tennessee Williams with sexuality and psychological malaise; Arthur Miller with social values and contemporary witchhunts; and William Inge with the tensions of small-town life in the Midwest. If their plays provided catharsis, others offered escape. This was an especially rich period for musical theatre, which, despite production costs, scored many of the biggest hits.

Although critics found Broadway productions generally thin and tame, small low-cost off-Broadway theatres began in the early fifties to offer more novelty, more experiment, more interesting revivals, and cheaper tickets. By the 1957–58 season, forty off-Broadway theatres were in use, staging more than one hundred productions. Off-Broadway also changed theatre style and technique.

Already on Broadway critics pointed to a new American style, generally known as "method" acting. As in other art forms in the fifties, this approach exalted self-expression: a role was developed through projection of the actor's own personality and physicality rather than through application of conventional stage technique. At the same time, set designers moved away from the scenery of mocked-up realism (movies did it better) to play on the audience's imagination, using partial environments and schematic or symbolic suggestion.

Off-Broadway productions went further: they abandoned the traditional proscenium and accustomed audiences to arena staging, with all its associated changes in sets, lighting, blocking; indeed, with whole new conceptions of drama. What Martin Esslin called the "theatre of the absurd"—particularly the works of Beckett and Ionescu—was a particular element of off-Broadway success. Small spaces could also sharpen the impact of stark reality, as in the Living Theatre's production of Jack Gelber's *The Connection*, which brought actors and audience together into the life of the addict. By 1959, off-Broadway theatre became the medium that attracted many of the most successful new leaders in poetry, dance, music, sculpture, and painting, who shared roles in promoting the new aesthetic of chance, improvisation, and the removal of boundaries between art and life.

In **music**, as in literature, the prewar emphasis on regional and folk materials was sharply diminished. But the decentralization of culture, which had been one aim of the federal arts programs during the Depression, developed markedly: there were more symphony orchestras, new opera companies, summer seasons, and important composers in residence at

universities across the country. Major radio networks maintained large staffs of musicians even as such popular programs as "The Voice of Firestone" and "The Bell Telephone Hour" moved to television. A new generation of orchestra conductors was American born and trained. Music departments of universities began to produce a wealth of competent instrumentalists and singers: the City Center Opera in New York was almost completely staffed with Americans.

Without the sociopolitical concern that dominated in the thirties, mature American composers, and such world-famous Europeans as Stravinsky, Milhaud, Hindemith, and Bartók worked in a variety of styles. Schönberg's twelve-tone system became part of the common equipment. Experimental centers for composition via tape recording and synthesizer were established at Columbia University and Princeton. The effort to combine classical idioms with jazz, which had enlisted such diverse figures as Scott Joplin, Paul Whiteman, Duke Ellington, and George Gershwin, was continued by Gunther Schuller, Dave Brubeck, and others as "third-stream" music.

The most radical experiments, in the movement led by John Cage, constituted a whole new aesthetic, reflecting sources as disparate as Zen Buddhism, tape recording, and cybernetics. The new aesthetic was not without precedent: critics easily linked Cage to the ideas of Dada and Symbolism. The extremes of Cage's own work may be represented by a composition that simply offered four minutes and thirty-three seconds of silence; another that presented sounds randomly selected from twelve radios playing simultaneously; and others that were created through decisions made by use of grids, dice, or the ancient Chinese *I-Ching*, or *Canon of Changes*. Some of the more important principles in the new aesthetic may be phrased as follows:

■ Art and its experience should not be distinct from the experience of life.

■ For music, all sounds are available; for dance, all movement; etc.

■ Chance and indeterminacy are characteristic of life, so should they be of art.

■ Thus, the composer's decisions should be removed from the composition of art.

Following such principles, composers of aleatoric music (*aleator* = dice-thrower) devised ways to leave decisions to performers, who became partners in creativity and adept in reading the necessary new systems of notation. With all sounds acceptable, traditional forms ignored, and every performance something different, a new attitude also was required of the audi-

ence. These were changes that extended to all the arts.

Popular music saw the decline of big swing bands and the innovation of the sophisticated and esoteric "bebop" jazz style of Monk, Gillespie, Parker, and others. "Country" music became a commercial success. The combination of country with what was known as "race" music resulted in "rock 'n roll" and the phenomenal but controversial popularity of Elvis Presley—a style of music and social dancing that variously featured sex, protest, raw emotion, infusions from third-world cultures, and both herd behavior and uninhibited individualism.

With these changes at all levels of composition and performance and with the availability of long-playing stereophonic recordings, music was the art that most readily exhibited a new cultural principle in the fifties: in a pluralistic society, a multitude of successful styles—something for everyone at the flick of the finger—was possible.

Dance, like the other arts, moved away from earnestly American subjects and sociopolitical concerns yet demonstrated a distinctly American style. In ballet, the major figure was George Balanchine, whose choreography and artistic direction made the New York City Ballet the preeminent American company. Balanchine's art was grounded in classical Russian training and inspired by music rather than story. Like much contemporary music, literature, and painting, his ballets emphasized formal values in composition and movement; the dance was lithe, crisp, and impersonal rather than emotionally individualized. Narrative and psychological import were more often found in the repertoire of the Ballet Theatre. Both of these two leading companies, however, also programmed ballets by Balanchine, Jerome Robbins, and others that were cheerfully American in subject, movement, and music, including *Fancy Free*, *Pied Piper*, *Cakewalk*, *Stars and Stripes*, *Square Dance*, and *Western Symphony*.

Modern dance continued mainly within the conceptual framework developed by such earlier leaders as Graham, Humphrey, Weidman, and Holm: the rejection of balletic conventions; the natural movement of the whole body with much attention to visual appeal; and the dramatic development of theme without the social content important in the thirties. One of the divergent forces in American dance was Alwin Nikolais, whose company used props, lighting, and electronic sound to treat movement as theatre—dancing, for example, under sheets and otherwise using props as extensions of body action.

A second, more influential, trend was led by Merce Cunningham, a graduate of the Graham company, whose association with John Cage redefined his ideas of dance. Cunningham set one piece for sixteen nonprofessional dancers, the better to show the possibilities of ordinary moves and postures. Mundane activities could be shown as dance. Chance rather than formal composition was important. Cunningham and Cage collaborated by creating choreography and music independent of each other. The possible bodily components within a complex movement might be analyzed and selected by dice or other device, in part as a means of discovering new combinations. The large-scale movements of individuals or groups were similarly determined or were permitted to occur randomly. Movement was in a sense treated abstractly, though Cunningham noted that the human body is naturally expressive. The performance, for the viewer, was a surprising event of uncertain significance for which no conventional expectations were appropriate. The effect of such choreography, by Cunningham and others, was closely related to the development of pop art and other efforts to reduce the aesthetic distinctions that were said to make art too remote from life.

Television sets, around 1950, sold at the rate of a quarter-million per month. After the Federal Communications Commission lifted a ban on new stations in 1952, the number of stations increased to about five hundred by 1956. By that time, there was much concern about the social effects of television: average daily household viewing time was reportedly five hours (supported by TV dinners) and programs were mostly entertainment. As a medium of public education, television seemed to follow the disappointing path travelled earlier by film.

The lasting pattern for commercial daytime programming, most of it lifted early from radio, was in place by the late fifties, along with the popular evening shows. Much live programming, especially drama, had given way to filmed production and old movies. Nevertheless, the first educational station—licensed as early as 1951—began telecasting in 1954. On networks, though advertising sponsorship generally muted controversy, newscasts and occasional special programs had already begun to change the public level—and conception—of information.

The effects of television on children were hotly debated. The new television generation, one critic said, would lack the active, constructive play of normal childhood. Homework would suffer, literacy would decline, kids would become insatiable consumers, and violence seen on the screen would become the indoctrinated norm of daily behavior. Others pointed to the expanded scope of children's knowledge, and many educators saw great potential for televised instruction in schools. Initially, at least, it was easy for classroom teachers to find that most of these claims, in some degree, were proving true.

Two films of 1955 remain significant because their popularity among younger audiences indicates

the beginnings of the ferment of the sixties: *The Wild Ones*, starring Marlon Brando, and *Rebel Without a Cause*, which launched the ill-fated Jimmy Dean as a cult hero for the coming decade.

THE VISUAL ARTS

In the postwar years, international interactions increased in all the arts. For the first decade, Abstract Expressionist painting was perhaps the major cultural export of the United States. At the same time, American design and architecture were much influenced by Europeans.

Painting, of all the forms of visual art, seems most open to influential stylistic change. Geometric abstraction, which had gained adherents gradually in the thirties, was submerged through the fifties. Mural painting, without ideological drive and federal funding, disappeared. The realist painting of the American Scene painters, hailed in the late thirties as the new national style for all the people, was replaced by the radically individualistic Abstract Expressionism—an esoteric style rooted in material that had little interest in the thirties: Cubism, Surrealism, and so-called primitive art.

The first few Abstract Expressionists, working as best they might within federal art programs, had found in Cubism an escape from the perspective space of traditional realism and a conception of the painting as an object rather than an illusion. Formalist visual dynamics provided hidden structure. The automatic action sought by Surrealists had promoted outer spontaneity and inner access to deeply imbedded emotion and imagery—the source of symbol that Jung considered innate and universal. A vocabulary of such imagery and totemic forms was provided by ancient and tribal art. The merging of these possibilities was aided in the early forties by the presence in New York of leading European artists. After the war, the existentialist attitude exalted the creation of being: the painting would be not merely a thing but an environment, a field of forces to be entered by the viewer. Metaphorically, the empty canvas was the human situation.

By 1952, when the primacy of Abstract Expressionism was formalized in museum exhibitions, the original group had multiplied. Hans Hoffman, who taught the control of color and form in plastic space, and other artists had formed their own school. Two main tendencies of style were recognized: "action painting" (the term coined by the critic Harold Rosenberg); and that less easily characterized abstraction that sought quiet, contemplative significance, relying chiefly on effects of color. Within such generalized groupings, however, it became a fundamental tenet that the work of any significant artist must present a distinctly personal image.

Thus, as the teaching of Abstract Expressionism extended through art schools and college departments across the country, students barely out of high school were urged, as a matter of first priority, to concentrate on the discovery of their private imagery. Traditional fundamentals of painting were deemed unnecessary, if not actually obstructive to the freedom of the new style. The developmental years of the first generation of Abstract Expressionists were ignored, even as the initial thrill of their mature achievement began to fade. Indeed, it began to appear that much of the work in the style was repetitively mannered: even if a painting were truly exploratory, the problem it posed might seem obscure or trivial, and the "look" could be easily produced by anyone. Moreover, evaluation was difficult.

Already by the mid-fifties, contrary ideas began to gain attention. Rauschenberg made collages reminiscent of the discards in Schwitters's Dadaist *Merzbilder*, the Surrealist clippings of Max Ernst, and the intellectuality of Duchamp, but with contemporary content and purpose. He had come under the influence of John Cage at Black Mountain College: art should not be separate from life; anything could be used in a work of art; any imagery could be cut out and pasted, transferred, or reorganized; what might seem meaningful need not convey any message; the appearance of chance or chaos itself might be meaning. The combination of such techniques into a three-dimensional construction that included an actual pillow and a stuffed rooster raised questions of the nature of illusion, reality, and art. Jasper Johns posed similar problems by painting flags—unframed images of a symbolic object with aesthetically sensitive brushwork—and progressed subsequently to yet more ordinary objects. Joseph Cornell placed simple oddments in outworn boxes. Here were alternatives to Abstract Expressionism that presaged the assemblages, Happenings, and Pop Art of the sixties.

Sculpture after the war became abstract and expressionist by abandoning the figure and customary modeling and carving. A new sense of form and a new aesthetic were reached through working directly in metal, especially by welding steel. Like Pollock's drips, De Kooning's muscular brushwork, or Kline's huge calligraphy, welding could exhibit process and structure; it could freeze the tensions between chaos and organization, ugliness and sensibility. David Smith's sculptures retained subject references in abstract forms, some of them fluent enough to be titled "drawings." Totemic or scriptural suggestions had special power when rendered in an industrial material: steel became a preferred material for church commissions. For large-scale public spaces, the sculpture of unlovely texture and color, of jagged torch-cut edge, could be

readily understood as an expression of the age of power, anxiety, and violence.

The genuinely popular sculptures in metal, however, were Calder's mobiles. Anyone could stand enthralled by their equipoise and constant variation, their nuances of freedom and chance within an exquisitely evident control. Mobiles were handmade high tech: they became a cultural phenomenon, a blameless fad.

Across the country, of course, sculptors continued with traditional materials and methods. Among the few whose figurative work in wood was widely known, Leonard Baskin was honored for life-size figures—nearly featureless, dumb, modern ancients, heroic only in their endurance. Around the mid-fifties, others began to work with "found" materials so that "junk" sculpture became a recognized style: in an affluent society, art from waste had its own significance.

In **printmaking**, the postwar impetus was sparked by the two-year tour of the Museum of Modern Art's exhibition "New Directions in Gravure." Abstract Expressionist painters were not commonly active as printmakers, but Stanley Hayter's teaching had promoted in graphics a similar attitude toward experiment with materials and expressive individuality. Hayter returned to Paris, but at least 135 artists had worked at his Atelier 17 in New York by the time it closed in 1955, and through those years, graphic art had been transformed.

In the late forties, annual national exhibitions of prints were initiated by the Brooklyn Museum of Art, the Library of Congress, and the Associated American Artists. From 1950 to 1954, the Cincinnati Museum of Art presented five international biennials of contemporary color lithography. Silk-screen prints won prizes frequently beginning in 1946. Woodcuts became a leading medium, perhaps partly owing to renewed interest in German Expressionism and the Japanese tradition: the material and equipment were inexpensive, multicolor printing was relatively uncomplicated, and large scale was readily achieved in planks or plywood. A new term, *collography*, was coined as papers, plastics, and other materials were glued to form a plate for printing, embossing, or both. Printmakers often worked with more than one medium even in a single print—a condition recognized in 1951, when the etcher's association was renamed the Society of American Graphic Artists.

Before the fifties, printmaking had been a minor offering in most art schools. Atelier 17 artists, like Mauricio Lasansky at the University of Iowa and Alfred Sheeler at the University of Wisconsin, were influential forerunners of the rapid expansion of studios and courses throughout the nation in the fifties as their own students became leaders among a younger generation.

Color lithography, however, developed more slowly. Few American printers were prepared to work with artists, and none could match the techniques of the French master printers. In 1956, Margaret Lowengrund moved the modest shop she provided to artists in connection with her gallery to join in the Pratt-Contemporaries Graphic Art Center. By 1960, the printer Robert Blackburn had helped Tatyana Grosman (who was not an artist) to bring out the first of her Universal Limited Art Editions, and a Ford Foundation grant had enabled June Wayne to establish the Tamarind studio—two of the major centers for important lithography in the sixties.

One other aspect of graphic art in the fifties was significant for art education. The artists and poets who worked together in printmaking projects were part of the general collaboration in the arts that stimulated the related arts movement in schools in the sixties.

Architecture in the postwar decade was dominated by a resurgence of the International Style, led by Mies van der Rohe. His dictum, "less is more," expressed the aesthetic of logic, purity, and proportion—rectangular beauty achieved through steel-structured slab and curtain wall, unornamented and flawlessly finished. Architectural successes were gems of technology for apartments, costly homes, office towers, and research complexes. They were elegant standing alone. But like the Lever Brothers and Seagrams buildings in New York, the better examples in American cities lost distinction in the subsequent mélange of undistinguished imitations.

Even before the mid-fifties, the International Style was under attack. Reinforced concrete gave freedom to expressionistic forms. Frank Lloyd Wright fitted a spiral to his son's home in the desert and to the futuristic Guggenheim Museum in New York. Pier Luigi Nervi engineered intricately ribbed domes to cover vast stadia. Breuer, Walter Netsch, and others supported roofs and walls of concrete by folding them as a child might fold paper. Eero Saarinen sculpted expressions of flight for airport terminals.[3] Le Corbusier used the freedom of concrete in the massive walls and soaring roof of the Ronchamps chapel, a modern extension of an ancient material to evoke an old faith. More radical than concrete were Buckminster Fuller's geodesic domes.

Another challenge to the International Style, "the new brutalism," emerged in England in 1953 first as an ethic and finally as appearance. Forms were to be determined by particulars of the building in operation rather than by elegance of geometry so that separate functions came to be given distinct housings: ducts,

3. Saarinen's TWA terminals at the John F. Kennedy and Dulles International airports were begun in the late fifties and finished in 1962.

pipes, and frames might be left uncovered. Materials were to be undisguised; concrete and brick were favored. Mass and texture replaced lightness and high finish. A related transition was seen in the late work of Louis Kahn, whose design process emphasized the needs of the activities to be accommodated in the building.

Still another departure, known as *new formalism*, or *neo-neo-classicism*, reasserted older pleasures of grace and ornament that had been outlawed by the ideologues of modern design. Slender arched facades, screens of pierced concrete modules or anodized aluminum, domes and vaults, and richly finished interiors began to be appear in exemplary buildings of the later fifties.

Architecture thus embraced several alternative priorities: the ultimate refinement of unornamented logical form, as in the continuity of the International Style; innovation in the technology of structure and materials; analysis of the functional requirements of users; and architecture as fine art, arousing the emotions by expressing the spirit of the client enterprise. These variant conceptions became more apparent as buildings designed late in the fifties were completed in the sixties.

Exemplars of style were not to be expected in mass housing. Homes in the city were built in "superblocks," which eliminated existing streets and clustered high-rise apartment buildings with more or less green space according to a single level of income. In New York, government funds isolated the poor; union funds built for the upper lower class; Metropolitan Life built and managed (carefully and durably) the Peter Cooper Village towers for the upper middle class north of Twenty-Third Street and, on the south, Stuyvesant Town for the next less monied bracket.

Suburban developments could be huge or modest: in either, two fashions were evident. The "western ranch" copied "California living"—one level, redwood siding preferred. The western ranch was an attempt to bring nature into the living area with patios, decks, picture windows, and decor featuring the crafts. The "split-level" was typically more expensive and conservative: its main achievement was the family room—the place for television, children's games, the fireplace, and the bar. In whichever style, the intent was clear: the good life, together, casual, quiet, and protected from factory, poverty, and crime.

Industrial design had become a recognized specialization in the thirties. Directly after the war, in 1946, the Museum of Modern Art celebrated the return to consumer manufacturing with a conference on "Industrial Design as a New Profession," a one-man show of the works of the versatile Charles Eames, and a show of dinnerware by Eva Zeisal.

Several other museums mounted similar exhibits in the late forties. In 1951, the Museum of Modern Art collaborated with the Chicago Merchandise Mart to begin a series of influential annual exhibitions of "good design": together, they educated manufacturers, retailers, and consumers. In the same year, Walter Paapke of the Container Corporation of America sponsored a conference on "Design as a Function of Management," the first in a series of annual meetings of leading designers, teachers, and students known after 1954 as the International Design Conferences in Aspen. The Society of Industrial Designers, founded in 1944, grew to a hundred members by 1949; merger with two other professional groups in 1957 created the Industrial Designers Society of America.

For the most part, the stylized angularity and streamlining that represented modernity in the thirties were replaced with clean, unornamented forms that emphasized function according to the properties of the material. For the commercial jet flights introduced in 1958, designers aimed for efficiency and comfort rather than the glamorous styling lavished earlier on ocean liners and railroads.

For the corporate or upper middle-class consumer, the sources of good design were truly international. German and Italian design recovered brilliantly from the wreckage of war. In interior furnishings, Scandinavian products—glass, tableware, stainless-steel flatware, textiles, and furniture—had their first great American success. In the United States, two furniture manufacturers, Knoll and Herman Miller, were outstanding in their commissioning of new designs in plastic, laminated wood, and metal from such leaders as Eames, Saarinen, and the sculptor Harry Bertoia.

Along with the Museum of Modern Art, other museums, magazines, trade shows, and travelling exhibits promoted public interest in contemporary design. For young couples and others of the less monied classes, good design could be achieved ingeniously with flush doors, painted crates, fibre carpets, "seconds" of stoneware and stainless steel, Noguchi's designs for Japanese paper lampshades, and so on— economic solutions explained, for example, in *Women's Day*, a magazine bought for a nickle in the neighborhood grocery.

The "seven guideposts" to good design, according to authoritative taste in the fifties, were these:

- **Function**: Form should follow function, should be suited to the job.

- **Humanization**: The form should fit the user—the body, the actions, the senses.

- **Materials**: The inherent properties of material, used rightly, would give function and beauty.

■ **Shaping Process**: Tools, materials, and process should be reflected in the form.

■ **Structure**: Parts should relate clearly to the whole, with no pretense.

■ **Economy**: Saving should be evident in materials and effort, in the making, use, and maintenance of the object.

■ **Appearance**: The product should be pleasing in color, texture, and shape.[4]

These principles, it should be evident, represented ideals that had been developed by the Arts and Crafts Movement and various secessions and werkbunds and were construed for machine manufacture by the Bauhaus and subsequent schools of design, such as the Cranbrook School in the United States. The term "organic design" was used in 1940 by the Museum of Modern Art in naming a design competition: that term and the principles of good design associated with it remained in favor through most of the fifties.

Nevertheless, marketing strategy encouraged fad, cheap appeal, waste, and built-in obsolescence rather than thoughtful design: prosperity required consumption. The oversized, tail-finned cars of the late fifties were a prime example. Lewis Mumford called them "arrogant chariots," and before they disappeared, the popularity of the ultra-modest Volkswagen "beetle" indicated that some consumers wanted a better production ethic.

Crafts gained unprecedented importance after World War II. One measure of public interest in crafts was an estimate that in 1957 some twenty million Americans were actively engaged in craftswork as either avocation or therapy. All the major crafts media were accorded the status of art in special museum shows and travelling exhibits. By 1954, so many statewide, regional, and museum-sponsored competitive exhibitions were taking place that a series of national conferences was launched, with regional committees to work on designated problems. Across the country, college art departments set up studios and curricula. The renamed American Craftsmen's Council grew in size and influence; *Craft Horizons* developed into a full-color journal of the movement; the School of American Craftsmen moved briefly to Alfred University (a center for ceramics) and finally to Rochester, New York; and America House was transformed by stages into the Museum of Contemporary Crafts, a neighbor of the Museum of Modern Art itself. Crafts had become a pleasure for many, a way of living for a few, a cultural embodiment of values, and a necessity for architects and designers.

Early in the fifties, it was seen that the cold, unornamented rectangularity of current architecture would create a demand for the color, texture, and individuality of crafted objects. Even more urgently, churches required human touch and spiritual warmth. Residential architecture, most notably in California, blended the indoor and outdoor decor, with crafts as the manifestation of nature and personality. Major exhibitions presented model rooms with crafted furnishings and decorations throughout. Architects brought leading artists and craftsmen together in commissions for mosaic murals, stained glass, rugs, and sculpture; in such collaborations, boundaries between craft and art were obscured.

Industrial designers called upon craftsmen to act as basic researchers in determining forms for manufacture; indeed, two of the country's leading silversmiths headed academic departments of industrial design, and several honored weavers worked regularly in the development of fabrics for automobiles, furniture, clothing, and interior decoration. By 1953, the term "designer-craftsman" came into use to title shows, competitions, and regional associations.

All this while, traditional small-scale crafts production continued in long-established forges, potteries, weaving mills, and glass studios scattered across the country. George Nakashima, an architect converted to woodworking, designed single masterpieces but had fourteen assistants. Husband-wife teams became common. By the end of the decade, the diverse population who earned a living in crafts included those designing in and for industry, small-scale production workers, independents aiming for one-of-a-kind creativity, artists who turned to crafts for some or most of their efforts, teachers, and a growing number of recent graduates. Many, of course, were active in several of these positions, yet—in some degree—each role tended toward a particular set of concepts and stylistic influences.

Early after the war, many of the leaders represented the Bauhaus approach to materials, process, and form and the related concept of integration of crafts with industry. The Japanese influence was especially strong in pottery, but it carried also a particular ethic and a sense of relationship between individual and tradition. The French were admired for the elegant modernism of their book design and more broadly for the collaboration of artists and craftsmen of the first rank. The dominant influence, however, was Scandinavian, especially in textiles, woodworking, silversmithing, and glass and other ceramics. The Scandinavian societies, indeed, were widely admired

4. These "guideposts" were paraphrased from those given in a film, *Seven Guideposts to Good Design*, produced by Louis de Rochemont Associates in 1958 and distributed by the McGraw Hill Film Company.

for an apparent balance of common sense and ideal-
ism, liberality and self-control. Shows of
Scandinavian design travelled the country. Importing
the best of Scandinavian ware and featuring noted
designers, Bonniers and Georg Jensen brought Fifth-
Avenue glamour to exemplars of the modest, function-
al "good design" ethic outlined above. But influences
on American craftswork were not limited to the mod-
ern Europeans. Museums exhibited and *Craft
Horizons* described the native traditions in crafts
around the world, and the historic masterpieces of
decorative arts. Young Americans went abroad to
study many cultures.

In 1950, the revered English disciple of Japanese
pottery, Bernard Leach, following an extensive tour of
lectures and exhibits, wrote an assessment of the
American condition. He had found scarcely a potter
who had mastered technique or form: the requisite
immersion in a tradition such as the Japanese was
nowhere evident. Marguerite Wildenhain, an honored
product of the Bauhaus, replied that there could be no
such dedication to any single tradition: Americans
were too diverse and individualistic; the many nations
offered too great a wealth of cultural resources.

For most of the decade, nevertheless, the work in
each craft generally kept within the current interpre-
tations of tradition, governed by a concept of func-
tional beauty. Techniques were mastered. There was
talk of an onset of academic taste. But in about
1957–58, just as in other arts, a sharp cleavage
occurred. Peter Voulkos, whose pots in Japanese style
won awards annually, showed at Bonniers construc-
tions, more sculpture than pottery, that combined
slab and thrown forms and that exhibited no conven-
tional beauty. Margaret Israel, a painter turned
ceramist, combined materials in works that were nei-
ther pottery nor sculpture, or were both. Lenore
Tawney, a painter turned weaver, produced tapestries
that some juries would not consider as weavings.

Reviewers saw in such work the evidence of a
growing revolt against the traditional limitations of
method and material. The Voulkos show revealed the
influence of Picasso and action painting—"the new
consciousness of spontaneity as a force, and the delib-
erate effort to achieve it; the charm of 'accident'. . .
the new freedom of the artist to express his particular
personality with directness and depth"[5]—all risky,
courageous, and the results ambivalent.

At the same time, there was talk of the "decadent
abandonment of standards" in European pottery and
of the current "cult of self-expression." Macramé was
near its peak of enthusiasm; rya rugs were popularly
available in kits; amateurism and the popularization
of the crafts were recognized as dangers. These devel-

opments near the end of the fifties showed, indeed,
that the crafts had gained equality in freedom and
vulnerability among the arts.

Museums expanded after World War II in num-
ber, in attendance, and in the scope of their opera-
tions. More new art museums were founded in the
United States in the fifties than in any other decade.
Public attendance rose steadily, as major exhibitions
were created and shown collaboratively by museums
nationally and internationally. The titles of a few will
indicate the variety of such exhibitions: "Masterpieces
of Primitive Art"; "Masterpieces of Korean Art"; "Greek
Gold"; "Jewelry from the Age of Alexander"; "Art
Treasures from the Vienna Collections"; "German Art
of the Twentieth Century"; "The Fauves"; "Gauguin";
"Matta." In both special exhibits and permanent gal-
leries, museums showed increased interest in crafts
and decorative arts; in folk art and "primitive" art; in
printmaking, photography, and industrial design.

Activities designed to attract a wider public were
not always distinct from the more specific aims of edu-
cation. At a Boston exhibition, "Sport in Art," an added
feature was a performance by the champion skater
Tenley Albright. Museum concerts relating music to
art became more common. More special galleries for
children and separate children's museums were estab-
lished. Educational materials were planned as an inte-
gral element in both temporary and permanent exhibi-
tions: informational placards became a standard ele-
ment in each gallery. Indeed, at the Art Institute of
Chicago between 1942 and 1953, Katherine Kuh oper-
ated a "Gallery of Art Interpretation," designed by Mies
van der Rohe, where she installed exhibits designed
particularly to reduce verbal explanations by guiding
direct visual perceptions.

Education departments, apart from their role in
exhibitions, became more involved in radio program-
ming and subsequently in television: in 1952 and
1953, the National Broadcasting Company produced
two network television series based on children's
classes at the Museum of Modern Art, with parents
working in art alongside their children in the second
series. These programs went beyond the museum to
advise parents on promoting art activities in the home
and extended into the schools with television and
kinescopes. Along with the usual docenting, classes
for adults and children, and cooperation with schools
in planning class visits related to the curriculum,
museums expanded their programs of publication and
of production of instructional materials for school
classrooms. Some museums and secondary schools
collaborated in essay programs. In the galleries, a few
experiments with such motivating activities as "trea-
sure hunts" were undertaken. Generally, however, this
was not a time when either school art teachers or
museum educators were excited about innovative

5. [Rose Slivka], *Craft Horizons* 17 (March–April 1957): 47.

strategies for art appreciation in the galleries, partly because of the then current conviction that the appreciation of art was best developed through working directly in the media.

Books for the growing art public, both surveys and monographs, were more numerous, more profusely illustrated in color, more varied in content, and more reliable in scholarship than ever before. Much attention was given to André Malraux's *The Psychology of Art: Museums Without Walls* (1949) and his *Voices of Silence* (1953). E. H. Gombrich's *The Story of Art* (1950) was written for teenage readers. Two expositions of Bauhaus theory were especially stimulating to art educators: *Language of Vision* by Gyorgy Kepes and Moholy-Nagy's *Vision in Motion*.

Two more theoretical works were important in graduate programs. Susanne Langer's *Philosophy in a New Key* was the first of a series of books concerned with an aesthetic unifying of all the arts, based on a theory of symbolization.[6] Langer distinguished between "discursive " and "presentational" symbols (subsequently linked by others to "linear" and "global" thinking) and proceeded to argue that the import of all presentational symbols depended on structural analogy with forms experienced through sensory data, including the dynamic form of emotional experience. As media of presentational symbolization, all the arts were linked. For the visual arts, Langer's theory fitted well with continuing investigations of creative processes, and it was especially helpful in promoting the understanding of nonfigurative works.

Langer's ideas of perception, form, and structural analogy relied in part on the principles of gestalt psychology—a body of theory that gained wide importance in the fifties and came to art education in Rudolf Arnheim's *Art and Visual Perception*.[7] Though the book had little initial application to the classroom, particularly in a period when expression was the dominant theme in art education, it was significant in relation to the development of research in graduate programs. Arnheim provided solid argument for a claim that could be critically important to art education: he showed visual perception—the grasp of form and pattern—as an active, fundamentally cognitive process. Gradually, the idea of the gestalt was extended to the entirety of an individual's situation, as in the conception of a "creative atmosphere" in the classroom.

Texts published in the late fifties by Monroe

Beardsley and Morris Weitz became influential in the mid-sixties, in the development of concern for aesthetics and criticism as essential bodies of content in art education.[8]

CONDITIONS IN EDUCATION

School children in the fifties, as one report borrowed the current cliché, were "growing up in an age of anxiety." Educational conferences and literature consistently identified global adversities: war, the threat of atomic annihilation, fear of communism, and the attendant distrust of the United Nations and its agencies. At home, the population grew and moved. Jobs required more education, as labor continued a long-term trend toward specialization even as automation began to replace workers. Society seemed more complex and massive; individuals less free. The anthropologist Margaret Mead repeated, in more ominous terms, what Dewey and Kilpatrick had said in the twenties: "we need . . . a totally new kind of teaching—a teaching of a readiness to use unknown ways to solve unknown problems."[9] And "the children we bear and rear and teach," she continued, "are not only unknown to us and unlike any children there have been in the world before, but also their degree of unlikeness itself alters from year to year."[10]

In the face of these changes, theory and practice of public education continued the trends of the thirties. Through most of the period, the initiatives belonged to the theoretical positions associated with progressivism, theories known then as *personalist* (education as the unfolding of individual potential) and *pragmatist* (reconstructionist, experimentalist, instrumentalist). The persistent conservative opposition were known in theory as *essentialists* (education for basic skills and knowledge) and *perennialists* (advocates of intellectual disciplines). Criticisms by these defenders of older traditions gained strength as world conditions grew more threatening.

In more usual terms, public education was increasingly dedicated to equality of opportunity (despite widespread opposition to racial desegregation), with due regard for the diversity of student background, interests, abilities, and needs. "Life-long education" became a common theme, and taxpayers readily funded statewide systems of new community colleges. A Mid-Century White House Conference called for the development of a healthy personality for all youth: the whole teaching-learning process was to be seen as thoroughly concerned with developmental

6. Susanne K. Langer, *Philosophy in a New Key* (New York, 1948). Copyrighted in 1942, the book was not well known in art education until the mid-fifties. Subsequent books were *Feeling and Form* (1953), *Problems of Form* (1958), and *Mind: An Essay on Human Feeling* (1967).

7. Rudolph Arnheim, *Art and Visual Perception* (Berkeley: University of California Press, 1954).

8. Monroe Beardsley, *Aesthetics: Problems in the Philosophy of Criticism* (New York, 1958), and Morris Weitz, *Problems in Aesthetics*, 1st ed. (New York, 1959).

9. Margaret Mead, *The School in American Culture* (Cambridge, Mass.: 1951), 40.

10. Mead, *The School in American Culture*, 34.

guidance, with the teacher as the primary agent of this school function.

The life-adjustment curriculum also followed from the thirties, building on such basic concepts as "needs," "developmental tasks," and "persistent life situations." The curriculum for elementary schools was fairly well agreed upon in regard to content, but complexity was added in the introduction of individualized programs and nongraded schools. Junior high schools were much concerned with the increasing independence and restlessness of adolescents and the development of teaching that would hold their interest. The high school program typically had three components: a set of academic courses required of students as "general" education; flexibly structured options for college entrance or vocational education (industrial, commercial, or home economics); and additional free electives to accommodate individual interests. Many high schools, however, were too small to do well with such diversity.

At all levels, interdisciplinary learnings were sought; the core curriculum continued in many secondary schools. The "community-centered school" was a favored concept: one plan to improve high school education envisaged individual student contracts that combined courses in school with a wide variety of learning experiences in community agencies and businesses—a proposal that basically revived one approach to vocational education before the First World War.[11]

Two psychologies of learning came to the fore: behaviorism and gestalt, or field, theories. (The latter, together with personalist theories of individual development, were most useful to art education.) More often than in the thirties, definitions of learning were extended beyond skills and knowledge of standard subjects to include the attitudinal and the aesthetic. The most influential of such analyses was Bloom's "taxonomy," which classified all learnings into progressive levels of attainment within three domains: the cognitive, the affective, and the psychomotor.[12] (For educators in the arts, the recognition of aesthetic learnings was an advance, but the artificiality of Bloom's categories created real disadvantages for many years.)

Taxonomies added complexity to demands for more stringent evaluation. The need to account for

learnings in all the new categories and to report also on several aspects of personal development implied that teachers should use not only standardized and self-made tests but also rating scales, sociograms, and anecdotal records.

Through the same years, criticism of the schools became a national preoccupation. In 1957, when the Soviet Union beat the United States in space by launching Sputnik I and II, dissatisfaction suddenly became crisis.

Inadequacies in schools had been obvious for years. The postwar "baby boom" was a major factor: in 1957, the public schools needed 142,000 more classrooms and as many as 180,000 more teachers. Some schools had no teachers for chemistry, physics, and mathematics. Many public school teachers were poorly prepared: fewer than half of them had a college degree in the late forties. Textbooks were inadequate. Schools were harrassed with McCarthyist tactics: hundreds of teachers lost their jobs as suspected communist sympathisers.

Attacks on K-12 education repeated several public dissatisfactions. Progressive education was blamed for many ills, though the Progressive Education Association disbanded in 1955, claiming its mission was accomplished. Parents complained that children brought home no book work. Ability grouping, designed to promote individuation, caused confusion and distrust. Some said schools gave too much time to current affairs; conservatives found the schools too liberal. The call to return to the "basics" and to eliminate "frills" came from advocates both of vocational and college preparation programs; the European system of separate schools to serve these two educational purposes was once again recommended. Teachers colleges were accused of giving too little attention to subject matter content in education and of requiring too many courses in methodology.

Through the early fifties, influential critics called for a return to intellectual rigor in the academic disciplines.[13] Among them were Robert Hutchins, president of the University of Chicago, and Arthur Bestor, a professor whose *Educational Wastelands* was one of the important topical books of the decade. The Council for Basic Education was formed in 1956. As early as 1951 and continuing into the sixties, eminent scholars joined projects to reform curricula in mathematics, the sciences, and foreign languages. Conferences and long-term study groups were supported by academic societies and federal funding under the National Science Foundation and the National Defense Education Act.

11. See *The School Executive* (March 1956). The proposal was developed by a group of twenty-five influential educators and fourteen architects over several years. Some such plan subsequently was tried in certain cities and continues as a frequent component in vocational education.

12. Benjamin S. Bloom, ed., *Taxonomy of Educational Objectives, Handbook I: Cognitive Domain* (New York, 1956), and David R. Krathwohl, Benjamin S. Bloom, and Bertram B. Masia, *Taxonomy of Educational Objectives, Handbook II: Affective Domain* (New York, 1964).

13. Two of the provocative intellectualist criticisms were Robert Hutchins's *The Conflict in Education* and Arthur Bestor's *Educational Wastelands*, both published in 1953.

Following the shock of the Sputnik launchings, observations and analyses of Russian education increased. Politicians and the media spoke of the "cold war in education." Admiral Hyman Rickover, the "father of the nuclear submarine" and a persistent critic of progressive education, advocated adoption of the Soviet school system. Between 1957 and 1964, federal, state, and local funding of public education doubled. The National Defense Education Act provided low-interest loans; funded facilities for teaching science, mathematics, and foreign languages; supported scholarships to prepare teachers of these subjects; and promoted the use of television and other audiovisual materials.

By the end of the decade, extensive and well-publicized studies sought to bring balance between criticisms and efforts to improve education. The idea of separate vocational and academic schools was rejected as undemocratic and educationally unsound. Among the most urgent needs cited were for better counseling and guidance, more challenging programs for the intellectually gifted, and the reduction of unsubstantial electives. More encouragement was needed to bring women into science and mathematics. Stronger support was needed to enable minority students to reach their full potentials. The teaching profession needed to be made more attractive and more selective, with salaries based partly on merit and with more classroom aides to enable better teachers to concentrate on teaching.

The Conant report recommended the elimination of small high schools; a schedule of seven or eight shorter class periods daily instead of six; and a more rigorous program of general education courses. Visual art was given reduced importance in Conant's judgment, according to one explanation, because it lacked any generally accepted curriculum.[14] The Rockefeller study urged a broader "pursuit of excellence" that would value the full diversity of human abilities.[15] At a time when art programs were threatened by demands for rigorous academic curricula, the Rockefeller report was particularly welcomed by art educators because it emphasized the constraints on individuality imposed by contemporary conditions and asserted as a national priority the need to nurture the potential for creativity and competence in every individual.

14. James B. Conant, *The American High School Today* (New York, 1959). Conant, a former president of Harvard University, studied fifty comprehensive high schools, with the aid of a staff funded by the Carnegie Corporation. The cited "explanation" was reported in Barbara A. Jones, "Point of View," *Annual Bulletin of the New Jersey Art Education Association* (Glassboro, 1964), 65–66.

15. Rockefeller Brothers Fund, Inc., *The Pursuit of Exellence: Education and the Future of America* (New York, 1958).

ART EDUCATION

Introduction

As art educators resumed international conferences and exchanges after the war, two themes were dominant: art as a medium of "one-world" understanding and art as a bastion of individuality in the mass technology of modern society. The fervor of these aspirations was evident in the ascendancy of Abstract Expressionism as the international leader in professional art. The official goal of American education in 1950 was the healthy development of the whole personality. Thus, the usual sources of influence coalesced: these were the years when the growth of the child through creative self-expression reached its fullest consensus as the purpose of American art education.

The Status of Art Education

Art educators were clearly aware of the postwar conditions that stimulated public interest in the arts. Sociologists, anthropologists and psychologists discussed these matters at art education conventions and symposiums; they were all working within the same complex of mass culture, lonely individualism, the urge for self-expression, and the itch of hands to make things real.

Two heroic leaders of the recent war dignified amateur art: Churchill and Eisenhower were well-known "Sunday" painters. Peacetime soldiers overseas followed them in the Army Arts and Crafts program. Preschoolers began with arts and crafts in the new nursery schools, and continued in the Girl Scouts, Campfire Girls, Boy Scouts, playgrounds, neighborhood centers, museums, and summer camps. Adult programs, both social and formal, multiplied throughout the community: in New York state in the mid-fifties, one of every five adult education courses was for arts and crafts.

The federal government followed public interest. In 1949, the Office of Education reestablished, after many years, a position of "Specialist in Education for the Fine Arts." For the White House Conference on Youth in 1950, Viktor Lowenfeld developed an exhibit showing the developmental stages of child art, an exhibit that subsequently travelled across the nation. Through the decade, Congress considered a variety of measures to expand federal support of the arts. Among these, international cultural and educational exchange programs were funded; as early as 1955–56, the idea of an arts endowment was anticipated in a proposal to allocate funds to states for cultural programming; and by 1958, the idea of a national center for the performing arts in the nation's capitol began to gain support.

More immediately important for art education,

the GI Bill promoted a rapid expansion of art education programs in colleges and universities, with new facilities, enlarged faculties, and a most significant increase in candidates for master's and doctoral degrees. Indeed, by the end of the decade, the doctoral degree had become a nearly universal requirement for tenured faculty appointment. Studio work became more diversified and sophisticated, whereas scholarship and research began finally to attain professional status.

In public schools across the country, however, conditions for art programs varied greatly. For some art teachers, there were new facilities, new hirings of teacher aids, free periods for planning, and released time to attend workshops and conferences. But for many others, it was a time of crisis. Budgets were strained by continuing military expenditures and the rapid increase in the school-age population. As criticism of education intensified, the popularity of arts and crafts programs in the community made it all the easier to consider school art an unnecessary expense, a nonacademic frill. In many new school buildings, facilities for art were excellent; but in the many outmoded, overcrowded, and temporary classrooms, the basic necessities of sink and storage were lacking. Despite the GI Bill, the shortage of art teachers was especially severe: in 1954, when the schools needed far more than the eighty-six thousand new graduates majoring in education, only about 2 percent of those were prepared to teach art.

As a result of these conditions, whereas a wealthy suburb like Scarsdale, New York, could provide two art teachers for four hundred children, San Diego had two art teachers for fifty-five thousand children; New York City had eleven travelling art supervisors for its half-million students. In Philadelphia, a supervisor was expected to work with four hundred fifty elementary teachers. Many elementary school systems simply had no art teacher or supervisor.[16] Across the nation, only about 10 percent of students in grades nine through twelve were enrolled in art. In Florida, according to a 1957 survey, "only 30% of the senior high schools offered at least one art course."[17] In Scarsdale, by contrast, 85 percent elected art in a high school where almost all students were in a college preparatory program. In many cities college preparatory programs would have discouraged electives in art.

Facing these difficulties, art teachers and the departments of education in several state goverments, worked harder than ever to reach out to the evident general support for the arts. In New York and

Virginia, "artmobiles" were developed to take exhibits of original works to schools and rural communities. Several sets of slides were produced to explain the importance of children's art. Schools as well as museums presented workshops for parents, downtown exhibits of children's art, and festivals of the arts. College departments of art education began to offer summer workshops for high school students. Many of these efforts were joined by increasingly vigorous professional associations.

Professional organizations for art education, growing at all levels from the local to the international, became the most notable source of new strength in the fifties. The move toward national unity that had faltered in the thirties came to success soon after the war, with the founding of the **National Art Education Association** (**NAEA**) in 1947. The four regional associations gave up much of their autonomy: art teachers joined their regional and the national association in one dues payment, with conventions held at national and regional levels in alternate years.

The allocation of responsibilities at national, regional, state, and local levels became a continuing problem. Although much responsibility for schools was assigned to the states, only ten states in 1952 reportedly employed directors of arts and crafts. State associations of art teachers, most of them departments of comprehensive state teacher organizations, therefore had certain strengths. But only the National Art Education Association had the potential to work directly with Congress, collaborate with federal education agencies and other national professional groups, and delegate national representatives to conferences at home or abroad. Soon after its formation, the National Art Education Association, through numerous committees, began to extend the pattern of specialized studies, reports, and publications already established by the regionals. Yet joint membership remained under four thousand through most of the decade, a minority of the national total of art teachers. It was not until 1958 that the National Art Education Association could employ its first full-time executive secretary and move its office from Kutztown State Teachers College in Pennsylvania to Washington, D.C.[18] In the meantime, the **Committee on Art Education**, through its conferences and occasional committee reports, continued to fill an influential role in bringing together leaders in art education with important artists, historians, critics, and social and behavioral scientists.

16. Victor D'Amico, "Coming Events Cast Shadows," *School Arts* 58, no. 1 (September 1958): 14.

17. Julia Schwartz, "Senior High School Problems," *School Arts* 56, no. 9 (May 1957): 43.

18. The first executive secretary of NAEA was Ralph E. Beelke (1958–61); his successor was Charles M. Dorn (1962–70). In Washington, NAEA occupied a small office in the NEA headquarters until it broke ties with NEA and moved into its own new building in 1977.

Figure 5-1. A developmental analysis, from Viktor Lowenfeld, *Creative and Mental Growth* (New York, 1947), 35.

SUMMARY	PRESCHEMATIC STAGE—FOUR TO SEVEN YEARS						
Characteristics	*Human Figure*	*Space*	*Color*	*Design*	*Stimulation Topics*	*Technique*	
(1) Discovery of *relationship* between drawing, thinking, and reality. (2) Search for concept. (3) Change of form symbols because of constant search for them.	Circular motion for head. Longitudinal for legs and arms. Head-feet representations develop to more complex form concept. Symbols depending on active knowledge during the act of drawing.	No orderly space relations except emotionally. "There is a table; there is a door; there is a window; a chair." "This is *my* doll" (emotional relationship).	No relationship to reality. Color according to emotional appeal.	No conscious approach.	Activating of passive knowledge related mainly to self (body parts).	Crayons, clay, powder paints, (thick) large bristle brushes, large sheets of paper (absorbent). Also, unprinted newspaper.	

The **International Society for Education Through Art** (**INSEA**), founded in 1952, was an outgrowth of the UNESCO Seminar on the Teaching of Arts in General Education, held in Bristol, England, in the previous year. The United Nations Educational, Scientific, and Cultural Organization had begun a program of conferences and exchanges of children's art as one of its earliest lines of activity to promote world peace, and it continued its work in art education after its sponsorship of the International Society for Education Through Art. Beginning with its general assemblies in Paris (1954) and in The Hague (1957), INSEA developed a worldwide structure with regional conferences to complement its international meetings.

In addition to INSEA, the long-established International Federation for Art Education held its ninth and tenth International Art Conferences in Sweden (1955) and Switzerland (1958). Other conferences, exchanges of art, and international exhibits were sponsored by such agencies as Art for World Friendship, the Institute for International Education, the American Friends Service Committee, and the International Red Cross. Every year from 1947 through the fifties, art teachers across the country sent children's work to the exchange program sponsored by the Junior Red Cross in collaboration with the National Art Education Association. The teachers themselves as well as college faculty taught and studied abroad in exchange programs. For several years in India, *Shankar's Weekly* published a special issue of children's art, a magazine of up to one hundred sixty pages, reproducing in full color a selection from as many as fifteen thousand drawings and paintings from dozens of countries. *School Arts* and the National Art Education Association journal *Art Education* ran several special issues devoted to school art in other countries. The hope that global understanding could be nurtured through children's art became one of the most inspiriting movements in art education.

Publications

Books on art education multiplied in the postwar years. In a survey conducted by *School Arts* in 1956, respondents "endorsed" more than eight hundred titles in art and art education. Most frequently chosen (and equally often) were Lowenfeld's *Creative and Mental Growth* and D'Amico's *Creative Teaching in Art*.[19]

Lowenfeld's book, published in 1947, was so influential, so representative of current educational priorities, that the fifties have been known as the "Lowenfeld era."[20] No such background of research combining therapy with children's development in art had previously been applied to the education of art teachers. Few art teachers would have known his earlier work, distinguishing "haptic" from "visual" modes of perception, the creative efforts of haptic individuals referring primarily to body feelings rather than visual experience. But his new book, in its analysis of the special needs of haptic children, profoundly influenced many teachers' ideas of art expression and their strategies of motivation. Developmental stages such as Lowenfeld described had been discussed since the twenties but never with such investigation of the psychological significance of the activity and the product and the consequent implications for teaching. The first revision, in 1954, added detailed charts to guide assessment of individual progress in seven areas of growth: emotional, intellectual, physical, perceptual, social, aesthetic, and creative. In a time when general education and the development of a healthy personali-

19. Kenneth Winebrenner, "Book Choices by 141 Art Educators," *School Arts* 56, no. 2 (October 1956): 27–30. Among the next most frequent choices were the philosophical works of Dewey and Read; *Art Today*; Gardner's *Art through the Ages*; Cole's *Arts in the Classroom*; *Exploring Art*, by Kains and Riley; and—significantly—books by former Bauhaus instructors Kepes and Moholy-Nagy.

20. Viktor Lowenfeld, *Creative and Mental Growth* (New York, 1947).

Figure 5-2. An evaluation chart added (see also Fig. 5-1), from Viktor Lowenfeld, *Creative and Mental Growth*, rev. ed. (New York, 1952), 98.

EVALUATION CHART
Preschematic Stage

Growth	Mental Age	Question	No	Yes
Intellectual Growth	4–5½	Does the child's representation of a "man" show more than head and feet?		
	5½–7	Does the child draw more than head, body, arms, legs, features? Are eyes, nose, mouth indicated? Are the features represented with different representative symbols?		

Growth	Question	None	Some	Much
	As compared with previous drawings is there an increase of details? (Active knowledge.) Is the child's drawing representational? Does the drawing show details?			
Emotional Growth	Does the child frequently change his concepts for "man," "tree," or details like "eye," "nose," etc.? Is the child free from stereotyped repetitions? Are parts which are important to the child somewhat exaggerated? Is there a lack of continued and too much exaggeration? Is the drawing definite in lines and color, showing the child's confidence in his work? Does the child relate things which are important to him?			
Social Growth	Is the child's work related to a definite experience? Is there any order determined by emotional relationships? Does the child show spatial correlations: sky above, ground below? Does the child show awareness of a particular environment (home, school, etc.)?			
Perceptual Growth	Does the child use lines other than geometric? (Lines when separated from the whole do not lose meaning.) Does the child indicate movements or sounds? Does the child relate color to objects? Does the child start in his modeling from the whole lump of clay?			
Physical Growth	Is there a lack of continuous omission of the same body part? Is there a lack of continuous exaggeration of the same body part? Are the child's lines determined and vigorous? Does the child include body actions?			
Aesthetic Growth	Do colors appear to be distributed decoratively? Is the meaningful space well distributed against the meaningless space? Does the child show a desire for decoration? Does the organization of the subject matter seem equally important to its content?			
Creative Growth	Does the child use his independent concepts? If the child works in a group, does he remain uninfluenced? When the child is alone does he spontaneously create in any medium? When the child is alone does he refrain from imitating for imitation's sake?			

ty were primary concerns, Lowenfeld set forth concordant goals for art education and a persuasive means of evaluation. By the mid-fifties, art teachers were asked for diagnoses of problem students, and Lowenfeld had to warn teachers against superficial and stereotypic misuse of his work.

D'Amico's book was revised in 1953, with changes indicative of the time. He had said the child was an innate artist. Now he began, by distinguishing the child from the adult artist, to correct the belief that the child should not be taught: "laissez-faire" was an ineffective concept. The child now was not an artist but a "creator." D'Amico had called for a blend of "academic" and "progressive" teaching: now he sought the sound values of each, not as compromise but as the key to a new and better art education. In the new edition, the chapter on theatre design was gone. In its place, fitting the trend in art and in school art, was "the child as inventor"—a chapter on collage and construction as experiment with found materials,

with an explanation of the pervasive importance of the Bauhaus.

These two authors were mutually supportive as professionals, and their books could be perceived as complementary, given the primary reference of Lowenfeld to psychology and of D'Amico to the working artist. This duality was not new—indeed, it was central to progressive education: the experience narrated in Florence Cane's *The Artist in Each of Us* began with teaching in the twenties, as an artist applying Jungian principles, at her sister Margaret Naumburg's Walden School. Some art educators, nevertheless, emphasized the differences.

In any case, these two lines of interest were characteristic of the fifties. Mendelowitz's *Children Are Artists* gave something of both to parents and elementary teachers. Other important books concerned with the psychology of art that contributed to the maturity of art education were Schaefer-Simmern's *The Unfolding of Artistic Activity*, Arnheim's *Art and Visual*

Perception, and Kellogg's *What Children Scribble and Why*. A translation of Piaget's *A Child's Conception of Space*, unfortunately, did not receive the concentrated attention that it would have rewarded. Indicative of current trends in classroom media were several books on art techniques: Lord's *Collage and Construction*, Emerson's *Design: A Creative Approach*, Johnson's *Creating with Paper*, Cataldo's *Lettering*, Winebrenner's *Jewelry Making*, and numerous books on papier-mâché, enameling, and textiles.

For art appreciation, one work specifically prepared as a secondary school text was Riley's *Your Art Heritage*: as a mark of the times, it was criticized for lacking "tangible reference" to art in industry and crafts and for its outmoded use of the term "minor arts." A beginning of new interest in interrelating the arts for aesthetic education was represented by Andrews's *Aesthetic Form and Education*.

The extension and the increasing professionalism of art education were evident in books concerned with particular clientele: *Art in Kindergarten* and *Art for the Slow Learner*, by Charles and Margaret Gaitskell; Bland's *Art of the Young Child*, Kramer's *Art Therapy in a Children's Community*; and the first books concerned with an age group that became generally recognized as a problem in the fifties—Gaitskell's *Art Education During Adolescence*, Reed's *Early Adolescent Art Education*, and the eighth Yearbook of the National Art Education Association.

The elementary grades were the focus of several well-received works by De Francesco, Erdt, Schultz and Shores, and Gaitskell. Other works addressed broader issues of purpose and direction in the late fifties. Barkan's *Foundation for Art Education* was notable for his use of sources in philosophy, psychology, and the social sciences. *Art in Education*, by Conant and Randall, was designed to prepare teachers: they sharply distinguished the newer from the former teaching and gave much attention to professional development and improvement of school art programs.

Purposes and Issues

In the early years of school art, its purposes were vocational, practical, or cultural, and its subject matter was expected to produce certain skills and knowledge. In the twenties and thirties, art, like other subjects, was expected to prepare the child for the comprehensive but specified responsibilities of adulthood. By the 1950s, however, art was declared by the National Art Education Association to be "less a body of subject matter than a developmental activity"; the values of art activities were to be immediate, not deferred.

At the level of slogans, convention themes, editorials, and keynote addresses, the importance of the

As an art teacher, I believe that . . .

ART EXPERIENCES ARE ESSENTIAL TO THE FULLEST DEVELOPMENT OF ALL PEOPLE AT ALL LEVELS OF GROWTH **BECAUSE THEY PROMOTE**
SELF-REALIZATION OF THE WHOLE INDIVIDUAL BY INTEGRATING HIS IMAGINATIVE, CREATIVE, INTELLECTUAL, EMOTIONAL AND MANUAL CAPACITIES **AND**
SOCIAL MATURITY AND RESPONSIBILITY THROUGH CULTIVATING A DEEPENED UNDERSTANDING OF THE PROBLEMS, IDEALS, AND GOALS OF OTHER INDIVIDUALS AND SOCIAL GROUPS.
ART IS ESPECIALLY WELL SUITED TO SUCH GROWTH **BECAUSE IT:**
ENCOURAGES FREEDOM OF EXPRESSION,
EMPHASIZES EMOTIONAL AND SPIRITUAL VALUES,
INTEGRATES ALL HUMAN CAPACITIES, **AND**
UNIVERSALIZES HUMAN EXPRESSION.
ART INSTRUCTION SHOULD ENCOURAGE:
EXPLORATION AND EXPERIMENTATION IN MANY MEDIA,
SHARPENED PERCEPTION OF ESTHETIC QUALITIES,
INCREASED ART KNOWLEDGE AND SKILLS, **AND THE**
CREATIVE EXPERIENCE IN SIGNIFICANT ACTIVITIES, **AND THE**
REALIZATION THAT ART HAS ITS ROOTS IN EVERYDAY EXPERIENCE.
ART CLASSES SHOULD BE TAUGHT WITH FULL RECOGNITION THAT:
ALL INDIVIDUALS ARE CAPABLE OF EXPRESSION IN ART,
INDIVIDUALS VARY MARKEDLY IN MOTIVATIONS AND CAPACITIES, **AND**
ART IS LESS A BODY OF SUBJECT MATTER THAN A DEVELOPMENTAL ACTIVITY.
BECAUSE ART EXPERIENCES ARE CLOSE TO THE CORE OF INDIVIDUAL AND SOCIAL DEVELOPMENT AND BECAUSE THEY PERVADE ALL PHASES OF LIVING, **THE NATIONAL ART EDUCATION ASSOCIATION** BELIEVES THAT **ALL** TEACHERS SHOULD HAVE BASIC TRAINING IN ART.

Figure 5-3. A position statement by the National Art Education Association, from I. L. De Francesco, ed., *Art Education Organizes* (Kutztown, Pa., 1949).

values of art activities depended on current social concerns. Supporting the broadest claims were sincere educational convictions of the function of art in the curriculum, which also reflected cultural trends. Even at the level of daily lesson planning, the art teacher's own sense of the importance of her work and of her personal rewards in art probably differed in the fifties from what they had been before the war.

Thus, the slogan *art for freedom* and its corollary *art for democracy* reflected the anxieties of the Cold War: independent thought and action, self-expression, and respect for the ideas of others were genuine, well-established, objectives of art in the classroom that gained a new kind of significance (i.e., a patriotic significance) during this period. *Art for world friendship* expressed an old hope, inspirited by new possibilities, that became an active, absorbing purpose for many art educators and that had direct effect on school programs. *Art in general education* was a response to the

postwar concern for humanistic education as a balance to scientism and technological overspecialization: art engaged the emotions, enlivened the senses, and stimulated the imagination. This purported balance was declared not only by art educators but also by philosophers, social and behavioral scientists, businesspeople, and planners. This rubric also represented the continuing pedagogical concern for integration in the learner, correlation in subject matter, and the popularity of core curricula. Indeed, the idea of art at the center of the curriculum, championed lately by Herbert Read, dated back in American schools to the work of Francis Parker in the 1870s.

The development of a healthy personality was the theme for the White House Conference on Youth in 1950, which expressed a cultural priority that had grown through the past three decades. A dominant aim in progressive education, this and closely related concepts were phrased as important goals in curriculum guides and other educational literature through the fifties.

All of the above were derivitive, more or less indirect as outcomes of a "developmental activity." They identified contributions to general educational purposes rather than learnings about art as "subject matter." Especially in reference to general education, personality, democracy, and world friendship, an education for humanistic values seemed to place visual art in a role like that of music, drama, dance, and literature. Increasingly, one found the "arts" distinguished as a unified sector in education, sharing common purposes.

At the level of planning for art curricula, however, a familiar set of more direct aims—creative self-expression, appreciation of art and beauty, and development of manipulative and organizational abilities—were maintained. Nevertheless, the specificity of art learnings was reduced by attention to the derivative values mentioned above. The importance of subject matter was further challenged as psychology led some art teachers to the idea that teachers could never really teach but could only serve as guides and facilitators. Accordingly, the statements of purpose in curriculum guides and committee reports began to replace definitions of outcomes by commitments to "offer opportunities for . . . " Creativity, it was said, could not be imposed; self-expression could not be other-directed; skills with tools and processes were to be gained only as needed for individual projects; and appreciation was an attitude, not a collection of facts about famous old products.

Statements of purpose changed somewhat in the late fifties. "Freedom" and "democracy" lost some of their exhortatory zest. With the emphasis on personal values, the improvement of the environment, either through appreciative sensitivity or through projects in design, lost ground as a specified purpose of art edu-

cation. Already by the mid-fifties, the public interest in creativity gave that concept a magnified importance in convention programs, workshops, and research. Though the creative process was not fully understood, the challenge of Sputnik made it a social issue so important that art educators began to claim creativity as their special province—an outcome distinguished from "self-expression."

Sputnik brought to the fore another lively interest, one related to the problems of creativity: the relationship between art and science. In the early postwar years, art educators had stressed the opposition of art and science: art education was to counterbalance the alleged impersonal objectivity of science. Through the fifties, however, many commonalities between art and science were discussed in influential studies of perception, form and structure, communication, and the creative process. At the Massachusetts Institute of Technology from 1952–54, a distinguished committee was invited to consider the benefits of a program in visual arts. The program was launched in the fall of 1957—the year of Sputnik—under the direction of Gyorgy Kepes, an eminent product of the Bauhaus: the study committee advised that both science and art "are products of analysis and synthesis, of intuition and a judicious perception of order."[21]

In the first year of Sputnik launchings, the topic chosen for the next convention of the Eastern Arts Association was *Art Education in a Scientific Age.* For awhile, art educators heard featured speakers on these relationships, among them Gyorgy Kepes, the botanist Paul Sears, the communications theorist Marshall McLuhan, the architect/designer Buckminster Fuller, and the sociologist Nathaniel Cantor. This interest, however, proved only temporary, apart from a few attempts at specialized curricula and occasional thoughtful writings—some of them relating to methodology in research.

Perception became an issue as an obvious initial element in creativity. Perception was shown by gestalt psychologists like Arnheim to be holistic, selective, cognitive, and conditioned by experience. Gestalt theory thus explained why the teacher's promotion of a stimulating, encouraging classroom environment— every element of personality, behavior, display, production, and decor combining into a perceptible whole—was the one certainty in teaching for creativity.

Aesthetic perception, Lowenfeld insisted, was an essential source of art, and *aesthetic growth* for all the senses was one of his educational goals. *Aesthetic education*, as explained by Munro, was the true function of the arts in general education: it should include not

21. *Art Education for Scientist and Engineer: Report of the Committee for the Study of the Visual Arts at the Massachusetts Institute of Technology, 1952–54* (Cambridge, Mass., 1957), 11.

only active participation in all the arts but also history and criticism.[22] Toward the end of the decade, partly through other studies in perception, partly through the concept of related arts, and probably as a reflection of ideas represented by Cage, Rauschenberg, the New York poets, and the off-Broadway theatre scene, there appeared a growing interest in the development of sensory awareness generally. At the same time, caution developed in the claims that identified art education as the sole agent of creativity; instead, aesthetic values were recognized as the essential and unique contribution of art, and the term *aesthetic expression* gained favor.

Through these years, with the increase in professional publications and meetings and with many more graduate students prepared to use these opportunities to speak out, the discussion of issues in art education grew in variety and volume. Issues, whether perennial or transient, emerged whenever current instances engaged opposing values and differing beliefs about art, society, individuality, or education.

One perennial issue arose again through administrative plans for elementary art. Only a few schools were staffed by a certified art teacher in a special art-room. More common were the "travelling" art teacher or supervisor who could occasionally visit, but many elementary classrooms had no help from art specialists. A popular postwar concept, the *self-contained classroom*, implying the classroom teacher's responsibility for all subjects, threatened to reduce further the quality of instruction in art. One response was the "art consultant," whose schedule developed as classroom teachers requested help in planning, in techniques and teaching methods, or in provision of instructional aids.

The question of who should teach art was not new nor were the arguments, but there were deep grounds of opposition. On one side was the claim that the classroom teacher, not the art specialist, knew the children best and could best ensure that art would flow from classroom activities without the rigidity of some scheduled weekly unit of time. The contrary opinion held that the understanding of children's art experience, their growth in *art*, and the development of effective learning experiences in art required special preparation that could not be expected among classroom teachers. But the values assumed in these arguments were based in turn on fundamental considerations of the nature of art and the purposes of art education. Elementary specialists, classroom teachers, and art educators alike were found on all sides of

this issue. Indeed, related differences continued among art educators themselves.

The tension between the inherent special values of art, on the one hand, and the contributions of art in general education, on the other, had been debated by Parker and Clark in the 1890s, and frequently since that time. In the fifties, discussions of correlation, integration, and the unique values of art repeated the positions at both extremes but most often ended in calls for balance, with the difference that personality had gained in importance as a major concern.

But here again were opposed values. What kind of person, as citizen, was wanted in the struggle against collectivism and totalitarianism? What conception of art was implied? Social growth (democracy in the classroom, in the parlance of the fifties) called for group projects determined by a majority of the pupils. But individual freedom (existential independence) and creative expression gave precedence to the needs of each student. Either of these positions implied pupil decision rather than teacher direction. Dewey and Naumburg had anticipated these factors when they debated the issue in 1930: now *freedom* could be questioned as a slogan for art education on tactical grounds because the schools were under fire for lack of discipline by people who saw school art as a frill. Moreover, some art educators said that the identification of art with freedom was misleading if not inaccurate: restraint was intrinsic to art, and Read had emphasized the discipline imposed by art media.

Competitions in art became an educational issue during the postwar years. The popularity of amateur art activities stimulated a variety of sponsorships of child art exhibits complete with prizes. Too often the awards went to imitations of adult imagery and technique. At the same time, art education increasingly emphasized originality and sincere appreciation of the art expression of all students. In 1952, the National Art Education Association approved a policy that recognized benefits from competition while it recommended that contests be eliminated for all but high school students with a major interest in art. The association also specified a number of considerations intended to restrain administrative approvals of contests.

Problems of teaching method, as always, arose not only from such philosophical and theoretic perplexities but also more simply from unsatisfactory results. The influence of Lowenfeld made *motivation* an important element in the art lesson, yet it was difficult to move a large group of children beyond momentary stimulation to a deeply felt surge of expression. Much personal attention was implied, yet teachers were advised not to talk too much; any intrusion could disrupt the creative process. Classroom organization had been easier in subject-centered lessons without individuation; now democracy

22. Thomas Munro, "The Arts in General Education," *School Arts* 49, no. 9 (May 1949): 300. A leading figure in the field of aesthetics, Munro was also an influential theoretician in art education: the components of his conception of aesthetic education can be seen as an early definition of what has come to be known as "discipline-based education."

Figure 5-4. A comparison of old and new teaching methods, from Howard Conant and Clement Tetkowski, "Which type of Program is Yours?" *School Arts* 53, no. 2 (November 1953): 9–10. Reprinted with permission of *School Arts*.

TEACHER-DIRECTED	PUPIL-DEVELOPED
Children show only passive interest in art activities in the elementary school and do not wish to take more courses in art, since they have been convinced that they are not talented.	*Children show great enthusiasm for art in the elementary grades and are eager to take additional art courses when given an opportunity to do so in the junior and senior high schools.*
Teacher confines art activities to scheduled lessons in specified periods, ignoring relationships of art to other classroom activities, and contributions to extracurriculars.	**Pupils** may use art whenever it is applicable and meaningful in any area within the general school program, integrating it with other subject fields and extracurriculars.
Teacher selects the subject matter and the art media to be employed, often repeating the same lesson at the same time every year with very little modification for individuals.	**Pupils** have a choice in the selection of subject matter and materials to be used, and may select activities according to individual backgrounds, needs, and timely interests.
Teacher demonstrates one definite way of working, in a step-by-step procedure, and makes it clear that each child is judged on how well he follows the method of the teacher.	**Pupils** are shown various ways of using any new tools and materials found successfully by others, but are encouraged to develop their own concepts and ways of working materials.
Teacher limits art activities to two-dimensional seatwork at individual desks, and restricts materials and tools to those which may be passed out quickly, cleaned up promptly.	**Pupils** can work in a variety of materials and processes in both two-dimensional and three-dimensional activities, either individually or as member of groups working together.
Teacher limits talking to questions directed to him after a proper raising of hands, and discourages any activity or use of tool which would result in noise or any informality.	**Pupils** are free to move about the room to secure materials and tools, and to discuss their work with others in a casual manner, without any restrictions on normal working sounds.
Teacher plans or selects prepared patterns for seasonal window decorations and other displays in the classroom or halls, to be copied in a very uniform and precise manner.	**Pupils** plan seasonal exhibits and other displays, and develop them as normal children's work, with a great deal of variety in color, size, shape, and individual expression.
Teacher plans, constructs, and paints stage scenery and all props, if there are any at all, and limits the work of children to chores such as filling in areas outlined by him.	**Pupils** participate in planning, constructing, and painting original stage scenes or backdrops for both school assembly programs and other dramatic activities in the classroom.
Teacher plans all displays of children's work, carefully selecting only that work which he regards as best or which may show off to advantage with administrators and others.	**Pupils** have a part in planning exhibitions of their own work, and every child has an opportunity to be represented without competing with false standards or other children.
Teacher regards the completed work as more important than the experience in developing it, as if the product desired was the paper itself and not the child's personality.	**Pupils** are not led to believe that the completed work is more important than the creative experience in making it, and receive many personal benefits from the activity itself.
Teacher gives letter grades based on conformity to rigorous standards and teacher aims, promoting competition between children to discover and attain objectives he has in mind.	**Pupils** realize that, if their work is evaluated at all by the teacher, it will be on the basis of individual growth with due regard for differing abilities and personalities.

implied both self-discipline and conformity to group governance—norms that had to be developed without actual imposition. Even the removal of row seating compounded advantages with difficulties.

Apart from guidance and management, the confidence that students were learning about art was shaken: self-expression and experiment, some art teachers protested, were not enough. The popularity of experiment with discarded materials led to claims that aesthetic quality was ignored. Or again, along with the enthusiasm for exploration, the general turn toward abstraction seemed likely to produce a new stereotype of form and style unconnected to personal life. A popular catchphrase, *process versus product*, represented the argument that the essential values of art lay in the

experience. But within the attention to process were further complexities. At the end of the decade, *breadth versus depth* became an issue for debate and a problem for research: the concern was that excessive emphasis on introduction to a variety of media was preventing the extended involvement required for an integrated personal expression, considered either as learning or as art product.

Given these dissatisfactions and uncertainties, some of the more recent assumptions were occasionally challenged: the belief that inborn talent was universal; the idea that children were corrupted by seeing adult works of art; the sense that it was wrong to teach children how to draw something. D'Amico was not alone in the fifties in saying that the "laissez-faire"

approach that was often supposed to be necessary for creativity was instead ruining art education. (Indeed, Dewey had said as much in the late twenties.)

By the end of the decade, a profound division was evident in art education. Those who became art teachers with a primary dedication to the development of children continued to find in Lowenfeld a sympathetic authority who offered a fully reasoned theory and an ample guide to practice. But those whose self-identities were grounded more strongly in art, who were strongly represented on the Committee on Art Education, began to protest that the psychological values available through their subject had become dominant. As an expression of this dissatisfaction, the term *artist-teacher* came into use. The quarterly bulletin of the Western Arts Association and *School Arts* began in 1958 to feature individual artists who had rather slight connections to teaching. In the journal of the National Art Education Association, Vincent Lanier claimed that the term *artist-teacher* was an affectation that degraded the profession, a mark of professional immaturity—"redundant, defensive, or contemptuous."[23] Willard McCracken replied that the concept was a sign of growth in the profession, representing dual capabilities.[24] For both of them, clearly, the fifties had been a period of increased understanding and potential. Although the Lowenfeld era was nearing its end, it was ending without rejection of his contributions.

The Art Curriculum

After World War II, art educators heard encouraging reports of continued professional progress in curriculum development. Planning was more often a cooperative districtwide process that was regarded as a form of in-service staff development: workshops invited classroom teachers as well as art specialists to share their abilities while contributing to plans. The result, rather than an administrative imposition, was more frequently a flexible guide that the collaborating teachers were more likely to follow.

Despite the claim that art was "more a developmental process than a subject," planning still required decisions on what was to be learned, and when—decisions about "scope and sequence," in curriculum jargon. But the problems of fitting subject matter into the K-12 span and into each year's schedule with adequate freedom had become more complex. Rather than teaching for ability in drawing or design or for any subsequent set of ultimate adult responsibilities, emphasis now went to the "needs of youth." Also, the

importance of individual expression had to be balanced against the goal of social growth, which usually implied group projects. The number of art media had increased. Exploration in the media tended to replace more direct (and more easily planned) instruction. The availability of audiovisual materials and—in many areas—museum trips, however welcome, added complication. Public relations became a more commonly expected responsibility: exhibits and community-related projects might be initiated for administrative impact as much as for learnings in art.

While responding to all these factors, the district curriculum guide had to be convincing as the representation of a coherent art program. Yet, for many reasons, a district plan had to provide freedom at the level of actual lesson planning. Correlation required special plans at each school, in each grade. The concept of art as an expression of daily experience implied even more spontaneity. Finally, with or without a district plan, the up-to-date teacher was not independent in determining art activities: more than before, attention to motivational strategy as well as the idea of "democracy in the classroom" called for active participation by the pupils in decisions. Collaborative planning thus required many sharings of ideas and much compromise.

Toward the end of the decade, all these considerations in the theory and planning of curricula in art were unavoidably affected by reform movements in science and mathematics education and by the Conant and Rockefeller reports mentioned earlier. Emphasis on the importance of certain academic subjects, on the redefinition of content in these subjects, and on "excellence" pushed likewise for reconsideration of art as a subject and for renewed concern for standards and methods of evaluation.

Evaluation had become more problematic. Before World War I, Walter Sargent, who was concerned mainly with drawing, had urged the need for standards to give credibility to art as a subject. But the tests and measurements that stimulated enthusiasm in the twenties and early thirties were discredited precisely because their standards were invalidated. After World War II, with art promoted as a developmental activity more than a subject, the problem of standards was raised anew.

Three types or purposes of evaluation were recognized: for reports to parents, children, and administrators; for the teacher in planning and improving the art program; and for children as part of the learning process. Given the emphasis on personal development, with process equal in importance to product, the traditional grading by letter or number was less informative than ever for reporting and counterproductive in the promotion of creative self-confidence.

For reporting on development, theory was ade-

23. Vincent Lanier, "Affectation and Art Education," *Art Education* 12, no. 7 (October 1959): 10, 21.

24. Willard McCracken, "Artist-Teacher—A Symptom of Growth in Art Education," *Art Education* 12, no. 9 (December 1959): 4–5.

quate: Lowenfeld and others provided extensive graded chartings of patterns of growth observable in varied media. For procedure, the ideal recommendation was a combination of many techniques—checklists, progress reports, narratives, observational notes, and collections of work. But this type of reporting was impractical: the classroom teacher was responsible for many subjects and usually lacked preparation in art, and the art specialist might be responsible for hundreds of students.

Apart from developmental considerations, three criteria suggested by Gaitskell were representative of current thinking: the quality of personal expression; attitude toward the work of others; and behavior in all kinds of art activities.[25] But "quality of expression" again begged the question of standards. Adult work was impermissible as a standard for schools. "Sincerity," some said, was the key to quality, but lack of sincerity seen in a child's art could be taken as evidence of inadequate teaching. Moreover, others said that "expression was not enough." Capable teachers sometimes said that the truly useful evaluation was the guidance they gave to students during the creative process, but this guidance did not provide reports to parents and administrators. In practice, many teachers avoided judgment in the classroom, praised and exhibited the art in egalitarian totality, and conformed to the reporting techniques established by the administration.

The Elementary Art Curriculum

The foregoing discussions of varied responses to shifting postwar concerns should not obscure a general pattern of continuity, allowing for the usual wide variations in a subject that lacked uniformity even within a school district. There was considerable continuity in the media and the types of activity. Changes that can be called characteristic of the fifties appear more often in the teachers' foundational thinking about goals, learners, art, and the appropriate methodology of school art. In many respects, these changes represented an extension of the Progressive Education Movement of the thirties.

For the youngest children, through preschool, kindergarten, and the primary grades, the commonly accepted values of art activities were contribution to personal and social growth, development of productive work habits, and promotion of creative self-expression and aesthetic awareness. At that level, the main considerations in planning were the exploration of media and the coordination of art with seasonal interests, holidays, and the general curriculum. Though the same principles operated in the upper elementary

grades, teachers had long understood that these children should be capable of longer attention and more small-muscle skills, that group work had special interest for these children, and that technical instruction might be more acceptable. The more recent developmental theories, of course, went further.

Beyond the generalized descriptions of development, the idea of "readiness" gained currency in the fifties. The much finer-grained concept of readiness could be directed to a class, a subgroup, or an individual. Early in the fifties, readiness was understood simply as adequate preparation for a particular learning experience, an assessment of ability and interest. Through the contributions of behavioral and social science typical of the fifties, the concept was rapidly elaborated so that readiness was understood to be affected by all the child's prior experiences, habits, attitudes—by all of her cultural background. Though art teachers surely had not always been blind to such considerations, the extended concept of readiness implied that the professional education of teachers and the norms of planning and classroom practice would grow more complex, more localized, and more individuated.

One extensive survey corroborated current texts in reporting that student interests were a primary source of curriculum decisions and that prescriptive plans for the sequencing of art activities were unpopular.[26] The same survey asked classroom teachers, art supervisors, and college professors to rate thirty-two different media in importance: given this remarkable range of possibilities, the preferred media still were clay, tempera, colored paper, chalks, and crayons.

Texts and curriculum guides for elementary art education often were organized under major families of media or activity, not to give main importance to the media as such but to suggest how art activities could be conducted to fit into the general curriculum. Thus, mural making might be treated as a separate category, whatever the medium, for its value as a group activity useful in social studies; papier-mâché might be linked to puppetry. Such advice avoided suggested schedules and left curriculum decisions to the teacher.

Among the simplest aids published for classroom teachers, the *Instructor* magazine remained representative: their "art packets for kindergarten through grade eight" simply provided thirty-two cards describing art projects—enough to get through the year—without stated purpose or educational guidance.[27]

25. Charles D. Gaitskell, *Children and Their Art* (New York, 1958): 397–98.

26. Reid Hastie, "Current Opinions concerning Best Practices in Art for the Elementary Schools and for Elementary School Teacher Preparation," in *Research in Art Education*, NAEA Fifth Yearbook, ed. by Manuel Barkan (Kutztown, Pa., 1954), 78–114.

27. Else Bartlett Cresse, *The Instructor Art Packets for Kindergarten through Grade 8* (Dansville, N.Y., 1956).

Superior to such materials were two graded series of books for the teacher and individual students—updated versions of the Prang series of 1904–05—which described and illustrated each activity as the work of fictional peers. These aids represented the fifties in their advice to the teacher and in their stimulation of individual student enterprise: they encouraged expression of personal experience, appreciation of other students' varied efforts, exploration of media, and increasing attention to techniques and expressive means as appropriate to grade level.[28]

Among curriculum guides, a substantial representative of the early fifties was New York City's elementary manual. Unlike its 1931 edition, the syllabus of required studies had been removed. The 1952 manual "stresses . . . the total development of the child and thus establishes art as an important area of general education. Emphasis is put upon individual experimentation with materials rather than upon uniform standards."[29] One indicative feature is its division into two sections: "Expressing Feelings and Ideas through Painting, Drawing, and Poster Designing"; and "Designing and Constructing with Various Materials: Clay, Blocks, Paper, Cloth and Trimmings, Yarns and Fibres, Puppets and Puppetry." (Experiences with woodworking tools also were included.) "Expression of feelings and ideas," be it noted, still belongs only to painting, drawing, and posters, but the other media are allocated nearly 50 percent more space. In each of the manual's two main parts, experiences are presented according to grade level. Finally, and typical of the thinking of the fifties, the guide closes with pages summarizing developmental phases in each of the groups of media.

The Secondary Art Curriculum

The basic pattern of the high school art curriculum—a general introductory course followed by specialized electives—did not change in the fifties. A large adequately funded school could offer major and minor programs in art, with electives in eight or nine fields and special courses for talented preprofessionals and college-bound students. Other schools, as noted earlier, might be wholly unable to offer art.

Built into the high school organization were several advantages. Art teachers were specialists who usually had the most advanced education in art; classes were smaller, averaging only about twenty to twenty-five students; and many classes met daily. Under these conditions, the possibilities for individual attention, variety of media, and adventurous personal pro-

jects were greater than at any other level.

Yet certain respected observers said that high schools lagged behind elementary schools in curriculum improvements. These critics contended that high school art courses were more often specialized in separation from the general curriculum. Instruction, they said, too often favored the talented, with "watered-down" imitations of work being produced in professional art schools. But high schools were expected to nurture talent; examples of correlation with other studies did exist; and other observers reported a new degree of flexibility, greater attention to general education, and concern for the values of art in daily living.

In comparison, the junior high school art program seemed more problematic. Though art teachers commonly were less experienced than their high school counterparts, they had more students. Typically, a dozen or more classes of thirty to forty students met twice weekly. Since art usually was a required course, the students were less likely to be there for their own interest. Junior high school teachers usually had homeroom responsibilities and other duties. Their budgets were lower than for high school programs, and the facilities were less often adequate.

The differences in preparation that students brought from their various elementary "feeder" schools often belied the assumptions of district curriculum guides. In some cities, supervisors had little time to promote uniformity at any level: in a large urban situation, four art teachers in the same junior high school were likely to provide four different types of art education. In other cities, teachers might meet frequently in workshops or resource centers to share lesson plans and cooperatively develop instructional aids. Such variation in junior high school programs was hardly new to the fifties, but the problems of early adolescent art education were addressed more often than previously in new publications and in the work of professional associations.[30]

The Contents of the Art Curriculum

Drawing and Painting

The blending of twentieth-century art theories that was achieved in Abstract Expressionism joined quite naturally with the general cultural interest in personality and creativity as influences on the teaching of painting and drawing. Moreover, the writings of Read, Lowenfeld, and others in art education, together with a burst of professional and popular books and articles on creativity, provided art teachers of the fifties with a better understanding of methods

28. Maud Ellsworth and Michael F. Andrews, *Growing with Art* (Chicago, 1950); and Flossie Kysar, Mabel E. Maxcy, and Jennie Roberson, *Young Artists* (Columbus, Oh., 1959).

29. Board of Education, *Art in the Elementary Schools: A Manual for Teachers* (New York, 1952), iii.

30. See, for example, Helen Cynthia Rose, "Directions in Junior High School Art Education: A Pilot Study of City Junior High School Art Programs," in *Research in Art Education*, NAEA Ninth Yearbook (Kutztown, Pa., 1959), 131–36.

Figure 5-5. One of a series of studies of "Purism" as a chosen "contemporary" style, by a student of Evelyn Surface, described by the editor as a "more deliberate and carefully calculated approach" to teaching. *School Arts* 53, no. 4 (December 1953): 21. Reprinted with permission of *School Arts*.

that would nurture the creative process.

A major element in the new approach, adopted from Bauhaus teaching, was experiment with media and tools to exploit their formal and expressive possibilities. *Research*, the term used by Cezanne, was now applied to the painting and drawing of fifth graders. Teachers and books described resist techniques with crayon, rubber cement, or waxed paper; "wash-offs" of tempera coated with ink; and painting or drawing with twigs, rags, sponges, corrugated cardboard, and other nontraditional tools. Crayons were melted, thinned with turpentine, and painted for the effect of encaustics. Art in higher education shared the same tendency: at all levels, some teachers insisted that fundamental learnings were being sacrificed while students merely sought novelty in media.

But experiment was also stimulated by the marketing of new media. Felt-tipped pens were in use by

1953, exciting students as a tool for fast sketching. Fluorescent watercolors, "oil pastels," and "water-crayons" were available in the late fifties. Liquid plastic, easily pigmented, could be used as a painting medium, as an adhesive in collage, as a paste for relief projects, or as an imbedding medium. The versatility of casein and oil paints was an option for exploration in well-funded schools.

These explorations of the media fitted with a second characteristic of school art in the fifties: a general shift toward abstract and nonobjective imagery. The adaptation of Abstract Expressionism did give children a new kind of freedom in art: spontaneity and intuition replaced uniformity—at least, ideally. Teachers found many easy motivational devices, and encouragment was unhampered by problems of rendering or interpretation. Nevertheless, a teacher's ideas were often evident in the classwork. "Drip-paintings," lacking any educational idea, could become just another routine class activity. It was such use of current professional styles that prompted the criticism that a new kind of academism was replacing the expression of personal life that should be achieved in child art.

At the same time, representation continued at all grade levels, and all styles, past and present, were available. Realism still was wanted for reference to daily experience, for countless illustrations in correlation projects, or for depictions of Elvis Presley. Symbolism appealed to adolescents concerned with private anxieties or fantasies. Pointillism promoted attention to formal properties and reduced the frustrations of attempts to render realistic detail. Collage, of course, was almost automatically a teacher's tech-

Figure 5-6. An experiment in "drip painting," by a student of Lucia B. Comins. *School Arts* 56, no. 5 (January 1957): 25. Reprinted with permission of *School Arts*.

Figure 5-7. World at War, by
John McNally, a student of
Toby K. Kurzband. *School
Arts* 53, no. 2 (October 1953):
19. Reprinted with permission
of *School Arts*.

nique for a unit on texture. As in the professional art
of the fifties, the distinctions between painting and
drawing were blurred, or made irrelevant, by collage
and other mixings of media.

Likewise, distinctions between drawing, painting,
and two-dimensional design often were deliberately
avoided or denied—partly, perhaps, because the prin-
ciples of design appealed to teachers as content that
still could be taught. Thus, painting could be consid-
ered as "color-design." Drawing with tempera applied
with the edge of a piece of cardboard or with a loop of
string could be a study in line. Finger painting
became a study of movement. The shapes and lines of
a represented object could be extended as "space-
cutting" to produce full-page abstraction. A still-life
study could be treated as a design through simplifica-
tion, and that process could be followed by its reverse,
the transformation of an abstraction into a represen-
tational composition. Experiment in the merging of
thin tempera to create a harmonious tonality could
lead to a design in cut paper or to a poetic representa-
tion in mixed media.

Drawing, according to some teachers, was best
thought of as a way to develop ideas, but the drawing
media also were useful to emphasize the variety of
qualities of expression in line, texture, and value. For
one teacher close to the New York art scene, good
drawing was like "action painting"—the record of ges-
ture. The influence of Nikolaides's text, *The Natural*

Figure 5-8. A collage studying texture and transparency,
by a student of Lois Lord. *School Arts* 53, no. 1 (September
1953): 14. Reprinted with permission of *School Arts*.

Way to Draw, was apparent in scribble techniques,
closely observed contour drawings, and rapid gesture
sketches.

Drawing media and watercolor were popular also
in a return to drawing from nature, as art became
engaged in another curriculum movement of the
fifties, "outdoor education." In courses of commercial
art and in projects for a yearbook, students still spent

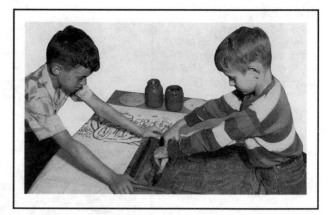

Figure 5-10. A curtain silk-screened, by third-grade students of Elizabeth H. Mack. *School Arts* 53, no. 4 (December 1953): 7. Reprinted with permission of *School Arts*.

Indeed, given the range of age, experience, preparation, and personal preferences among art teachers throughout the country, it is sensible to observe that all the traditional problems of figure drawing, portraiture, perspective, landscape, and still life were still alive, approached through all the techniques devised in earlier generations.

Printmaking

Silk screen, with inks more suitable for schools, was probably the biggest enthusiasm of the fifties in printmaking. Children as early as the third grade used silk screen with lacquer film, tusche, and stencils for posters, yearbooks, and school curtains. Silk screen was the mass-medium for school art: once the design and setup were ready, dozens of children could share in hundreds of reproductions.

The search for inexpensive substitutes for drypoint continued, and simplified approaches to lithography became more common. Linoleum and wood block techniques remained popular, especially for graphic design and textile projects. The experimental spirit in schools found alternatives to these traditional block-printing materials—even before the term *collography* was much used—by gluing almost any material of equal height to a base of wood or cardboard: rubber tires in particular were easily obtained, readily cut with scissors, and reliable in inking. Younger children continued to enjoy repeat patterns, printed with sticks, vegetables, erasers, and innumerable other objects.

Photography

Photography was still mainly a camera club activity a half-century after Lewis Hine successfully taught it at the Ethical Culture School. According to one report, "the more than 21,500 nation-wide photographic entries in the 1952 Scholastic Art Awards . . .

Figure 5-9. A contour drawing, by a seventh-grade student of Robert Henkes. *School Arts* 57, no. 2 (October 1957): 15. Reprinted with permission of *School Arts*.

much of their time developing skill in pen-and-ink illustration. Murals continued as group projects for social growth, with themes related to world friendship, community interests, or correlated studies.

Figure 5-11. A photogram, by an elementary school student of Pearl Greenberg. *School Arts* 56, no. 9 (May 1957): 21. Reprinted with permission of *School Arts.*

gave evidence of a growing interest in this art area on the part of secondary art students."[31] (Several entries, however, were allowed to each student.)

Art teachers still were not likely to be prepared to teach photographic techniques, and darkroom equipment adequate for class instruction was expensive. A more subtle difficulty was apparent in the common opinion that photography was a tool, a "mechanical craft," not an art. To combat that bias, students at the Rochester Institute of Technology put on a show of their experimental work, "the first of its kind in the East." Eighty public school art teachers, students, and art supervisors were invited to see that "the creative

camera has a definite role to play in the high school art class."[32] Apparently, photography could be called creative only because it was experimental.

Certainly students were interested in the process, even without cameras or darkrooms. Some teachers found that classes were fascinated by the use of darkroom chemicals as a medium in drawing. Photograms had become a popular art activity, unquestionably creative since students manipulated the objects of imagery. Where no actual photographic materials were used, imitations of photo-montage were made with magazine clippings: teachers said that students were highly motivated by an activity that required no skill but produced a modern result. The teacher's challenge was to avoid trivia, to move the student beyond the level of sheer fun in order to develop a sense of design in a personal graphic communication. But the same could be said for many art activities of that period, where the materials, the process, and the result were inherently intriguing.

Sculpture

Sculpture, or three-dimensional design, attracted unprecedented interest in the fifties: it offered apparently limitless possibilities for exploring materials and forms. As in drawing and painting, instructional media showing contemporary examples validated an equally flexible acceptance of style. To list the materials is to suggest the ingenuity: clay, soap, wood, stone, solid and liquid plastics, rubber molds, copper, aluminum, alabaster, wire, reed, string, paraffin, cinder block, cardboard, pumice stone, cellophane, fire brick, plaster, and salt blocks; also, scrap metal, tin cans, flash bulbs, glass, old clocks, buttons, metal sponges, screen mesh, used hardware, foam glass, florists' plastic, old sand molds from foundries, and plastic hair curlers. Even second graders could carve a durable material developed by an art teacher to roof his own house—a mixture of sand, portland cement, zonolite (vermiculite), plaster of paris, and water. An article extolling welded steel as the new professional medium suggested that welding might be popular and safe, under competent guidance, even with children as young as fifth graders.

Driftwood became a fad in the fifties for decorators, vacationers, and those art teachers who were justly concerned with the development of aesthetic sensitivity to the environment. But the greatest enthusiasm went to mobiles. The public loved Calder's works, and soon the question in school art was not whether you made mobiles but what you used to make them. Almost anything that hung could qualify, from wind chimes to Christmas tree ornaments.

31. Bess Foster Mather, "Camera Clubs for Junior and Senior High Schools," *School Arts* 52, no. 7 (March 1953): 219.

32. Stanley Witmeyer, "The Camera-Man Has a Muse," *School Arts* 50, no. 7 (March 1951): 229.

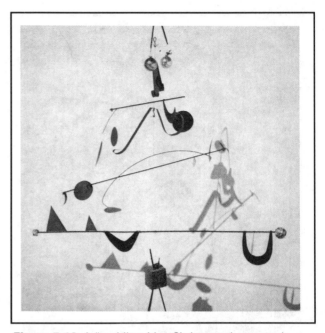

Figure 5-13. A "mobile with a Christmas theme made from umbrella staves, tin can tops, steel baling strips, judicious use of cork," by a student of Lucia B. Comins. *School Arts* 56, no. 4 (December 1956): 21. Reprinted with permission of *School Arts*.

Figure 5-12. "Primitivism" in an absorbent florist's material, by Barbara Dressler, a student of Roy V. Schoenborn. *School Arts* 58, no. 8 (April 1959): 22. Reprinted with permission of *School Arts*.

Yet amid such excitement, one survey reported that sculpture was not taught beyond the junior high school in a number of large cities, where the greatest variety of equipment and media would usually be found (i.e., sculpture was not offered as a high school elective—almost as though it were too much fun to be taken seriously).

Design

In some respects, ideas about the teaching of design in the fifties differed from those that had been popular in the thirties. Through most of that earlier decade, abstract art was in low status, and although nonrepresentational paintings and drawings began to be introduced in schools, these often were called "designs." Generally, however, design was "applied art." Where the practicality of art in daily living was of paramount importance during the Depression, "design" still commonly implied a plan for making something or its decoration. But the mere drawing of exciting new products with modernistic styling could also be considered "designing." In those years, before Bauhaus was widely known in America, instruction in basic elements and principles of design was frequently opposed by teachers who felt that Dow's "art structure" was outmoded. Apart from theoretical considerations, correlated units determined much of the art curriculum.

In the fifties, public excitement about streamlining was replaced by an international concept of "good design" (see p. 106-107). In school art, however, projects in design for daily living lost interest: self-expres-

Figure 5-14. Experimental designs in plaster, by students of William Bealmer. *School Arts* 49, no. 1 (September 1949): 11. Reprinted with permission of *School Arts*.

sion was more important. Nevertheless, design could be seen as a kind of productive thinking with a distinct educational merit, as a natural working of the human mind in its drive for organization and order, endowed with aesthetic value.

This conception was supported by Bauhaus theory, which had become influential. The elements and principles of visual organization were considered fundamental, especially for junior high school students, either to prepare them for high school art or to redress the deficiencies in their elementary art education. The Bauhaus offered two approaches. The teacher could set a problem concerned with a particular visual element (e.g., line, shape, value) or organizational principle (e.g., balance, unity, contrast). The common alternative was to promote experiment with a chosen material to discover its special potentials of form and process. A veteran art educator could observe that this concentration on visual fundamentals was in fact a renewal of the teaching of Dow's "art structure," and with allowance for certain changes of aesthetic and method, such a claim of continuity might be upheld.

Space and texture were given new emphasis. In two-dimensional work, models were provided by nonobjectivist painters like Mondrian, the more advanced graphic designers, and the Bauhaus, where design and painting had not been separated. The term *three-dimensional design* came into use as a near-synonym for abstract sculpture, with examples from Pevsner, Gabo, Lippold, and Fuller, whose work with string across space was readily copied in classrooms. Some of the standard projects from professional schools could be adopted with equal ease for children:

Figure 5-15. An experimental design with toothpicks, by a student of Robert Kaupelis. School Arts 53, no. 1 (September 1953): 29. Reprinted with permission of *School Arts*.

folded paper could be used for studies of transformations of planar materials, and toothpicks, paper clips, and coat hangers, for experimental structures.

Other changes in the teaching of design principles were underway here. The principles of design might be approached through intuition and experiment in the production of nonobjective art, as noted above. Surface decorations were less fashionable. The old concern for design of something useful for the home was more often taken up by the crafts. But because creativity demanded an end product, the practical difficulties remained of teaching about design as planning and as aesthetic quality in products of industry.

Some of the prominent texts of the fifties were ambivalent. Erdt said almost nothing about design. It was perhaps symptomatic of the situation that Gaitskell wrote well of design in manufacture, but suggested few activities, and illustrated his principles by analyzing paintings by Cezanne. Barkan, whose

book was not directly concerned with curriculum, deplored the common separation of architecture and industrial design from the fine arts but went no further. De Francesco, however, was clear. He limited elementary design experiences to surface decoration and opposed direct teaching of elements and principles of design to young children. He printed an exemplary secondary curriculum, based on "areas of living," in which architectural studies were substantial and good design was to be promoted through crafts, graphics, and theater, whereas design of manufactured products was avoided. D'Amico, in his revised edition of 1954, repeated verbatim his 1942 chapter on design: its criticisms of common teaching methods remained valid, and his principles and recommendations had not yet affected classroom practice as though teachers still had children designing objects that would never be made and that would have required materials and processes beyond their experience.

Graphic design offered the best possibilities for fulfilling the principles of design education represented by D'Amico. Students could be motivated by making products that were put to use in meeting real needs emerging from life in the school and community—the usual placards, posters, correlation projects, displays, and yearbooks. Topics that would appeal to young idealists at every grade level, from safety and health to the Marshall Plan and the United Nations,

were easily suggested. Monograms and stationery stimulated personal interests. Modern products and style strengthened motivation: current media provided exciting examples, and the LP record jacket, new in the fifties, became a favorite project, even though the schoolroom prototype was not usable.

In graphics, students as designers could experiment with at least some media to learn of their potentialities. They could plan with the production process in mind and carry out quantity reproduction with block prints, stencils, or silk screen; more advanced students could plan for commercial printing.

Style did change. In the thirties, modernism had been expressed through new typefaces and dynamic layouts, along with hard-edged simplification and the infinite nuances of airbrush illustration—the graphic dimension of Art Deco. Graphic design in the fifties was less simply stylized but perhaps more flexibly inventive and expressive, and these differences were reflected in certain characteristic approaches to teaching. Designing became less a procedure of carefully completed planning and more a process of improvisational, experimental, organic composition. Abstract thinking, abstract imagery, and symbols began to replace realist illustration. A few particulars may illustrate this generaliaation.

Lettering was still taught at times by grids and formulas of proportion, and the models of medieval

Figure 5-16. The first two steps in a series of experiments leading to poster design, by students of Jane Gehring. Below left, the first problem, a study of space division using rectangles of cut paper. At right, six examples of the second experiment, "involving the addition of transparent design areas," which suggest the influence of the Bauhaus teachers Moholy-Nagy and Kepes. *School Arts* 51, no. 10 (June 1952): 344. Reprinted with permission of *School Arts*.

Figure 5-17. A poster, by a student of John A. Ghrist, Oil City, Pennsylvania. *School Arts* 56, no. 2 (October 1956): 11. Reprinted with permission of *School Arts*; 45 percent.

manuscript continued to inspire some students. But the newer teaching favored experiment with any tool and its natural mark—a Bauhaus approach—or the freehand composition of an expressive word. Rather than the labored completion of a word in the wrong proportion, teachers in the fifties encouraged freehand trials on separate paper shapes that could be moved readily or changed quickly, thus avoiding those irremediable errors that frustrated so many children. And with this method, lettering tended to become a more integral component of the composition.

The graphic project could emerge within a unit that began with problems in abstract composition—experiments with specified shapes, lines, grids, transparencies, tissue overlays, or texture. Collage offered the play of wit in texture and pattern. Where photography entered the preparation for commercial printing, as in the design of the yearbook, paper sculpture, puppets, clay figures, and other three-dimensional elements could be developed or adapted for section dividers and spot illustrations.

Film became a medium for graphic design. With the emulsion removed, children could experiment with painted imagery for animation. In a few schools, enterprising teachers improvised the stands, panels,

and lighting that enabled students to produce short animated films directly through the camera.

Such changes, derived from the professional art world, strengthened the validity of experience in design as general education, which engaged wit, ingenuity, and a wider range of art talent than the drawing ability that had hitherto identified the "class artist." The graphic design effort could be an individual response to a personal need or interest, a collaborative bulletin board experience of a "design team," or a series of window displays in a neighborhood store. In some secondary schools, an "art staff" had its own work space, with the prestige of selection to carry out important assignments. In the stronger secondary art programs, especially in the larger cities with specialized high schools, a four-year "commercial art" course became the main contribution of the art department to vocational education.

Design in the home and community, so important in art curricula in the 1930s, lost status after World War II. One survey in 1954 found that "aesthetic reorganization of the environment" was mentioned so seldom in the literature of art education after 1941 that this objective was deleted from the list of nine to be used in analysis of contemporary curricula.[33]

In the thirties, practicality had been important in school art, and the socioeconomic distress that nurtured local civic and cultural bonds had been reflected in community-oriented group art projects. In the culture of the fifties, individualism was dominant: personal expression was valued above group experience or utilitarian skills. As in clothing design, the media common in earlier lessons in home design could not provide a real experience in actual construction. Realism of another sort was a problem in big cities: the slick curriculum guide for junior high schools in New York City called for the beautification of their own bedrooms by children who had none or whose homes were slums or high-rise housing projects.

There were exceptions. De Francesco, in the secondary curriculum mentioned earlier, specified the design of homes, industrial buildings, and community centers and plans for the improvement of neighborhoods. In several cities large enough to employ a staff of planners who needed public understanding, the processes of urban design were introduced in schools by professionals working on real projects. Students could see the charts, drawings, and models and emulate such work in their own neighborhoods. Home planning and interior design electives were available in the more comprehensive secondary school pro-

33. Vincent Lanier, "The Status of Current Objectives in Art Education," in *Art and Human Values*, NAEA Fourth Yearbook (Kutztown, Pa., 1953), 124.

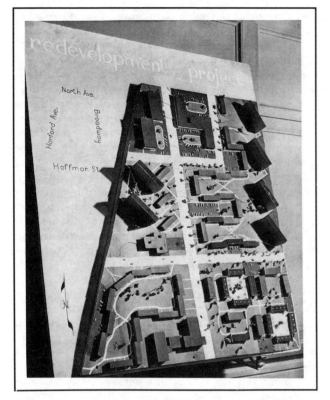

Figure 5-18. A model redevelopment plan, by a student under direction of George F. Horn in Baltimore. *School Arts* 56, no. 9 (May 1957): 16. Reprinted with permission of *School Arts.*

grams. In big cities, technical high schools developed preprofessional skills in floor plans, models, and renderings. The childhood versions of these, with squared paper, boxes, and colored papers, were continued in some elementary classes. Despite the lack of enthusiasm in several current texts, a handful of unpublished doctoral theses showed continuing interest in the role of school art in the community.

Theatre design continued as a means of correlating the arts with other studies. Though the enthusiasm for local pageantry diminished after the thirties, television and instructional film stimulated further interest in puppetry and masks so that these became required studies in some of the preparation programs for art teachers. In elementary schools, masks were especially useful in projects on "primitive peoples." Both masks and puppets promoted emotional expression, psychological projection, the sense of drama, and the current emphasis on imaginative experiment with unconventional materials. Music, dance, and creative writing were easily brought into play, and the culminating production brought the experience of merging personal interests with group purposes as a means of social education.

Clothing seemed vulnerable to the principle that design could be learned only in a medium that permitted experiment while enabling the student to develop an understanding of the forming processes. In elementary grades, it was no longer acceptable to color outline drawings in workbooks or to cut paper garments to fit flat dolls. Most of the texts of the fifties said little or nothing about clothing design beyond the mention of costumes for plays or studies of foreign lands; discussion of clothing worn in class was occasionally recommended. Beginning usually in the seventh or eighth grade, girls learned to sew and use patterns in home economics classes, and in some schools, the art teacher collaborated when those classes took up questions of good appearance. Boys presumably had no interest in clothes: their projects in industrial arts were, with corresponding presumption, denied to the girls. For high school students, the Scholastic Art Awards program included fashion design as a separate category that attracted comparatively few entries, most of them stereotypic, pallid illustrations with fabric swatches attached. Generally in the art curriculum, clothing was scarcely recognized as a workable medium of expression, imagination, or invention or as a means of access to the principles of design.

Industrial design in school art programs continued to decline, for reasons already evident in the thirties. Yet there remained a belief that the appreciation of design of manufactured products was important as aesthetic education and the idea that designing, as a practical, universal, human activity, should have a place in schooling.

Children still made surface decorations, though ornament was anathema to the contemporary design aesthetic. Teachers reported successes in such projects as the modeling of futuristic cars in folded paper or the construction of nonfunctioning lamps using coat hangers—the lingering of teacher interest invested in the kind of efforts that D'Amico deplored.

In a few new secondary schools, the facilities of the "fine" and "practical" arts were so thoughtfully related that art students could plan and produce furniture, handbags, and other projects using equipment and instruction in home economics and industrial arts shops. Beyond the specialized technical high schools in big cities, an exemplary program at the Abraham Lincoln Junior-Senior High School in Philadelphia attracted more than half of the four thousand students to the joint Department of Fine and Industrial Arts: nine broad areas of art, graphic arts, textiles, ceramics, metal, wood, electricity and electronics, mechanical drawing, and transportation were available as well as a general shop course.

The relationship between industrial and fine arts programs was discussed through the fifties, with

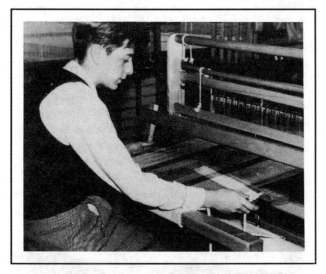

Figure 5-19. At the Abraham Lincoln Junior-Senior High School in Philadelphia, fine and industrial arts were unified. *School Arts* 55, no. 5 (January 1956): 20. Reprinted with permission of *School Arts.*

opponents and frustrated advocates on both sides. Certain leading art educators, in words reminiscent of the pre–World War I years, called the division of the two domains entirely artificial. The values of collaboration were cited. The crafts, however, were a disputed territory because they could be taught either as art or as industrial process. Moreover, industrial arts educators had their own internal disagreement about their basic mission—whether industrial arts was vocational or general education—while the Smith-Hughes funding had its specifically legislated vocational purpose.

Still, the art educational leadership continued to invite contemporary designers to address their conventions. A few preparation programs for art teachers included something of industrial design. At Teachers College, Columbia University, where Edwin Ziegfeld, the one-time director of the Owatonna Project, headed the Department of Fine and Industrial Arts Education (with no industrial art), Arthur Young maintained the course in the appreciation of industrial design that he had initiated in the thirties. But the course offered no solution to art teachers' practical problems in developing "industrial" design activities in the schools.

Crafts

Because they enabled the student to carry an idea to completion of a product, crafts provided the nearest approach to industrial design in most art programs, just as professionals in crafts produced prototype designs for manufacturers. The originality and excellence of student work exhibited and published

showed that the crafts were media for art, capable of individual expression, requiring and rewarding intensive experience. The generalized idea of "handicrafts," as an undefined repertory of projects that might have no exemplars of quality, increasingly gave way to the media recognized in professional work. Supported by widespread public involvement as amateurs and consumers, the crafts became a major domain of school art in the fifties.

The preparation of art teachers for work in the crafts was often inadequate: for many it was necessary to learn quickly in order to keep ahead of students and embarrassing to be unable to explain what had gone wrong. Their capability gradually improved, as instructional film producers moved into the field, numerous authoritative books were published, and crafts courses became a major attraction in part-time and summer graduate programs.

Ceramics was the one crafts medium considered an absolute essential in the school art curriculum, partly due to the increased recognition of the therapeutic values in art. Lowenfeld's publications, in particular, showed the possibilities of work in clay for the visually impaired, and his explanation of the "haptic" individual emphasized the importance of plastic experiences. School equipment and materials improved: electric kilns became increasingly common, wheels less expensive, bisque-fired colors easier to use. In older elementary schools, a "clay room" could be set up in the basement, and the janitorial staff might become responsible for the kiln and for the preparation of dry clay. Along with the interest in clay for the projection of personality, some of the more enterprising teachers developed murals of ceramic mosaic as a collaborative social learning that ensured a measure of success for everyone.

Textile and other fiber artists, exploring traditions around the globe, stimulated a wider variety of forms and techniques in art classes. Batik, introduced by Arthur Dow decades earlier, began a slow revival. Tie-and-dye became a fad at the level of fun with practical potential; schools lacked the time (and children, the discipline) needed for the intricate designs achieved in Africa and India, but even third graders could work in four colors. Macramé, for hangings or more functional decor, was equally popular in shops as well as in schools. Block-printing projects became freer and more ambitious. Stenciled hangings and placemats served the purposes of correlation.

Weaving gained popularity, partly through varieties of loom, partly through the freedom encouraged in experiment with nontraditional materials. Manufacturers offered cheaper looms, large and small: student used lap looms, card looms, Navaho looms, and bead looms as well as individual table looms and two-harness floor models. Teachers, fol-

Figure 5-20. Stitchery on burlap, by a student of Nancy Belfer. *School Arts* 56, no. 2 (October 1956): 13. Reprinted with permission of *School Arts*.

Figure 5-21. Enameled jewelry by students of Henry Petterson. *School Arts* 55, no. 5 (January 1956): 11. Reprinted with permission of *School Arts*.

lowing professionals, reported the use of such materials as wood shavings, unravelled burlap, window blinds, melon seeds strung, plastics, and cloth strips from unlimited sources for weaving.

Stitchery was lifted to new levels by such artists as Mariska Karasz. Students could combine experiment with tradition in either creative compositions or useful products—handbags, caps, belts, scarves, table runners, blouses. Rugs became popular in school art. The rugs of George Wells and others excited interior designers, and high-speed hooking tools enabled students to complete their own designs in dimensions fully practical for their homes. Teachers could use different approaches to rug design. They could encourage students to work "intuitively," as Abstract Expressionist painters with no advance plan, by starting directly in the material with any color. Alternatively, the design could be developed as the final problem in a multiphased unit, with the rug as the culminating activity.

Jewelry and enameling became the third main area of crafts in schools, with metalwork usually restricted to small forms. Jewelry could be taught as design in the current styles, combining Bauhaus and late Art Deco influences. But the contemporary popularity of crafted, as distinguished from manufactured, jewelry depended partly on unconventional forms, materials, and techniques. These were qualities that put jewelry within the interests and capabilities of students and that fitted with current art educational values. History offered many examples of pins, bracelets, rings, combs, and other ornaments made with such inexpensive materials as copper, wire, bone, wood,

stone, shells, clay, glass, and even human hair—to which students in the fifties could add plastic.

Enameling became practical, even for third-graders, and almost too easy, as manufacturers supplied inexpensive kilns and precut metal forms. Indeed, the medium was so readily satisfying to students that it might be avoided by teachers who were not yet prepared to lead the first successes into more advanced and artful projects.

The improvements in these three families of crafts media were, of course, gradual and representative of only the stronger art programs. Nor were these the only media in use. Leather and beadwork were favored in certain regions. Wood, though mostly a property of industrial arts classes, was common in the lingering elements of elementary manual arts. Indeed, with all sorts of materials promoted as experimentally valid throughout the art program, it was the tradition of useful forms, now elevated to the level of art, that provided identity and educational purpose for the crafts.

Appreciation

Through most of the fifties, the rationale for appreciation activities followed the changes developed in the thirties. The term *appreciation* itself fell into disrepute, associated as it was with the faults of picture study and its imposition of a moralistic taste, its burden of biographical and historical data, and its nonaesthetic anecdotal interpretations. The principles

of the thirties were restated: learning through creative work to feel, think, and act like an artist; developing awareness of all the world's art in all its forms and, indeed, of the aesthetic values everywhere in daily living; making personally important choices and judgments; and learning that democratic citizenship included responsibility for improving the aesthetic quality of the environment.

For elementary schools, even with the expansion of instructional materials and museum services, many of the recommended activities in art appreciation had been common since the beginning of the century. Children were to learn to work together through committees for beautifying the school and its grounds, for displays, flower arrangements, beauty corners, selections of reproductions, and all manner of special events. Appreciation of book art could be promoted through illustration of correlated subject material. Any creative work would have its inherent appreciative value.

But fine arts were not wholly ignored. There were new efforts to stimulate children's imagination and self-direction; there were the innovations of television; and some teachers were pleased to find that children enjoyed twentieth-century artists who still seemed outrageous to many adults.

In secondary schools, the ninth-grade general art course often was designed primarily around appreciation, with a comprehensive scope emphasizing modern art and design in all its forms, using experiences in media as dependent components of more extensive units. This was the kind of course that had been recommended in 1929: in the late forties, two student texts were produced specifically for such courses: they remained popular through the fifties.[34] Neither book was chronologically organized or historical in content; both were organized by the forms of art and beauty common in daily life, with no emphasis on the fine arts; both were concerned mainly with twentieth-century examples. The authors introduced art as an essential of good living, emphasizing the understanding of art as a normal attribute of the healthy democratic personality. In New York City, such a course was required in the ninth grade and art history was given in an advanced elective, with a text written for that purpose.[35]

Late in the fifties, the rationale for appreciation was strengthened by a few leaders who suggested that art was not the only field of creativity and that the domain to be claimed for art education with greater validity was the aesthetic. Furthermore, it was argued, an art education intended for everybody should not be dependent on a special gift or talent. To express the conviction that art should be recognized as an essential in general education, an incisive term was introduced: *aesthetic literacy*.

Yet, at the same time, D'Amico asserted that activities specifically devoted to the appreciation of art had nearly disappeared from the curriculum. In some way, he concluded, teaching for appreciation must have been too difficult; a need for research to overcome that problem was called for.[36]

Related Arts

Activities that brought together two or more of the arts, for any of several purposes, attracted increasing interest after World War II, and began to advance a coherent rationale.

In convention themes and programs, in reports of educational commissions, and in the publications of professional organizations, the arts became recognized as a distinct and essential domain in general education, reflecting universal forms of human expression. A limited conception located the fundamental unity of the arts in their function of communication. The formalist analogies proposed in the thirties, which found the elements and principles of design comparable among all the arts, grew more popular in the fifties. A joining of both approaches could be supported by the works of Suzanne Langer and others in philosophy and psychology and by the analytical components of Bauhaus teaching. The collaborations of professionals in the arts appeared as validation of theories and served as models for schools. Proponents of related arts in schools argued that if a general secondary-level course in visual arts were to be required, music, drama, and dance would have equal claims so that the only feasible required course would have to include all the arts.

Working from results more than theory, art teachers within their own classes most commonly related to music as a stimulus to expressive drawing. But mere listening was passive: movement of the brush or crayon with the music promised a more active self-expression. Poetry, stories, and plays intensified interest in art. Formalist discussion and interpretation could be interspersed with creative effort. In social studies units, the conception of related arts strengthened the claim for equal importance. At times, home economics and the industrial arts vied for position among the fine arts.

As early as 1947, the Philadelphia Museum of Art

34. Florence W. Nicholas, Mabel B. Trilling, and Margaret M. Lee, *Art for Young America* (Peoria, 1946); and Luise C. Kainz and Olive L. Riley, *Exploring Art* (New York, 1949). *Art for Young America* in its subsequent editions illustrates changes in thinking through the decade: the first bibliography depended heavily on materials published earlier than 1925, most of which were replaced by 1960 with works published after World War II.

35. Olive L. Riley, *Your Art Heritage* (New York, 1952).

36. D'Amico, "Coming Events Cast Shadows," 10–11.

gave several series of classes to hundreds of school children, each series featuring the several arts of one country or region. Ambitious festivals of the arts, programmed by the public school systems in such cities as Chicago and Dallas, furthered the sense that the arts were a distinct sector. Where collaboration was most active, curriculum planning, administrative thinking, and the politics of the budget together brought de facto recognition of arts departments as a conjoint operational unit in the school structure. In the mid-fifties, an interdepartmental team in the School of Education of New York University developed a year-long graduate course in related arts, and a special program in "creative arts" was offered to liberal arts graduates earning the master's degree in elementary or secondary education. In 1951, Missouri announced a new undergraduate degree with a major in art education and a minor in music education, designed as an economy in staffing rural schools. In 1953, an arts-centered K-12 school was proposed. By the end of the decade, momentum had gathered that soon would make the "related arts" a powerful contender for funding, research, and program development.

Research

In the late thirties, efforts to improve art education through the coordination of research met several obstacles. The few art educators who were adequately prepared methodologically had no community of engaged scholars, no body of ongoing research to define and stimulate lines of investigation, and no publication devoted to research in their own field. Progress in the development of these needed conditions in the fifties has been considered a mark of maturity of art education in the United States.

For the first few years, the unprecedented population of postwar doctoral students, whose mentors were the first generation of doctorates in art education, produced theses that typically were not experimental. Data on conditions, practices, or opinions were certainly needed: in a nation of autonomous school districts, art teachers were especially independent; federal surveys were lacking; and the national organization still was young. Thus, doctoral research more often took the form of descriptive studies or of curriculum design related to a particular location or topic. In every subject area, similar efforts were characteristic of what was called "action research": teachers already in practice were encouraged to apply at least moderately disciplined research techniques to the analysis of the conditions, methods, and results of their own work.

In mid-decade, considerable excitement, much of it distrustful, was stirred in graduate programs as experimental methodology began to be introduced, especially at the Pennsylvania State University under

the leadership of Viktor Lowenfeld. Critics contended that the methods of scientific research were inappropriate to the study of the creative process. Findings, they said, would be irrelevant: art was subjective, an open-ended process; controlled conditions could never simulate the unpredictable variables to which creative art responded; and the research was too often done by academics and students with little teaching experience. Such criticism continued, even as graduates adept in the new methodology moved into college teaching positions across the country to prepare the next generation.

In 1959, the NAEA Ninth Yearbook, *Research in Art Education*, organized its reports and commentaries "under five headings: philosophical-psychological research, research into creative behavior, research into teaching process, surveys and descriptive research, and research into problems of teaching handicapped and exceptional children."[37]

Pervading these loose categories, interest in creativity was paramount. In 1955, a committee of the National Art Education Association reported that no brief definition of creativity was possible. But Lowenfeld and his students, concerned with art, and the psychologist Guilford, whose scope was unrestricted, were already in the midst of several years of independent effort to define the personality traits associated with creativity.[38] Guilford, in studies for the U.S. Navy, had identified several general factors or aspects of creative ability related to the sciences; Brittain at Penn State drew from the literature of creativity a similar set related to art.[39] Beittel and Lowenfeld, after correlating the two results, concluded that "creativeness whether applied in the arts or in the sciences has common attributes."[40] Further correlational investigations were in progress, with cooperation by faculty and students at the Ohio State University.

Other studies led De Francesco to stipulate five levels of creativity: expression, proficiency, invention, innovation, and emergent.[41] Though creativity was

37. *Research in Art Education*, NAEA Ninth Yearbook (Kutztown, Pa., 1959).

38. Viktor Lowenfeld, "The Adolescence of Art Education," *Art Education* 10, no. 7 (October, 1957): 5–12. In this early description of ongoing research, Lowenfeld reported considerable agreement with several of Guilford's list of traits.

39. Brittain's set of attributes associated with creativity included sensitivity to problems; fluency; flexibility; redefinition; analysis; synthesis; consistency of organization; and originality. This set is nearly identical to Guilford's revised set, as compared in Viktor Lowenfeld and Kenneth Beittel, "Interdisciplinary Criteria of Creativity in the Arts and Sciences: A Progress Report," *Research in Art Education*, NAEA Ninth Yearbook (Kutztown, Pa., 1959), 38.

40. Lowenfeld and Beittel, "Interdisciplinary Criteria," 39.

41. Italo De Francesco, "A New Dimension for Art Education," *Art Education* 12, no. 6 (June 1959): 12.

still his primary goal, he found studio experience alone inadequate to "raise aesthetic literacy." The development of criteria for judgment of aesthetic quality emerged as the next most difficult research task, whether related to creativity, aesthetic growth, teaching method, or evaluation.

As the complexity of the research tasks facing the profession became more apparent, the coherent program of investigations at Penn State seemed exemplary. Each university, it was proposed, should concentrate its research efforts on one selected problem area, and some kind of clearing house of information was needed.

For several reasons, these ideas were not realized, although increased stimulation and support for research came from varied sources. Syracuse University sponsored two conferences on "creative arts education." Professional organizations established committees on research. The Eastern Arts Association issued an entire bulletin on research in 1951. Research reports became a regular feature of the Western Arts Association quarterly. With the fifth and ninth yearbooks of the National Art Education Association devoted to research, the association launched *Studies in Art Education* in 1959 to provide regular publication of scholarly studies. The profession was now prepared for the unprecedented levels of funding for educational research that were to become available in the coming decade.

SUMMARY

After World War II, American education labored under a new set of global forces: the United Nations, the end of colonialism, the Korean War, the threat of atomic destruction. Social conditions at home challenged school administrators: the shifting population, the baby boom and the resulting shortage of buildings and teachers, and the pressures of anticommunism and loyalty oaths. In 1954, the Supreme Court began the long process of school desegregation. Television seemed both a menace and a possible salvation.

Industrial production soared. The community spirit of the prewar Depression receded. These were important years for the social sciences and psychology: the troubled individualism of the fifties was reflected in works of art and intellect—*The Lonely Crowd, The Age of Anxiety, The Empty Canvas.* A healthy personality became a major social and educational goal. Teachers studied personalist psychologies, together with group dynamics, to nurture personalities while managing the overfull classroom. At the same time, schools were criticized for excessive liberality, failure to teach the basics, and failure to keep up with the advances of science and technology. New emphasis on subject matter was probably the most important educational change in the late fifties, as

eminent scientists and mathematicians joined in projects to revise curricula.

Creativity, self-expression, and mental health—values that gained unusual importance among the public and in schools in the fifties—were already established as major goals in art education (and in progressive educational circles). In the idea of "general education"—a core of learning for all students at all levels—the essential role of art was widely acknowledged. Thus, Lowenfeld's explanation of the seven kinds of growth to be nurtured in the right kind of art experience made him the most influential and characteristic art educator of the fifties, even as some protested what they considered undue emphasis on the psychological and therapeutic values of art. The concern for "art in daily living," so prominent in the community-oriented thirties, diminished.

The style of school art changed in the fifties, following the success of Abstract Expressionist painters, abstract sculptors, and Bauhaus theories—a clear instance of unanimity among society, education, art, and art education. Fitting the style and the dominant educational aims, art teachers promoted individual experiment with media and form. The ascendancy of crafts in the fifties provides a similar instance.

In two domains, the professional status of art education was strengthened. The first of these was organizational: The International Society for Education through Art became the first durable and effective worldwide agency in the field; at home, four regional groups combined to form the National Art Education Association. The second was the development of graduate education, research, and publications that in turn improved undergraduate art teacher preparation and ongoing professional development as well.

FURTHER READINGS

Alschuler, Rose H., and La Berta Weiss Hattwick. *Painting and Personality: A Study of Young Children.* 2 vols. Chicago, 1947.

Barkan, Manuel. *A Foundation for Art Education.* New York, 1955.

Cane, Florence. *The Artist in Each of Us.* New York, 1951.

Erdt, Margaret Hamilton. *Teaching Art in the Elementary School.* New York, 1954.

Gaitskell, Charles D. *Children and Their Art.* New York, 1958.

Gaitskell, Charles D., and Margaret R. Gaitskell. *Art Education during Adolescence.* Toronto, 1954.

Kellogg, Rhoda. *What Children Scribble and Why.* San Francisco, 1959.

Kepes, Gyorgy. *The New Landscape in Art and Science.* Chicago, 1956.

Logan, Frederick M. *Growth of Art in American Schools.* New York, 1955.

Lowenfeld, Viktor. *Creative and Mental Growth.* 2d ed. New York, 1952.

Moholy-Nagy, L. *Vision in Motion.* Chicago, 1956.

Munro, Thomas. *Art Education: Its Philosophy and Psychology.* Indianapolis, 1956.

National Art Education Association. *NAEA Yearbooks 1–9.* 1949–59. The fifth and ninth yearbooks are devoted to research.

Read, Herbert. *Education through Art.* 2d ed. New York, 1945.

Schultz, Harold A., and J. Harlan Shores. *Art in the Elementary School.* Urbana, 1948.

Ziegfeld, Edwin, ed. *Education and Art: A Symposium.* UNESCO, 1953.

1960-1969

At the end of the fifties, according to one survey,[1] Americans were the most confident people on earth: the nation's domestic problems, it seemed, would be resolved if the external threat of communism and nuclear war could be contained. Instead, the sixties brought widespread protest, rebellion, and rioting. Among leaders in art education, however, this social upheaval was less an influence than were the deeper cultural changes and related movements in education and the arts. Unprecedented federal funding assisted a variety of far-reaching proposals for change in purpose, content, and method.

SOCIAL AND CULTURAL CONDITIONS

Social Factors

The narrow victory of John F. Kennedy over Richard Nixon in the presidential election of 1960 has been viewed as confirmation of a moderate consensus. After a disastrous foray to dislodge Castro from Cuban dictatorship, Kennedy recovered public approval through his stand against the Soviet attempt to establish Cuban missile bases and through a subsequent ban on nuclear testing. Plans were prepared for civil rights legislation, a tax cut, and a "war on poverty." Thousands of young idealists joined the new Peace Corps.

The Kennedys were young, glamorous, and cosmopolitan; intellectuals and artists had seldom been so welcome at the White House. Especially because optimism in the Kennedy years was easy for younger Americans, the psychological impact of the president's assassination in 1963 was devastating.

Lyndon Johnson moved quickly to sustain the momentum of the Kennedy administration through his Great Society program—the tax cut, the Civil Rights Act of 1964, the Economic Opportunity Act, Medicare, a voting rights bill, legislation for elementary and secondary education, and the creation of national endowments for the arts and humanities. But by 1968, further progress toward the Great Society had fallen under the escalating cost of war in Vietnam.

Especially to the African-American population, the government seemed more concerned with communism halfway across the globe than with democracy at home. Until the mid-sixties, the African-American leaders of the campaign for equality were experienced, widely respected, and disposed toward carefully planned litigation or political action. From the Montgomery bus boycott in 1955 through the sit-ins, the freedom rides, the 1961 voter registration drive, the march in Washington in 1963, and the Selma marches in 1965, nonviolence was the rule. White liberals worked and marched beside African-Americans in the civil rights movement: in the summer of 1965, some eight hundred white college students worked to register voters in Mississippi, even after three workers were murdered. Federal action enforced desegregation at the University of Alabama. Robert Kennedy, the U.S. attorney general, intervened to protect African-American children against state troopers in Birmingham in 1963, and the marchers at Selma needed the protection of the National Guard.

In the weeks following Birmingham, there were hundreds of riots. Thirty-four African-Americans were killed in the Watts riots in the summer of 1965. The destruction of downtown Detroit in July 1967 left forty-three dead: the first casualty was a white looter, shot by a white store owner. Riots in scores of cities followed the assassination of Dr. Martin Luther King in 1968. The National Advisory Commission on Civil Disorders identified the causes of these civil disturbances as "pervasive discrimination and segregation"; "black migration and white exodus"; "black ghettos"; "frustrated hopes"; the "legitimation of violence," including media content; "powerlessness" and the sense of exploitation. All these factors converge, said the commission, and "almost invariably the incident that incites disorder arises from police action"—the police representing "white power, white racism, and white repression."[2]

1. A study by Hadley Cantril is cited in Godfrey Hodgson, *America in Our Time* (New York, 1976), 69.

2. The commission's report is exerpted in Walt Anderson, ed., *The Age of Protest* (Pacific Palisades, Ca., 1969), 35–38.

The white cultural rebellion was less easily explained, partly because it had begun with the beatniks in the relatively calm fifties, partly because its composition and motivations were diverse. The "counter-culture" included not only belligerent campus rioters, dropouts, communes, cultists, and addicts but also a congeries of intellectuals, professionals, and a huge margin of part-time participants.

Campus uprisings were most easily examined. By 1968, the peak year of these disorders, there were four times as many college students as in the forties. The "multiversity" seemed bureaucratic, impersonal, exploitative, and an instrument of the military-industrial complex—an institutional facsimile of the whole society, as viewed by its critics.

The student protesters, in all their diversity, similarly represented the whole counter-culture. They were typically from upper middle-class families, academically talented, enrolled in an academically superior institution, and committed to traditional values found in the Bill of Rights. They were usually students in liberal education programs, seldom in vocational or professional preparation. Kenneth Keniston distinguished two "ideal types": first, the "political activist," who responded to perceived restrictions of rights on campus and was looking for a coalition, a leader, and an immediate local cause; second, the "withdrawn, culturally alienated" student, for whom dropping out of "the System" was the only evident option.[3]

Other observers blamed progressive education, permissiveness, the breakdown of families, affluence, and Vietnam, with draft registration as the sharpest provocation. Campus protest merged with antiwar demonstration. The American armed forces in Vietnam, despite becoming more powerfully and brutally aggressive, were no closer to victory. The whole counter-culture constituency, along with eminently respectable clergy, physicians, lawyers, and short-term activists, were increasingly drawn into the peace movement. In the spring of 1968, Lyndon Johnson decided not to run for reelection.

In August of 1968, the nation's television viewers saw Chicago police batter a huge gathering of demonstrators outside the Democratic National Convention. Nixon campaigned and won with a plea to "the silent majority," who wanted law and order and who presumably opposed the tactics of protest. But the mass of public opinion had already begun to doubt the war in Vietnam, and in the first year of Nixon's presidency, his strategists began to prepare for the long process of withdrawal.[4]

3. Kenneth Keniston, "The Sources of Student Dissent," in Anderson, ed., *The Age of Protest*, 227–45.

4. Hodgson's analysis of public opinion toward the war (*American in Our Time*, 384–98) indicates a complexity of attitudes rather than any common set of values and determinations.

Beside these major themes of protest, a more general spirit of activism and advocacy developed in the sixties. Rachel Carson's 1962 book, *Silent Spring*, helped to stimulate restriction of pesticides, action against smog, the National Environmental Policy Act of 1969, and the first Earth Day in 1970. The "consumer movement" began with Ralph Nader's suit against General Motors. Calls for "black consciousness" and "black power" aroused the pride of other groups, not only the obviously repressed Chicanos and native Americans but all the plurality of immigrant populations that were supposedly homogenized in the "melting pot."

While WASP (white Anglo-Saxon Protestant) power receded in the United States, the nation's economic dominance was reduced by the recovery of production in Europe and Japan. Science and technology spread into the "third world" as colonies became nations. The World Bank, the International Monetary Fund, and the United Nations pursued their missions. Peace Corps volunteers, foreign exchange students, television news, global air travel, and continued immigration gradually made Americans more worldly. Television took viewers out of their world with the most astonishing imagery ever seen—the astronauts of Apollo 11 walking on the moon.

Intellectual Currents

Space technology brought together the most diverse achievements of the human mind in the sixties. The intellectual influences of new materials, lasers, and satellite communications, for example, were inestimable. Merely the photographs of "spaceship Earth"—Buckminster Fuller's powerful term—profoundly strengthened the ecological consciousness developing through the decade. And all of this depended upon, was part of, an even more pervasive force—the "cybernetic revolution," the extension of intellect that ushered in the "age of information."

The layperson's conceptions of self, species, and environment were further affected, for example, by plastic hearts, organ transplants, the deciphering of the genetic code, studies of communication among whales and porpoises, deep-sea explorations, and the reduction of identity into numbers.

Philosophers responded both to science and social crises. Some thought their traditional work outmoded by the recent emphasis on linguistic analysis and scientific positivism. Others analyzed the logic and method of science; certain art educators studied such analyses as guides to better research. Automation, genetics, and medical science created problems of individual being. The atmosphere of rebellion raised questions about morals, freedom, social responsibility, and justice. The philosophies of existentialism and phenomenology were extended

from professional conference and publication to studies of their implications for art education.

Among the conceptions that stimulated most intellectual discussion were the *structuralism* of the anthropologist Claude Levi-Strauss and Noam Chomsky's *deep structure* of language as revealing basic human mental patterns. More widely popular were Marshall McLuhan's perceptions of communications media as determinants of culture. A favorite among art educators was Buckminster Fuller, whose geodesic dome exemplified his belief in the tetrahedron as the basic structural unit in nature. Fuller, who deservedly called himself a "comprehensivist," saw an intimate relationship between art and science in the "ability of the imagination to formulate conceptually"; thus, art education could contribute to science as "the conservator of intuition, imagination, and unique initiative."[5] The critic Susan Sontag discussed others whose works were basic to the "new sensibility": Nietzsche, Wittgenstein, Antonin Artaud, C. S. Sherrington, John Cage, André Breton, Roland Barthes, Siegfried Gidieon, Norman O. Brown, and Gyorgy Kepes.[6]

Culture and the Arts

The sensibility of the sixties, according to critics and artists whose writings were exceptionally stylish and intellectualized at the time, was distinctly nonliterary and nonrational. The immediate experience of all the senses was more validating, more extensive of life. In the boredom of Warhol's films, in the hypersensitivity of the "high," in the illogic of Happenings, in the Minimalist object, the perception of each bit was to be prized but not interpreted: meanings were not to be sought in either artworks or mundane objects (which were often the same).

The interrelatedness of the arts followed from emphasis on sensory experience. Works of art, like life, were to be perceived not as structured forms but as events, as objects being simply what they were. The musicologist Leonard B. Meyer called this an aesthetic of "radical empiricism" or "transcendental particularism."[7] He saw the "end of the Renaissance": no more of "man as measure," no moralizing, no expression of personality. Followers of Cage avoided the responsibility of compositional decision. Artworks were exhibited as anonymous. Artworks were presented as transient incidents, as indeed they sometimes were. Ultimately,

Conceptualism, a new departure in art, questioned whether creativity required actual production.

With these commonalities came contradictions. Science was opposed by some artists and embraced by others. Critics noted a reduction in the separation of high and low art, and many artists worked toward that end: Happenings and street theatre, for example, were democratic and informal both as compositions and as social events. To the contrary was the claim that only "difficult" art could be worthwhile: the appreciator of art should require as much preparation as the engineer. Somewhere between these two attitudes was the vogue called *camp*—an aesthetic of snobbism, said Sontag, which savored flawed attempts at style in an unpremeditated variety of commonplace products, out-dated clothing and decor, old films, and behavior: "good because it's awful."[8] In a culture that urged everyone to "do your own thing," as experiment and the flouting of convention became ends in themselves, the common characteristic of all the arts was their plurality of styles.

In fact, stylistic variety made the arts both more difficult and more democratic. Public interest increased, arts organizations proliferated, and arts sponsorship bought corporate prestige.

Government support of the arts, initiated in the thirties and abandoned with World War II, returned during the sixties. The Department of State continued international exchanges of works, performers, artists, and designers. President Kennedy appointed August Heckscher as Special Consultant in the Arts. The U.S. Office of Education established its Cultural Affairs Branch in 1962, providing important support for arts education. In 1965, after years of slowly mounting pressure, Congress created the National Foundation on the Arts and Humanities, with a federal council and two corresponding national endowments. The first state art council was legislated in New York in 1960; by 1967, each of the fifty states had created an agency to administer the new federal funding, and these in turn stimulated the growth of community arts organizations. All the arts were to benefit.

Literature was most influential in nonfictional approaches to current issues. Reporters, retired generals, think-tank specialists, and government officers wrote on third world problems, deterrent weaponry, and foreign policies: in 1965 alone, at least six books on Vietnam, with "quagmire," "torment," and "nightmare" in their titles were published. Notable writing related to "the negro revolt" included Alex Haley's *Autobiography of Malcolm X*, James Baldwin's *Fire Next Time*, and the words of Martin Luther King, Jr. Several books described the civil rights campaign in

5. Buckminster Fuller, "The Condition of the Arts in Contemporary Science and Education," in *Seminar on Elementary and Secondary School Education in the Visual Arts*, ed. Howard Conant (New York, 1965), 49, 31.

6. Susan Sontag, "One Culture and the New Sensibility," in *Against Interpretation* (New York, 1969), 298.

7. Leonard B. Meyer, *Music, the Arts, and Ideas: Patterns and Predictions in Twentieth-Century Culture* (Chicago, 1967), 83, 158.

8. Sontag, "Notes on 'Camp'," in *Against Interpretation* (New York, 1966), 275–292.

Mississipi in the summer of 1964. William Styron was awarded the Pulitzer Prize for *The Confessions of Nat Turner*, which was based on a statement by that nineteenth-century African-American leader made before his execution.

Social commentary and criticism included John Gardner's *Excellence*, James B. Conant's *Slums and Suburbs*, Hecksher's *Public Happiness*, Michael Harrington's account of poverty in *The Other America*, Seymour Melman's *Our Depleted Society*, and Paul Goodman's *People or Personnel* and *Growing Up Absurd*. Louis Mumford and Jane Jacobs contributed new studies to the standard literature on city problems. The importance of Rachel Carson's *Silent Spring* warrants a second mention. For women, possibly the most provocative book of the decade was Betty Friedan's *Feminine Mystique*. Tom Wolfe was acclaimed for his stylish accounts of popular culture in *The Kandy-Kolored Tangerine-flake Streamline Baby* and *The Electric Kool-Aid Acid Test*.

The situation was too turbulent, it was said, to nourish imaginative writing. But critical praise went to such varied authors as John Updike, John Cheever, John Barth, Joyce Carol Oates, Katherine Anne Porter, and Harvey Swados. Southern authors could still be discussed as a regional group. American Jewish culture became another category of fiction, in the novels of Philip Roth, Bernard Malamud, and Saul Bellow. Joseph Heller's satire of army life in *Catch-22* was popularly extended to the whole contemporary experience. William Burroughs established addiction as a substantial subject in *The Naked Lunch*. The culture of the Beats was represented by Kerouac's *The Big Sur* and in the translation of Henry Miller's *Tropic of Cancer* and *Tropic of Capricorn*, which were celebrated as triumphs of sexual liberation.

Most of the important poetry of the decade continued from the styles and groups of the fifties—the Beats, or San Francisco Renaissance; the New York Poets, collaborating with other artists; and the anguished "confessionals," some of whom ended in suicide. The joining of the self to nature—a "universal sensibility," a sensibility fitting environmentalism and the new sense of "spaceship Earth"—attracted more young poets.

Other ideas were particularly representative of the sixties. Jack Spicer wished to make poems of real objects, real "like a newspaper in a collage is a real newspaper."[9] Poets spoke of intuition as a method. Words were linked with no obvious meaning. The poem was a mosaic, a collage, a field of shifting perceptions and connotations. Beyond intuition was "conceptual" poetry: following John Cage, serial music, and formalistic analysis, one might merely indicate a scheme for the collation of any of the variables possible in a poem printed or spoken—variables such as typeface, parts of speech, punctuation, rhyme, rhythm, or meter. Not always, but generally, the narrative, the episode, and discursive syntax were gone from avant-garde poetics.

Theatre in the sixties, like many other aspects of the culture, saw postwar conventions under attack by an unrestrained variety of new ideas. In resident companies across the country, artistic directors brought in to vitalize the local stage clashed with business-minded administrators who shared the conservative expectations of the average audience. Although finances kept Broadway, and even off-Broadway, close to the patterns of box-office success, the new ideas of theatre were put together on the cheap under a new tag: "off-off-Broadway."

Performances were held in basements, lofts, churches, cafes, parks, on sidewalks and streets. "Happenings," a serious fad of the early sixties, used incongruous environments—"found spaces"—for irrational events.

Such locations fitted the theories of Cage and his associates: aesthetic sensibility should be everywhere. Theatre was to be merged with life and thus should be like life—unpredictable, chancy, spontaneous. Accordingly, the playwright and the literary script were downgraded; the drama grew through group improvisation and the imagination of the director. Verbal content diminished, displaced by sensation—visual effects, action, any other sounds, and even touch—for the play was to be experienced, not merely watched, and actors were intermingled with audience. In this scene, realism as illusion and the introspective "method" acting of the fifties already were passé. Shock and confrontation became prime values: here the theorists looked back to Artaud[10] and the Surrealists.

A second major element of the off-off-Broadway style was the "absurdist" pessimism developed after World War II in the works of Beckett, Ionescu, Genet, and others: settings surreal, symbolic, comedic, or commonplace; characters hopeless or inexplicably optimistic, with a not quite demented logic. These plays were frequent fare off Broadway; they were advanced offerings in regional and college companies in the sixties; and by mid-decade, they were part of the new equipment of young playwrights.[11]

Two other elements of experimental theatre in the sixties are relevant to art education. First, it grew in

9. Spicer is quoted in Donald Allen, ed., *The New American Poetry* (New York, 1960), 411.

10. Antonin Artaud called for a theatre of spectacle and cruelty in *Le Theatre et Son Double* (1938), published in translation by the Grove Press, 1958.

11. Martin Esslin, *The Theatre of the Absurd*, rev. ed. (New York, 1969), is the usual reference for its subject.

awareness of the whole world's diversity of concept, form, and method. Second, though it was often accused of being "theatre for theatre's sake," the self-styled "guerilla theatre," raiding whatever population it found on the streets and sidewalks, was thoroughly activist and propagandistic. Both had implications for art education.

Meanwhile, on Broadway, the leading playwrights of the fifties faded with fewer successes. With certain exceptions, like Miller's *Price*, Broadway was not strong on issues. In the two most important new writers, Pinter and Albee, there was something of the surreal and absurdist: a bit strange, disquieting, and obscure of meaning. For untroubled entertainment, Neil Simon was the star of the decade, averaging a hit a year. Of musicals, *Fiddler on the Roof* was the best beloved. In the late sixties, though, it was said that every musical had to be against something, and the "first rock musical," *Hair*, spread its success on the road as a hi-tech off-off-Broadway spectacle of youth rebellion.

At the end of the decade, the boundary between performance art and theatre was blurred; anyone could make theatre anywhere; and all the arts worked together—demonstrations very relevant to art educators.

For **music**, the sixties was a period of watershed change and development in styles and audiences, equipment and techniques, patronage and marketing. There were more ways to make music, more recordings, festivals, symphony orchestras, rock groups, and international exchanges. In New York, the new Philharmonic Hall and the Metropolitan Opera House at Lincoln Center verified the prestige of high art, and the Ford Foundation commissioned four American operas (none very successful). Eminent musicians foresaw the end of their tradition, while at the same time preclassical music aroused new enthusiasm: classes in the recorder and guitar became popular and the sales of baroque recordings multiplied. As cultural exchanges intensified interest in international folk music, universities initiated courses in ethnomusicology. In short, the popular limits were expanding.

The middle class mainstream music of film and Broadway was relatively stable: *Hello Dolly* and *The Sound of Music* were best-sellers. Country and western music, now fully commercialized, still mixed simplicity with popular sentiment. For the adolescent and college market, rock 'n' roll, or more broadly, rhythm and blues, offered psychedelic energy and themes of sex, drugs, and rebellion. Rock groups and folksingers like Joan Baez and Bob Dylan became voices of the counter-culture. Combining these styles and appeals with imagination, wit, and charm, the Beatles arrived in 1964—the most authentic representatives of youth in the sixties.

Jazz had already become a specialized taste in the bop era; in the sixties, the "free-form" improvisations of Ornette Coleman, John Coltrane, and others replaced the cool sophistication of bop with unrestrained emotion. Their rejection of the traditional structures of harmony, rhythm, and melodic phrasing led to the claim that, with this new freedom, jazz had finally caught up with other twentieth-century art forms.

In the domain of what some still called "classical" music, a perplexing array of choices faced young university-based composers. The preceding generation had come to maturity during the evolution away from traditional harmony, rhythm, and form. "Twelve-tone," or "serial," techniques were used at will. Composers spoke of "textures" rather than chords, and "notes" were now "pitch classes": a whole new vocabulary of formal analysis was taught.

For followers of the aesthetic led by John Cage, any sounds could be music and all the arts could be combined. A new experience was essential, with chance as the best guarantor of the unexpected. The result was an unprecedented period of experiment—unconventional sound sources; tape recording, often combined with atypical uses of instruments in odd combinations; extravagant stage directions; minimal determination of frameworks for improvisation; and the necessity of unique notational systems.

Electronics had created a vast new realm of possibility. A theoretically unlimited range of sounds could be created by synthesizer, and these could be processed for additional effects. Tapes could be edited and recombined. The appropriate language was numerical. The exploration of this new universe was akin to science; already in 1958, the composer-mathematician Milton Babbitt had asked, "Who Cares If You Listen?"[12]

Especially with the synthesizer composers saw the possibility of total serialization—a predetermination of all the dimensions of sound. This would be music for reproduction, not for performance. A crucial question arose: with no performer, no interpretation, no freedom for the composer within predetermined formulation, could there be the sudden inspiration, the suggestive accident, the expression of feeling that had heretofore been integral to creative art?

Composers, of course, went their several ways, but asking in common that audiences really listen to sounds. Young people attended concerts of the new music, if only as adventure. The sounds of the synthesizer, especially, were entrancing.

For **dance**, this was an expansive decade. By 1967, some eighty professional and semiprofessional ballet companies were reported. The Ford Foundation

12. Milton Babbitt, "Who Cares If You Listen," *High Fidelity* 7, no. 2 (February 1958): 38–40, 126–27.

gave more than 7.5 million dollars to eight companies to raise their level of performance. The Department of State sent American ballet and modern dance around the world, and tours of traditional groups from other cultures suggested new possibilities for American choreographers. Federal funding from the new National Council on the Arts rescued the American Ballet Theatre and supported modern dance groups as well.

Ballet was glamourized by the defection of the Russian star Nureyev and his partnering with England's Margot Fonteyn. The honor of position in Lincoln Center went to Balanchine's New York City Ballet. But there were other major companies in New York and elsewhere; the young companies of Robert Joffrey and Alvin Ailey were particularly vital. Ann Halprin, Lew Christensen, and Erick Hawkins were influential in the West. Gerald Arpino, Eliot Feld, and other young choreographers continued to bring elements of modern and popular dance into ballet.

Modern dance, by now a common study in college and a major division at the Juilliard School, had its brief tradition: Ruth St. Denis and Ted Shawn still danced in the sixties, and preeminent figures like Martha Graham, Jose Limon, Anna Sokolow, and Merce Cunningham led a second and third generation of modern dancers. Companies were small, and though they danced in the style set by their leaders, they could more freely experiment and collaborate. Groups led by Paul Taylor, Meridith Monk, Lucinda Childs, Yvonne Rainer, and Twyla Tharp were especially close to ideas that stimulated the avant-garde in the sixties. Not technique, not subject matter, but point of view, said Sokolow: its sources were life itself:

> My works never have real endings; they just stop and fade out, because I don't believe there is any final solution to the problems of today. All I can do is provoke the audience into an awareness of them.[13]

At the Judson Dance Theater (in a midtown New York church) Robert Dunn and his wife brought together ideas from Cage and Merce Cunningham, Pop Art, Happenings, and avant-garde music and poetry. Several visual artists joined the group. Anyone could dance. The awareness was of the reality of the commonplace: mundane activities, household objects, banal dialogue, the television tuned by chance, simple movements repeated to force attention, and unpredictability. A script, if any were used, left decisions to the dancer. Any object, any position, any move could be interesting as it existed; its significance was its own.

Communications media contributed to the merger of art with life, the confusion of knowledge and image, and thus to the import of tangible, homely experience. The technology of communication had never so suddenly wrought such change.

In 1965, satellite television was established, and Community Antenna Television began—not quite, but almost, the "pay-TV" envisioned and debated since the forties. By 1969 television programming was broadcast in color; the Apollo 11 moon landing was transmitted worldwide; and Canadians complained about the "trash" programmed in the United States.

Book sales were not reduced, but Americans spent much more for comic books than for public libraries or for all the books in elementary and secondary schools. Reportedly during the decade, 163 magazines and at least 160 newspapers died, unable to match the immediacy and verisimilitude of television. But the "underground" press flourished for every counter-cultural reader: the investigative reporting of some journals, like *Ramparts*, the Berkeley *Barb*, and the Los Angeles *Free Press*, scooped the syndicated services and achieved wide impact while weakening the credibility of mainstream media.

In film, the term "underground" was something of an honorific. Low-budget "independent" filmmaking (apart from Hollywood and commercial work) had become an international interest in the fifties, with photographic verity assembled as any mix of documentary, fantasy, or poetics. Ford Foundation funding and a festival of such films at the Musem of Modern Art in 1965, confirmed the status of film as art. Films might be "underground" in their social compassion, in the sexual imagery of *Flaming Creatures*, in the beatness of *Pull My Daisy*, or in the value-negative boredom of Warhol's films. But few Americans saw such films compared with the range and size of audiences for Hollywood successes like the antiwar satire *Dr. Strangelove* or the futurist fantasy *2001—A Space Odyssey*. In whatever genre, however, film had become a representative medium of the new sensibility—visual more than literary, seen from multiple perspectives, a mosaic of bit perceptions, presentational more than discursive (in Langer's terms), flexible and relativistic in time and space.

The prophet of media awareness was Marshall McLuhan, hailed because he said in such lively terms what the advent of computer and television had widely demonstrated: "the medium is the message." The new media of communication were transforming human perception, thought, and behavior just as Gutenberg's movable type had done. Critics could trace these changes back at least to the late nineteenth century and show the cumulative interactions since then among, say, pyschology, semantics, linguistics, mathematics, the sciences, and the arts. The results of this process were dramatically evident in the sixties.

13. Quoted in Selma Cohen, *The Modern Dance: Seven Statements of Belief* (Middletown, Conn., 1966), 36.

THE VISUAL ARTS

In the upheaval and protest of the thirties, art had been created and understood as a contribution to a social cause. In the sixties, art was disengaged. According to Barbara Rose, a young critic and historian who was very much a part of the New York art scene, "disappointed political idealism, without hope for outlet in action," had been "displaced to the field of aesthetics."[14] It is the variety and interconnection of "ideologies" that creates difficulty in the description of art in the sixties: as the sculptor-writer (and sometime experimental choreographer) Robert Morris said at the end of the decade, "the current art swamp is awash with trickling mainstreams."[15]

The work that most completely repudiated Abstract Expressionism in the early sixties became tagged as Post-painterly Abstraction and Hard Edge. Post-painterly Abstract painters, it was claimed, replaced existential self-projection with impersonality, emotion with intellect, and vital gesture with technical finish. Already in 1957 Ad Reinhardt had forbidden all traditional styles and devices: no texture, brushwork, forms, design, colors, space, movement, or subject; no easel or palette, no action or expression. Through the early sixties, he showed "black" paintings—squares transected by bands so nearly indiscernible that some viewers denied their presence. Frank Stella in the late fifties showed series of monochromatic paintings in black, copper, and aluminum.

These were paintings presented as real objects, but that status remained problematic. The problems were perceptual or metaphysical: even if the frame were abandoned, with its imposition of an illusory space, the canvas, or ground, remained as a material carrying paint, a rectangular plane against a wall. Stella painted monochromatic concentric squares or squared spirals, enhanced their physical status with extra-deep stretchers, and replaced the rectangle with dynamic angular shapes. Frames were constructed to push the canvas into the third dimension. Some painters replaced paint with plastic globs. Sam Gilliam and Richard Tuttle rejected both stretcher and paint: their unsupported dyed cloths were hung from the wall or placed on the floor.

Acrylic paints contributed to new interests in color. Kenneth Noland, Ellsworth Kelley, and others used flat, clashing hues at maximum intensity to attain the object quality. Morris Louis stained flowing stripes into the canvas from the back surface. Others kept their stripes hard-edged: "wallpaper," some critics scoffed. Olitski and other Color-field painters dyed and

sprayed expanses of luminous nuance. Richard Anuszkiewicz studied "the effects of complementary colors of full intensity when juxtaposed and the optical changes that occur as a result."[16] Op Art became a popular style even without color: the black-white configurations of Vasarely and Riley caused optical vibration that had the effect of energy emanating from the painted object.

Very different from the new abstraction was Pop Art. The term was initiated in England in the mid-1950s and became an accepted style in the United States around 1962. A symposium at the Museum of Modern Art showed that its definition was less obvious than its derivation from commercial graphics—simple representation with clean-edged shapes in flat, cheerful, often strident color. Its subject matter implied acceptance (with a possible touch of camp humor) of the taste and values of popular culture—the imagery of celebrities, cosmetics, signs, advertising, packaging, mass production, and ordinary household objects. Some felt that Pop was satirical. Certain artists said that it was noncommittal, that its ready-made imagery was a means of impersonality as a reaction to expressionism. Lichtenstein said that it was a way of looking programmed, so literal that it couldn't be approached as art. Warhol commented that "the people who really like art don't like the art now, while the people who don't know about art like what we are doing."[17]

Toward the end of the decade, critics spoke of *post-pop* or *second-generation pop*. In 1969, some of this work was included in a significant exhibition, titled "Aspects of a New Realism." One element of Pop—the noncommittal use of banal subject matter—was seen as a way to continue representation without traditional canons of taste and value. Certain paintings recalled earlier compromises with abstraction, Precisionists like Charles Sheeler and Ralston Crawford, or the light of Edward Hopper. Several of the artists worked with various peculiarities of photographic reproduction and with ambiguities of perception and imagery. Commenting on the exhibition, Sidney Tillim called for moral commitment as requisite for a substantial revival of representation. William S. Wilson saw that the old faith in appearance had been influenced by the operational conceptions of reality and the systematic processing of information employed in contemporary science.[18] The very concept of visual representation was no longer simple.

14. Barbara Rose, "Problems of Criticism, IV," in Amy Baker Sandback, ed., *Looking Critically: 21 Years of Artforum Magazine* (Ann Arbor, 1984), 78.

15. Robert Morris, "Some Notes on the Phenomenology of Making: The Search for the Motivated," *Artforum* 8 (April 1970): 65.

16. Statement for the MOMA catalog *Americans 1963*, ed. Dorothy C. Miller (New York, 1963), 6.

17. From a discussion broadcast in 1964, the transcript was edited and reproduced in Sandback, ed., *Looking Critically: 21 Years of Artforum Magazine*, 30–32.

18. Sidney Tillim, "Figurative Art 1969: Aspects and Prospects," and William S. Wilson, "Operational Images," in *Directions 2: Aspects of a New Realism* (Milwaukee, 1969).

Sculpture in the early sixties was dominated by the characteristic postwar work in welded steel. But the newer work in steel was more cooly abstract—studies in form, structure, and thrust that avoided emotionality and grew sometimes so huge that heavy industrial methods were required. Gabriel Kohn and others continued to develop abstract sculptural forms in laminated wood, a material that suggested both technology and primitivism, lending itself to massive simplicity. Plastics offered new possibilities: polyesters, fiberglass, and acrylics produced factory finish in planar or biomorphic forms—a specifically contemporary, impersonal look.

A decisive shift was marked in 1961 by a Museum of Modern Art exhibition, "Art of Assemblage." Many of these works showed no interest in the established concepts of sculptural form; some showed elements of Pop sensibility. Nevelson's use of miscellaneous wooden objects, Seley's welded automobile bumpers, Chamberlain's auto parts, and Brecht's wall cabinets filled with odds and ends featured materials that were never intended for art. Among the new works in sculpture, the most purely Pop were Oldenburg's monumental trivia—the clothespin, the spoon, and so on—and his "soft" fabrications of such products as the typewriter. All of these had their own aesthetic qualities, but a new criterion was evident in which a work of art was to be "interesting" and presumably novel rather than traditionally beautiful or profoundly significant. Moreover, the qualities of the material itself and the sense of the process of forming were to be the focus of aesthetic attention.

Further questions of sculptural definition and aesthetic were provoked by Ed Kienholz's interior settings, which were composed of actual objects, and George Segal's white plaster casts of ordinary people with commonplace props. Marisol made figural groupings of wood slabs and plaster, adding sensitively penciled features—a combination of Assemblage and Pop. Red Grooms extended such tableaux into cheerful satire, deliberately vulgar and tasteless, using flat, disproportionate standing cutouts and garish slap-dash tempera. All such work, together with the legacy of Happenings and artists' engagement in dance, brought the concept of "theatricality" into discussions of sculpture—or better, of three-dimensional art, since many of the younger artists denied that their work was sculpture.[19]

Movement became a common interest, whether machine driven, electronically programmed, or, like George Rickey's large metal blades, precisely balanced to respond to the slightest currents of air. In other

works, sensors triggered changes in the piece in response to movements of the viewer. Electrical circuitry controlled light as a medium of movement. Gyorgy Kepes's students at the Massachusetts Institute of Technology suggested new relationships of art and science. Rauschenberg and the engineer Billy Kluver organized artists and engineers into months of collaboration, culminating in a series of performances titled *9 Evenings* and a foundation called *Experiments in Art and Technology*.

In 1965, exhibitions and critical writings confirmed the arrival of a new style, finally known as Minimalism, but variously called *ABC art*, *primary structures*, *post-geometric structures*, *object sculpture*, *specific objects*, *literalist*, or *cool, art*, *art of the real*, or *third stream*. That there were so many tags within this grouping follows from the variety of artistic problems that separated its leaders: Donald Judd, Carl Andre, Sol Le Witt, Larry Bell, and Robert Smithson. Whatever their differing concerns, the works were typically rectangular, symmetric, and usually devoid of interest in color, texture, or dynamic movement. Minimalist art was of maximum purity, with no suggestion of external reference or implication. The work was commonly modular, a repetition of one form, a series of isomorphic forms changing in dimension according to some arithmetic progression, or a structure of blocks exhibiting such serialization. Works were fixed to the wall or placed on the floor: Carl Andre, in particular, favored modular units with little vertical measure, like bricks or square metal plates. Such works were ridiculed as sterile, pretentious, hyperaesthetic, or a new kind of emperor's clothes. Alternatively, they were admired for their logic, their purity and rigor, their final rejection of the past, or for the sensitivity of their aesthetic decisions—indeed, for their beauty.

These, like Reinhardt's black paintings, were objects of contemplation. In a sense, Dan Flavin's arrangements of fluorescent tubes were forerunners of the absolute, shaped light being a perceptual object without mass. And through the decade, the gallery space itself—now ideally white, windowless, and unfurnished—had become an integral element in the aesthetic situation of object, viewer, and space. There was to be no illusion, no psuedoreality. It was important that the object, like the viewer, stood on the floor: no base or plinth was permitted to establish the traditional distinctive status of sculpture. Each showing was unique to that space.

The term *installation*, however, was mainly reserved for a different genre that encouraged maximum freedom of materials, conformation, and significance or denial thereof. The installation, like a static moment from a Happening, was to be a phenomenon, a new experience, strange and arresting. The installa-

19. The first Happening is said to have occurred in 1953 at Black Mountain College, where Cage and Rauschenberg collaborated as students. In the sixties, Allan Kaprow and later Claes Oldenberg were considered the leaders of Happenings as a new art form.

tion gave the artist the greatest opportunity to exercise a major interest of the decade: the forces and the instrinsic qualities of materials that could be made apparent. Moreover, notwithstanding the interest in its parts, the whole configuration, including the space, was to be manifest as a good gestalt: the early idea of the "good form" as a coherent shape extended to an entire situation.

Even more reduced than Minimalism was Conceptual Art: the form sufficient only to body forth the idea. At the extreme, the production was in fact immaterial: art was the idea alone, the essential creative achievement. The most trivial whim, the most absurd proposition, once scripted like an element of a Happening, could be offered for appreciation. Yet, when realized, some of these concepts—from drawings on the gallery wall, to mirrors placed along the shores of the Yucatan, to earthworks—were provocative enough, poetic enough, or enigmatically monumental to stimulate far-ranging commentary.

Environmental Art formed primal objects in and of the landscape. The architect-sculptor Tony Smith recalled that, in the early fifties, the unfinished New Jersey Turnpike had shown him how tiny was sculpture and how vast it might be. By the end of the sixties, money could be found to finance Smithson's huge spiral in a barren landscape and Heizer's monumental carvings from the slopes of a mesa—works on the scale of the pyramids and pre-Columbian ruins. In pursuit of the idea, the artist had become a fundraiser, a publicist, and a commander of technological artisans and engineers.

Printmaking became a basic part of the creative (and economic) activity of the major European and American artists of the sixties, whatever their primary media, whatever the style. Several conditions came together.

Facilities for experiment and production were funded. Through ten years at Tamarind, some one hundred artists received two-month grants to work in color lithography. During this period, Kenneth Tyler founded the Gemini GEL workshop in Los Angeles. Universal Limited Art Editions helped New York painters to produce books and portfolios of their work and added etching to lithography after the mid-sixties. Silk-screen techniques were already available in industry.

These media fitted current styles. Abstract Expressionists could use crayon and tusche with full spontaneity by working directly on the stone. Both lithography and silk screen could give the flat color and crisp edge of Post-painterly Abstraction. The simplified imagery associated with commercial silk screen was naturally suited to Pop Art, especially with such new materials as metallic papers, fluorescent inks, and plastics. Airbrush, stencils, and photomechanical techniques were borrowed from industrial practice and used in either medium.

As a result, through enterprising workshops and publishers, the public could buy works that were large, richly colorful, decorative, stylish, and immediately accessible from a limited original edition by a leading contemporary artist at low cost. Prints thus contributed rapidly to the general acceptance of new styles.

Architecture, despite its inherent constraints, shared with the other arts several tendencies of the sixties: diversity reflecting the diversity of the culture; formalism combined with inventive technology of materials and structure; increased attention to sensory enrichment; strong contrasts of form and scale; and both reassertion and rejection of tradition. These changes began to show, as in the other arts, in several influential works conceived in the late fifties (though completed in the sixties).

Paul Rudolph's "late-Brutalist" Art and Architecture Building at Yale was praised for its powerful contrasts of vertical and horizontal; for the textural play of concrete poured in fluted forms and finally hammered; and for the complex planning of functional forms, even though student activities were poorly accommodated. Critics saw in it traces of Wright's old Larkin Building and of De Stijl works by Rietveld and Doesburg. The Richards Medical Research Buildings, a cluster planned primarily for user needs, made Louis Kahn probably the most honored architect of the period. Saarinen's airport terminals, soaring forms achieved through reinforced concrete and tensioned cable roof, were completed in 1962. The modernized neoclassical beautification of Lincoln Center (colonnaded facades by Abramowitz, Harrison, and Johnson enclosing a plaza) became the model for performing arts centers.

For ordinary office buildings, the glass box continued, but increasingly windows appeared recessed behind a concrete grid of preformed elements. Modularity appeared not only in prefabrication of components and in complete units for residential complexes (like Moshe Safdie's *Habitat* at the Montreal World's Fair) but also as a principle of planned expansion for entire towns. Air-supported enclosures came into use for sports centers. Buckminster Fuller proposed a plastic dome to cover much of New York City. For students in architecture, structures held up only by tension were required projects.

Between the architecture and the sculpture of the sixties, interesting affinities appeared. Tony Smith practiced in both fields: the presence, scale, and thrust of a form in space were mutually essential. A huge black Picasso in a Chicago plaza would call attention to the sculptural impact of the X'd girders reinforcing the adjoining Hancock Tower. The vogue for such external structure extended to the exposed, painted ductwork within: certain buildings could be

sensed as Assemblage. Minimalist sculptural works, in their rectangular purity and modular repetition, could be taken as models of architectural sensibility. Many types of buildings were sculpturesque: Marcel Breuer's massively cantilevered Whitney Museum, Kevin Roche's slanting towers of concrete and glass, the upthrust arcs and cylinders of Bertram Goldberg's Hilliard Housing in Chicago, and any number of homes in unfinished wood or white neo-Cubist concrete. By the end of the decade writers referred to New Geometrics and Post-Modernism.

Such buildings, considered as a class of architecture concerned only with the building as an independent entity, became the subject of fundamental criticism in Robert Venturi's important book, *Complexity and Contradiction in Architecture* (1966). To replace that "exclusive" attitude, Venturi called for a more difficult "inclusive" approach to design that would engage not only the surrounding context of form and style in neighboring buildings but also the complexity of people's activities and values, indeed, of the whole contemporary culture. (As one expression of that culture, Charles Moore added "supergraphics" to the architectural repertoire. For full awareness of popular styling, architectural students at Yale made study trips to Las Vegas.) Given this broader context, architecture would verge on city planning.

The humanization of urban centers had already begun. Zoning codes permitted higher construction in exchange for setbacks that provided plazas, plantings, seats, and walkways. A destroyed building could be replaced by a "vest-pocket" park. A few small-scale housing developments provided homelike units. A row of backyards became a common greenery. The offices in Kevin Roche's Ford Foundation Building looked into an enclosed courtyard of trees, shrubs, and a pedestrian walk. The atrium returned. The Hyatt Regency Hotel in Atlanta rose around a spacious glass-roofed core where guests wandered among palms, fountains, lagoons, hanging gardens, and multistoried crafted wall hangings—the conference center as paradise.

The economics of downtown real estate development, however, did little for the urban poor. They were displaced by costly new construction and by highways and parking lots for middle-class commuters. Old inner-city housing continued to deteriorate, while high-rise low-income projects of the fifties, often cheaply built and socially misconceived, became a new kind of slum. Meanwhile, small-city downtowns were abandoned for fringe-highway shopping strips and suburban malls.

Industrial design was increasingly internationalized, both in practice and style. Prestigious design firms with global clientele brought together a wide range of specialists in materials, processes, and products, in packaging, display, and exhibition design. The computer began to enter the technology of design, aiming toward visualization of forms and a more rigorous study of human factors (*anthropometrics, ergonomics*). A single product might be international in its components.

The prewar modernist look and rationale, no longer avant-garde or elite, was reasserted and adopted everywhere by image-conscious businesspeople and professionals. Typewriters, for example, might vary around the world mainly in the sharpness of their corners. Still, there were identities. Scandinavians were respected for a certain clarity and restraint in furniture, textiles, ceramics, and tableware; Germans for their technical excellence and logic of machines and appliances; Italians for imaginative daring in clothes and furnishings, for Fiat's smart car styling and Olivetti's office equipment (in 1966, theirs was the first desktop computer).

Later in the decade, a more trendy, chic mode appeared in furnishings and clothing, combining elements of Op and Pop, Art Nouveau, Surrealism, space-age imagery, and futuristic cartoons. Plastics were no longer used for imitation but for their own validity in color, texture, and function and often for their ability to match the inventive forms of contemporary sculpture. At about the same time, the sensibility of camp appeared in products of a more personal nature, deliberately a bit kitschy and retrograde.

Throughout the postwar world, industrial design had been viewed as a vital element in reconstruction and development. Design became an instrument of foreign policy. Whether for commerce or as demonstrations of the "American way of life," various federal agencies funded travelling exhibits of American design from 1954 through the sixties, with Moscow as a particularly designated site. The International Council of Societies of Industrial Design (ICSID) was founded in 1957. UNESCO sponsored ICSID seminars in 1964, 1965, and 1967, with interest in reconciling socialist and democratic philosophies of design.

Such recognition helped some designers to see their field as a conscience for manufacture and society. Whereas market strategy called for novelty, low cost, and superficial styling, the idealism of early modernists was inherent wherever design thinking went deeper.[20] In the Industrial Designers Society of America, there was dispute about design education, phrased as "teaching design as art or as a market discipline" or as "teaching for what is or what ought to be." Discontent among designers resembled Venturi's criticism in architecture. Public dissatisfaction was evident: in 1962, President Kennedy asked for

20. Arthur J. Pulos, *The American Design Adventure* (Cambridge, Mass., 1988), 184.

"national measures to be established by which the quality of the man-made environment could be monitored in the public interest."[21] Ralph Nader's "Raiders" had considerable public support in their investigations of dangerous products, and through the decade, rejection of "the consumer society" was a major item of cultural rebellion.

Graphic design after the war had rather generally followed the principles of "good design." The "modernistic" typefaces designed around 1930 were already out of fashion: rigidly geometric faces like Futura and Spartan were replaced by the softened and sensitively systematized Univers and Helvetica. Photographic type composition gave the designer great flexibility and largely outmoded hand lettering. The possibilities of color in print were enhanced by improvements in color film, processing, and color separation and by use of offset-lithography instead of letterpress.

In the sixties, corporate modernism was served by Bauhaus principles of contrast and asymmetric equilibrium, commonly subjected to the logic of grids. In advertising art, a mid-decade reaction was led by Milton Glaser and Seymour Chwast's Pushpin Studios, featuring informality and wit, with sketchy, cartoonlike illustration. The culture of rock and hallucinogens contributed to the "psychedelic" style, especially in posters. Television became a specialized domain, descended from film titling and animation: the flowing transformation of imagery transcended all earlier considerations of graphic taste and style. In the next few years, the whole new realm of design by computer became apparent.

Crafts continued the postwar upsurge, and—if the term is permissible—reached a certain maturity in the sixties. Contemporaries saw several supportive conditions: federal funding channeled to the crafts through new state arts commissions; the return of ornament in architecture and the requirement of allocations for art in new federal buildings; the need for symbol and warmth in churches; nostalgia for the reality of objects and handwork; and a new eagerness for sensory experience. Moreover, the freedom of experiment and collaboration in all the arts of the 1960s openly invited the participation of the crafts.

The movement was international. Fifty countries were represented at the First World Congress of Craftsmen in 1964. From this meeting came the World Crafts Council, a nongovernmental member of UNESCO. Lausanne inaugurated its International Tapestry biennials in 1962. Munich held International Handicraft fairs. The Milan Triennale was the leading international exposition of architecture and industrial design: in 1964, the United States won the top award

for its first exhibition in the crafts category.

As the role of craftsmen in industry broadened, the status of craftsmen as artists grew stonger. "In the future," they were told by Marshall McLuhan, "the role of the craftsman will be more important than ever before."[22] Craftsmen now were more than artisans; most were graduates of colleges or professional schools. The ceramist Voulkos exhibited metal sculpture. Richard Artschwiger, a furniture maker, worked with Oldenburg and transformed his own furniture into sculpture. Painters entered crafts: Lichtenstein showed Pop Art ceramics at the Castelli gallery; Motherwell and Frankenthaler designed tapestries. The Museum of Modern Art exhibited jewelry by painters and sculptors. Louise Bourgeois turned from weaving to sculpture; the painter Lenore Tawney helped to redefine weaving and also exhibited constructions and boxes. There were designer-craftsmen, production craftsmen, production designers, artist-craftsmen, and artist-designer-craftsmen.

Artist-craftsmen moved from the utilitarian toward the sculptural. The old idea of changing society through the ethic of crafts had weakened; the new goals were self-discovery, an individual statement, a strong image. What happened in art was done in crafts. Abstract Expressionist deformation was led by Voulkos in ceramics and by Tawney in weaving, a rejection of traditional beauty in a search for power. Op Art in ceramics came in zebra stripes, decal transfers, and bright enamels; Nik Krevitsky's wall hanging, *Op #2*, achieved moiré effects through layers of plastic mesh. Pop Art could be any household object made in clay, a textile guitar as "soft sculpture" after Oldenburg, or the jewelry of J. Fred Woell, which floated bottle caps and political badges in plastic. Minimalist and Hard-Edge styles were rendered in ceramics. The Museum of Contemporary Crafts exhibited *Fantasy Furniture*, with function subordinate to wit and imagination. The camp look could be had in ceramic mugs, ornamented with the photo-silk-screened images of Jean Harlow, Queen Victoria, or Johnny Weismuller as Tarzan. *Funky* works—a ceramic elephant foot as an ottoman, for example, upholstered in fake leopard fur—appeared late in the decade. For many of the new generation in crafts, art was fun. In their schooling, there was no deliberate pedagogy, there were no predetermined forms. The great influence, said one older ceramist, was television: "a most persuasive and sophisticated source of images and inventive use of bright colors. . . . The whole piece is an image."[23]

21. Quoted in Arthur J. Pulos, *American Design Ethic: A History of Industrial Design to 1940* (Cambridge, Mass., 1983), 423.

22. Quoted in Dido Smith, "A Report on the World of Marshall McLuhan, the Artist and the Electronic Environment," *Craft Horizons* 26, no. 6 (November–December 1966): 42.

23. Erik Gronborg, "The New Generation of Ceramic Artists," *Craft Horizons* 29, no. 1 (January–February 1969): 51.

Two media require particular notice. Glassblowing, never defunct in industry, became an art form in the sixties, principally through the work of Harvey Littleton and Dominick Labino. Littleton was a potter, the son of an executive of the Corning Glass Works, whose interest in glassblowing was stimulated during a trip to Italy. Labino was a vice president and director of research in the Glass Fibers Division of Johns Manville. They collaborated in a seminal workshop at the Toledo Museum of Art in 1962. By 1966, a national invitational exhibition was presented by San Jose State College. As with other media through the decade, glassblowing was already turning from traditional forms toward sculpture.

The fiber arts were perhaps the most expansive crafts media of the sixties. Knitting, crocheting, stitchery, appliqué, macramé, loom and off-loom weaving, and especially tapestry were revitalized in a great variety of materials and forms. Plastics were readily incorporated. Wall hangings had the power of grand scale; Hella Skowronski was commissioned to cover an area twenty-four by sixty feet and used one hundred thousand feet of metal chain and forty-five thousand industrial fasteners. Armatures brought three-dimensionality; hangings became independent of walls, and fiber constructions took their place on the floor with other sculpture.

A summary of the decade was provided in 1969 by the exhibition "Objects U.S.A.," a collection commissioned by the Johnson Wax Company of Wisconsin. The one common stylistic element, said a reviewer, was "the quality of distortion, of deliberate distortion, the vogueish element that most of these artist-craftsmen depend upon to give their pieces pizazz." None the less, this was an exhibit full of movement, "ideas, social commentary . . . the most popular yet at the National Collection of Fine Arts, Smithsonian Institution."[24]

Museums continued the postwar momentum. By the early sixties, the nation had more than six hundred museums of art. Among the notable new buildings and additions throughout the country were those in Syracuse, Fort Worth, Oakland, Utica, Santa Barbara, Baltimore, Los Angeles, Philadelphia, Buffalo, San Francisco, Houston, New York, and Lincoln, Nebraska. Specialized new museums signified broadened public interest: Asia House, the Jewish Museum, the Museum of Negro History and Art, the Washington Gallery of Modern Art, and museums for textile art, graphic art, primitive art, and early American folk art. The Toledo Museum added a wing

specifically for crafts studios. The famed Barnes Collection, private since 1924, finally opened to the public. The Cooper Union Collection in New York became the Cooper-Hewitt Museum, the Smithsonian Institution's museum of design. In Washington, two branches of the Smithsonian, the National Collection of Fine Arts and the National Portrait Gallery, moved into the old Patent Office Building. Still another Smithsonian unit, the Joseph Hirschhorn Museum, announced its opening in 1971.

Collaboration between museums, philanthropies, and government agencies here and abroad became more common and complex and more diverse in attention to world heritage. A show of Picasso came from Paris and London, and several Russian museums contributed to a Guggenheim exhibition on Kandinsky. There were major exhibits of Japanese and ancient Indian art; imperial Chinese treasures were sent from Taiwan; and "7,000 Years of Iranian Art" appeared in seven American museums. Most ambitious was the exhibition of contents of the tomb of the Egyptian King Tutankhamen. Funded by the United Arab Republic, the "King Tut" show appeared at sixteen museums between 1961 and 1964 and was closely related to the international effort to preserve Egyptian antiquities from inundation by the new Aswan dam. Museums also helped to stimulate public interest in the rescue of masterpieces flooded in Florence. Along with such large-scale successes, a new level of public appreciation, together with improved curatorial capabilities, enabled even small regional museums to mount important exhibitions of lesser-known movements and individual artists.

Attendance multiplied. In Boston and New York, annual admissions equaled nearly one-third of the metropolitan population. Attendance at the Metropolitan Museum of Art was a bit over three million in 1959; it rose to nearly six million during the 1964–65 season. In Brooklyn, museum attendance increased by 27 percent from 1959 to 1960. When the Metropolitan showed its new acquisition, Rembrandt's *Aristotle Contemplating the Bust of Homer*, 86,770 persons surged into the museum in four hours.[25]

The increased popularity of the art museum, according to one analysis, was due to several conditions: increased money and leisure, with "a public cultivated to a new consciousness of styles, periods and modes . . . the coming of age of a generation that became attached to museums when young because of the museums' intensive programs of child education."

24. Robert Hilton Simmons, "The Johnson Collection of Contemporary Crafts," *Craft Horizons* 29, no. 6 (November–December 1969): 66.

25. These attendance figures, however, are questionable. A former director of the National Gallery wrote that the Metropolitan Museum had falsified attendance reports for years, and so had his own institution, until he "foolishly" stopped the practice. See John Walker, *Self-Portrait with Donors* (Boston, 1969), 305.

The media, using full-color spreads, gave more space to museum features, and exhibition techniques became more attractive.[26]

Popularity revived longstanding disputes over the purpose of art museums. Respected conservatives cautioned that the place of scholarship was threatened, that the curatorial function was shifting to emphasis on exhibition, that standards of quality would be lowered with art too readily promoted as entertainment and as a faddish veneer of culture. Others welcomed the appeal to a more diverse population. For them, the educational mission was properly dominant. In the current of enthusiasm for togetherness in the arts, it also was easy to see the museum as the cultural center of the community.

In Toledo, where music was offered as early as 1914 and annual attendance exceeded the city population, many of the visitors came for regularly scheduled concerts and classes in music. Around the country, new museum spaces were built specifically to accommodate the performing arts, with closed-circuit television throughout. Television showed museums as interesting and accessible. At the Philadelphia Museum of Art, CBS cameras followed the popular singer Barbra Streisand through older galleries in a series of full-color programs; promotion for the program put Streisand's picture on the covers of *Vogue* and *Look*. In Boston, where the Museum of Fine Arts had its own television staff, nearly one thousand programs had been produced by 1967. Among additional attendance builders were improved docent programs, audiotaped gallery guides, book-length scholarly catalogues, local museum magazines, museum shops, and chartered art tours.

But now museums had more visitors than they could afford. In addition to extra management and security, other expenses for new exhibition techniques, conservation laboratories, computerized archives, and education were incurred. Acquisitions were more costly. Admission fees were initiated, with anxiety that the socioeconomic status of attendance would be affected.

Basic museum funding from endowments, gifts, and municipal support met only about three-quarters of the costs. Income from membership programs scarcely exceeded the cost of enticements. Private and corporate foundations began to contribute substantially to major exhibitions, lectures, research, and, in some cities, to general operations. The Ford Foundation funded curatorial internships and an artist-in-residence program. Some corporations gave museum memberships to employees; others distributed hundreds of thousands of booklets on artists and exhibits. Congress reclassified museums as educational institutions, thus reducing their taxes.

Federal support grew. In 1964, the Office of Education upgraded its Cultural Affairs Branch into the Arts and Humanities Branch, with an enlarged budget under the direction of Kathryn Bloom: her charge included special concern for museum education. The Elementary and Secondary Education Act of 1965 funded programs for research and other activities relating to museum education. By 1967, with the new federal endowments and state arts councils in operation, 172 different programs were reportedly allocating funds to museums (of all kinds) through over four hundred separate appropriations.[27]

These new possibilities enlivened the already changing attitude among museum directors. The Boston Museum of Fine Arts presented a brief memorial exhibition tracing the career of President Kennedy, mainly through photographs; nearly one hundred fifty thousand attended in its four days. Thomas Hoving, as the new director of the Metropolitan in New York, saw in the arts the same revolt, the same "distrust of all vested interests" common to the hippie world. His controversial exhibition "Harlem on My Mind" was a multimedia documentary aimed to meet the need for shows "that will have a very significant and contemporary social impact." He hung the Pop artist Rosenquist next to David and Leutze. He hired ghetto kids to help adult guards quiet juvenile disorder.[28] Thomas Buechner at the Brooklyn Museum, to make all its collection accessible, opened the storage rooms to visitors.

"Outreach" became a watchword. Hoving appointed a committee to study ways of decentralization; Buechner opened Community Gallery in the Bedford-Stuyvesant area with a showing of the work of African-American artists. The Smithsonian Institution, with a neighborhood advisory committee, launched the Anacostia Neighborhood Museum in a former movie theater. The NET Film Service was at hand to record its opening. The Anacostia offered studio classes and summer programs for children and adults and an annual "Festival of the Arts" in addition to its exhibitions. The Newark Museum, where attendance had dropped drastically after the 1967 riots, built an exhibit of African art into a cultural festival, with photos, films, a fashion show, musicians, and dancers. In Dallas, the museum opened an auxilliary gallery at the airport. The Virginia Museum of Fine Arts developed a statewide network of affiliates and added three artmobiles to its fleet, each of the four with its own curator travelling a planned circuit twice

26. McCandlish Phillips, "Attention Soars: A New Outlook for Museums," *Museum News* 62, no. 7 (March 1962): 33–37, reprinted from the *New York Times*, November 27, 1961.

27. Eleria C. Van Meter, "The Developing Federal Government-Museum Relationship," *Museum News* 45, no. 9 (May 1967): 27.

28. Thomas Hoving, "Branch Out," *Museum News* 47, no. 1 (September 1968): 15–20.

in the school year. The North Carolina Museum of Art established a permanent gallery for the blind. The Detroit and Toledo museums helped the University of Michigan Hospital to set up a loan program for patients, with framed reproductions and brief comments on the artists. The Museum of Modern Art, in addition to its other educational efforts, operated an international travelling exhibition program.

In many cities, members of the Junior League served as docents for museum art education; Kathryn Bloom had worked with the league for some twenty-five years developing these collaborations. The Brooklyn Museum bussed children to the New York World's Fair for a full day of sketching and photography. In Portland, the museum worked with the schools in creating eighteen slide programs designed to improve the college preparatory curriculum. For schools without access to a museum, the National Gallery of Art produced a variety of films, exhibits, and slide programs with recorded lectures: these were sent on free loan to thousands of schools each year.

As these conventional instructional techniques were extended, other approaches were developing. Museum educators meeting to consider "McLuhanism" were told that the "the age of the lecture and of the teacher up in front passing out data" had ended: in the new learning environment, the student must be actively engaged in discovery and insight.[29] Meanwhile, a behavioral psychologist at the Milwaukee Public Museum tested devices for monitoring visitor performance on a variety of programmed-learning machines: the visitor thus was interacting with an exhibit for which learning objectives had been specified. This interactive response could be motivated by quick feedback, scoring lights, home award stickers, tickets to special events, or refunds of fees.[30]

Books on art, once produced for a limited readership, now were assured a highly profitable mass market. Every major exhibition and each current shift of style stimulated new demand and new possibilities for scholarship and criticism. Such occasions, however, were not responsible for some of the major art publishing undertakings of the time, most notably McGraw Hill's fifteen-volume *Encyclopedia of World Art*. Josef Albers's *Interactions of Color* was not a book but a package of some two hundred reproductions of color studies, accompanied by a text and commentaries on the relationships within specific studies. The five books published as the *Vision and Value Series* were significant of much of the intellectual influence upon art in the sixties. Gyorgy Kepes, as editor,

brought together the ideas of leaders in the visual arts and the physical and social sciences relating to contemporary conceptions of visual form, as evident in their titles: *Structure in Art and in Science*; *Module, Proportion, Symmetry, Rhythm*; *Sign, Image, Symbol*; *The Man-Made Object*; and *The Nature and Art of Motion*.

An important segment of the market was fueled by the introductory courses in art history that fulfilled the humanities elective requirement in many college curricula. H. W. Janson's *History of Art* provided the authoritative chronological survey favored by most instructors: Helen Gardner's *Art through the Ages*, first published in the twenties, was updated and enlarged to offer a less rigorous alternative. The titles of other works that were either intended or adaptable as texts are more indicative of the thinking that influenced artists and art educators in the sixties: *Art and Illusion: A Study in the Psychology of Perception*, by E. H. Gombrich; *The Language of Art*, by Nelson Goodman; Albert Elsen's *Purposes of Art*; and Edmund Burke Feldman's *Art as Image and Idea*.

CONDITIONS IN EDUCATION

In an assessment of social changes, a National Education Association study commission in 1963 noted that science and technology, especially automation and computers, were raising production, using fewer workers, and thereby changing occupational expectations. Industry, government, and communications were increasingly centralized, and what was large grew larger and more bureaucratic. The mass media homogenized culture, even as people assumed the right to more individual choices, more leisure, and more pleasure. These were only the most general of the difficult conditions described by the commission within which the schools would have to produce a more educated work force, a more responsible citizenry, and more sophisticated consumers of goods and communication.[31]

The school population was larger than ever. Seventy percent of Americans lived in cities; 20 percent lived in the metropolitan areas of New York, Chicago, Philadelphia, Los Angeles, and Detroit. In the urban core, the influx of Hispanics and southern African-Americans continued as whites moved to the suburbs. Poverty, discrimination, and cultural deprivation—familiar already to inner-city teachers—produced the most urgent school crisis of the sixties. Social scientists and educators together called for more social workers and smaller classes, for nursery schools, enrichment programs, work-study plans, and programs to identify and develop special talents

29. "McLuhanism and the Arts," *Museum News* 46, no. 7 (March 1968): 14.

30. C. G. Screven, "The Museum as a Responsive Learning Environment," *Museum News* 47, no. 10 (June 1969): 7–10.

31. Richard I. Miller, *Education in a Changing Society* (Washington, D.C., 1963).

among inner-city children.

It was to such needs that Congress addressed Title I of the Elementary and Secondary Education Act of 1965. The remaining four sections of the act provided funds for books and audiovisual materials for school libraries; for supplementary educational centers and services; for national regional research and training laboratories; and for strengthening state departments of education. The Economic Opportunity Act of 1964 provided for a job corps and work-study programs for youth, a work-training program, and a community action program that included adult basic education. The Coleman Report, ordered by the Civil Rights Act of 1964, confirmed that minority children started school with educational deficiencies that became even more serious by the end of school. These children lacked the one factor that consistently was related to student success: access to the culture of affluence.

Through the latter half of the decade, as unrest and rebellion intensified, public schools came under attack as agencies of the oppressive "establishment," and not a few influential educators shared in this assessment.

Curriculum Movements

Together with these challenging social conditions, educators had to cope not only with the increasing revision and expansion of knowledge but also with the continuing criticisms of failure to teach the "basics." The sixties saw a record output of books on curriculum theory, strategies of curriculum change, and flexible organization of school programs made possible by the computer. Early in the decade, most attention went to efforts to revise and strengthen subject matter and to revitalize research on classroom methodology. Among the books related to these efforts, probably none influenced art education as importantly as did Jerome Bruner's *Process of Education*.[32]

The Disciplines Approach

Bruner's book represents several of the main ideas in education in the early sixties. First was the belief that no curriculum revision could be valid without the participation of leading scholars and practitioners in the subject field, for these were the active, authoritative workers in the *discipline* represented by the school subject: indeed, the book resulted from one of many conferences of scientists, mathematicians, scholars, and educators collaborating on curriculum reform. Second was the conviction that the teaching of the subject should aim toward the understanding of the *structure* of the discipline, that is, understanding the concepts and principles by which the knowledge and work in the field were organized and guided. "To learn structure," wrote Bruner, "is to learn how things are related."[33] This conviction had a corollary that gave welcome support to art education: the student should learn by doing, by discovery, by appropriate emulation of the advanced practitioner, not by routine exercises. Art educators also were pleased by Bruner's emphasis on the importance of intuition in creative work in any field, a theme that he developed in another book, *On Knowing: Essays for the Left Hand*.[34]

Another of Bruner's concerns was the idea of *readiness* for learning. In regard to the development of cognitive capacity in the child, he depended primarily on the theories of Jean Piaget, whose work enjoyed a strong revival of interest in the sixties. Bruner added the belief, or "hypothesis," that "any subject can be taught effectively in some intellectually honest form to any child at any stage of development."[35] But to do so, it would be necessary to learn how to present the concept in a way appropriate to the "thought-form" of the child's developmental stage. A second element of readiness was *interest*, a concern that had engaged art teachers for many years.

This "disciplines approach" gradually became so important to art education that it may be worthwhile to refer to judgments made at the end of the decade by Arthur Foshay, a theorist frequently consulted by art educators.[36] Foshay saw the disciplines approach as a way out of the impasse between the sheer factuality of traditional subject matter and Deweyian problem solving (his "complete act of thought"). Among other advantages, Foshay noted that the disciplines approach presented subject matter in a way that made sense to students; that it offered an operational definition of understanding matched by inquiry; and that it gave to general education the sense that basic concepts have general applicability. Foshay also saw limitations. As the idea of the disciplines required that each be taught by its own logic, the curricula that had been developed on this basis led only to further work in the same discipline: the problem of the integration of knowledge was unresolved. Unless the inquiries of the disciplines could be more purposefully integrated for focus on life problems within the student's experience, such education would lack relevance. Furthermore, the disciplines approach entailed changes in teacher education that had not been achieved.

32. Jerome S. Bruner, *The Process of Education* (Cambridge, Mass., 1960).

33. Bruner, *The Process of Education*, 7.

34. Jerome S. Bruner, *On Knowing: Essays for the Left Hand* (Cambridge, Mass., 1962).

35. Bruner, *The Process of Education*, 33.

36. Arthur Foshay, "How Fare the Disciplines," *Phi Delta Kappan* 51, no. 7 (March 1970): 349–52.

The Behavioral Curriculum

Another major effort toward educational reform in the sixties employed behaviorist theories to meet demands for more clearly specified learnings and more positively measurable results—a resurgence of the emphasis on efficiency and accountability that had been built into American education before World War I. Behavioral psychology had begun in observing actions (responses to stimuli) that were coupled with pleasing or unpleasant results (negative or positive reinforcement of the action). In the programmed instruction demonstrated to Bruner and his associates at the Woods Hole conference, the leading behavioral theorist of the time, B. F. Skinner, showed how a learner's response to a single incremental task could receive immediate feedback, which in itself would be rewarding and which would guide the individual onward to the next increment of the intended learning.

Thus the design of a behavioral curriculum required that the complexity of each intended learning be analyzed into a progression of simple steps that would move the learner to a specified result. This intended result, and each step along the way, would be stated as *behavioral objectives*—outcomes that could be evidenced in an observable behavior or a product that would clearly meet or fail to meet a predefined criterion of success. The most popular handbook for the design of behavioral curricula was Robert F. Mager's *Preparing Instructional Objectives*, itself a specimen of programmed instruction.

Advocacy for behavioral curricula became so widespread and influential that the method was mandated throughout certain districts or states. Teachers found that the specification of learnings, objectives, and criteria was difficult and time-consuming. Although sets of behavioral objectives could be purchased, it was also evident that the observation and tabulation of the behaviors of a multitude of students in each class put an impossible demand on the teacher. More fundamental faults were argued. Even though a taxonomy for Bloom's category of *affective* learnings was published in 1964,[37] no definite observable behavior could be specified for many affective, or qualitative, learnings, nor could the method give any measure of long-term learnings.

Many schools turned to the idea of "competencies" for a more practical phrasing of educational objectives. In one state, a list of competencies to be required of teachers themselves exceeded one thousand items. Despite excesses and even though critics found behavioral conceptions of learning fundamentally damaging, the movement influenced several aspects of education, and many said for the better,

insofar as teachers were asked to think more clearly about the complexity of learning sequences and the need for useful evaluation of results.

Not bound to behavioral objectives but more broadly an outgrowth of concerns for equality and excellence in education as a national asset, the Carnegie Corporation began the development of the National Assessment of Educational Progress in 1964. The Fund for the Advancement of Education added support in 1967. Working through the Educational Testing Service, the project formed panels of experts in each major school subject (including art) to establish learning objectives, criteria, and "assessment exercises." Through the decade these were reviewed, revised, tested, and further revised. By 1969, the first national assessment was carried out in the areas of science, citizenship, and writing; literature, mathematics, and music were scheduled for the next assessment year.

Humanizing the School

Through the same years, during the promotion of behavioral curricula and amid growing impetus toward some national system of academic testing, a quite different movement developed. As one educator phrased the situation, "The schools can decide now whether they are to be more humane, more sensitive to student needs, and more able to serve the individual; or, they can become even more rigid and inflexible so that only the conforming students will pass through."[38] These latter qualities could be blamed for the high number of school dropouts, and indeed, the same characteristics were perceived in universities by students in rebellion. In one sense, humanizing implied a return to the learner-centered education of the early fifties. In another context, humanizing meant responding to the needs of the inner-city school and its students or, more broadly, responding to all of the depersonalizing, uncaring aspects of society. A number of popular books carried these themes of criticism and protest.[39] Bruner himself concluded that emphasis on the structure of the disciplines was wrong without concern for relevance to students' life experiences: he saw a need to bring school and society together—a need for a "community of learning."[40]

37. D. R. Krathwol et al., *Taxonomy of Educational Objectives, Handbook II: Affective Domain* (New York, 1964).

38. Norman K. Hamilton, "Alternatives in Secondary Education," in *Humanizing the Secondary School*, ed. Norman K. Hamilton and J. Galen Saylor (Washington, D.C., 1969), 2.

39. Among the books of criticism that were strongly grounded in personalist teaching and social protest were John Holt's *How Children Fail* (New York, 1964); Herbert Kohl's *36 Children* (New York, 1968); and Jonathan Kozol's *Death at an Early Age* (Boston, 1967).

40. Jerome S. Bruner, "The Process of Education Revisited," *Phi Delta Kappan* 52, no. 1 (September 1971): 18–21. Bruner's thinking in the later sixties was developed in essays collected in *The Relevance of Education*, ed. Anita Gel (New York, 1971).

For school administration humanizing implied goals pertaining to personal qualities and caring relationships. Humanizing implied openness to experiment and trust in the judgment and creativity of school principals and classroom teachers. For the curriculum, humanizing meant relevance to students' personal lives, involvement of students in planning, and development of flexible options. Among the administrative devices to support such curricula were individualized instruction, team teaching, multigrades, differentiated staffing, minicourses, schools without walls, and alternative schools.[41] The larger the city, the more important it seemed to decentralize administration and engage neighborhood interests: in 1967, the Ford Foundation began support of community control in subdistricts of the New York City school system.

Books on curriculum that strongly impressed leading theorists in art education could in turn enter the thinking of art teachers in the schools. Among those that were influential in the sixties was Hilda Taba's *Curriculum Development: Theory and Practice*,[42] which considered various influences on curriculum development, followed Deweyian experientialism, and proceeded to analysis of subject matter and construction of study units. *Democracy and Excellence in American Secondary Education*[43], by Harry S. Broudy, B. Othanel Smith, and J. Burnett, was important for the humanist movement and important also because Broudy became a leading proponent of aesthetic education. John Goodlad was an influential advocate of the arts in the classroom: his *School, Curriculum, and the Individual*[44] provided a useful model for curriculum design through consideration of the subject matter, the student, and the school as a social agency. Another of Goodlad's important publications was his *School Curriculum Reform in the United States*.[45] Two criticisms of professional preparation for teaching were published in 1963: James Conant called for more substantial education in the liberal arts and cognitive subject matter; James Koerner, with similar intent, advocated the complete elimination of teachers colleges.[46]

To promote access to all forms of professional literature for research and development in the various subjects, the **Educational Resources Information Center (ERIC)** system was created in 1966 by the U.S. Office of Education. In 1971, the system included nineteen "clearinghouses," most of them at universities. Each was assigned to a different, multidisciplinary educational field for reviewing, abstracting, and indexing diverse materials, with compilations issued periodically. In art education, the system was immediately useful to graduate students, but the penetration of research into school curricula remained uncertain.

ART EDUCATION

Introduction

At the level of national publication and leadership, art education showed litle direct impact from the social disruptions of the sixties, including the war in Vietnam, with certain exceptions: increased concern for the disadvantaged children of inner cities and the beginnings of new attention to women in art, to African art, and to the art of native Americans. For individuals in art education, the influences were mediated, filtering into a general sense of change and uncertainty and sometimes into protest, as personal values were tested. Some art teachers saw that the outburst of radical new conceptions in professional art might challenge basic assumptions, and some felt the appeal of a liberated or intensified aesthetic attitude. But there was no widespread concerted move to bring the new styles into the classroom. Instead, the dominant force for change in art education was the general pressure for "excellence" in American schooling, with the responsive movement that was commonly phrased as a shift from pupil-centered to subject-centered curricula. The main result was a redefinition of the goals and content of art education.

The Status of Art Education

The provisions for art and music in the nation's public schools were surveyed by the National Education Association in 1961–62.[47] Questionnaires were distributed to school principals selected to represent a full range of size in elementary and secondary schools and in school districts across the country. The results should not have surprised experienced art educators, but for the fact that many of them were employed in larger school districts where provisions for art were usually better. Moreover, what they knew locally had not been described nationally for many years and never in such complete quantitative form. The cold numbers were cited as a shocking challenge.

41. William Henry Schubert, *Curriculum Books: The First Eighty Years* (Washington, D.C., 1980), 184.

42. Hilda Taba, *Curriculum Development: Theory and Practice* (New York, 1962), 184.

43. Harry S. Broudy, B. Othanel Smith, and J. Burnett, *Democracy and Excellence in American Secondary Education* (Chicago, 1964).

44. John Goodlad, *School, Curriculum, and the Individual* (Waltham, Mass., 1966).

45. John Goodlad, *School Curriculum Reform in the United States* (New York, 1964).

46. James B. Conant, *The Education of American Teachers* (New York, 1963), and James Koerner, *The Miseducation of American Teachers* (Boston, 1963).

47. National Education Association, Research Division, *Music and Art in the Public Schools* (Washington, D. C., 1963), research monograph 1963-M3.

Actually, time allotments and enrollments in art had increased somewhat in the past five years. Among the elementary schools responding, only 3.5 percent reported a reduction of time for art in 1961 as compared to 1956–57, whereas in 20 percent, the time allotment had increased. The amount of time, however, was left to the classroom teacher's discretion in nearly one-half of the schools. Where a definite time allotment was established, a median of sixty minutes per week was reported in small districts; the median for schools in large districts was eighty minutes weekly in the first three grades, increasing to ninety minutes in grades four, five, and six. But about 5 percent of the responding elementary schools had no formal instruction in art.

Art was taught by the regular classroom teacher in more than 90 percent of the elementary schools. About one-fourth of those schools—most often in larger districts—had help from an art specialist. Children were taught by an art specialist alone in fewer than one-tenth of the schools. Although classroom teachers were the usual teachers of art, fewer than 30 percent of the schools made the ability to teach art a condition of employment. Some kind of in-service instruction was offered to teachers in the majority of schools, but sequential courses of study were provided by only 38.5 percent of them—again, most often in larger districts that were more likely to have prepared their own courses of study.

A "spare" room was used for art instruction in only 12 percent of the schools; only 74 percent reported provision of paper, paints, and other two-dimensional materials. A ceramic kiln was reported in about 20 percent of the schools, and looms for weaving in less than 16 percent. Enamel kilns were much rarer. In sum, for every kind of provision for art, substantial gaps existed between the strong programs known to leaders in the field, the average programs, and the least favored.

The same generalization applied to secondary schools. In the sample that reported, art was offered by more than 90 percent of those schools enrolling more than one thousand students, but by fewer than 30 percent of those with enrollments smaller than three hundred. Most junior highs and most large high schools had art programs, but among all the secondary schools in the survey, grades seven through twelve, more than 46 percent offered no art at all.

Enrollments in art, expressed as a percentage of the total secondary school population, had increased in the past five years, both in courses for credit and in extracurricular activities. In a few of the reporting junior highs (11.5 percent), *all* students were taking art. But overall, enrollments remained discouragingly small. Even excluding the more than 46

percent of secondary schools that offered no art, only 15 percent of students in grades seven through twelve were enrolled in art in 1961–62. Fewer than 15 percent of large high schools required a course in art for graduation.

Similar findings were reported from an extensive study by two art educators in 1964.[48] What these surveys showed, again, was not a decline but rather the general and perennial inadequacies, the persistent inequalities.

The current problems of school art at a time of growing public enthusiasm for the arts were widely attributed to the contemporary pressures for academic excellence represented by the Conant Report and by corresponding admissions requirements for higher education. Five academic courses with homework left little time for electives. Many high schools gave no Carnegie unit credits for art courses in student transcripts. Guidance advisers reportedly believed that few colleges considered art studies in decisions on admission, a belief proven false through a national survey conducted by art teachers in New Jersey.[49]

Despite these difficulties, the sixties offered encouragement. The Educational Policies Commission devoted its last study to the advocacy of art education.[50] During the decade, twenty states appointed art supervisors for the first time.[51] In North Carolina, enrollments in art reportedly doubled between 1962 and 1964.[52] In Seattle, a "magnet" program in a ghetto high school demonstrated the power of the arts to promote desegregation and to identify talent in minority populations. In higher education, fifty new art teacher certification programs[53] and dozens of new graduate programs[54] were established in the sixties. The number of college graduates prepared to teach art in 1968 had increased by 200 per-

48. Reid Hastie and David Templeton, "Profile of Art in the Secondary Schools—Report of a National Survey," *Art Education* 17, no. 5 (May 1964): 5–9.

49. "College and University Acceptance of High School Art Credits for Admission," *Art Education* 21, no. 7 (October 1968): 31–38. The survey was conducted by the Research Committee of the New Jersey Art Education Supervisors' Round Table, chaired by Dr. Thelma Newman.

50. The final report of the Educational Policies Commission of the NEA and AASA (established in 1935), titled "The Role of the Fine Arts in Education," was published in July 1968 and reprinted in *Art Education* 21, no. 7 (October 1968): 3–7.

51. John Michael, "Women/Men in Leadership Roles in Art Education," *Studies in Art Education* 18, no. 2 (Winter 1977): 9.

52. Perry Kelly, "Art Education in North Carolina," *Art Education* 20, no. 6 (June 1967): 26–27.

53. John Michael, "Women/Men in Leadership Roles," 19.

54. Elliot W. Eisner, "Graduate Study and the Preparation of Scholars in Art Education," *Art Education*, Sixty-Fourth Yearbook of the National Society for the Study of Education, Part II, ed. W. Reid Hastie, Chapter 12 (Chicago, 1965), 274–298.

cent since 1950—the largest increase in any subject excepting foreign languages.[55]

The strongest stimulus came through the unprecedented level of federal funding for art education. In the U.S. Office of Education, the budget of the Arts and Humanities Program was augmented by funds allocated under Title IV of the Elementary and Secondary Education Act of 1965. A team of arts specialists directed by Kathryn Bloom administered scores of research projects, including seminars, conferences, surveys, and individual or team studies, many of which will be mentioned below under appropriate headings.[56] The U.S. Office of Education's Bureau of Elementary and Secondary Education allocated Title III funds to state departments of education to support a variety of special programs and centers for the arts in a program called Projects to Advance Creativity in Education (PACE). At one point in the sixties, the U.S. Office of Education administered sixty-seven different programs that could support arts education. In 1969, the National Endowment for the Arts began its Artists in the School Program, which became widely popular, heavily funded, yet sharply criticized by art educators. There were still other channels by which monies from two national endowments assisted school programs in the arts and humanities. Among the regional centers related to the Educational Resources Information Center system, the Central Midwestern Regional Educational Laboratory (CEMREL) and the Southwestern Educational Research and Development Laboratory (SWRL), were to become particularly important in visual arts education.

An influential private philanthropy, the JDR 3rd Fund, set up by John D. Rockefeller III in 1964, began its Arts in Education Program in 1967. Kathryn Bloom left her position at the Office of Education to direct the fund from 1968 until its termination in 1978 after the death of Mr. Rockefeller. The fund was especially active in funding pilot projects in school districts across the country, aiming to bring "all the arts to every child" within the general education curricula.

Professional organizations were increasingly involved in collaboration with state and federal administrative agencies and in efforts to influence legislation and funding for education and the arts. The National Art Education Association began to acquire the bureaucratic connections and techniques already common among the associations representing other school subjects. Its executive secretaries (Ralph G.

Beelke, 1958–62, and Charles M. Dorn, 1962–70) monitored legislative developments, testified before congressional committees, and linked National Art Education Association officers to friends of the arts in Congress. But they also assisted in the planning of funded conferences, seminars, and research projects and worked on membership services, new publications, and the biennial conventions.

The regional conventions within the National Art Education Association continued in alternate years through 1972, when the program chairpersons were the National Art Education Association vice-presidents–elect for the respective regions. The nineteenth World Congress of the International Society for Education Through Art, held in New York in 1969, was hailed as the most important art education meeting in the United States.

Federally Funded Conferences

Among the projects funded by the U.S. Office of Education in the mid-sixties, three conferences on art education should be introduced at this point because of their pervasive influence and because they revealed much about the status of art education at the time.

The "**Seminar on Elementary and Secondary School Education in the Visual Arts**" was held at New York University, October 8–11, 1964.[57] Its aim was foundational and exploratory—to identify the purposes and deficiences of art education and to recommend measures for its improvement through further funded programs. Most of the forty-two invited participants were not art educators; rather, they were distinguished artists, art historians, and critics, together with eminent representatives of academic disciplines and more general education.

This group heard the recent statistical evidence of the meager provisions for school art, reinforced by negative reports of its educational quality. With differing views of the importance of expression, aesthetic sensitivity, and intellectual development among the purposes of art education, the participants focussed on the inadequacy of the preparation of art teachers and their instructional equipment. The college programs for future art teachers, they agreed, had too little concentration in studio media, far too little study of art history and criticism, and too much coursework in educational theory and methodology. To guide curriculum revision at all levels, to lead institutes and

55. "Editorial," *Art Education* 22, no. 8 (November 1969): 31, reporting an NEA Research Division Study, "Teacher Supply and Demand in Public Schools, 1968."

56. Harlan Hoffa and subsequently Stanley S. Madeja were art education specialists under Kathryn Bloom in the Arts and Humanities Program of the U.S. Office of Education.

57. Conant, ed., *Seminar on Elementary and Secondary School Education in the Visual Arts.* Conant, chairman of the Department of Art Education at New York University, was director of the project. In an earlier address to the National Committee on Art Education and in testimony before Congress, he had called for more deliberate teaching for deep understanding of art rather than permissive self-expression. He advocated reduction of studio activity and emphasized history and criticism as the main basis of art education.

cadres for widespread in-service education of teachers, and to develop massive production of films and other audiovisual teaching materials, the participants recommended enlisting the most articulate fine artists, distinguished art historians and critics, and museum leaders. In its composition, conclusions, and recommendations, this first such conference in art education closely resembled the directions of earlier curriculum reform projects in science and mathematics: it reinforced the conception of subject matter derived from professional practice, with notable emphasis on the history and criticism of art. One further effect of the conference was the spread of enthusiasm for recruitment of practicing artists into schools.

The **"Seminar in Art Education for Research and Curriculum Development,"** held at the Pennsylvania State University from August 30 to September 9, 1965, was the most significant conference of the decade in art education.[58] In the strategy of the Arts and Humanities Branch, its purpose was to stimulate the kinds of projects recommended at the New York University meeting one year earlier. Planning for the seminar, however, had developed from discussions beginning as early as 1962 among faculty members in art education at both the Pennsylvania and the Ohio State Universities.[59] In contrast to the New York University meeting, which was designed to gather ideas from representatives of general educational interests and professional practice in the visual arts, most of the thirty-eight participants and twenty observers at the Penn State seminar were art educators.

The conceptual structure of the seminar was based upon five problem areas common to curriculum planning in any subject: the consideration of purpose, content, the teaching-learning process, the learner, and the curriculum itself. Accordingly, foundational papers were given by specialists in philosophy, the visual arts,[60] educational and developmental psychology, sociology, and curriculum theory. Following each of these papers, an art educator delivered a prepared commentary on assigned aspects of the same problem area, leading to general discussion among the participants. The second, longer, phase of the ten-day program was devoted to the development

of actual research proposals by the participants and observers in consultation with the invited specialists.

Much of the thinking that redirected curriculum development in art education after the mid-sixties was articulated in papers presented at the Penn State seminar. Several of the key ideas were brought together in Manuel Barkan's proposals for curriculum reform:

■ Art education could be conducted as a humanistic discipline.

■ The structure of art existed in three domains—the productive, historical, and critical—each with its practitioners serving as models for curriculum.

■ The teaching should employ both problem-centered and discipline-centered strategies.

■ Objectives and activities for learning should be developed through focus on life problems as "organizing centers."

■ Because no school system had the capability of developing adequate curriculum guides and resources, the regional centers for research and curriculum development proposed by Elliot Eisner should have the further responsibility for developing, testing, and disseminating guides and unit packages containing all needed resources.[61]

The **"Conference on Curriculum and Instructional Development in Art Education"** met in Washington, D.C., September 20–22, 1966.[62] Its general purpose was to extend the impetus of the Penn State seminar to those who could directly promote curriculum reform: among the seventy-nine reported participants were twenty-six state directors of art education, many leaders of state art education associations, and representatives of the National Art Education Association and the National Endowment for the Arts. The message of the Penn State seminar was delivered by three of the speakers from that earler meeting and by advance distribution of papers by Manuel Barkan and Elliot Eisner.

A recurring theme was change—in goals, educational methods, and organizational means of gaining public and governmental support. As a goal for schools, Arthur Foshay saw "competence" replacing generalized "growth" and "development": for competence, the student should gain in ability to learn the modes of inquiry in each discipline through problems

58. Edward L. Mattil, ed., *A Seminar in Art Education for Research and Curriculum Development* (University Park, Pa., 1966).

59. Arthur Efland, "Curriculum Concepts of the Penn State Seminar: An Evaluation in Retrospect," *Studies in Art Education* 26, no. 4 (Summer 1984): 205–11. In this valuable article, Efland identifies the initial Penn State leaders as Edward Mattil and Kenneth Beittel and those at Ohio State as Manuel Barkan, Jerome Hausman, David Ecker, and Elliot Eisner.

60. Representing the visual arts were the historian Joshua Taylor, the critic Harold Rosenberg, and Allan Kaprow, one of the innovators of Happenings who was then a professor of fine arts.

61. Manuel Barkan, "Curriculum Problems in Art Education" in Mattil, ed., *A Seminar in Art Education*, 240–55.

62. Alice A. D. Baumgarner, ed., *Conference on Curriculum and Instruction Development in Art Education: A Project Report* (Washington, D.C., 1967).

dealing more directly with reality. Instead of "readiness," conceived as a point in a common developmental pattern or as a "generalized set of attitudes," art teachers should be concerned with a more active and specific student "intention." Speaking for the Educational Policies Commission, James Russell agreed with Foshay's advice: art as a discipline should contribute to the humanistic values in education.[63] If so, the school art curriculum would be changed, as both the seminars at New York University and Penn State had recommended, to bring the study of history and criticism to parity with studio work.

A specific objective of the conference was to assess the grass-roots potential for curriculum change. For that purpose, state directors described in advance their work and their perceptions of obstacles and needs. At the conference, four work groups met daily to develop final reports on such conditions at state and local levels and to propose strategies for progress. Commenting on the work groups as conference evaluator, Asahel Woodruff added to the understanding of the status of art education.

The Penn State seminar had shown Woodruff that, at the national level, researchers and theoreticians were engaged in new analyses of purposes, content, and methods; they were oriented toward "new frameworks and new concepts." In contrast, this conference showed that at the state and local levels, the concern was how to survive and do better in traditional programs. The work groups, he observed, initially had avoided fundamental problems and slid into current operational complaints. But they had begun to recognize the need for change, and they suggested action on two fronts: for new ideas of the contribution of art to general educational goals and for strategies to overcome the disinterest of the public and "power groups."[64]

This brief meeting could not have produced immediate curriculum reform, given the power of each school district in the nation to determine its own curriculum. But recognition of the gap between theoretical proposals and practical obstacles did lead to subsequent ambitious curriculum projects directed at state and local levels. (Significantly, the first art education efforts undertaken by the JDR 3rd Fund under Kathryn Bloom were projects in local school districts.)

Bloom's efforts at the U.S. Office of Education had resulted in a total of fifteen conferences between 1964 and 1966, with additional meetings otherwise funded. But by the end of her tenure, funding declined, as war and discord replaced the last glow of the Kennedy era. In 1970, Harlan Hoffa, who had attended all of those conferences as arts specialist under Bloom, could credit them with only three positive results: the beginnings of advanced placement programs in art; improvement in television education, marked by a distinguished guide to curriculum planning,[65] and the launching of the major curriculum development project for art education in that era, at CEMREL.[66] (This project and its publications became so well known that the acronym CEMREL entered the professional jargon and literature as a standard term.)

CEMREL. Early in 1967, the Aesthetic Education Curriculum Program was initiated jointly by the Ohio State University and the Central Midwestern Regional Educational Laboratory. This most important effort grew from the recommendations of Barkan and Eisner at the Penn State seminar. The first phase in this project was carried out at the University by a team of researchers led by Barkan, Laura H. Chapman, and Evan J. Kern. Their task was the formulation of theory, conceptual content, procedure, and resources for curriculum development in aesthetic education. Their product, after nearly three years of work, was a monumental handbook intended to be used during the second phase, by curriculum writers at CEMREL.[67] The Aesthetic Education Curriculum Program at CEMREL was directed by Stanley Madeja, who had worked under Kathryn Bloom at the U.S. Office of Education. Closely linked was the laboratory's engagement in the Arts in General Education Project at University City, Missouri, launched in 1968 by the JDR 3rd Fund under Bloom's direction.[68]

By 1977, CEMREL had produced forty-four curriculum units for elementary grades, bringing together the visual arts, music, dance, literature, theater, and film. Programs to prepare teachers for aesthetic education were set up with several schools and arts centers. The curriculum was promoted through several state education departments, most strongly in Pennsylvania, and through many publications and professional meetings.[69] The project was unprecedent-

63. Arthur W. Foshay, "Changing Goals and Art Education," in Baumgarner, ed., *Conference on Curriculum and Instruction Development,* 16–33; James E. Russell, "The Role of the Arts in Education," in Baumgarner, ed., *Conference on Curriculum and Instruction Development,* 62–77.

64. Asahel D. Woodruff, "Report of the Conference Evaluator," in Baumgarner, ed., *Conference on Curriculum and Instruction Development,* 100–10.

65. Manuel Barkan and Laura H. Chapman, *Guidelines for Art Instruction through Television for the Elementary Schools* (Bloomington, Ind., 1967).

66. Harlan Hoffa, *Analysis of Recent Research Conferences in Art Education,* Final Report (Bloomington, Ind., 1970), project no. 8-E-093.

67. Manuel Barkan, Laura H. Chapman, and Evan J. Kern, *Guidelines: Curriculum Development for Aesthetic Education* (St. Louis, 1970).

68. Stanley S. Madeja, *All the Arts for Every Child: Final Report of the Arts in General Education Project in the School District of University City, Mo.* (New York, 1973).

69. Stanley S. Madeja and Sheila Onuska, *Through the Arts to the Aesthetic* (St. Louis, 1973).

ed in its scope and duration. Surely it enriched the conceptual store of art education. Yet it had little lasting effect on the curriculum.

Publications

Publications in art education multiplied in the sixties. Probably the one volume that most completely represented the thinking of leading art educators in the mid-sixties was the Sixty-Fourth Yearbook of the National Society for the Study of Education, Part II.[70] But the full ferment of ideas and activities through the decade was documented in the reports of funded research projects and of the conferences and seminars described above: probably the most substantial of these were the report of the Penn State seminar and the CEMREL *Guidelines*.

The National Art Education Association strengthened its newsletter, its basic periodical (*Art Education*), and its young scholarly journal (*Studies in Art Education*). Its expanded program of publication included three monographs to guide art instruction;[71] a mid-decade status report by a study commission;[72] a series of research monographs; a number of conference reports; monographs on creativity, art room facilities, and art for gifted students; and an offical position statement on provisions for art education, *The Essentials of a Quality School Art Program*.

Among the more theoretical texts, June McFee's *Preparation for Art* was especially significant (even though it was directed to the education of classroom teachers) in its use of recent research to formulate a new theory of the child's process of expression in art, with inferences for teaching. McFee's foundational sources in psychology and cultural anthropology represented typical intellectual directions of the fifties—the understanding of the human as a perceiver, a processor of information, an individual uniquely conditioned by a personal environmental experience. Her "perception-delineation" theory drew upon many current educational interests, such as gestalt psychology, field dependence or independence, creativity, value formation, response sets, perceptual "screens," cognitive styles, and personality development. In her understanding, for example, "readiness" was no longer a determinable preparedness for a specific learning but an ever-changing condition for interpreting "what he sees in his

immediate situation."[73] Her book was unusual and influential also in its emphasis on art as a form of communication, in its concern for the environment, and in its implications for multicultural education.

The surge of interest in perception was evident also in texts for elementary art teaching by Anderson, Conrad, Linderman and Herberholz, and Donald and Barbara Herberholz. Perception was the title topic of books by Yochim and by Gordon and Wyman. Rueschhoff and Swartz linked visual perception to concept formation and aimed toward an expanded awareness of art and design in the environment, with special attention to audiovisual instruction.[74] Hastie considered perception as a basic element of the creative process.

Early in the decade, creativity remained a primary goal. Barkan's *Through Art to Creativity*, based on field work conducted during the late fifties, indicated the role of art in general education. His documentation and analysis of classroom teaching gave the book permanent value, and his use of camera and tape recorder provided a model for subsequent research. Cole's *Children's Arts from Deep Down Inside* gave further testimony on the contribution of emotional expression to mental health and social growth in a multicultural classroom. Two books on creativity, both very useful to art teachers, one authored by Eisner and the other edited by Brittain, came out in 1964.[75]

The most comprehensive text for students or professionals involved in elementary education was Lansing's *Art, Artists, and Art Education*, a book both philosophical and practical in its purpose and valuable for any level of public education. Especially at the elementary level, the Lowenfeld tradition continued, with Brittain providing further revised editions after Lowenfeld's death in 1960. But by 1965, a distinct challenge was evident in the popularity of Wachowiak and Ramsey's *Emphasis: Art*. Another alternative, the related arts curriculum, was promoted in 1968 in Chandler Montgomery's *Art for Teachers of Children*. Yet the market for conventional workbooks seemed stable in 1963: Blanche Jefferson's graded series of large-format lesson sheets, with teachers' manuals, could have been written at any time since World War II.

70. W. Reid Hastie, ed., *Art Education*. Sixty-Fourth Yearbook of the National Society for the Study of Education, Part II (Chicago, 1965).

71. Ann M. Lally, ed., *Art Education in the Secondary School* (1961); John A. Michael, ed., *Art Education in the Junior High School* (1964); Mary Packwood, ed., *Art Education in the Elementary School* (1967).

72. Jerome J. Hausman, ed., *Report of the Commission on Art Education* (Washington, D.C., 1965). Hereafter, *NAEA Report of the Commission*.

73. June K. McFee, *Preparation for Art* (Belmont, Ca., 1961), 101. The book had seven printings in as many years. Its second edition (1970) was broader in purpose, responsive to criticisms of her "P-D" theory, and thoroughly updated in its use of research in the sixties.

74. Phil H. Rueschhoff and M. Evelyn Swartz, *Teaching Art in the Elementary School* (New York, 1969).

75. Elliot W. Eisner, *Think with Me about Creativity* (Dansville, N.Y., 1964); and W. Lambert Brittain, ed., *Creativity and Art Education* (Washington, D.C., 1964). Eisner's brief essays were published first in the *Instructor Magazine*. Brittain compiled essays from issues of *Studies in Art Education*, together with an extensive bibliography.

Two texts on secondary art education were designed for future teachers, first by Vincent Lanier and later by Guy Hubbard.[76] Both, but Hubbard more forcefully, cited data to warn of the meager status of art in schools. Both provided a variety of sample curricula. Both were concerned with perceptual development and the role of art in culture. Lanier was balanced, sensitive to socioeconomic differences among students, and conventional at a high level. Hubbard clearly represented concerns of the later sixties for diligent use of detailed curricula; for goals of knowledge and understanding with a deemphasis on studio experience; for more sophisticated attention to evaluation; and for more dedicated organized professionalism.

More philosophical in tone and content but equally representative of the period was Kaufman's *Art and Education in Contemporary Culture*.[77] C. P. Snow was cited on the oppositions of science and art; gestalt psychology funded the discussion of perception; and Kepes's *Language of Vision* illustrated one aspect of the educational goal. Kaufman's major message argued for dedication to the intrinsic values of high art in offsetting the depersonalizing materialism of technology, mass communication and production, and the spurious attractions of popular arts.

For art appreciation studies in high school or college, a broadly inclusive text, *Art: Search and Self-Discovery*, was written by an art educator, James Schinneller.[78] The book was unusual in its extensive treatment of architecture, design, environmental aesthetics, and urban planning. (The latter concerns grew more in public awareness than in art education in the sixties.) Schinneller moved quickly from historical and multicultural bases to an emphasis on contemporary forms and ideas: his second edition brought the student to the full range of stylistic currents of the mid-sixties. Among the many books guiding creative work in art media, the experimental freedom of professional printmaking in the sixties was transmitted to the classroom by three art educators.[79] Another art educator, John Cataldo, continued his contributions to the teaching of graphic design.[80] Pearl Greenberg added to the renewed emphasis on art quality in her book on children's drawing and painting.[81]

The psychology of children's art was not dismissed in the move to establish school art as a "discipline." Rhoda Kellogg showed again how the sequence of representational devices in young children's drawings expressed universal patterns of human cognitive development.[82] Hilda Lewis edited the contributions of international leaders to a conference at the University of California, Berkely, cosponsored by the International Child Art Center of San Francisco.[83] Lark-Horowitz, Lewis, and Luca brought together decades of research as the basis for advice on teaching art in elementary schools.[84]

A very different collection was Eisner and Ecker's *Readings in Art Education*.[85] In a field that had been, as the authors noted, mainly atheoretical, this was a selection exemplifying the diversity of views, past and present, on central perennial issues that should be addressed by coherent theory. Showing the need for and the possibility of better research as the ground for more adequate theory, the book represented a new level of expectation in professional preparation made possible by the recent growth of graduate studies, research, and scholarly publication.

The literature of art education was notably deficient in attention to aesthetics, which was identified at the Penn State seminar in 1965 as one of the four parent disciplines of art education. Already in press before the seminar, however, was Ralph Smith's *Aesthetics and Criticism in Art Education*, the first anthology to address that deficiency.[86] A second important addition to the professional literature, therefore, was Smith's inauguration of the *Journal of Aesthetic Education*. Eisner and Ecker's *Readings*, the edited report of the Penn State seminar, and Smith's two contributions were published in the same year, 1966—a mark of the intensity of activity in art education in mid-decade.

Purposes and Issues

The broad campaign for reform of educational subject matter in the late fifties and early sixties was undertaken as a qualitative necessity independent of the old tensions between practical objectives and less definite humanist goals. In the sciences and mathematics, a reconceived instructional content initially needed no further justification; educational purposes

76. Vincent Lanier, *Teaching Secondary Art* (Scranton, Pa., 1964), and Guy Hubbard, *Art in the High School* (Belmont, Ca., 1967).

77. Irving Kaufman, *Art and Education in Contemporary Culture* (New York, 1966).

78. James A. Schinneller, *Art: Search and Self-Discovery* (Scranton, Pa., 1961); a second edition was published in 1968.

79. Michael Andrews, *Creative Printmaking* (Englewood Cliffs, N.J., 1964); Arnel Pattemore, *Printmaking Activities for the Classroom* (Worcester, Mass., 1966); and Henry Rasmusen, *Printing with Monotype* (Philadelphia, 1962).

80. John Cataldo, *Graphic Design and Visual Communication* (Worcester, Mass., 1966).

81. Pearl Greenberg, *Children's Experiences in Art: Drawing and Painting* (New York, 1969).

82. Rhoda Kellogg, *The Psychology of Children's Art* (New York, 1967).

83. Hilda Lewis, ed., *Child Art: The Beginnings of Self-Affirmation* (Berkeley, Ca., 1966).

84. Betty Lark-Horowitz, Hilda Present Lewis, and Mark Luca, *Understanding Children's Art for Better Teaching* (Columbus, Oh., 1967).

85. Elliot W. Eisner and David W. Ecker, eds., *Readings in Art Education* (Waltham, Mass., 1966).

86. Ralph A. Smith, ed., *Aesthetics and Criticism in Art Education* (Chicago, 1966).

were not in question, and curriculum change could be established quickly by statewide adoption of texts and methodology. But in art education, which lacked any such system, the redefinition of the subject could only be gradual, and it was not enough to reassert the values of creative self-expression and some sort of appreciation. To affirm the social contributions of school art, it was necessary to link the possibilities of the subject to rapid changes in society, education, and the arts themselves with more comprehensive thinking than had been achieved before. For such thorough explanations of educational purpose, another term gained currency: *rationale*.

Analyzing various rationales for art education, the prestigious and independent Educational Policies Commission projected the symptoms of the sixties more broadly into the future.[87] Some of the common reasons for valuing the arts seemed inadequate to the commission: although the arts had indeed been important to great civilizations in the past, this alone could not justify their future place in schools; the value of art experiences (the "art-for-art's-sake rationale") was unquestioned, but some more certain utility would have to be shown; the therapeutic power of art had been demonstrated but only for some, not all, of the school population.

For promotion of creativity, however, the commission saw a special advantage in the arts since advanced training was not prerequisite for valid personal achievement. There was more of the phrasing of the sixties in the commission's argument that the arts nurtured the "acceptance of subjectivity," the "making friends with the nonobjective aspects of one's mind." Finally, the old argument for the "worthy use of leisure time" had become the "end of work" rationale. In the sixties, social groups were withdrawing from the system. The commission saw the alienation of American youth from the Puritan work ethic: if computers and robotics should indeed come to replace human labor, a new kind of stimulating, communicative value would be found in the arts. To the commission, creative experience seemed more important than appreciation; no particular value was attached to knowledge about the arts; and the ancillary relation of the arts to other subjects was not considered.

Art educators welcomed that policy statement. But the National Art Education Association's own Commission on Art Education already had urged new directions for the latter sixties. Their report, without denigrating the secondary, derivative contributions of school art, insisted that its primary purpose derived from the inherent values of art itself, taught as a demanding and disciplined subject. The scope of the

subject, defined here as at the Penn State seminar, went beyond individual creative experience to include the work of designers, planners, historians, and critics.[88]

The primary inherent values, however, were not neatly separable from the so-called derivitive purposes. At the end of the decade, Lansing argued that the "major aim" of art education was obviously "the production of artists and connoisseurs of art" but also of "life": thus, for validity as general education, the teacher would have to bring about a generalized transfer of knowledge and attitudes from the domain of art to the whole of experience.[89] Yet he held to a scope of artworks more restricted and less directly relevant to daily life than that of, say, McFee. From a different ground, among those who advocated reduction of work in art media, or studio experience, Ralph Smith argued specifically for *aesthetic education* as a response to the general social need for an education in values. Elsewhere in the literature of the sixties are frequent references to "aesthetic behavior" and to "sensitivity," "awareness," "judgment," and "social responsibility" relating to aesthetic quality in the natural and man-made environment. The concept of aesthetic and perceptual "literacy" was drawn from the definition of art as a basic subject with specifiable learnings.

Furthermore, the "derivitive" benefits of art education could not be dismissed without ignoring contemporary society. In the National Society for the Study of Education Yearbook of 1965, McFee described a number of needs of poor minority children that implied objectives other than teaching art as a subject. In one New Jersey city, two student art teachers sadly decided that their subject could not offer what their classes needed most. At Arizona State University, art education students calling themselves "Give a Damn Art Teachers" worked with community youth in a juvenile institution. Art programs in prisons proliferated. The Urban Child Center at the University of Chicago described seventy-four compensatory education projects using art.[90] Kathryn Bloom and her team at the U.S. Office of Education supported the four-day "Seminar on the Role of the Arts in Meeting the Social and Educational Needs of the Disadvantaged" in the same year, 1966, that others at the U.S. Office of Education organized a national conference on education for the disadvantaged.

87. Educational Policies Commission, "The Role of the Fine Arts in Education," *Art Education* 21, no. 7 (October 1968): 3–7.

88. Frederick M. Logan, "The Development of Art Education in the Twentieth Century U.S.A.," in *NAEA Report of the Commission*, 64–65; Manuel Barkan, "Curriculum and the Teaching of Art," in *NAEA Report of the Commission*, 69.

89. Kenneth M. Lansing, *Art, Artists, and Art Education* (New York, 1969), 268.

90. Cited by Ronald H. Silverman, "Guest Editorial," *Studies in Art Education* 11, no. 1 (October 1969): 3. (This issue was devoted to "art and the disadvantaged.")

There was little doubt that art experiences could build self-esteem, strengthen cultural identity, and stimulate a general readiness for learning. "Leisure education" and "problem-solving" could still be claimed. In sum, it could be said that many ideas of purpose had endured for decades with subtle responses to shifting ideas and social priorities and with steadily growing sophistication. For the near future, it was most distinctive of the sixties that—at least in theory—the purposes of generalized individual development and support of learning in other subjects were superseded by the affirmation of art as a distinct and more comprehensive subject.

Not only were the purposes of art education and proposals for new directions in curriculum hotly debated but also the collateral issues inherent in these proposals. The entire effort to follow Bruner's ideas in revising art education seemed to depend on the premise that art could be considered a discipline like science or mathematics.

Certainly art was not commonly recognized as a scholarly field with its own rules of inquiry producing a unique kind of knowledge. Bruner spoke of structure as the essential content to be learned. Artists were not governed by a structure of axioms, semantics, logic, procedure, precedent, or hypothesis and verification. Yet art could be said to have its ways of working, its concepts, and a formal structure (known to teachers as the principles and elements of design or composition). A second criterion for status as a discipline could be satisfied by the observation that no similar experience was produced through any other field of work.

Others thought that it was the teaching, not the subject itself, that had to be established as a discipline. But opinions on the status of education as a discipline varied as widely as the definitions employed. As to art education, some said that it could produce no original knowledge until it developed an independent method and body of research or, more generally, that art education was no discipline because it depended entirely upon other fields for its theory and practice. In Feldman's view, art education could be considered a discipline because it engaged students in a unique humanistic learning and brought together source materials in a way duplicated by no other study.

The debate on structure was quieted somewhat by Barkan's formulation at the Penn State seminar: the structure of art as a school subject conjoined the structures of creative art, art history, art criticism, and aesthetics. Later on Lansing's text took Bloom's taxonomies of cognitive and affective learning as a framework for identifying structure in art education: the structure was considered as the knowledge and attitudes necessary for an educated art experience. Art teachers, however, did not agree that they wanted

their field conceived as a discipline; they remained wary of connotations of rules, preconceived products, and the domination of knowledge over intuition and imagination.

Intertwined with the movement to reinforce the school art curriculum was the perennial "artist-teacher" issue. In the late fifties, the call for the "artist-teacher" was mainly an effort to reassert the art content in what had become a child-centered curriculum and to present the art teacher as somewhat more an artist and somewhat less a psychologist. This position had been represented by D'Amico as early as the 1930s and maintained by the Council on Art Education throughout its existence. Those who emphasized the teacher as artist were less likely to agree with the position represented by Barkan, beginning around 1962, whose concern for the curriculum made the historian, critic, and aesthetician nearly coequal with the artist as authoritative sources for curriculum content and the teacher's role correspondingly diverse.[91]

Yet Barkan and others argued that the child, in Bruner's process of learning in art, truly would *be* an artist, historian, or critic. The next step—not Barkan's—logically would put the artist in the classroom.

The widely respected historian of art education Frederick Logan already had shown sensibly how the goals, preparation, and responsibilities of artists and school teachers differed.[92] Manzella made the most of the difference in 1964: school art was bad because the graduates of art teacher preparation programs were hopelessly undereducated in art, and one remedy was to bring professional artists into the schools as teachers.[93] The argument was flawed but provocative. The New York University seminar in 1965 used essentially the same premise to recommend that leading artists and scholars be engaged to improve the quality and extend the scope of art teaching at every level and that professional artists be recruited to teach in secondary school classrooms.

Thus by 1965, when national endowments for the arts and humanities were created, art educators themselves had helped to provide the rationale by which they could be bypassed, as the federal agencies pursued their loosely defined responsibilities for education and the support of professional artists.

91. Manuel Barkan, "Transition in Education: Changing Conceptions of Curriculum Content and Teaching," *Art Education* 15, no. 7 (October 1962): 12–18, 27. Reprinted in Eisner and Ecker, *Readings in Art Education*, 420–30.

92. Frederick M. Logan, "Artist in the Schoolroom: A Modern Dilemma," *Studies in Art Education* 1, no. 2 (Spring 1961): 66–84. Reprinted in Eisner and Ecker, *Readings in Art Education*, 431–443.

93. David Manzella, *Educationists and the Evisceration of the Visual Arts* (Scranton, Pa., 1963).

(margin note, handwritten): Debate whether art was a discipline

An alternative employment of artists was suggested in 1964 by a presidential Panel on Educational Research and Development. Its report proposed "music and art centers," staffed with practicing artists, for innovative education within the school system.[94] Several such projects were funded later in the decade, with considerable enthusiasm, as programs for unusually interested or talented children. Critics, however, feared that these afterschool programs would be used to eliminate art from the general curriculum.

At the end of the decade, the CEMREL *Guidelines* recommended that "members of the artistic community should be consulted" to ensure authenticity in curriculum planning. Under Madeja, the idea was taken further: the development of the final unit resource packages employed artists, not as consultants, but as the actual authors of the curriculum.

In 1969, the National Endowment for the Arts began its Artists in the Schools Program with an allocation of $100,000, to which the Office of Education added $45,000. By 1972, this cooperative funding totaled $2,500,000: the issue that had grown through the sixties had reached a new level as a question of national educational policy.[95]

Behavioral objectives became an issue in art education in the same period when the pressure to demonstrate curriculum efficiency could no longer be avoided. Since the revolt against "scientism" in the 1930s, the mission of school art as open-ended creative expression had excluded predetermined outcomes. In the late sixties, as the general drive for academic excellence threatened to dominate the curriculum and as art education shifted toward more cognitive content, behavioral objectives offered competitive utility and seemed somewhat less inappropriate. Moreover, behavioral specification of hypotheses and results seemed to promise improvement in experimental research in art education.

Yet art educators were wary. Bloom's taxonomies of learning had provided new analytical tools, but their separation of cognitive, affective, and psychomotor learnings seemed to distort or deny the unity of the creative process. Mager's programmed instruction for designing behavioral objectives gave to the whole idea the repellent aspects of systematized binary logic. When Woodruff advocated behavioral objectives at the Penn State seminar and at the subsequent Conference on Curriculum Development in Art Education, he observed that "the notion appears to provoke some feelings that the essence of an esthetic

field might be violated by forcing it into something as highly structured as a behavioral act. The notion is relatively new in this field and not altogether digestible yet."[96]

Woodruff's work with art educators continued. In 1968, in each of the four National Art Education Association regions, he led preconference programs for research training that were explicitly an "outgrowth of [the] Penn State Conference, 1965." In the next year, a second workshop preceded the national conference. These programs provided art education with the most complete proposals for the use of behavioral objectives in research, curriculum design, and classroom teaching.

Behaviorists recognized that in the complexity of human interaction with the environment much of stimulus and response was internal. Woodruff presented a "cybernetic cycle" of information processing through individual values, perceptual screen, and feedback assessment that led to an adjusted response—the process that McFee had built into her "perception-delineation theory." In this construct, learning was behavioral adjustment, and the education that society needed was guided change in behavior.

Thus, art was construed as interaction with certain objects in the environment. But educational objectives phrased in terms such as "appreciation" were inadequate for behaviorists because they lacked specifiable referents, whereas behavioral statements could specify objectives, conditions, content, and observable results. The claim was no less valid for art, said Woodruff, once it was understood that a feeling component existed in every interaction with the environment and in every resulting concept—concepts of objects, situations, events, processes, and relations. Thus, in reference to the production and appreciation of art, Woodruff conjoined Bloom's *cognitive* and *affective* categories, and he replaced *skills* (gained simply through practice) with *instrumental competencies* that required and demonstrated conceptual development.

One further principle was essential: a concept could not be given by the teacher; rather, it could only be developed by the learner through the cybernetic cycle in response to experience.

From this base, Woodruff moved to curriculum and teaching. Reaching back to Kilpatrick's *project method* of the 1920s (and thus inferentially to Dewey) he developed the *carrier project* as a feasible, satisfying vehicle for specified learnings. Progress through the project would be incremental. The art teacher would have to become analytical: at each step, what concepts and competencies would be needed? Toward these developments, what information, from what sources, with what tools and materials? And what

94. The Panel on Educational Research and Development, *Innovation and Experiment in Education* (Washington, D.C., 1964), 36.

95. Elliot W. Eisner, "Is the Artist in the School Program Effective?" *Art Education* 27, no. 2 (February 1974): 20.

96. Woodruff, "Report of the Conference Evaluator," 105.

behavior would evidence each incremental gain?

Participants in these National Art Education Association workshops could spend an afternoon sharing the difficulties of designing a project at the potter's wheel, identifying the requisite conditions, concepts, and competencies for learning to raise a cylinder, and arguing the criteria of height and thickness of a wall. In the search for behavioral evidence of growth in appreciation, it was hard to give up concerns for values and attitudes. In reference to teaching, reactions of participants ranged from utter rejection to full conversion, with a middle view that acknowledged the value of more sophisticated planning but doubted the feasibility of implementing it in American schools unless teachers were ready to accept packaged curriculum units designed by specialized theorists. It was in certain areas of research that the techniques of analysis and specification seemed most readily useful.

Criticisms of the trend toward quantifiable assessment in art education and of behavioral curricula in particular had appeared before these two National Art Education Association workshops. Eisner in 1967 conceded possible benefits of the behaviorist approach: close analysis might clarify beliefs and values, produce better relationships of ends and means, promote better understanding of cognitive and affective learning processes, and lead to more effective tools for assessment.

But at the same time, Eisner and others warned of unsound premises and negative probabilities. Though it seemed logical to define objectives before planning the curriculum, it might not be psychologically valid either for teacher or students. In the dynamic, complex classroom process, the number of possible outcomes greatly exceeded the capacity to prescribe content and behavioral criteria, especially in the arts. If teaching were limited to ends that could be behaviorally demonstrated and only to those that were prescribed, the result would be an unwanted uniformity. Verbalized behavioral tests were not dependable; performance tests were time-consuming, not dependable, and usually artificial. What was needed, Eisner argued, were not standardized measurements but qualitative judgments, and he devoted much attention in later years to qualitative evaluation, to the teacher as "critic," and to "educational connoisseurship."[97]

Criticism from existentialist and phenomenologi-

cal positions were a reminder that the movement for behavioral objectives had come at a time when individualism—and at the extreme, antirationalism and even anarchical attitudes—was at a peak in American society. The philosopher Eugene Kaelin told the National Art Education Association national convention in 1969 that the self-determination of the student should be paramount. Education should promote the "existential transcendence" of the student "toward that individual he would like to become." The classroom environment and the teacher personally would have to be open to the creative expression of the student: where "the student leads, the teacher follows." "To allow [the behavioral scientist] to begin the enterprise on the basis of correlations already set up between other students of the same age and background would represent the greatest tyranny of the group over the individual since the invention of parents," and would perpetuate "a second kind of tyranny—that of the past over the future."[98]

But behavioral objectives were gaining approval. At the same convention, in a workshop led by Woodruff, Guy Hubbard and Mary Rouse showed behaviorist planning in their projected series of texts for elementary art education, and both Donald Jack Davis and David Ecker contributed explanatory materials. Barkan and Eisner already had moved in some degree toward the use of behavioral objectives. Davis soon authored a book on the subject for the National Art Education Assocation.[99] Kenneth Lansing, in 1969, could say proudly that his was "the only textbook in art education to present behavioristic objectives for the preprimary, primary, intermediate, and junior high levels of the elementary and secondary schools," and he based those objectives on Bloom's taxonomies.[100]

The Art Curriculum

Pressures for Change

As the states hastened to establish agencies to channel the exciting flow of federal funding in mid-decade, curriculum design in art education at all levels began to be influenced by the provisions of the Elementary and Secondary Education Act, the establishment of endowments specifically for the arts and humanities, and the conceptions promoted through U.S. Office of Education conferences organized by Kathryn Bloom. A common policy in federal and state agencies was the treatment of the arts as one distinct

97. Elliot W. Eisner, "Educational Objectives: Help or Hindrance," *School Review* 75, no. 3 (Autumn 1967): 250–60. The article is followed by three commentaries and a response by Eisner. He published similar views in "The New Rationality in Art Education: Promise or Pitfall?" *Art Education* 22, no. 2 (February 1969): 6–10. See also Jerome Hausman, "Teacher as Artist and Artist as Teacher," *Art Education* 20, no. 4 (April 1967): 13–17.

98. Eugene F. Kaelin, "Are 'Behavioral Objectives' Consistent with Social Goals of Aesthetic Education?" *Art Education* 22, no. 8 (November 1969): 4–11. The quoted passages are found on pp. 6–7.

99. Donald Jack Davis, *Behavioral Emphasis in Art Education* (Reston, Va., 1969).

100. Lansing, *Art, Artists, and Art Education*, vii.

sector in the school program.

Certainly school activities that brought the arts together were common already around the beginning of the century, in plays, pageants, tableaux vivantes, and "aesthetic dance." The vitality of the arts used throughout the curriculum was a feature of progressive education. The opposed idea that the best relationship of the arts was to each other, which James Mursell had asserted in the thirties, became an organizing concept for some of the innovative programs in the sixties. But even in these curricula, the arts were more often directed toward or fortified by new interest in the humanities and aesthetic education.

Related arts programs never achieved a common form or a definition of the arts involved. Often they were temporary collaborations among two or three interested and versatile teachers—an English teacher who led a dance band or an art teacher who created stage sets. If a key person departed, the program collapsed. Home economics or industrial arts might be involved without music. The visual arts might be limited to painting, sculpture, and architecture. Literature might be excluded. Dance was the least likely component.

The conceptual framework, if any, varied. One unifying theme drew from the ideas of Read and Langer: the common thread could be the expression of feeling. Many programs were built on the proposition that all arts employed the same elements and principles of composition, but the strained analogies were criticized: texture in music or in dance was simply not the tactile quality of fabric or sculpture, and so on. Others found that the creative process could be the focal core. Geraldine Dimondstein proposed four "features" of all artworks as fundamental concepts: their definition and description; their distinguishing characteristics; their elements and principles; and the "experiential approach" in creating or responding to the work.[101] In a conceptually uncomplicated pattern, ninth-grade students circulated through each art area before choosing one course to fulfill a graduation requirement. Another option—for any kind of curriculum—worked through visiting artists and speakers, films, and trips to museums or performances: a New York State program in the late 1960s provided "well over 1,000 performances for more than one million secondary school students" and began similar efforts in elementary schools through external organizations like Young Audiences.[102]

Aesthetic education claimed a further goal for

the unified arts. Even in the efforts of Mann, Barnard, Alcott, and Peale in the 1830s, art education always had aspired toward some kind of aesthetic development. In the nineteenth century, the aesthetic vision grew from faith that school art would lead to love of beauty and, thus, to truth and morality. In the early days of museums and photo-reproductions, picture study was a more deliberate inculcation. Dow and his successors variously expected work in the art media to result in good taste, good craftsmanship, communication of feelings, or good judgment in civic and domestic design. None of these intentions had been wholly abandoned, and in each, an aesthetic theory was at least implicit. But until the mid-sixties, there had been no concerted movement toward a curriculum built on analyses of aesthetic theory that might dominate or even absorb the established conception of art education. This movement developed, however, with no real consensus of purpose or rationale.

One group, centered at the University of Illinois with Ralph A. Smith as the leading art educator and Harry Broudy as the presiding philosopher, saw aesthetic perception and judgment as the key to an education in values that was desperately needed in a time of cultural crisis. The highest concentration of aesthetic values would be found in great paintings; only acknowledged masterpieces warranted attention. Through such exemplars, children could master the essentials of the critical process: description, analysis, interpretation, and evaluation. This progression fitted the hierarchy of cognitive learnings set forth in Bloom's taxonomy. The learnings would be generalized to the full extent of humanistic education, to personal conduct, civic responsibility, and social relations.[103] This conception was elaborated by Smith and Broudy in many publications and conferences, while related philosophical issues were brought to the profession by Smith as editor of the *Journal of Aesthetic Education.*

An alternative approach—indeed, a number of alternative possibilities—appeared in the CEMREL *Guidelines.* As curriculum theorists, the authors claimed validity for aesthetic education in its contribution to the established general educational aims of personal development, societal improvement, and transmission of cultural heritage. Where Smith limited his method to "aesthetic criticism" of masterpieces, Barkan and his colleagues retained the duality of production and response. In one sense narrower than Smith's, they set aside humanistic studies as concerned distinctively with ethical problems. But their aesthetic domain was broadened to include all of the

101. Geraldine Dimondstein, "A Proposed Conceptual Framework in the Arts," *Studies in Art Education* 10, no. 2 (Winter 1969): 6–11.

102. Reported of the Statewide Performing Arts Education Program in *Division of the Humanities and the Arts* (Albany, 1970), n.p.

103. Ralph A. Smith, "Aesthetic Criticism: The Method of Aesthetic Education," *Studies in Art Education* 9, no. 3 (Spring 1968): 12–31.

arts and extended to the "man-made and natural objects and events" of the environment. The content and activities to be specified in their curriculum units were drawn from artists and historians as well as critics and aestheticians. The writers of the *Guidelines* were capable producers of art as well as theorists: for them, it was not inconsistent that a thoroughly systematic scheme for curriculum design, with a massive provision of conceptual content, was introduced as a plan to increase the student's capacity for aesthetic experience, with emphasis on "direct psychological response."[104]

In the curriculum materials produced during the second phase of the Central Midwestern Regional Educational Laboratory project, sensory experience was indeed basic. The preparatory conceptual research embodied in the *Guidelines* was subordinated: aesthetic philosophy, it was said, was a "small umbrella with which to cover the whole arts program," especially in elementary classrooms.[105] With regard to method, CEMREL's unit packages were designed to be "teacher-proof," enabling students to carry out a variety of learning activities even where instructors lacked theoretical preparation. The effect on content, according to one of the authors of the *Guidelines*, was reliance on the traditional formal elements of art, with loss of the initial framework of aesthetic learnings.[106]

In regard to administrative organization, Central Midwestern Regional Educational Laboratory leaders saw several possibilities. Their plan proposed a distinct area of studies with daily classes in every grade. Alternatively, with separate courses in each of the arts, aesthetic content could be introduced either to these courses or in appropriate contexts in the other school subjects—"the aesthetics of language, the aesthetics of science, and the aesthetics of mathematics."[107] In any of these options, however, aesthetic education was distinguished from those programs that failed to treat each art as a discipline, conceived all the arts as unified by formal or other commonalities, and lacked the concepts of aesthetic philosophy (i.e., the many programs loosely tagged as "related arts").

Still other versions of aesthetic education were proposed. One of these insisted on the essential primacy of immediate sensory experience, with little or no concern for philosophy. Another, quite in contrast, aimed directly at the skills of reasoning to be nurtured in children through the discipline of aesthetic philosophy. Vincent Lanier spoke for those who saw the need to begin in the student's everyday experience, helping them toward awareness and judgment of aesthetic values in the commonplace physical environment and in the popular media. For Lanier, what he had long advocated as a realistic strategy for art appreciation had matured to the higher and more general level claimed for aesthetic education.

Humanities courses, mostly in high schools, became the most popular vehicle for relating the arts. Educators followed public interests and concerns: ethical and spiritual learnings were wanted; cultural studies seemed neglected in the campaign to strengthen science and mathematics; world leadership called for multicultural understanding; high schools copied college patterns of core requirements; and the integration of the curriculum was still a goal. The arts could add interest, motivation, and relevance to academic material; in turn, a humanities course could justify a threatened arts program. Federal legislation provided rationale, agencies, and funds.

The status accorded the term "humanities" was evident in the sheer variety of courses given the name. The role and content of the arts varied accordingly. Closest to the conventional conception were courses that brought the arts and literature together with broad social studies and aimed to encompass the whole history of human problems, beliefs, and values. Especially if the scope were global, the content might be organized around "great" themes or topics, and the culturally appreciative studies of the arts would be most fully extensive. If the course were limited to the "western heritage," a chronological development would be more feasible. In either case, and whether the arts were engaged seriously or used merely as illustrations or moments of relief, the art teacher in the instructional team would not have been adequately equipped by the usual college art history survey taught in the sixties.

In some instances, the "humanities" course was no more than language arts, visual arts, and music aimed toward "understanding the arts" and asserting that the arts and the humanities were identical (despite the separate federal endowments). Rather than a single course, a humanities program could be a more or less thoughtful introduction of arts content into regular high school courses. (One such program, called CUE, will be described below.)

Still another kind of course or program called "humanities" was based directly on contemporary forms of age-old problems found in the students' own experience and intended primarily to engage and motivate inner-city youth through an "education for the real world." Creative as well as appreciative activities in the arts often were planned to encourage the student to link personal situations and expressions to

104. Barkan, Chapman, and Kern, *Guidelines*, 9.

105. Madeja and Onuska, *Through the Arts to the Aesthetic*, 6.

106. Evan J. Kern, "The Aesthetic Education Program and Curriculum Reform," *Studies in Art Education* 25, no. 4 (Summer 1984): 234.

107. Madeja and Onuska, *Through the Arts to the Aesthetic*, 8, 9.

the art of other times and cultures—to the humanity that lived before and beyond the deprivations of their neighborhoods. But the approach through the contemporary and personal was not necessarily depressing. One such course in a midwestern city was taught by an art teacher who was a painter and an old-time jazz trumpeter; his most popular team member was another art teacher famed among students as a builder of racing cars.

The humanities approach was less often developed in junior high school, but even elementary education was encouraged to apply the Brunerian principle that basic concepts such as these could be introduced at any age. Whatever an interdisciplinary arts curriculum initiative was named, it usually required teamwork among teachers, together with extra effort, materials, and money. These extras too often were lost when external funding ended. But in the sixties this negative experience was not yet common: the movement to unite the arts in the curriculum reached its full development in the next decade.

Disadvantaged learners were not a new problem in art education. Arts programs for kids in big city neighorhoods were at least as old as Jane Addams's Hull House in Chicago of the 1890s, where John Dewey was a friend. Teachers College, Columbia University, originated in such a free school in the 1880s. In the thirties, the Depression had stimulated federal welfare programs that included the arts and education. Since then, however, a whole generation of art teachers had experienced no such governmental support for social idealism in the classroom. To them, the federal funding of the sixties was new and so was the national concern for ethnic groups, minorities, and the poor, which had grown through the campaign for desegregation.

The disadvantaged included not only African-Americans and Hispanics but also native Americans, isolated rural children, and recent immigrants. What art teachers had learned from working with such children was seldom compiled and published.[108] This was not a common field of research in art education before the mid-sixties. Silverman reported that in a list of seventy-four projects using art in compensatory education, only about a dozen provided adequate assessment data. Yet, with little proof, there was general belief through the sixties in the value of art in special programs for the disadvantaged.

Funded projects included summer classes (staffed with classroom teachers, remedial specialists, and psychologists as well as art teachers); model schools and districtwide art centers; and in-service education

for teachers. The goals for such projects were remedies for familiar problems: dropouts and delinquency; lack of identity, self-esteem, and motivation; short attention span and poor work habits; environmental squalor; and the learning impediments attributable to cultural deprivation.

The strategic and tactical advice for such projects was typified in one of the U.S. Office of Education conferences organized under Kathryn Bloom's direction in 1966, this one at Gaithersburg, Maryland. From the viewpoint of the anthropologist, it was important that teachers learn and respect the culture of their students and to avoid the simple imposition of mainstream ideas of art and life: use of popular media and folk art of the culture would add a sense of relevance and strengthen identity. A psychologist observed that apathetic adolescents might respond to artists as provocateurs of social change. Experience in neighborhood centers had shown the importance of engagement with parents and community leaders. The existing body of research on effects of sensory deprivation indicated the value of perceptual stimulation. Experts agreed that these children should be led to work from the concrete to the imaginative. Work with tools would compensate for undeveloped small-motor skills. Frequent exhibition of student work would help to build self-esteem. Elsewhere, McFee recommended that children's confidence would increase if they were helped to learn about art in ways that were familiar and well guided, without stress on individuality and originality.

The Gaithersburg conference revealed also two opposed attitudes toward the aims of art projects for the disadvantaged. Those who saw a need for fundamental reform of society called for the artist as agent of change to be brought into the schools as well as into nonschool centers as cohorts or even replacements for school art teachers. For them, the school was the enemy of change, the instrument of the status quo. Yet one of the aims of compensatory education was the development of accommodation to societal norms and institutions, with the school as exemplar and training ground. Although some were energized for immediate action, others—mainly educators—saw the need for thorough research. The situation was reminiscent of the New College of Teachers College in the thirties, where art education students and all others were required to engage in some form of social work, as Professor Counts and his associates exhorted educators to lead the reconstruction of society.

The influence of these projects on subsequent art education is not easily assessed. Certainly out-of-school centers proliferated. Some teachers did shift from traditional curricula to develop art activities from the popular media and from the common experiences and problems of their students. To some

108. Among well-known books, see Natalie Cole, *The Arts in the Classroom* and *Art from Deep Down Inside*, and June K. McFee, *Preparation for Art*. See also McFee, "Art for the Economically and Socially Deprived," in Hastie, ed., *Art Education*, 153–74.

extent, therefore, this was a movement away from the idea of any single established curriculum or body of content, away from any mainstream conventions of form and style, away from the models of art disciplines, and toward the flexibility and personal concerns that were urged as goals of "humanized" education in the late sixties. It might be said, in other terms, that the influence of art programs for the culturally deprived moved away from the momentum of the Penn State seminar by emphasizing the student personality and the society, while the subject was instrumental. But for those who conceived art as a social medium of engagement with ongoing experience, the movement would have been in precisely the right direction.

Curriculum Research and Development Projects

The technique of curriculum design in art education had developed quite regularly before World War II, despite changes in every aspect of the curriculum itself, from graded drawing manuals to Smith's detailed schedule for industrial drawing, through the Prang publications and National Education Association committees of the 1880s and 1890s, the plans of Bailey and Sargent and the graded texts and workbooks preceeding World War I, the publications of Mathias, Winslow, and Whitford in the twenties, and the more complex design of the integrated units and the Owatonna Project in the thirties. After World War II, however, emphasis on creative self-expression and individual development reduced the concern for uniform content and sequence of learning. The resurgence of these concerns in the sixties and the stimulus of federal funding described above, brought a new level of interest in curriculum theory and technique.

The inadequate status of curriculum guides was shown in the National Education Association survey of music and art education in 1963. Fewer than 54 percent of public secondary schools offered art courses; of that number, only 57 percent followed a written curriculum; fewer than 40 percent of the curricula had been revised within the previous five years.

But the usual kind of revision would hardly have mattered in the opinion of conferees at the New York University and Penn State seminars because local art teachers, they believed, had neither the time nor the requisite expertise for curriculum design. A recapitulation of elements of curriculum planning asserted at the Penn State seminar (not all of them congruent) indicates a new level of expectations:

■ Formulation of content through understanding of cognitive structure and operational processes employed by artists, art historians, art critics, and aestheticians

■ Description of objectives, behavioral or other-

wise, that would facilitate assessment of learning outcomes

■ Use of both discipline- and project-centered approaches for organization of teaching and learning activities

■ Use of questioning about social, cultural, and spiritual values of art in many cultures and historical periods as a contribution to humanistic education

■ Analysis of extended projects or units to identify each concept and competence needed as incremental learnings, with the teaching, learning activities, and materials needed for each

■ Assessment of learning outcomes according to predefined criteria

■ Design and production of materials for teaching and self-instruction, including teaching machines as well as conventional media, followed by dissemination, teacher training, systematic evaluation, and redesign

Given such scope and complexity, the research and development centers recommended by Eisner and Barkan seemed inevitable: completely packaged curricula would be produced for adoption by school districts. Barkan suggested that such curricula could meet the varied needs of all the nation's schools if they were designed to fit perhaps seven sociometric models. As the particularity of schools was reconsidered, however, an alternative approach was proposed: the centrally designed product rather than completed plans and packages would be the guide to planning that could be carried out in the local district, with instructional materials made widely available. Both of these two kinds of curriculum development projects followed the Penn State seminar.

THE "TV GUIDELINES." The idea of a sophisticated framework to aid local planners was put to use directly by Manuel Barkan and Laura Chapman, who wrote *Guidelines for Art Instruction through Television for the Elementary Schools* for the National Center for School and College Television.[109] These "TV Guidelines" exemplify the principles summarized above. Planning would proceed through determinations of goals, subgoals, content, teaching materials, teaching activities, child activities, and behaviors that were to be encouraged. Learnings and activities fell into two categories:

109. Barkan and Chapman, *Guidelines for Art Instruction through Television.* See also Laura H. Chapman, "Subject Matter for the Study of Art," *Art Education* 20, no. 2 (February 1, 1967): 20–22.

making and response. For lessons emphasizing "making," subgoals and content were derived from stages of the creative process: children would learn ways of getting, visualizing, and elaborating ideas and of using media to give them form in works of art. In lessons emphasizing "response," children would learn how "informed observers" (critics) used words to define, describe, interpret, explain, and make judgments or statements of value according to criteria.

To provide focal interest in each lesson, four "organizing centers" were recommended: subject, theme, or idea; medium and forming process; art form; and style or cultural idiom. On the claim that no direct guide to sequence could be derived from the history or media of art or from developmental patterns (other than simple physical capabilities), the planner could start with a focus on any of the organizing centers. One selected element of learning content would be carried through all four centers to form a cluster of lessons that would show the scope of the visual arts while maintaining continuity. Seasonal interests, local events, and holidays would be used as subject matter or theme.

The "TV Guidelines," of course, did not produce instructional materials. Otherwise, they could have guided elementary art teachers just as well as television writers: indeed, the structure for curriculum planning, as subsequently elaborated by Chapman, became the foundation of notable guides published by the state of Ohio.

THE STANFORD-KETTERING PROJECT. A second project exemplifying the principles advanced at the Penn State seminar was led by Eisner at Stanford University, with funding by the Charles H. Kettering Foundation. Staffed by graduate students and collaborating elementary school teachers, the project produced a curriculum for the usual self-contained classroom, complete with an extensive correlated kit of instructional materials to be shared throughout the school.

The curriculum embraced the three domains recommended at Penn State. In the productive domain, lessons were designed to promote the acquisition of what Woodruff would have called operational, or "process," concepts, associated by Eisner with the "mode" and media of artworks. In the historical and critical domains, lessons were built on concepts employed in basic principles or generalizations about art (e.g., "Compositions can be active or static" and "Artists have frequently criticized the periods in which they lived").[110] For evaluation, "instructional

objectives" were criterion-referenced descriptions of behavior and content to be learned. But Eisner added "expressive objectives," which described the learning experience in terms that supported individuality. The curriculum materials provided for seven units, each consisting of about nine lessons. Each lesson plan identified the domain(s); concept or mode; principle or medium; rationale of purpose; objectives; motivation and learning activities; instructional materials; and evaluative plan.

Thus, the curriculum was structured and sequential and built upon conceptual content derived from the professional disciplines of art. Though its products were not widely disseminated, the Stanford-Kettering project was influential: it was, in effect, a two-year model of planning, production, and field testing for the kind of curriculum development that Eisner and Barkan had recommended.

CEMREL. The CEMREL *Guidelines* mentioned earlier provide the most detailed representation of advanced thinking about curriculum design for art in the late 1960s. This was not in itself a curriculum, however, nor was it confined to the visual arts. It was developed to assist the designers of packaged curriculum units for aesthetic education and therefore was concerned also with music, dance, theatre, literature, and the general environment.

The *Guidelines* exhibit the contemporary concern for specification of every element of a learning experience. An adequate "curriculum sentence" would state: (1) a subject (usually the student); (2) a verb ("activity descriptor"); (3) an object of attention; and (4) an object as context. Thus, for example: "The (1) student is (2) describing (3) the composition of (4) a charcoal drawing of a still life." It will be noted that the model sentence contains no specification of criteria for evaluation of the intended learning. There were, however, criteria for evaluation of the effects of the unit, for teachers as well as students, such that the design could be improved before production. There was no commitment to behavioral objectives: evaluation was said to be too complex to be left to the "measurement specialists," and though it was to be a serious concern for the curriculum writers, the problems of evaluation of student learning were not treated in detail.

The *Guidelines* also were influenced by the contemporary interest in game theory. Curriculum design was likened to a game: in the "curriculum game," the "moves" were the choices of possible specifications to complete the formatted sentence. Games have rules, which in this handbook were carefully stated principles of educational adequacy. The array of choices for curriculum moves was presented in a series of appendices that filled some 547 pages.

One appendix presented a total of 1,195 brief quotations culled by the research team from the liter-

110. Elliot W. Eisner, "Curriculum Making for the Wee Folk," *Studies in Art Education* 9, no. 3 (Spring 1968): 48; and idem, "Stanford's Kettering Project," *Art Education* 23, no. 8 (November 1970): 4–7. See also Gilbert A. Clark, "Beyond the Penn State Seminar: A Critique of Curricula," *Studies in Art Education* 25, no. 4 (Summer 1984): 226–32.

ature of aesthetics, the arts, and curriculum theory that embodied concepts that could suggest purposes, content, centers of attention, or evaluative criteria. Many terms for "centers of attention" were listed in a thesaurus, under six categories that indicate the scope of the intended aesthetic education: natural and man-made objects and events; general characteristics of art forms; functions of art forms; sensuous qualities of art forms; persons concerned with the artistic community; and settings for the arts. Also listed were 281 verbs to serve as "activity descriptors." Verbs were classified in seven categories that represent intended learning behaviors: react, perceive, produce/perform, analyze, value, judge, and talk. Each of these verbs was employed in six illustrative "curriculum sentences," one for each of the five arts and one for the general environment.

This huge collection of materials was then cross-indexed and coded on "keysort" cards (a predecessor of computers) that enabled the player of the curriculum game to select a desired class of possibilities from which to choose a component of a curriculum sentence. The *Guidelines* thus provided an unprecedented assembly of researched material, organized for suggestive use in a carefully systematized procedure. The research work might appear as a demonstration of the proposition that the entire responsibility for curriculum design could not be left to any team of local teachers.

In the second phase of the CEMREL Aesthetic Education Curriculum Program, the production of curriculum packages followed a carefully buttressed procedure. The design of a unit was begun by content specialists in the arts disciplines who worked with curriculum developers to organize selected concepts into a topical outline. Once the content and learning objectives were defined and an appropriate sequence of learning activities was determined, the writers, designers, and media specialists prepared materials for an initial classroom trial by the team. After evaluation and revision, the unit was tested again in a normal classroom situation. More detailed evaluation—analyses of teacher and student reactions, oberver reports, and assessment of learnings—led to final production of the package in preparation for pilot testing in collaborating schools.

THE UNIVERSITY CITY PROJECT. CEMREL's project in aesthetic education remains the prime example of centralized research and development for school art curriculum. An exemplar for another approach, the heavily funded project in a single "model" school district, was conducted in the same period in nearby University City, Missouri. This was the Arts in General Education Project, the first of three school district projects financed by the JDR 3rd Fund under Kathryn Bloom's leadership. With Stanley Madeja as staff director at University City, CEMREL assisted in planning and evaluation and made some of its materials available.

This model school project involved students in all elementary and secondary grades. Aiming initially "to permeate the general education program with arts concepts in order to improve the level of arts instruction," the project concentrated more practically on production of eight curriculum units relating the arts to social studies (environmental and community concerns) and English (language and theatre arts). Another six units were described as "interdisciplinary arts." Beginning in 1969, the project was allocated funding for one of the first six artists in residence programs funded by the National Endowment for the Arts.

The procedure tested the capacity of a school district to develop its own curriculum. Selected teachers took a leading role in the design and testing of the units, supported by released time and aided by workshops, arts specialists, and CEMREL evaluators. The final report concluded that "while teachers proved essential for some parts of the curriculum development process, they are probably not the best possible initiators and leaders in that process."[111] One of the problems was that the absorption of the teacher-designers in their own classroom program tended to reduce the generalizability of the produced units, even among other schools within the district. The average time elapsed in the production of each unit was sixteen months. It appeared that school districts might be better able to revise for local purposes curriculum materials that were produced for general use by specialists. On either option, it seemed that all teachers would need more thorough preparation for such a curriculum: the teachers tended not to follow the written plan; they judged the units according to the pleasure exhibited by students (an indication of the unessential status of arts education); and they effectively resisted the use of behavioral objectives of the kind advocated by Woodruff.

THE HUBBARD-ROUSE ART CURRICULUM. An adjunct component brought into the University City project was the elementary-level curriculum, in its "prepublication version," that Guy Hubbard and Mary Rouse at Indiana University had been developing since as early as 1963.[112] Through these years, Hubbard and Rouse had worked with classroom teachers to create lesson plans that would enable them to achieve substantial learnings without depending upon an arts specialist. Student texts, not workbooks, gave the child instruction for each lesson. The content was sequential through the six elementary grades, with an emphasis on productive concepts and

111. Madeja, *All the Arts for Every Child*, 95.
112. Guy Hubbard and Mary Rouse, *Art: Meaning, Method, and Media* (Westchester, Ill., 1973).

skills. Behavioral objectives were specified. In the teacher's manual, plans were written for unsophisticated intelligibility, with each step instructed in practical detail, including the requisite or appropriate allotment of time.

In the 1969 version at University City, teachers favored the organization and utility of the curriculum. Some felt that the plans impeded creativity through excessive structure. Again came the expectation of fun in activities that had long been considered a relief from more important school disciplines. Even so, a subsequent reviewer found that the Hubbard-Rouse curriculum, after its publication in 1973, achieved its purpose in many of the schools that lacked the support of art specialists.[113]

Two state programs represent other methods of change and further illustrate the variety of conceptions of the humanities. In New York, the CUE project grew out of a collaboration with the U.S. commissioner of education, beginning around 1962, in distributing reproductions and slides from the National Gallery to schools across the country. For the use of these materials, a humanities course was the initial choice. But instead of pushing a new course into curricula, it seemed better to plan the integration of each of the arts into major secondary school subjects, thus reaching all students and showing relationships more fully. Books were produced, one each for social studies, science, home economics, and industrial arts. Each book offered complete lesson plans using "cultural items," mainly films relating to arts or foreign cultures, to implement the curriculum in the designated subject. The standard format of the lesson plan included cultural item; curriculum area within the subject; purposes; synopsis of the cultural item; suggested preparations by the teacher; points for attention; follow-up activities; related activities and questions; related creative activities; and related materials and resources.

As the basis for planning, thirteen schools submitted their courses of study for the ninth grade (commonly the last year of compulsory schooling). The arts fitted into the courses included painting, music, sculpture, literature, theatre, graphic arts, photography, film, and minor arts. The National Gallery provided each school a yearlong exhibit of forty reproductions. The Asia Society supplied exhibits of non-Western art. CUE included exhibits of Mexican and African arts. National Educational Television donated $100,000 for a television program titled "Cultures and Continents." Other efforts included live performances, workshops, a newsletter, and a variety of assessment procedures. In 1968, the New York State Education Department formalized this curriculum relationship

in its own administrative structure by establishing the Division of the Humanities and the Arts. The CUE project was followed by another, SEARCH, which extended into the seventies with support by the JDR 3rd Fund.

In Missouri, the statewide secondary school curriculum committee, as part of its ongoing work, entrusted two college faculty members with the preparation of a two hundred–page guide for a separate course, Allied Arts, designated as a humanities course.[114] The arts included were music, literature, painting, sculpture, and architecture. Drama was subsumed under literature; dance was not considered. The guide was as much a text for teachers as a plan for instruction: it followed a McGraw-Hill book, *The Humanities*, which it recommended as a text for the course.

This was not a course in appreciation of masterpieces nor was it an experience in creative expression. Its stated purpose was to develop critical judgment through understanding of the principles of the arts as found in daily life. Yet there was no attention to design in graphics, clothing, industry, or home furnishings. Seven basic "questions" served as organizers of the course: subject, function, medium (elements in each art), organization, style, judgment, and works of art (creative process, response, and content). These organizers, however, were presented for each of the arts separately: any interrelationships among the arts were to be revealed through study of some such combining form as opera.

Thus, the course was not typically a "related arts" experience. In effect, the arts were treated as constituting the humanities, although the universal and perennial problems usually identified with the humanities were hardly considered. As the guide noted, teachers for such a course had not yet been produced, but one Missouri teachers college soon developed a certification program and later a graduate program in the "allied arts."

"Depth versus Breadth"

During the fifties, the art curriculum was expected to present a wide variety of experiences in media and techniques to meet the diversity of student needs and interests and to develop a comprehensive appreciation of art. But when variety became a controlling principle, according to critics, the common results were superficial understandings, trivial products, and unrealized student potential. In contrast to such emphasis on "breadth," researchers at Penn State tested the advantages of "depth" experiences that allowed

113. Clark, "Beyond the Penn State Seminar," 227.

114. Missouri, State Board of Education, *The Allied Arts, A High School Humanities Guide for Missouri* (Jefferson City, Mo., 1963). Members of the Curriculum Production Committee were Alfred W. Bleckschmidt, Director; Leon Karel; and Alfred Sterling.

students, like professional artists, to work extensively on their own problems of form, expression, and technique.[115] The Penn State findings favored the "depth" approach. Although subsequent research on these alternatives was less decisive, "depth" came to imply continuity and coherence, fuller development of truly individual expression, and a more authentic understanding of art values and processes. As the campaign for curriculum reform developed, "depth" was readily linked to the concept of art as a discipline and to the defense of studio activity as a substantial learning experience.

The Elementary Art Curriculum

The ideas employed in the projects just described (i.e., the ideas characteristic of the late sixties) can be found also in contemporary books on elementary school art education, even in books that otherwise differ in many respects.

Probably the most general change from texts of the fifties was the agreement that the curriculum should balance *making* with *appreciation*. In Barkan's terms, *production-criticism* would be balanced with *history-criticism*, though this balance would be reached gradually, with exploratory production dominating in the primary years. In Lansing's rationale, "To reach educational objectives through art . . . a person must make and appreciate art. Thus, the major aim of art education is the production of artists and connoisseurs of art."[116]

Common also was the emphasis on cognitive learnings in the structure of the field, whether structure was construed as "visual concepts" (line, color, shape, form, texture, design elements, or composition) or, alternatively, as in Lansing's adaptation of Bruner, as the learnings needed by an artist or connoisseur. As Rueschhoff and Swartz put it, "there are basic concepts in the arts, comparable to those in science and mathematics, which can be presented in a meaningful progression."[117]

The importance of multisensory experience, beginning in preschool education, had never before been so strongly emphasized, both as the beginning of aesthetic education and as the initial step in cognitive development. The up-to-date plan for a learning experience was expected to specify the sensory stimulus for perception and the concept intended to be thus introduced or developed. Although this might have seemed merely high-falutin' talk for standard practice—the class visit to the grocery was certainly

"multi-sensory," and music for motivation was already conventional—the new emphasis fitted both the pedagogical analysis of cognitive and affective domains of learning and the quite opposite celebration of the senses in sixties culture.

Another change during the sixties was the growing agreement that lesson plans should specify the intended learning outcomes. In comparison to Lowenfeld's descriptions of progress in seven aspects of growth, authors in the late sixties showed somewhat reduced concern for the whole personality and a common dependence on the three domains of learning that were structured in Bloom's taxonomies. A National Art Education Association monograph on elementary school art explicitly stated that learning objectives would fall into Bloom's three categories (*cognitive, affective,* and *psychomotor*).[118] Lansing arrayed the learnings of artist and connoisseur under the same headings. The taxonomical heirarchy of cognitive learnings was evident commonly in the definition of expected outcomes—in terms like *aware, recognize, fact, understanding, judgment.* For affective objectives, art educators used such words as *sensitivity, appreciation, respect, interest,* and *pleasure,* which they recognized as difficult to measure. Bloom's psychomotor domain was problematic. As Lansing observed, not much could be said about skills alone; for performance in art, terms like *be able to* were used to denote a more complex competence.

With the stress on verified learnings came a renewed demand for sequential graded curricula. The understanding of sequence in the graded curriculum was modified, however, by two of the concepts advanced by Bruner. Insofar as the structure of art was construed as the visual elements and principles of composition, art educators were well aware of the relevant patterns of development in children's pictures. (Lansing's text was unusual in its attention to the work of Piaget on cognitive development.) It was agreed that the progress of learning in art was not controlled by any necessary sequence of facts, concepts, or experiences with media, so it was easy to accept Bruner's proposal that any concept could be introduced at any age in some form that was honest. Thus, the idea of the *spiral curriculum* fitted naturally: in the upper grades, the content and media introduced in the primary grades could be repeated in more advanced forms appropriate to the children's maturity.

In contrast, however, to changes represented in current writings and funded projects, most elementary art teaching through the sixties continued to depend upon activities in inexpensive media. Although the self-contained classroom was said to

115. Kenneth R. Beittel, Edward L. Mattil et al., "The Effect of a 'Depth' vs. a 'Breadth' Method of Art Instruction at the Ninth Grade Level," *Studies in Art Education* 3 (Fall 1961): 75–87.

116. Lansing, *Art, Artists, and Art Education,* 268.

117. Rueschhoff and Swartz, *Teaching Art in the Elementary School,* 111.

118. Packwood, ed., *Art Education in the Elementary School,* 72.

have fallen from fashion and a National Art Education Association position paper had called for an artroom and an art specialist in every school, elementary art still was usually taught in the classroom with limited aid, if any, from an itinerant specialist. Given the new expectations in content, media, and organization, the gap between the exemplary and the average may have been greater than ever.

The Secondary Art Curriculum

Through the sixties, little change in the organization of art programs in secondary schools was evident. In more than half of the nation's high schools, the program still was simply a succession of general arts courses. Larger or wealthier schools commonly offered electives in separate media to follow a general course. The most common electives, in order of their popularity, were drawing and painting, general crafts, ceramics, commercial art, graphics, art appreciation, metal and jewelry, sculpture, and weaving.

The independence of secondary art programs is evident in the variety of other electives. The following is a condensation of diverse titles: advanced art, sketching, figure drawing, oil, etching, senior studio or workshop, applied art, design, lettering, posters, advertising design, illustration, yearbook layout design, sign painting, photography, costume or fashion design and illustration, textile design, stage design, display, arts and crafts, leather, woodcarving, art welding, mosaics, collages, art history, contemporary art, museum trips, art production, art service, special art, allied arts, fine arts, humanities arts.

By the mid-sixties, partly due to the popularity of humanities courses, art teachers showed new interest in the history of art. Statements of goals began to emphasize the understanding of art, or "visual literacy," as the main purpose of high school art programs. "Problem-solving" and phrasings of competence in goal statements modified talk of creative self-expression. But within these subject-centered tendencies, journals and conferences, like the texts of Lanier and Hubbard, gave special importance to the particular character of the school community and to curricula designed for the needs, interests, and limitations of inner-city or rural populations. There were thus two aspects of the role of art in the mission of general education.

With these subtle shifts came increased tension in the identity problem of the artist-teacher. After 1965, from the New York University seminar through the start of the artist-in-school program, external agencies urged the teacher to become a more authentic artist; art teacher preparation programs felt the pressure to emphasize studio production. At the same time, curriculum revision asked the teacher to become more broadly competent in history, criticism, and aesthetics, perhaps in the other arts and humanities and

surely in the theory and technique of curriculum design. For some, the goal of "understanding" suggested the subordination of studio activity. Yet on the other hand, the call for more "depth" and less "breadth" in creative work implied a more nearly professional competence in the teacher as artist. One metropolitan art supervisor reported that the younger art teachers were, in effect, resolving those tensions and developing in their students more sophisticated understanding through attention to contemporary artists and styles, to criticism, and to the cultural currents in which art was engaged.[119]

In a few secondary schools, both senior and junior highs, art shared in innovative curricula. Team teaching could bring art into authentic relations with other subject matter. Computer-controlled modular scheduling enabled students to plan personally as much as 35 percent of their schedules, with longer studio sessions and more independent study. For teachers, modular schedules could give the efficiency of large grouping for lectures, demonstrations, and media presentations and thereby save time for more flexible patterns of work with small groups and individuals. Teaching machines were still a prospect, but instructional media were more effective in modular scheduling. These initiatives were described with a certain exhilaration, but Madeja, in his compilation of exemplary programs, noted that most schools had not made such changes and that "the effect of these concepts on art education programs has been minimal."[120]

Junior high art programs were modified in some cases by the advent of middle schools; otherwise, the organization of courses changed little in the sixties. Almost all junior high curricula were built around the general art course, and since few high schools required art for graduation, art teachers still planned the course as the last chance to influence the lives of most of their students. But if the school offered a sequence of general art or a few electives, these might simply be early versions of the senior high program.

Writings on junior high school art continued to emphasize the student personality, with much attention to developmental psychology—the interests and motivations of early adolescence with the problems of self-image, sex roles, aspirations, and social behavior. Curriculum guides anticipated that young teens would be interested in technical mastery, be self-critical, and thus be easily discouraged. The distinction between the visual-minded and the haptic students, it was said, would require increased sensitivity

119. Al Hurwitz, "Issues Relating to the Curriculum of Senior High School Art Programs," *Art Education* 21, no. 4 (April, 1968): 16-19.

120. Stanley Madeja, ed., *Exemplary Programs in Art Education* (Washington, D.C., 1969): 10.

and tact in the teacher.

Pressure for academic excellence threatened the conception of the junior high as dedicated to individual exploration. Thus, "understanding art," as a newer goal, implied more learning of history, more awareness of contemporary forms and styles, and more discussion of personal preferences. Students also were to be engaged in aesthetic judgment in the practical context of personal and community life because such situations would meet the requirements of realism and relevance in their final art course. Understanding the nature of art also implied no reduction in learning about the elements and principles of visual design or composition. But these learnings would best be achieved through individual creative work because, in all that was said of adolescent psychology, the nurturing of self-expression remained essential.

The Contents of the Art Curriculum

Whatever the forces for change, apparently no art activity of the fifties was abandoned in the sixties. Although leaders insisted that essential learnings in art were more important than derivative contributions to other subjects, correlation was continued with enthusiasm. Curriculum reform called for authoritative definitions of scope and sequence, but whatever a curriculum guide might say, most art teachers continued to build their own yearly plans with lessons or projects refined through successive use, plans that "worked"—manageable, motivating, and adequate according to their own purposes. And many resisted uniform plans or schedules on the grounds that the dynamics of each student group were paramount and unique, that the flow of genuine interest was unpredictable.

Teachers who acknowledged creativity as a primary goal continued to seek activities that might break students free from clichés and preconceptions that inhibited imagination. Often the stimulus was novelty of medium, tool, or form. As the decade progressed, students responded to the phenomena of social and cultural disorder, sometimes more readily than did their teachers. By the late sixties, the new styles in the arts, with all diversity of concept, form, and method, began to be reflected in the classroom.

Drawing and Painting

Among the media and processes employed to promote aesthetic perception and avoid inhibitions, wash-offs and resists and the various uses of melted crayon as encaustic were already common. Sand was sprinkled on glue, mixed into tempera, or included among pigments found in nature.

Here and there, students painted with photo developer on print paper; with household bleach on colored papers; with bottled shoe-polish applied by the dauber inside the cap; and with the smoke of a stick of pine. Much the same lesson could be taught by tools that were undignified and apparently clumsy but capable of unique effects—sponge, cloth, string, cardboard, knife, twig, or plastic mustard dispenser.

A similar strategy teased out controls that seemed impossible: paint with smoke; blow ink puddles through a straw; pour ink and manipulate its flow on the paper; dribble tempera and oil paints together. An experimental, playful attitude and the recognition of formal possibilities were the keys to success.

These novelties were legitimized, at least for teachers, by Bauhaus teaching and by the practice of some of the most successful of contemporary artists. The important potential learning—the realization that aesthetic quality was independent from conventions of material and technique—was established in current aesthetics. But the outcome of such classroom experiments, whether triviality, misconception, or fundamental insight, depended precariously on the sophistication and acumen of the teacher and the subsequent application of the learning.

Multisensory awareness, not simply an expansion of the sensibility of the student in visual arts, was also a requisite of the various conceptions of relation among the arts. Thus, as the recorded sounds of the forest stimulated visual art, music was not mere stimulus but the medium for perception of formal analogues, according to the age of students and the sophistication of the teacher. Nothing new, but increasingly popular in the sixties: patterns of sound became patterns of color; the discussion of poetry preceded its expression in paint.

The idea of drawing as the natural mode of thinking in art, already resurgent in the fifties, was strengthened in the sixties. Gestalt psychology, best

Figure 6-1. An ink drawing made with a broken tongue depressor, for emphasis on imagination and texture, by Paula Gillen, a sixth-grade student of Diane Podrat. *School Arts* 67, no. 10 (June 1968): 8. Reprinted with permission of *School Arts*.

Figure 6-2. A tempera painting, by Marion Howaniak, a fourth-grade student of Lois Lehman. *School Arts* 69, no. 10 (June 1970): 16. Reprinted with permission of *School Arts*.

Figure 6-3. A tempera painting of a car carrier, by Randy Cunningham, a fourth-grade student of Loeva Bell Owens. *School Arts* 67, no. 10 (June 1968): 17. Reprinted with permission of *School Arts*.

Figure 6-4. The inner-city neighborhood of Evans Owens, a student of Bernard R. Byrd, Jr. *School Arts* 67, no. 10 (June 1968): 22. Reprinted with permission of *School Arts*.

Figure 6-5. Pop Art, in felt pen and crayon, by Judy Cole, a sixth-grade student of Joan Alves. *School Arts* 69, no. 3 (November 1969): 35. Reprinted with permission of *School Arts*.

known to art education through the writings of Arnheim, affirmed the cognitive nature of perception. Piaget described the child's perceptual progress as conceptual development. The historian Gombrich demonstrated the inevitable individuality of perception in representational drawing. McFee showed the child's perceptual screen, the determinant of "delineation," as the product of the entire personal experience. These were contributions of theory unfamiliar to many teachers. But any decently prepared art teacher who accepted the working methods of the professional artist as the model for curriculum could acknowledge the importance of drawing in the transformation of idea into image. Drawing was also study: art teachers even read suggestions that the ban against "copying" be reconsidered, in view of the practices of professional artists in studying the work of their predecessors.

Though subject matter and media changed little, the rationale and educational use shifted somewhat. Teachers employed the close scrutiny of natural

Figure 6-6. A drawing by Benjamin Carter, a sixth-grade student; the supervisor of art was Al Hurwitz. *School Arts* 67, no. 1 (September 1967): 13. Reprinted with permission of *School Arts.*

objects—a seashell, an insect, a piece of bark—to bring students into the expansion of concepts of form in art and design during the sixties. If elementary classes drew out of doors, not only perception but aesthetic organization and the *evaluation* of the aesthetic product were to be developed. With perception understood as the basis of originality, the painting and drawing of still life, with more freedom and variation of method, regained some of its former status. Pop Art helped to validate the representation of mundane things. Figure drawing from a classmate as model, beginning as early as the second grade, was an individual study of the visual elements and an empathetic perception, praised on humanistic and psychological grounds. Self-portraiture was valued as a response to the inner urgencies of adolescence, which could be introduced through the work of any number of famous artists.

More mature students could be keenly interested

in the new styles of the decade even though teachers might question whether any understanding was gained beyond the mere imitation of appearance. Abstraction, though not new, seems to have required a degree of ingenuity in the assignment of problems: bottles, with three kinds of line; the skyline in specified values; the planes of the face, in cool and warm colors; or the cross-section of a cabbage as form for a painting. Around 1968–69, students were able and sufficiently disciplined to produce the black-white vibrations of Op Art. Pop imagery went beyond perceptive drawing to cultural comment; by the end of the decade, actual objects—furniture and garbage cans—were being painted, and the more or less witty but always colorful decoration of fireplugs approached the epidemic.

As to media, oils became somewhat more affordable so that advanced students could either work toward the skills of the masters or move beyond tempera in contemporary styles. Acrylics were marketed to schools beginning around 1964; though not cheap, they were especially helpful in drying quickly and in the explorations of hard-edge abstraction.

Printmaking

Art teachers followed the art world in exploration of new forms and techniques. To students, printmaking might seem somewhat independent of skilled drawing: indeed a successful student print might match the mature artist in direct expression if not in complexity, subtlety, or iconographic depth. To

Figure 6-7. Op Art, by Rick Caras, a ninth-grade student of Ann Heidt. *School Arts*, 69, no. 3 (November 1969): 17. Reprinted with permission of *School Arts.*

encourage more schools to join in the "recent surge of interest," a National High School Print Show was organized in 1964; some seven thousand entries were received. Hung at the Metropolitan Museum in the summer, the exhibit was given a two-year tour by the Smithsonian Institution's Travelling Exhibition Services. A portfolio of examples proved that the graphic media could lead talented students to a high level of conception and discipline.

Silk screen, woodcuts, and linocuts grew more ambitious. "White on white"—embossing—followed quickly from professional examples. Collography added print imagery to student interest in collage. For etching plates, teachers tried flattened tin cans, sheet iron, galvanized sheets, and aluminum. Lithography remained impractical, though various resist products were called prints. Monoprints were perhaps excessively popular. Descriptions of classroom printmaking suggest that ingenuity with materials was as important as introduction to nonobjective imagery. Duplicator paper or waxed stencil paper, drawn upon or scraped, could provide transfer to another paper

and the result therefore could be called a print. Tissue, glued to a base and dampened, gave an unpredictable color transfer. Rollers, or brayers, were cut into or given relief by string or other materials. Printing blocks were made of gesso, paraffin, copper foil, foam rubber, self-adhering weatherstrip or foam bandage, and commercial packaging: an egg carton could be cut in an unpredictable number of cross sections to produce a repetition of as many forms.

Printing began in kindergarten, with sticks, erasers, or vegetables. By fourth grade, one class could work with drypoint and etching on zinc, print with color, and through several weeks of open studio, produce two hundred copies of an illustrated book of writings.[121] Fifth graders, in a correlated study of "The Westward Movement," produced more than one thousand linoleum prints for an edition of thirty books, beginning with thumbnail sketches and printing with a lawn roller filled with water—faster than an old

121. Harold McWhinnie, "Fourth Graders Are Printmakers," *School Arts* 60, no. 5 (January 1962): 17–19.

Figure 6-8. Psychedelic style in a linoleum print, by Bruce Sandberg, a high school student of Gerald F. Brommer. *School Arts* 67, no. 10 (June 1968): 9. Reprinted with permission of *School Arts.*

Figure 6-9. A block print for a fifth-grade book on "The Westward Movement"; the teacher was Clifford T. McCarthy. *School Arts* 64, no. 1 (September 1964): 11. Reprinted with permission of *School Arts.*

book press.[122] Sixth graders worked with silk screen through an entire school year, printing book covers, shirts and skirts, posters, curtains, and yardage for clothing.[123]

Photography

Organized instruction in the aesthetics and techniques of camera and darkroom continued slowly to gain acceptance in schools. A high school teacher reported optimistically that photography was possible in schools (the camera club attracted teachers as well as students) at a time when a small city high school had been offering photography for fourteen years and a Los Angeles high school offered a series of three courses in photography.[124]

The camera was widely recognized by mid-decade as a tool for developing perception of the surface qualities and structure of forms, notably in the work of Bartlett Hayes at the Arts and Communications Center at Phillips Academy in Andover, Massachusetts. Elsewhere, four- and five-year-olds shot rolls of 35-millimeter film, instructed only by demonstration of the viewfinder, shutter, and film advance, with the other controls taped over and a glass filter to protect the lens.

The art program in Newton, Massachusetts, followed Hayes's visual perception program, using cheap cameras; junior high students worked also with slides, film, audiotape, and other equipment to create photo essays and projection programs. For youth projects that often had social goals, Kodak began to supply quantities of inexpensive cameras.

Most art education texts of the decade were rather quiet about photography. McFee recommended the camera as a motivator for a hypothetical problem boy in fourth grade because he liked tools and could be creative with real things. Lanier printed the syllabus of an existing high school course and led a funded project in uses of newer media. Rueschhoff and Swartz, whose major concern was visual perception, asked teachers to use the camera to show children the elements of design in nature but did not suggest photography by children themselves. Lansing agreed with those who said that photography was the art most familiar to children; he recommended the Poloroid or the old box camera not for study of elements of design but for capturing the expression of aesthetic qualities and human emotions or for documentation of school, town, and neighborhood. Hubbard's discussions of secondary art education gave limited space to media

and none to photography.

Given this ambiguity among leaders, many teachers still had no education in the techniques of the camera or darkroom. Though an elective in photography was common in teacher preparation programs, to require it was a bold move in 1970.

Film making was occasionally urged as a school art activity, but projects engaging children in actual work with an 8-millimeter camera were rather rare in 1970. Even in college art programs, both studio courses in film and animation equipment still were uncommon. To draw directly on film, however, neither training nor special equipment was needed, though the sequence of motion might be uncontrolled. Art teachers in the sixties continued to join enthusiastically in workshops to experiment with felt markers, pen and ink, or watercolor on old film from which emulsion was removed by household bleach or simple scraping. In upper elementary classes, children could individually complete twenty or more frames on separate strips that then were spliced or share a continuous length divided into segments. Instead of film, acetate sheets could be cut into strips, spliced, and hand-fed through the projector. Audiotapes could accompany filmstrips. One large group of seventh graders used an 8-millimeter camera with cut paper forms to make about three hundred feet of animated color "cartoons." By 1970, three books were available on filmmaking and animation in schools.[125]

Sculpture

In the later sixties sculpture seems to have become the most interesting activity in the art class, for both students and teachers. Several explanations are apparent.

It was common in those years to define art as making something out of nothing or out of anything. From the level of phenomenology, psychology of creativity, or the school budget, sculpture fitted the definition. Reality was more complex than in painting, expression more intense than in design. New materials, tools, and techniques were naturally attractive. Shown a few examples of contemporary work, students often discovered possibilities of construction and form with little need of instruction.

Welding, the major sculptural medium at the beginning of the decade, actually entered school art. With help from industrial arts, sandcasting graduated from plaster on the beach to foundry practice, using styrofoam forms, real molding sand, and molten aluminum. Self-hardening clays, "Sculpmetal," volcanic rock, and authentic sculptor's wax permitted more

122. Clifford T. McCarthy, "A Printing Experience," *School Arts* 64, no. 1 (September 1964): 8–13.

123. Ray R. Wilson, Jr., "Screen Printing in the Sixth Grade," *School Arts* 60, no. 7 (March 1961): 15–17.

124. The Los Angeles high school curriculum is given in Lanier, *Teaching Secondary Art*, 108.

125. Douglas Loundes, *Film Making in Schools* (New York, 1970); Yvonne Anderson, *Teaching Film Animation to Children* (New York, 1970); John Lidstone and Don McIntosh, *Children as Film Makers* (New York, 1970).

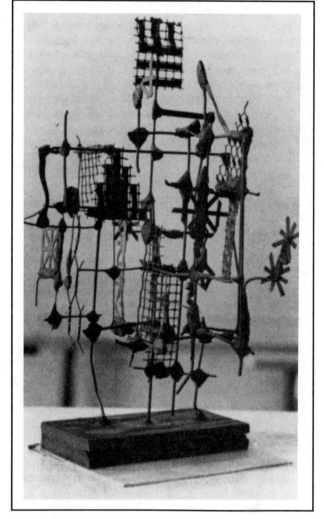

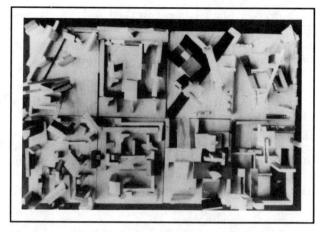

Figure 6-11. A wood sculpture reflecting the style of Nevelson, by Fred Prassack, Warren Roberts, and Don Green, ninth-grade students of Dan Kelleher and Suzanne Swabb. *School Arts* 67, no. 10 (June 1968): 21. Reprinted with permission of *School Arts*.

Figure 6-10. A sculpture in metal, by Helen Gathercole, a high school student of Jack Brady. *School Arts* 67, no. 10 (June 1968): 5. Reprinted with permission of *School Arts*.

nearly authentic products. Structure, the creation of form by the repetition of units—toothpicks, paper clips, nails, bolts, coathangers, dowels, and acetate bookcovers—was made easier by new industrial glues, epoxies, liquid solder or metal, and the braizing rod. Similarly strengthened, figurative wire sculpture was given the look of Giacometti by coatings of liquid metal, plaster, and metallic spray paint.

An influential show of Assemblage at the Museum of Modern Art authorized the uniting of anything, with Nevelson a favored inspiration: tin cans, the class collection of boxes, woodscraps built up higher than a sixth-grader could reach. An "abstract tree," permanently installed, reached twenty-one feet above the ground; its major members were railroad ties, assembled with about one hundred seventeen-inch bolts. George Segal was imitated by coating wire

mesh or papier maché with plaster or the new Pariscraft, a product developed for medical casts: two eleventh graders built a six-foot-high roller skater by this method.

Among other sculptors whose work motivated school art were Gabo, Brancusi, and Hepworth. Moore's forms led one class to collect bones as their medium. Given the option of nonrepresentational or Surrealist sculpture, one high-school student put antlers on a dress dummy. Pop Art reached sculpture classes late in the sixties—a "hippie" created in plaster, a cucumber in papier maché, a "soft" guitar in fabric, after Oldenberg. Marisol's figures—wood constructions with line drawing—were especially interesting to students. Her works played with realism and image: they were witty, contemporary, perceptive, deceptively simple, and imitable. Kinetic sculpture went beyond mobiles: one group made "wind sculptures" of eight-foot-by-one-inch aluminum poles, plastic tubes, and concrete bases, with a four-foot-by-eight-foot styrofoam sheet for each student. Installed outdoors, multiple coats of textured acrylic paint protected the styrofoam from the weather. Contemporary styles in sculpture that apparently were not influential in school art during the sixties were Minimalism, Conceptualism, and earthworks.

Sculpture shared general educational goals. Multisensory experience took a sixth-grade team beyond painting and sculpture to provide an environment where children could control visual, tactile, and auditory sensations. Teachers cited the psychological values of three-dimensional self-portraits. They liked sculpture for group experiences; in one high school class, each group arranged wood scraps in cigar boxes and sprayed them with black paint so that these mod-

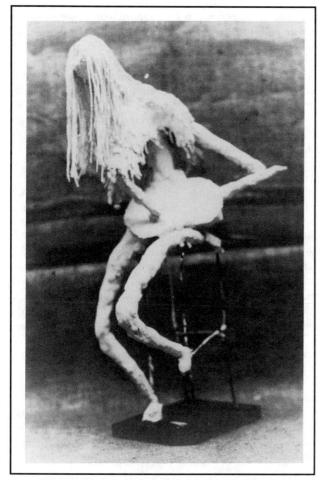

Figure 6-12. A "hippie," sculpted in plaster by Debbie Abel, an eleventh-grade student of Lila J. Wells. *School Arts* 69, no. 10 (June 1970): 38. Reprinted with permission of *School Arts.*

ules could be assembled on a large panel in the manner of Nevelson.

Class projects in sculpture culminated correlated units. For study of the Middle Ages, sixth graders used papier maché to create a jousting tournament and a feast in the Great Hall, complete with fired ceramic dishes, fabric wall hangings, and stained-glass effects in windows. For National Library Week, fifth graders rendered famous book characters. Dinosaurs, as big as five-by-twelve feet, were formed on wood armatures by a sixth-grade class. Built in the cellar, they were later exhibited on the lawn. A junior high school class followed the lunar landing with their own moon discoveries in a unit on "creative space thought"; they used wood, clay, wire, papier maché, mesh, plaster, and Sculpmetal, all in one project. Fifth graders discussed exhibits of kinetic art in Berkeley, at New York's Jewish Museum, and the nine Evenings of Theater and Engineering organized by Rauschenberg

and Billy Kluver. Their science teacher helped them to think of light, motors, and other means of movement for their sculptures and helped again with the installation of lights and the use of batteries.

Sculpture, beyond experiment, could fully engage a young person's social concerns. One high school senior explained that her work began in an art history class with the study of contemporary artists. One of them, she said, was Marisol,

who was making a social commitment with life-sized wooden models of people, famous or otherwise. Our problem was to take one of the artists and try to see life as they saw it and attempt to solve the problem they were trying to solve. I decided to make a comment on what is becoming the ideal woman in America; the stereotyped fashion plate. A pretty face, with little or no depth of character. Very tall, practically emaciated. I realized that this was not what the majority of women in the United States are like, but these are the type that get the most publicity."[126]

Design

In the movement for curriculum change, design was given scant attention. Within the discussions of art as a discipline, the theorists of art education often overlooked professional designers along with the historians and critics of design. A negative attitude toward design as a "parent discipline" could have been explained easily: first, the history and criticism of design lacked status as scholarly disciplines; second, these capabilities were unimportant in the education of most art teachers; third, the products of functional design were said to be aesthetically impure and not formed freely through the creative imagination; further, with the exception of graphic design, most schools could not facilitate the development of models and prototypes. Finally, for many teachers as well as artists and designers, design was not a discipline distinguished from art. Rather, as Dow and Ross had proposed long before, design comprised the structure and the language of art.

With no further agreement as to purpose or content, art teachers continued to approach design through the usual variety of conceptions of the term: an activity, capability, or object; a decoration or styling; a set of principles of visual organization; a plan presented through drawings or models; or the attributes to be appreciated in exemplary products. In elementary classrooms, some of what was called design might have been called "handwork" fifty years earlier. High school electives in commercial art or clothing design might be staffed by teachers whose

126. Betty Peterson, Kentridge High School, Kent, Washington, commenting on an illustration of her work in *School Arts* 69, no. 9 (May 1970): 23. Reprinted with permission of *School Arts.*

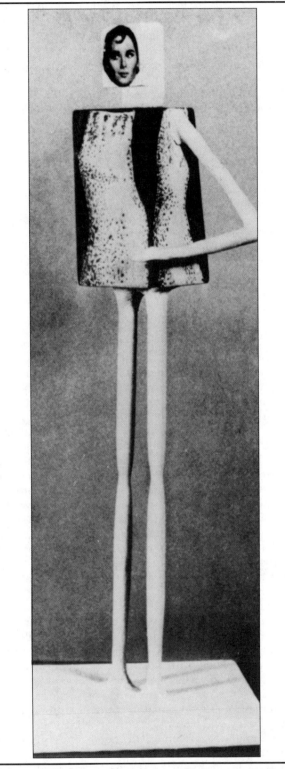

method and content, for better or worse, were based upon personal experience in the field. Otherwise (if any generalization can describe design in the K-12 art curriculum) the content was derived mainly from the first-year college courses required of all art majors, courses in "design fundamentals" and "design with materials."

The newer methodology continued the trend of the fifties, treating design as a way of seeing and thinking and favoring the set problem or the open-ended experiment but not the exercise or uniform product. In a period of increasing interest in perception, under the cumulative influence of men like Moholy-Nagy, Kepes, and Buckminster Fuller, and with the exciting explorations of contemporary scientists and artists alike, teachers were concerned less with decoration. New visual aids revealed shapes, lines, textures, and rhythms in common surroundings. Positive and negative shapes were an advanced concept for teaching. Rubbings were to reveal texture everywhere. As sources for discovery of form, students went to nature or to the built environment—to grasses, rocks, tree bark, insects, honeycombs, railroad tracks, and architecture. Promoting these perceptions was much of the goal in teaching design.

Typical problems asked the student to discover in some common object (hand, chair, or kitchen utensil) a simple form to be repeated by drawing or printing. To repeat regularly, to make a border or pattern, would have been old-fashioned: the repetition instead was to be random, to create a texture or indeed an

Figure 6-14. A conception of organic design, promoted through close observation of a sea shell, was expressed in this drawing by a high school student of W. Ron Crosier. *School Arts* 69, no. 3 (November 1969): 20. Reprinted with permission of *School Arts*.

Figure 6-13. The sculpture inspired by Marisol, described in the text, by Betty Peterson, a twelfth-grade student of Wes Soderberg. *School Arts* 69, no. 9 (May 1970): 23. Reprinted with permission of *School Arts*.

Figure 6-15. Teacher Carl Greco helped elementary school students to escape the monotony of traditional repeat designs by combining negative and positive shapes. *School Arts* 65, no. 9 (May 1966): 35. Reprinted with permission of *School Arts*.

"abstract composition." As another means of repetition, leaves, twigs, or pebbles could be glued to panels or imbedded in newly available liquid plastics. Cloths and carpet scraps provided a variant study of texture. Thus, collage grew ever more popular and more interesting: the old representational mosaics of macaroni and beans were still made, but they lacked educational complexity. A prize might have gone to a panel of

Figure 6-16. An experimental mosaic developed by a ninth-grade student of Charlotte Grieser, using vinyl tile, colored sand, shells, and granite gravel. *School Arts* 62, no. 3 (November 1962): 23. Reprinted with permission of *School Arts*.

depleted water-color tins: it offered the rhythmic unity of small rectangles, the variety of residual colors, and the prestige of transformed junk.

From individual collage to mosaic mural was less a conceptual shift than an expansion of purpose and logistics. School mosaics in the sixties grew in size, number, and variety of purposes; they used more materials and were planned for longer life.[127] The project could engage a hundred students and the janitorial staff for a year. "Mosaic" murals were made of stones, wood scraps, tiles: the materials ranged from store-bought confetti to genuine Venetian tesserae. Murals might be purely abstract—one group achieved its "psychedelic" effect with shards of glass and scrap plastic—or commemorative of town history or school life.

Three-dimensional design was extended from the fifties, differentiated from abstract sculpture, appar-

127. Larry Argiro, "Mosaic Art," *School Arts* 64, no. 10 (June 1965): 10–14.

Figure 6-17. A construction of wood, toothpicks, and bristol board, by George Romans, a third-grade student of Ruth S. Landis. *School Arts* 67, no. 10 (June 1968): 17. Reprinted with permission of *School Arts*.

ently, only by the teacher's sense of purpose or per-
haps by the recency of the teacher's college career.
The nomenclature might be fudged: a form carved in
wood could called an "abstract design." Still typical of
the problems brought down from the college course
was the exploration of the structural possibilities of
toothpicks or coat hangers or the development of a
freestanding form from a single sheet of paper, cut
but intact. The "enchanted tree," built by fourth
graders from boxes and tapes, with perches for birds
and animals, represented the continuation of elemen-
tary art projects, with contemporary design concepts
as distinct as the teacher chose to attempt.

Secondary teachers could be more explicit, and
some could clearly relate design fundamentals to var-
ied forms in the visual arts. An eighth-grade unit on
structure began with slides, magazines, and discussion:
the students' balsa-wood constructions showed their
sense of structure in architecture, furniture, and other
products as well as in sculpture.[128] Another teacher pro-
vided boxes and asked students to "create a design
which when rendered on the volume, will draw the eye
around the form" through "repetition of color, shape,
or texture." The project, according to the teacher, gave
"a fine transition between painting and three-dimen-
sional design. Its implications on sculpture, package
and industrial design are quite apparent."[129]

Design projects also could be currently topical.
An outdoor mural showed townsfolk the students'
hopes for the future. Among all the mask projects, at
least one brought in the graphics of social upheaval.[130]

128. Richard Pilarski, "Introduction to Structure in Design,"
School Arts 61, no. 8 (April 1962): 17–18.

129. Jeremy Collins, "Painting around a Volume," *School Arts*
68, no. 5 (January 1969): 8–9.

130. Paul Berg, "Twentieth Century Masks," *School Arts* 69, no.
6 (February 1970): 18–19.

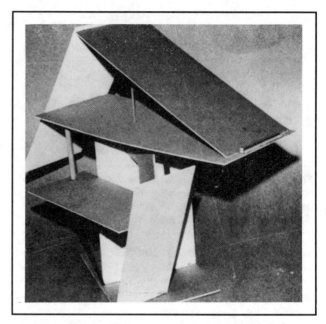

Figure 6-18. A structural design by Stephen Campitelli,
Mike Roth, and David Jack, seventh-grade students of
Thomas A. Jambro. *School Arts* 68, no. 2 (October 1968): 43.
Reprinted with permission of *School Arts.*

Many a collage of magazine imagery depicted aspects
of current culture. One of these projects grew from
discussion of such problems as the war in Vietnam,
the civil rights movement, big city crises, drugs, and
"the revolt of modern youth."[131] In another project,
five hundred students contributed to a walk-through
Assemblage. Each of them had used collage on a one-

131. Louis J. Miller, "The Social Scene in Collage," *School Arts*
67, no. 8 (April 1968): 18–19.

Figure 6-19. A montage us-
ing shattered safety glass, by
Franklin Penrose, a twelfth-
grade student of Rosanna
Moore. *School Arts* 67, no. 10
(June 1968): 15. Reprinted
with permission of *School
Arts.*

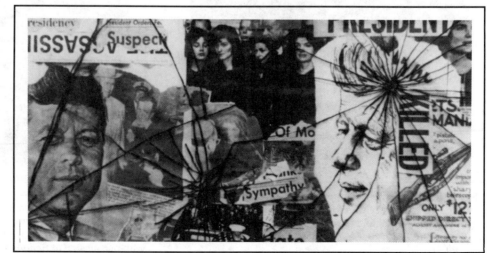

cubic-foot box to respond to a single question: "What's on my mind?"[132]

With regard to functional design, as distinguished from fine arts, several texts represented a current range of opinion. Until World War II, school work in "applied design" had aimed toward practical adult capabilities. In the sixties, similar content had a different purpose and, of course, a new form, grounded in new theory.

McFee spoke of perception and designing as the "foundational abilities" of all art. Further, she explained design in architecture, advertising, clothing, and industrial products as systems of cultural communication that were educationally important for every child—a learning of language and values rather than of making.[133] Linderman and Herberholz organized curriculum content under four categories: fine arts; crafts; design (elements, fashion, advertising, and industrial design); and architecture (homes, commercial structures, landscapes, and parks).[134] To the same inclusive categories of design, Rueschhoff and Swartz devoted more than one-quarter of their recommendation for content in the elementary curriculum. Schinneller allocated more than 43 percent of his text to design, architecture, and the environment. These authors were primarily concerned with awareness and understanding, not with production. But Hubbard, who cited Schinneller as the best reference for secondary art content, also expected teachers to be able to guide students in their own design activities. However, Lansing, at the end of the decade, saw these fields of design as professional specializations that were inappropriate in general education, even in the secondary curriculum.[135]

Graphic design, still with its place in correlated units, was least confined to "make-believe" and continued to contribute real products to motivating projects in the school and community. Advertising or commercial art remained one of the more popular high school electives, though neither term reflected the contemporary diversity of graphic design. Skill in lettering seemed less important, just as it did in professional programs owing to the increasing variety of paste-up and transfer options. These letterforms became more useful in silk-screen reproduction through the photographic preparation of stencils, which also enabled a few secondary students to incorporate halftone imagery. At the same time, teacher attitudes and student efforts could become less exacting and more adventurous following the work of artists like Rauschenberg and Johns, the advent of supergraphics in architecture, and the growing informality of professional graphic design.

Design in the home and community, as noted in the previous chapter, had lost importance in art curricula after World War II. Still, such activities were continued by teachers who believed that art should be engaged in all realms of experience. Children did make drawings, paintings, and murals about their neighborhoods and homes, though this was not designing. *School Arts* briefly ran a monthly column on "art in the home." Upper elementary classes made drawings and shoe-box models of favorite rooms. Interior decoration could be found in home economics programs, sometimes in secondary-level general art courses, and in at least a few art electives in large high schools.

Architecture as a distinct study retained a certain status through the early sixties. A few teachers in grades seven through twelve reported units with slides, discussions, field trips, floor plans, elevations, scale models, site specifications, and studies of structure, including Fuller's domes. Such projects already met the coming demands for "practice in the discipline" and for clearly specified outcomes. And as subject-centered curriculum reform developed in the mid-sixties, architecture offered several further advantages: a history long since organized for schools and ready for contribution to humanities courses, with styles representative of cultures and observable in most cities; established critical criteria and literature; a professional society interested in public education; and local practitioners willing to visit the classroom.

Figure 6-20. To promote awareness of architecture and environment, teacher Betsy Farmer asked second graders to build model shelters expressing openness. *School Arts* 69, no. 8 (April 1970): 13. Reprinted with permission of *School Arts.*

132. E. G. Rice and Betty Rice, "What's On My Mind?" *School Arts* 66, no. 7 (March 1967): 5–11.

133. McFee, *Preparation for Art*, 383.

134. Earl C. Linderman and Donald W. Herberholz, *Developing Artistic and Perceptual Awareness*, 2d ed. (Dubuque, 1969), 122.

135. Lansing, *Art, Artists, and Art Education*, 286.

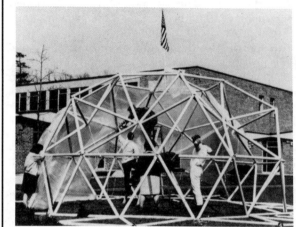

Figure 6-21. The geodesic domes of Buckminster Fuller inspired this structure of surplus cardboard tubes, by students of Sam Busselle. *School Arts* 67, no. 2 (October 1967): 10. Reprinted with permission of *School Arts*.

In 1965, architecture still could be considered an element of "design in the home and community." By 1970, that broader concern for design was extended to the whole physical and visual environment.

The environmental concept had further dimensions. In art education, McFee's 1960 text emphasized the psychological influences of the environment, which she construed as not only physical but socio-cultural—an information field, a value system, a shaper of art expression. Educational theory more generally began to see the classroom in action as the "learning environment." As gestalt psychology moved beyond its initial concern with forms perceived visually to include the configuration perceived in a global situation, the lay public found a new catchword: the "whole gestalt" was the individual's psychological environment.

Conservationists became environmentalists in the sixties. One of the popular appeals of conservation was aesthetic. Ladybird Johnson's White House Conference on Natural Beauty (1965) brought the First Lady an enduring esteem. Beautification, one of the earliest goals for school art, gained new dignity, and the community appreciated students' work in murals, the school grounds, or "garden spots" in the lobby. And any natural form in school art, even a collage of leaves, could be claimed as "environmental."

Aesthetic education and perceptual awareness could begin with aesthetic qualities in the environment. But in that decade of civic activism, art teachers were told that their social responsibility in environmental education did not end in aesthetic values alone. Health and conservation were entailed in the judgment of good design. The styling of a car was less important than the pollution it generated by an inefficient engine, wrote one art educator, and the educa-

Figure 6-22. The experience of adolescence in inner-city Newark was delineated by Eason Evans, a junior high student of Margery W. Brown. *School Arts* 68, no. 8 (April 1969): 33. Reprinted with permission of *School Arts*.

tion was incomplete until the student understood the complexity of individual action in environmental politics. These were not the interests of the majority of art educators. Nevertheless, a series of six units developed by the Central Midwestern Regional Educational Laboratory exemplified the possible scope of aesthetic education in the environment: the aesthetic, social, physical, and functional factors; the certainty of change; the criteria for judgment; the need for decision; and the possibilities of organization for improvement.[136]

If the concept of aesthetic education thus supported a modest place for urban design and community planning in the curriculum, it did not provide a simple approach. Early in the sixties it had been said that the Owatonna Project, the model of school art contributions to small-town uplift in the Depression, had little relevance to contemporary crises in big cities. In 1965, at a conference sponsored by Urban America, Inc., Ralph Smith suggested that "urban aesthetics" would be "best handled as a complex social problem with an aesthetic dimension."[137] June McFee discussed sociological complexities; perhaps the most basic problem was the tension between traditional American individualism and the essential interdependence of life in the big city.[138] Fundamental cultural values and perceptions would have to change—no easy challenge for art education.

Federal funding was available. Under the Arts and Humanities Act of 1965, high school students in Philadelphia and Washington engaged in "Neighborhoood Commons" projects. In Baltimore, where the Anti-Poverty Act funded a summer program concerned with environmental problems, the Harbor Renewal project was brought into the art curriculum, and a local realtor followed student recommendations for the improvement of a block of row houses. Students in a small Wisconsin city produced a design and model for a completely new community. In other cities, students worked on plans for urban renewal, civic centers, and improvements in parks and playgrounds.

It is worth noting that this slight reemphasis in art education through the decade did not come about simply through the dominant conditions in art and education. This was a response to unpredicted forces: social activism; environmental interest groups; and federal programs designed to meet both immediate social needs and long-range needs in public educa-

tion. Federal support, however, was only temporary.

Theatre design held a place in the secondary curriculum as an elective in a few high schools but more usually was a special project for interested individuals. In elementary schools, teachers continued to find new ways for children to make variants of the basic types of puppets and marionettes: their use on television stimulated interest while their educational values were undiminished. Growing support for related arts activities favored the use of dramatizations that involved music, dance, scenery, costumes, and sometimes lighting.

One junior high school project, stimulated by a television program on Egyptian wall paintings, was exemplary. An art class produced an assembly program concerned with the threat of the Aswan Dam to ancient Egyptian tombs. A play was written in which archaeologists met tribesmen and discovered a tomb. Production by the art class included a life-size statue of a dead princess, a casket of jewels, a golden mirror, and a fourteen-foot-high mural as well as sets and planning of sound effects and music. Additionally, the class made and sold block-printed stationery and scarab jewelry of "Egyptian Paste"—clay mixed with glaze.[139] But a number of respected new texts on art education gave no attention to theatre in any form. One pair of authors believed that such activities were being squeezed from the curriculum, at least in elementary grades, by emphasis on individual creativity and academic subject matter.[140]

Crafts

By the 1960s, the expansion of crafts in teacher preparation programs had resulted in more capable and sophisticated instruction, at least in secondary schools. More schools had better equipment. New texts and visual aids, and *Craft Horizons* in particular, brought representations of current professional work to the art class. In turn, various reports and reproductions showed that student work through the decade developed in scale and in freedom of form and technique.

Surveys confirmed that art teachers considered crafts very nearly as important as drawing and painting. In spite of these gains, some writers felt that too many teachers still relied on published projects with instructional routines that inhibited the promotion of originality. This difficulty was especially common in elementary schools, where few children had teachers adequately prepared to do more than follow instructions.

136. Madeja and Onuska, *Through the Arts to the Aesthetic*, 86ff.

137. Ralph A. Smith, quoted in "A Report for Urban America, Inc. on the Education of Children and Adults in Aesthetic Awareness of the Environment of Man" (Madison: University of Wisconsin, 1966), 27. Mimeo.

138. June King McFee, "Poverty and Urban Aesthetics," in "A Report for Urban America, Inc.," 40–58.

139. Ruth Friedman, "Tragedy of the Tombs," *School Arts* 65, no. 9 (May 1966): 36–37.

140. Charles D. Gaitskell and Al Hurwitz, *Children and Their Art*, 2d ed. (New York, 1970), 301.

Ceramics continued as the most popular of the crafts media. More specifically, the National Education Association survey for 1961–62 reported that in grades seven through nine about two-thirds of the schools included ceramics in a general art course, whereas about one-quarter offered a separate course in ceramics. In grades ten through twelve more than 57 percent of the schools included ceramics in a general art course; about 40 percent gave a separate course in ceramics. (The report gave no comparable data for elementary schools.)

For younger children, advice to teachers changed very little. Some of the material guiding teachers still could produce a batch of useful objects to take home or a roomful of formula animals. The better contemporary texts gave technical advice with the aim of nurturing the students' confidence in personal efforts: techniques were to be demonstrated or illustrated but not dictated in a step-by-step procedure.

Older students in the better programs were acquainted with the ceramics of Pre-Columbian, native American, Egyptian, and oriental cultures.

They could see such influences in contemporary American examples, and their own work reflected these trends in the scale of their slab and pinch building, the alteration of thrown forms, draped and slung slabs, free coil construction of ornamented form, richly textured surfaces, and purely aesthetic objects free of utilitarian purpose. In at least a few schools, reduction firing was possible, and students handled raku ware from the kiln to the sawdust. In the late sixties, Pop Art came into ceramics. Students produced vegetables, breakfasts, household items, and hippy figures: one teacher named as influences Oldenberg, Johns, Rauschenberg, Segal, Lichtenstein, and Marisol.[141]

141. The artists are named and some of the student works are shown in Elizabeth Stein, "Pottery Goes Pop," *School Arts* 68, no. 8 (April 1968): 35.

Figure 6-24. Pop Art in clay, by Jerald Baker, a tenth-grade student of B. Lavorgna. *School Arts* 69, no. 9 (May 1970): 13. Reprinted with permission of *School Arts*.

Figure 6-23. A terra-cotta pot by Sandra Palmer, a tenth-grade student of M. D. Brown. *School Arts* 69, no. 9 (May 1970): 8. Reprinted with permission of *School Arts*.

Glass was a new adventure. A few teachers in Harvey Littleton's workshop at the Toledo Museum engaged in the development of a kiln adequate to at least give students a beginning idea of glassblowing. Others found that sheet glass could be slumped over a clay form or soft brick; at 1,400° F enamel powder, rods, and bits of colored glass would fuse without melting the sheet. Colored glass was fired in ceramic slabs and combined with hand made tiles in mosaic.

For **textiles**, or **fiber arts**, this was probably the most stimulating decade, as school art teachers followed professionals toward greater freedom of materials, techniques, and form.

Stitchery and appliqué, combined more often than not, were popular at all levels. Hangings could be representational (portraits and landscapes in yarn, neighborhoods, or famous persons) or abstract ("take a walk with a line"). A "mural" as long as thirty feet could carry a theme for correlation. Almost any material could be glued or sewn: leather, plastic, wire, copper foil, or whatever so that the interplay of colors, textures, and dimensions could become a theme in itself. Thus, new terms like *fabric collage* and *cloth assemblage* appeared in professional circles to signify the transformation of craft into art, and school children were correspondingly liberated.

Weavers found still more simple looms around the world.[142] The *weft* could be anything more or less flat and elongated: for a unit on Africa, children used grasses, vines, and twigs. ("God's Eyes" became a fad.) Without a loom, indeed, without weaving, threads were pulled and gathered. Weaving became sculptural in two ways. Like a spider, a student could weave across the spaces in loops of reed or wire, across forked branches, or across built forms: Naum Gabo was referenced. Or a completed woven form could be shaped into three dimensions and exhibited freestanding.

Batik—a sophisticated color study for older students, yet simple enough for third graders—became more painterly as professionals developed the medium. Printing by block or screen enhanced student clothing; batik and tie-dye became emblems of youth culture; and stitchery or appliqué could add wit or beauty.

Macramé and the hooked rug continued; riya rugs provided further qualities of texture and color. By the end of the decade, no other area of the art curriculum offered more varied opportunities for individual achievement than did the fiber arts. But the only usual separate elective in these media was weaving, and it was offered in fewer than 10 percent of junior and senior high schools.

Jewelry and enameling gained further public recognition as contemporary creative forms in the six-

142. Sarita Raianey, *Weaving without a Loom* (Worcester, Mass., 1966).

Figure 6-25. Weaving on a reed form, by a fifth-grade student of Patricia Trotter. *School Arts* 67, no. 4 (December 1967): 7. Reprinted with permission of *School Arts.*

ties, and so too, gained status and quality in public schools. A second generation of skilled professionals had spread across the country, and younger art teachers were better prepared to improve the quality of school facilities and student work. Metalwork did not progress equally: costs and noise were excessive, and the personal appeal seemed less immediate.

New materials were exciting and easy to use. Epoxy glues solved many problems. Plastic aluminum, a hardware item for mending radiators, could be molded, attached to other material, and buffed. Acrylic modeling paste dripped onto waxed paper produced organic or "free-form" jewelry; glass, beads, stones, and thread were pressed into the wet medium. "Hydrocal" was stronger than plaster of paris for pins and was easily enhanced with water color and fixatif. An air-drying plastic gel, sold as "Daz-l-glas," could be cast or imbedded in resin: twenty-four colors were offered, with transparent, opaque, pearl, metallic, and fluorescent options.

Commonplace materials were used in new ways: ceramic beads or pins, sometimes with enamel; woven beads; even papier maché. Junior high students stacked, glued, cut, and finished forms of wood veneer. Lapidary work with backyard stones was possible even for fifth graders; older students combined stone with metal.

Casting techniques, adapted by professionals from dentistry, were perhaps the major growth factor for high school jewelry in the sixties. The lost-wax process was popular; one idea was to drip melted wax onto ice for organic surprise. Crystobalite, used in dentistry, was better than plaster. Stanley Madeja worked with a leading jeweler, Christian Schmidt, to develop a method of casting metal in a pair of charcoal blocks. The better-equipped schools had centrifu-

gal machines; vacuum casting, though not for schools, came in near the end of the decade.

By that time, a whole new range of possibilities for uses and forms of jewelry had begun to reach the schools, fed by attention to non-European cultures and the aesthetics of youth revolt and dramatized in 1965 by the Museum of Contemporary Crafts in its exhibition "The Art of Personal Adornment." The new status of jewelry was further evident in the collabora-

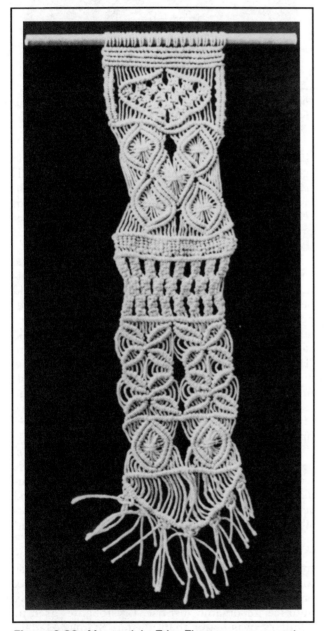

Figure 6-26. Macramé, by Trina Zimmerman, a seventh-grade student of Sally Jones. *School Arts* 69, no. 5 (January, 1970): 38. Reprinted with permission of *School Arts*.

tion of the jeweler Christian Schmidt with the art educator Reid Hastie in a text that illustrated the creative process as clearly in jewelry as in painting.[143]

Appreciation

Through the early sixties, knowledge and appreciation of art still was expected to develop primarily through or in conjunction with the activities of making art. In 1964, Hoffa told the New York University seminar that "art history and/or appreciation is an offering in only one secondary school in ten."[144] At the beginning of the decade, however, a few leading art educators had begun to call for primary emphasis on the study of artworks rather than studio work.

The term *appreciation* was increasingly inadequate—a loose connotation of acquaintance and approval in a decade of behavioral objectives, taxonomies of learning, and demands for academic excellence. Most teachers thought that a chronological history of art as taught in colleges was unsuitable for general education in high school: indeed, the professional association of art historians itself had a splinter group opposed to conventional yearlong sequences of lectures. Yet the common alternatives—aesthetic education, humanities courses, and related arts—were none of them aimed directly or solely at learning in the visual arts.

The theoretical output of the conferences and pilot studies described above came too late to have a cumulative effect on curricula in the sixties. The compilation of concepts in aesthetics provided in the CEMREL *Guidelines* never reached the main population of teachers. Few college programs in art education had begun to approach art history, criticism, and aesthetics as disciplines. Teachers themselves were hardly prepared for the full response to art described by Smith and Feldman that would require powers of description, analysis, interpretation, and evaluation. No consensus existed as to the scope of what was to be appreciated—whether only masterpieces of fine arts or the whole range of fine arts, crafts, and all forms of functional design; whether the Western heritage or the whole body of world art; whether popular arts, the neighborhood, the physical and visual environment, or the mass media.

For elementary art education, two texts represented somewhat conservatively the thinking about appre-

143. Reid Hastie and Christian Schmidt, *Encounter with Art* (New York, 1969).

144. See Conant, ed., *Seminar on Elementary and Secondary School Education in the Visual Arts*, 53. Hoffa prepared his data as an art education specialist in the U.S. Office of Education. Conant reports that among Hoffa's sources was the NEA survey for 1961–62, which showed that about one-third of the senior high schools and fewer of the junior highs offered a course in "art appreciation," sometimes apparently as a title for a general art course.

ciation at the end of the decade. Lansing's students would develop as "connoisseurs" through a knowledge of aesthetics as applied to art and practical life—to products, urban planning, the environment, and even to housekeeping. Yet for Lansing, masterpieces of art would suffice to provide the standards by which the aesthetic qualities to be found in everything else might be appreciated: his suggested topics in aesthetics do not include forms of functional design. He noted that aesthetic principles must be presented to elementary school children as concretely as possible since most of them could not handle abstractions readily before their eleventh year. Instruction in art history, Lansing said, should give a simplified progression from primitive and Egyptian art through the major Western periods and give some idea of famous artists. His book did not suggest curriculum plans or deal directly with classroom techniques.

Rueschhoff and Swartz offered a quite different approach. Their purpose was the enhancing of visual perception to enrich appreciation and promote aesthetic behavior. In their model curriculum, each "learning episode" was concerned with one of the elements of visual form. The learning began with work in an art medium. This first activity was followed by discussion of an exemplar (usually illustrated by a reproduction or slide) that illustrated the selected visual element as used in a work of art, architecture, craft, industrial design, or urban planning. The plan for each episode specified vocabulary, instructional procedures, expected outcome, and related activities. Many if not most of the exemplars were twentieth-century works or products, but these authors wanted some idea of art history to be developed in the elementary grades.

The actual teaching for appreciation, throughout the ferment of the later sixties, continued to come mostly as introduction to experiences in making art. Such enrichment, however, still provided little education about art history as a discipline, about contextual, iconological, and crosscultural concepts and methods, for example, or about the work of art historians. Nor was such introduction or illustration designed directly to develop concepts of aesthetics and criticism or engage students in critical discourse.

In many elementary schools, interest in art appreciation increased, even though most of them saw little innovation in method. The typical forty-five- or fifty-minute art period allowed only a few minutes for an introductory showing of slides or reproductions or an evaluative chat after cleanup. Elementary artrooms, though they were uncommon, could build appreciation more effectively through ample displays, ready audiovisual equipment, and the special atmosphere of a place for art. Under good conditions, travelling art specialists could be admirably efficient. A classroom teacher could build anticipation and retention by regularly changing displays: a "picture of the week" or a featured artist would enable third graders to try a similar subject. Next year, they might find suggestions for palette or technique; sixth graders could compare Breughel to Braque. Through a year, first graders could develop a beginning awareness of style and identify the work of, say, Renoir. Even kindergarteners talked about pictures in one program for reading readiness. Across the country, Parent-Teacher Association committees for art recruited "picture ladies," whose classroom visits probably improved upon old-fashioned picture study: they were interested and specially prepared, and it had been found that children liked modern art—Picasso, Matisse, abstraction, and even nonobjective styles.

In most secondary schools, art appreciation belonged mainly to the general art course. Generalizations are unreliable: the scope and frequency were a local and often individual option. Many teachers included appropriate elements of art history in every unit and in studio electives as well. But an elective in "understanding art" might still incorporate creative work. A few insisted that insertions of history controlled by studio purposes were forced and artificial. At one extreme of content for appreciation was the chronological survey of fine arts. At the other, the text on "art in daily living" that originated in a university course related to the Owatonna project in the thirties was available in a new edition for the sixties.[145] One course for "understanding art" was merged with English to reach more students. Through the whole decade in a wealthy New Jersey suburb, a versatile art specialist was assigned one period daily for contributions to several academic subjects so that art reached most of the school population.

Beyond the classroom, if interest was strong, support for art appreciation could take many forms. In school galleries, students chose and arranged the art displayed. Citizen groups continued or initiated purchases for school collections. In Minneapolis, art teachers on special assignment planned summer in-service workshops. Pittsburgh sent students to National Scholastic Art Award exhibits. There were more artmobiles, more educational television programs. *Art Education* offered articles on contemporary artists and current museum exhibitions. *School Arts* carried regular features on twentieth-century and earlier art as well as a *Young Peoples' Gallery*—more than the magazine had done since World War I.

145. Ray Faulkner, Edwin Ziegfeld, and Gerald Hill, *Art Today*, 4th ed. (New York, 1964). According to the preface to the first edition, the book was a "direct outgrowth" of experimental coursework in the General College of the Univesity of Minnesota in the mid-thirties.

A burst of public recognition of African and Afro-American art after the mid-sixties moved into school art. Afro-American study programs, museum shows, slide publications, monographs, and a distinctive new journal helped to spur interest and provide materials. The Pittsburgh school system developed a teachers' guide and bibliography. Art education periodicals ran profiles on contemporary Afro-American artists. Writers pointed to the contribution of cultural heritage to the personal sense of identity and self-esteem and equally emphasized the historical and aesthetic value of African art and its importance in the education of all Americans. The same considerations subsequently were extended to the art heritage of other minority populations.

As these many factors worked to revitalize and redefine art appreciation, art teachers began to want more study in art history, and many were busy in revising curricula in art history and the humanities. But aesthetics and criticism, apart from research projects and pilot programs, were still distant from school art at the end of the sixties.

Figure 6-27. A crayon drawing, by sixth-grade student Zabach Lowe, illustrating an article, "Accent on Africa," by Bernard I. Forman. *School Arts* 68, no. 3 (November 1968): 30. Reprinted with permission of *School Arts.*

Research

Research in art education in the sixties increased in quantity and sophistication and in the variety of problems investigated. There were more doctoral students, unequalled federal support for individual and collaborative investigations, the stimulus of new directions for curriculum, and a wealth of relevant research in other desciplines. Looking back in 1971, Donald Jack Davis calculated that as much as 27 percent of all research in art education published since 1880 had been done in the past ten years. Through that decade, he found that most of the studies were descriptive or experimental; only a few could be called philosophical, and almost none were historical. Of the four general topics of research that he had identified from the earlier postwar period, concern for therapeutic values of art had declined, whereas interest continued in creativity, the study and teaching of art, and the interrelationships of art and personality.[146] In the sixties, however, those categories were indistinct—all might be factors in a single problem.

Art Appreciation

Better education in art appreciation was clearly needed. Elliot Eisner demonstrated the inadequacies of the usual curriculum by administering his *Art Information Inventory* and *Art Attitude Inventory* to eighth-grade students in affluent Chicago suburbs. Their responses showed little knowledge of artists, art media, or the elements and principles of art. They showed little understanding of the role of art in society. Only about one-third of the students had attended an art museum or talked about art at home. And most agreed that "Good art is a matter of personal taste."[147]

One element of progress in art education, beginning in the fifties, was the development of researchers who were capable of utilizing investigations in other disciplines to strengthen the techniques and theoretical bases of their own work. Thus, a variety of studies of perception and aesthetic sensitivity were foundational to new research related to appreciation: Attneave's treatment of perception as information handling; Witkin's concept of field dependence/independence; Barron's relating of personality to preference for simplicity or complexity; and Childs's series of investigations of aesthetic preference and the related problems of assessment. Moreover, federal funding enabled art educators for the first time to do as those

146. Donald Jack Davis, "Research in Art Education: An Overview," *Art Education* 24, no. 5 (May 1971): 7–11.

147. See Eisner's comments on this research in his "American Education and the Future of Art Education," in Hastie, ed., *Art Education, 311–14.* See also Eisner, "The Development of Information and Attitudes towards Art at the Secondary and College Levels," *Studies in Art Education* 8, no. 1 (Autumn 1966): 45–50.

others had done (i.e., to carry out a series of research projects in one complex problem area).

In the campaign to improve teaching for art appreciation, the central institution was the Ohio State University. The work of Barkan, Chapman, and Kern on the "TV Guidelines" and the CEMREL *Guidelines* has been described earlier. David Ecker added to theory and teacher education through projects that engaged the collaboration of philosophers, historians, critics, professors of art education at other institutions, teachers, doctoral candidates, and undergraduates. Apart from published articles, Ecker led a research and development project funded by the U.S. Office of Education in summer 1965[148] (which ended just days before the Penn State seminar and involved several important participants at Penn State) and an Institute for Advanced Study in Art Appreciation in summer 1966, supported by the National Foundation on the Arts and Humanities. A third project at Ohio State University, a "developmental conference to establish guidelines for pilot programs" in teaching art appreciation, funded by the U.S. Office of Education's Arts and Humanities Branch, was conducted by Jeanne Orr in January 1966.

Among the art educators collaborating in the Ecker projects were Manuel Barkan, Elliot Eisner, Robert Saunders, and Edmund Feldman (who had spoken and written on art history and criticism as humanistic education for many years). Vincent Lanier contributed to the 1965 project a paper advocating the "canalizing" of the appreciation (i.e., directing instruction to the particular audience to "teach pupils to talk about their own aesthetic responses and their artistic preferences.")[149] Another contribution came through Ecker's association with the philosopher Eugene Kaelin, whose phenomenological approach emphasized attention to the immediately apparent qualities of the "aesthetic surface"—ideas that subsequently were important in the CEMREL *Guidelines*. Ecker, like Smith and Feldman, was concerned with a process of description, analysis, interpretation, and particularly with the aesthetic grounds for judgment. Beyond the refinement of theory, the educating of teachers was the aim of Ecker's projects: students in 1966 taught the critical process in local schools. The analysis of classroom recordings of discussions of artworks thus became a method both of research and of teacher education.

Also in the summer of 1966, the U.S. Office of Education funded a research project conducted by the George Washington University at the National Gallery of Art. Designed to improve the use of museum resources in teaching appreciation, the project was directed by Dr. Margaret Kiley, with Jerome Hausman of the Ohio State University as evaluator. Thirty-nine experienced secondary art teachers participated. The problems in teaching art appreciation that the teachers most commonly identified were the organization of course content, the need for teaching methods that would make the content seem relevant to students, the uses of instructional resources, the development of standards and evaluation of learning, and the local conditions for art education. The most helpful of the four main program offerings, according to these teachers, were lectures in the history of art and an audiovisual media workshop. Considered less useful were gallery tours and instruction in painting techniques. The program culminated in the design by each teacher of a curriculum plan addressed to a chosen topic or problem. Hausman's report emphasized two governing principles: the history of art was to be understood as the history of ideas in the culture as expressed in art; and the separation of history and appreciation from personal expression in art media was to be avoided.[150]

The relation between studio emphasis and the newer concern for history, criticism, and aesthetics was continually recognized as a major issue. The 1966 summer institute at Ohio State demonstrated techniques of teaching for art appreciation using both a "studio approach" and an "appreciation-oriented approach," but, in fact, both included creative work in art media. Frances Anderson later found, not surprisingly, that aesthetic sensitivity was promoted by a typical art-producing curriculum: the ability to make good choices, however, was not claimed to constitute learnings in history, criticism, and aesthetics.[151] Michael Day, noting the scarcity of instruction in art history, reported in 1969 that a combination of historical study and studio activity among junior high school students resulted in higher scores in written tests than did instruction in art history alone.[152] But this was neither criticism nor aesthetics.

148. David W. Ecker, *Improving the Teaching of Art Appreciation, Research and Development Team for the Improvement of Teaching Art Appreciation in the Secondary Schools* (Columbus: Ohio State University Research Foundation, U.S.O.E., 1966), ERIC document 011-083.

149. Vincent Lanier, "Talking about Art: An Experimental Course in High School Art Appreciation," *Studies in Art Education* 9, no. 3 (Spring 1967): 32–44.

150. Jerome J. Hausman, *The Museum and the Art Teacher* (Washington, D.C.: George Washington University, U.S.O.E., 1966) ERIC document 010-443. This report gives no indication of attention to earlier related efforts, particularly the Rockefeller Institute project involving five museums in the late thirties.

151. Frances Elisabeth Anderson, "Aesthetic Sensitivity, Previous Art Experience, and Participation in the Scholastic Art Awards," *Studies in Art Education* 10, no. 3 (Spring 1969): 4–13. To measure sensitivity, Anderson used Childs's matched-pairs picture-preference test.

152. Michael Day, "The Compatibility of Art History with Studio Art Activity in the Junior High School Art Program," *Studies in Art Education* 10, no. 2 (Winter 1969): 56–65.

The formulation that most clearly distinguished aesthetics and criticism from creative activity in art media was developed at the University of Illinois, under the influence of Harry Broudy. The ruling concept, however, was that of aesthetic education. An extensive project, directed by a faculty member in the School of Music, was conducted at the university's laboratory school, and in 1967, Ralph A. Smith directed an eight-week Institute for Advanced Study in Aesthetic Education.[153]

The old cultural ambition called art appreciation had never been given attention of such quantity and quality as it received in the sixties. The decade saw high-level agreement that history, criticism, and aesthetics should have parity with the making of art in schools. But research achieved no resolution of the alternative conceptions of purpose, scope, content, and method nor of the relation of visual arts education to the other arts and the general school curriculum.

Creativity

A second major research campaign in the sixties was developed at the Pennsylvania State University, where investigation of creativity continued work begun in the fifties. Among the most important initial resources for this research were studies of personality traits associated with creativity that had been conducted by the psychologists J. P. Guilford and Frank Barron and the Minnesota Test of Creative Thinking designed by Paul Torrance. The later publication of Getzels and Jackson's comparison of highly creative and "high IQ" students added interest to the ongoing studies at Penn State.[154]

Guilford had contrasted two types of productive thinking: *convergent* (bringing together toward one correct answer) and *divergent* (trying different possibilities with no need of one right answer). Divergent thinking was strongly associated with three traits that Guilford had identified as factors in creativity: *spontaneous flexibility*, *ideational fluency*, and *originality*.[155]

These traits were widely accepted, but Brittain and Beittel, through a series of studies, concluded that tests for creativity in art would have to be developed within the field: tests for generalized creativity were inadequate. The third major collaborating researcher was Robert Burkhart, whose *Spontaneous and Deliberate Ways of Learning* described two distinct "creative strategies" with corresponding personality traits in both students and teachers, together with advice on effective techniques of promoting creativity.[156] A significant methodological feature of these studies was the evaluative commentary of students regarding their own work.

Burkhart and Beittel continued the documentation and analysis of the process of individual students in producing drawings. By 1963, they had refined their categories so that they spoke of *spontaneous*, *divergent*, and *academic* students. Only the first two were regarded as originative: the *spontaneous* (holding constant some vaguely conceived imagery and trying many alternative approaches to it) and the *divergent* (emphasizing discovery with no constancy of the "problem"). Both of these behaviors might be needed in a creative process. The third type, the *academic* student (previously called *deliberate*), used an already known technique or procedure to achieve a predetermined outcome—not truly an originative way of working, according to these researchers. These constructs gained immediate currency and, with the implications for teaching that Burkhart proposed, were the subject of a number of studies by other researchers.

In the same period, Beittel, Mattil, Burkhart and others at Penn State began the comparison of effects of *depth* and *breadth* in art studio instruction that has been mentioned earlier.[157] In the major reported study, three groups of ninth graders in a terminal required art course were the subjects. Through a school year, the "depth" group followed a specially designed curriculum in painting. The designed curriculum of the "breadth" group gave experiences in several media. Both experimental curricula included enrichment by several media. A control group followed the curriculum of the previous year, essentially a breadth approach. Their art products were judged for aesthetic quality and "spontaneous handling," which was defined "in terms of freedom and ease of movement in the use of materials and rendering of forms."

153. Ralph A. Smith, "An Exemplar Approach to Aesthetic Education: A Preliminary Report" (Urbana, 1967). Mimeo. Smith's final report is included in Richard Colwell, *An Approach to Aesthetic Education*, 2 vols. (Urbana, 1970).

154. Jacob Getzels and Philip W. Jackson, *Creativity and Intelligence* (New York, 1962). Art educators were interested in this provocative comparison of "high creative" and "high IQ" students, their family backgrounds, and their status in schools. Creativity was supported, but "high creatives" were less easily managed and less approved of by teachers. There was a question of whether art teachers held the same preference: if so, were they really promoting creativity?

155. J. P. Guilford, "Traits of Creativity," in Harold H. Anderson, ed., *Creativity and Its Cultivation* (New York, 1959), 142–61. More specifically, Guilford described fluency as the ability to produce significant ideas quickly: he identified four subtraits (*ideational*, *expressional*, *associational*, and *word* fluency). Flexibility was measured by the number of alternative possibilities suggested by

an individual. *Adaptive* flexibility was adjustment to conditions. *Spontaneous* flexibility was not required by conditions; it represented openness and freedom from stereotype and convention.

156. Robert C. Burkhart, *Spontaneous and Deliberate Ways of Learning* (Scranton, Pa., 1962).

157. Beittel, Mattil, et al., "The Effect of a 'Depth' vs. a 'Breadth' Method of Art Instruction at the Ninth Grade Level," 75–87. Reprinted in Ecker and Eisner, *Readings in Art Education*, 246–58.

Only the depth group gained significantly in aesthetic quality and spontaneous handling. An overall gain in "art quality" was found only with gains in both aesthetic quality and spontaneity. But the report states that "ideational creativity is clearly related to the achievement of progress in ART QUALITY regardless of instructional or methodological differences. It may be that the better pupils are good regardless of how they are taught because they are capable of being more self-determining in general, both ideationally and artistically."[158]

As noted earlier, these findings fitted well with the emerging emphasis on subject matter and excellence rather than global personality. Though students and teachers reportedly preferred the breadth approach, the experimenters suggested that the favorite activities in school did not necessarily result in the most valuable learnings, whatever the subject. By mid-decade there were calls for a "balance" of depth and breadth experiences: Leon Frankston replied that depth could not be achieved within such a compromise unless the school offered additional time for the breadth component, an obvious improbablity.[159] The net result was a theoretical preference for depth, a reinforcement of the concern for more effective teaching, and little change in actual curricula.

The study of spontaneous and divergent students, their creative strategies, and teaching techniques continued. Time-lapse photography recorded sequences in the development of drawings so that researchers could engage students in "self-reflective" consideration of their processes, as an instructional approach to the artist's continuous evaluation in working. In testing more and less explicit "feedback" in the form of the photographs, in comparison to more or less explicit intervention by the instructor, Beittel concluded that even the most capable learners (the "spontaneous-high" students) would not progress without good instruction.[160]

Thus, the effort to develop an understanding of creativity in art had led from the identification of theoretical types (convergent-divergent, spontaneous-divergent-deliberate-academic) to the effects of conditions upon outcomes of aesthetic attitude and sensitivity, changes of strategy, and qualities of art products. The manipulation of conditions evolved into alternative strategies of teaching.

The research programs at Penn State and Ohio State, though they have been described as the two major institutional campaigns of the sixties, were neither wholly exclusive of other interests nor independent of each other. Teaching methods had been an explicit concern of the Ohio State work in art appreciation. Appreciation was also a concern at Penn State; self-reflection upon creative processes was a topic of dissertations at Ohio State in the early sixties; and the Penn State seminar originated in the mutuality of interest in the two faculties.

Other Research

Doctoral theses in art education tell us much about the theoretical interests and practical concerns of their time. In the sixties, the annual national output grew to twenty or more.[161] Their topics, of course, were conditioned by several factors: the practical limits of time, scope, complexity, and resources; the current research stimulating further investigation; and the personal and professional interests of students and advisers. Most of the graduate programs in art education were too small to generate the continuity and depth of research achieved at Penn State and Ohio State. But there were strong programs in several other large state universities, at Stanford, at Columbia, and at New York University. Their doctoral graduates, as they joined the faculties of other institutions, passed along interests and methodology.

Doctoral studies at most institutions tended to focus less on the further development of theoretical constructs than on the effects of teaching techniques in relation to existing theory. With regard to classroom method, Beittel's interest in "learning-set" and types of feedback were developed elsewhere into the contrasting of "directive" or "convergent" teaching and "self-instruction."[162] Problems in creativity were somewhat more popular than those relating to appreciation and aesthetic sensitivity. Perception, though it was frequently related to attitude, awareness, appreciation, and learning, was perhaps too technically demanding to be commonly the primary focus of a dissertation. The documentation and analysis of student-teacher

158. Ecker and Eisner, *Readings in Art Education*, 254.

159. Leon Frankston, "The Case for Depth in Art: A Reaction against the Kaleidoscopic Effects of the Breadth Approach to Teaching Art at the Secondary School Level," *Art Education* 20, no. 7 (October 1967): 4–9.

160. Kenneth R. Beittel, *Selected Psychological Concepts as Applied to the Teaching of Drawing* (University Park, Pa., Pennsylvania State University, U.S.O.E., 1966) ERIC document ED 012 804, C.R.P. no. 3149.

161. This discussion of doctoral research is based largely upon the standard reference, *Dissertation Abstracts*. Lengthy examination of this source, however, does not produce wholly reliable data, in part owing to the multiplicity of categories or key words under which abstracts are indexed and partly because the flow of data from universities seems sometimes irregular.

162. The interest in nondirective teaching and self-instruction should be considered in relation to the popularity of existentialist ideas and the general antiauthoritarian claims of the late sixties. Similarly, the preeminence of Abstract Expressionism and related spiritual interests should be considered in relation to the high cultural value accorded spontaneity and the characteristics that defined the spontaneous style in drawing, when these theoretical constructs were developed.

interaction, employed at both Ohio State and Penn State and much "in the air" in the sixties, was employed in a variety of research efforts elsewhere.

Problems in creativity and method were frequently linked to a particular medium or form of art, most commonly to painting and drawing, but also to sculpture, crafts, and collage. Apart from problems of the creative and appreciative processes and the appropriate methods of teaching, the most common subjects for doctoral projects were surveys and designs of curricula at all school levels. Evident among these was dissatisfaction with the programs to prepare teachers of art, including the elementary classroom teachers who would carry much of the art educational responsiblity. Among the designs for K-12 programs, correlation appeared as a continuing goal for some art teachers, with related arts as the focus of a generous handful of curriculum plans. There were surprisingly few studies of the possibilities of television, programmed instruction, and other audiovisual media. The administration and supervision of school art was a related frequent concern, and a few surveys concerned teachers themselves—their education, their responsibilities, and their opinions on professional matters.

Philosophical studies averaged about one each year: phenomenology, existentialism, Deweyian pragmatism, and current trends in aesthetics and art were among the issues that might influence planning, teaching, and research. Historical studies evidently held less interest.

Cross-cultural studies increased modestly as more foreign students arrived and ethnic antecedents began to gain respect. But a number of other cultural trends growing through the sixties were hardly reflected in doctoral research: among the less popular topics were religion, the environment, education in museums and community centers, special curricula for the gifted and talented, and adult education. Amid the development of legislation and educational programs to aid minorities and other disadvantaged persons and despite the influential work of June McFee, research by doctoral students in art education showed little corresponding response: what was done during the sixties was most often the effort of more experienced scholars and professionals.

It remains to be noted that the techniques and tools of research in art education were greatly strengthened through the variety of research reported above, the federally funded projects, and the drive toward measurable objectives, testing, and national assessment. A successful doctoral student in the fities might have completely ignored the courses in statistics, testing, and measurement that became common requirements in the sixties. The instruments developed by professionals like McFee, Beittel, Eisner, Burkhardt, Rouse and others became the repertoire of graduate departments across the country. Doctoral students went on to develop their own tests, scales, and survey forms as their research required. Art education entered the seventies with substantial expansion of its agenda and capabilities for research.

SUMMARY

On either a cylical or a "pendulum" theory of the national history, the swing toward a liberal, activist federal government was due in the sixties: the Kennedy-Johnson social agenda developed on a thirty-year schedule just as turn-of-the-century progressivist objectives were achieved in the thirties. Federal legislation funded a variety of educational programs and research projects and created endowments for the arts and humanities. Federal authorities intervened to enforce court rulings on racial desegregation. But national and global forces collided: the eruption of the Cold War in Vietnam triggered social upheavals that ended Johnson's Great Society. (Any such brief summary of the sixties would be simplistic.)

Already in the late fifties, cultural change was evident in each of the arts and in collaborations combining music, theater, dance, poetry, and the visual arts. If the arts were disengaged from social concerns in the sixties, as some have said, the multiplicity of styles expressed a new scope of freedom—a broadened choice of aesthetic values and personal attitudes, an expansion of the possibilities of forms of art. Many issues were shared, with perception and sensitivity at the center: high art in contrast to (or composed of) mundane forms and behaviors; individual psyche and action versus formal anonymity; chance as opposed to systems; the inward contemplation of the isolated aesthetic object or the group sharing of a nonsensical common environment in Happenings; the significant privacy of Cornell's boxes or engineered audience participation; the aesthetic object displaced by attention to process, displaced again by the pure conception reluctantly put on paper, then magnified a thousand-fold in the blasting of a mountain or bulldozing of the desert. From dozens of new style-terms in the sixties, a few survived: Action Art, Pop Art, Neo-Dada, Op Art, Minimal Art, Literalism, Process Art, Conceptual Art, Color Field, Kinetic Art, Earthworks, Environmental Art, Happenings, Performance Art.

Public education likewise developed under influences already apparent in the mid-fifties. Theory and methodology were affected by intellectual currents in the social, behavioral, and physical sciences, in linguistics, mathematics, and communications. Public criticism in the fifties blamed progressivism (which had become mildly institutionalized) for failure to teach the "basics." Intellectual criticism called for a return to humanist traditions. Leaders in the academic disciplines convened to bring the K-12 learnings

up-to-date. These forces came together: by the early sixties, curriculum reform was dominated by emphasis on "excellence" in subject matter reformulated by experts in each field.

Proof of learning was wanted: behavioral objectives became a major enthusiasm, but at the same time, more wholistic methods of evaluation and reporting were encouraged. Classroom innovations included television, programmed learning, and flexible class groupings made possible by computerized scheduling. After the mid-sixties, supported by federal programs, new attention went to the inner city, to minorities and the disadvantaged: by the end of the decade, along with "competencies," the new call was to "humanize" the schools.

Art education entered the sixties under a certain dynamic force of its own, although as a responsive enterprise, its directions paralleled broader cultural trends. Broadly characterized, the movement was to reduce emphasis on the personalist art education advanced so powerfully by Lowenfeld. Barkan had urged a stronger foundation in social sciences and philosophy of art. McFee built her *perception-delineation* theory on sociology, anthropology, psychology, and the needs of urban children. The call of the Committee on Art Education for emphasis on art and artists was carried into the sixties in journals and conferences.

Alternative reconceptions of art education abounded. Related arts activities had developed gradually throughout the progressive era. The popularity of such programs was nurtured in the sixties by exemplary enthusiasm among professional artists, by the concept of the arts as a balance to mass technology, and by deliberate federal policy. With similar support but with more intellectual emphasis, humanities programs gave new focus to integrative core curricula that had become common in the thirties. Perceptual awareness and aesthetic literacy were among the terms representing other proposals for new directions in school art.

The major redefinition of visual art as a worthy independent subject followed from curriculum reform projects in other content fields. In the literature of such projects, art educators responded especially to Bruner's description of any subject as a discipline possessing a conceptual and procedural structure best known to its practitioners. Accordingly, the structure of visual art as a school subject would be drawn from scholarship and practice in art history, art criticism, aesthetics, and the production of art. Two or three of these four domains of discipline were beyond the competence of most art teachers. The implied task for curriculum research and development indicated need for centralized expertise: art products were never before so diverse; history could not be taught to children by

the traditional lecture; criticism and aesthetics were seldom studied in art teacher preparation programs.

At the same time, to gain precision in the definition and assessment of learnings, the methodology of behavioral objectives was advocated to art educators. Their response was mixed: analysis and evaluation were needed, but many believed that the required prescription of ideas, processes, and outcomes was antithetical to the inherent essentials of art. Yet the very definition of art was in question.

To the outburst of new styles, art education responded in the usual manner: stylistic innovations were transmitted not by any gathering of leadership but by the more adventurous teachers in higher education and K-12 artrooms, stimulated by periodicals and exhibitions. More generally than particular styles, what the alert art educators shared was an openness to new forms and media; a new aesthetic climate with emphasis on perceptual awareness and philosophical acuity; and the example of professionals in relating the arts.

In any prior decade, such a variety of ideas might have had little effect. In the mid-sixties, new federal programs brought curriculum experts and art professionals to meet with art educators. The resulting formulations provided a base for projects in curriculum research and development that continued into the seventies. Federal funds further supported an unprecedented expansion of doctoral research. The direct impact of research upon classroom practice, it is generally agreed, is too limited to be taken as a measure of its pervasive value to education. Indeed the influence of the sixties upon education in the subsequent decades cannot yet be fully documented. The probability is that it will be seen as a watershed decade in school art.

FURTHER READINGS

Conant, Howard, ed. *Seminar on Elementary and Secondary School Education in the Visual Arts.* New York, 1965.

Eisner, Elliot W., and David W. Ecker, eds. *Readings in Art Education.* Waltham, Mass., 1966.

Hastie, W. Reid, ed. *Art Education. The Sixty-Fourth Yearbook of the National Society for the Study of Education, Part II.* Chicago, 1965.

Hausman, Jerome J., ed. *Report of the Commission on Art Education.* Washington, D.C., 1965.

Hoffa, Harlan. *Analysis of Recent Research Conferences in Art Education.* Final Report. Bloomington, 1970. Project no. 8-E-093.

Madeja, Stanley S., with Sheila Onuska. *Through the Arts to the Aesthetic: The CEMREL Aesthetic Education Program.* St. Louis, 1973.

Mattil, Edward, ed. *A Seminar in Art Education for Research and Curriculum Development.* University Park, Pa., 1966.

Music Educators National Conference. *Toward an Aesthetic Education.* Washington, D.C., 1967.

Epilogue

rriving at 1970, looking back over the entire enterprise of school art, we should try to make sense of the record of national events, public reactions, trends in all the arts, the books, conferences, projects, the thousands of teachers: we should reflect on big questions and discern perennial issues.

Has art education responded to changes in society, education, art, and our ideas of the individual? If so, were these responses merely cosmetic and opportunistic? Have they gone below the surface of publications, conventions, and grantsmanship? Whatever the revised purposes, the new theories, and the changes in classroom activities, has cumulative wisdom developed? Years ago, I thought these questions could be answered in some such words as the following:[1]

■ Art in the schools has been practiced and praised successively as contributing to the national wealth and moral fiber, the exercise of the faculties, adult competence, social efficiency, mental hygiene, community welfare, patriotism, world peace, and the whole personality development of the individual. But increasingly, the life of art has been valued for itself.

■ Simple illustrations of the trend lie close to the historical surface. We may recall how the definition of art has changed to fit the cultural model—the neoclassical rationalist, the romantic idealist, the existential hero. For Victorians, the job of art was the revelation of beauty and order. For Dow, art education was the cultivation of fine choices; for Kilpatrick, the application of problem solving. In the twenties, art became the vehicle for personal freedom; in the thirties, for

social values; in the fifties, for self-expression; in the sixties, for celebration of the commonplace or for protest against the establishment or for the refuge of pure contemplation.

■ Other examples may be given in terms of materials and methods. When the aim of art education was industrial and its theory idealistic, the materials were chalk and slate or pencil and paper and the method was a series of abstract exercises and linear renderings. When the materials were used for application of principles of composition, the method was closely defined problems or free experiment with a variety of media. As personal values and more authentic art experience became paramount, deep engagement with a single material appeared more important than the utility of projects and structured courses. When appreciation and cognitive understanding were sought, the materials were verbal and illustrative—readings, reports, the museum, and audiovisual media.

Not bad, perhaps, but such reflections should be reconsidered: within those changes are questions that remain unanswered, debatable, open to the individual informed judgment. And are these not in fact really perennial issues, never finally resolved, that arise from the nature of art and public education?

Can we understand curriculum, past, present, and future, as experts advise us, by consideration of the society, the subject, and the individual? If so, does the argument of John Dewey with Margaret Naumburg in 1930 persist, setting the social process and function of education against the primacy of individual mental health and thus raising questions about the conception of art in education?

Does the public always expect three fundamental results from its school system: moral citizenship; mastery of basic subjects; and preparation for work? If so,

1. The following three paragraphs, with a few updating additions, are taken from my unpublished doctoral dissertation, "A History of the Department of Fine and Industrial Arts of Teachers College, Columbia University" (Ed.D. diss., Columbia University, 1959).

how shall art education establish its contribution? Is there any connection between ethics and aesthetics? Can art be a basic subject? What, if any, role should art claim in preparation for work? With civic planning an increasing necessity to enhance the quality of life, should the design disciplines contend with art, history, and aesthetics for admission into school art? How does our history inform our thinking on such questions?

Do we find any relationship among the arts—any commonalities—as we reconsider their response to (or their influence on) sociocultural trends? Is there any historical evidence that current work in the other arts might provide guidance for visual arts education?

Are there other perennial issues?

Finally, shall we test the proposition that the past illuminates the present? With the sixties reassembled as a launching pad for the following decades, what has happened—what goes on—with aesthetics, criticism, and the history of art; with related arts, aesthetic education, and the humanities; with research using the physical sciences and behavioral sciences as models; with pluralistic and multicultural art education; with concern for minorities and the disadvantaged; with external support to equal the stimulation of the federal funding of the sixties?

Is it too much for an art teacher to think about? To recall again a comment by Jacques Barzun in reference to the complexities of contemporary life, "anyone who thinks at all is something of a cultural historian."[2]

2. Jacques Barzun, "Cultural History as a Synthesis," in *The Varieties of History: From Voltaire to the Present*, ed. Fritz Stern (Cleveland, 1956), 393.

❦ Bibliography ❧

HISTORY OF ART AND ART EDUCATION

Bayley, Stephen, Phillipe Garner, and Deyan Sudjic. *Twentieth Century Design*. New York, 1986.

Bennett, Charles Alpheus. *History of Manual and Industrial Education 1870 to 1917*. Peoria, Ill., 1937.

Clark, Gilbert. "Early Inquiry, Research, and Testing of Children's Art Abilities." In *The History of Art Education*, edited by Brent Wilson and Harlan Hoffa. Reston, Va., 1985.

Council on Museums and Education in the Visual Arts. *The Art Museum as Educator*, edited by Barbara Y. Newsom, and Adele Z. Silver. Berkeley, 1978.

Ebken, Ruth, ed. *Prospect and Retrospect: The Eastern Arts Association, 1910–1960*. Eastern Arts Association, 1960.

Efland, Arthur. *A History of Art Education: Intellectual and Social Currents in Teaching the Visual Arts*. New York, 1990.

Howe, Winifred E. *A History of the Metropolitan Museum of Art*. 2 vols. New York, 1946.

Korzenik, Diana. *Drawn to Art: A Nineteenth Century American Dream*. Hanover, N.H., 1985.

Larkin, Oliver W. *Art and Life in America*. Rev. ed. New York, 1966.

Logan, Frederick M. *Growth of Art in American Schools*. New York, 1955.

———. "The Development of Art Education in the Twentieth Century U.S.A." In *Report of the Commission on Art Education*, edited by Jerome J. Hausman. Washington, D.C., 1965.

Nye, Russel. *The Unembarrassed Muse*. New York, 1970.

Pulos, Arthur J. *American Design Ethic: History of Industrial Design to 1940*. Cambridge, Mass., 1983.

———. *The American Design Adventure*. Cambridge, Mass., 1988.

Schubert, William Henry. *Curriculum Books: The First Eighty Years*. Washington, D.C., 1980.

Soucy, Donald, and Mary Stankiewicz, eds. *Framing the Past: Essays on Art Education*. Reston, Va., 1990.

Wilson, Brent, and Harlan Hoffa, eds. *The History of Art Education: Proceedings from the Penn State Conference*. University Park, Pa., 1985.

Wygant, Foster. "A History of the Department of Fine and Industrial Arts of Teachers College, Columbia University." Ed.D. diss., Columbia University, 1959.

CHAPTER ONE: THE 19TH CENTURY

Abbott, Josephine L. *Outlines for the Study of Art*. New York, 1891.

Augsburg, D. R. *Drawing Simplified: A Text-Book of Form Study and Drawing*. Boston, 1892.

Bailey, Henry Turner. *A First Year in Drawing*. Boston, 1894.

Barnard, Henry. *American Journal of Education* 1 (1856): 686–95.

Bartholomew, William. *Bartholomew's Sketches from Nature*. Boston, 1855.

———. *Teacher's Guide: Companion to Bartholomew's Drawing Book No. 1*. Boston, 1867.

———. *Teacher's Manual to Accompany Bartholomew's National System of Industrial Drawing*. New York, 1876.

[Bartholomew]. *Drawing in the Public Schools by the Use of the Smith Books Condemned*. New York, 1874.

Chapman, John G. *The American Drawing Book*. New York, 1847.

Clarke, Isaac Edwards. *Art and Industry, Industrial and High Art Education in the United States, Part I, Drawing in Public Schools*. Washington, D.C., 1885.

Clement, Clara Erskine. *An Outline History of Painting for Young People and Students*. New York, 1883.

Cross, Anson K. *Color Study*. Boston, 1895.

———. *Free Hand Drawing: Light and Shade and Free Hand Perspective*. Boston, 1892.

Daniels, Fred H. *The Teaching of Ornament*. New York, 1900.

Dewey, John. *Lectures in the Philosophy of Education: 1899*, edited by Reginald D. Archambault. New York, 1966.

Emery, M. S. *How to Enjoy Pictures, With a Special Chapter on Pictures in the School-Room by Stella Skinner*. Boston, 1888.

Ferber, Linda S. and William H. Gerdts. *The New Path: Ruskin and the American Pre-Raphaelites*. New York, 1985.

Francoeur, Louis Benjamin. *An Introduction to Linear Drawing*, trans. by William Bentley Fowle. Boston, 1825.

Froebel, Friederich. *The Education of Man*, trans. by W. N. Hailmann, edited by William T. Harris. New York, 1904. Original publication: Keilhau, Germany, 1826.

Goodyear, William Henry. *A History of Art*. 6th ed. New York, 1889.

Hall, James. *With Brush and Pen*. 3rd ed. New York, 1897.

Hamilton, George. *The Elements of Drawing*. London, 1812.

Hicks, Mary D., and John S. Clark. *The Use of Models: A Teacher's Assistant in the Use of Prang Models for Form Study and Drawing.* Boston, 1889.

Hildreth, Ellen Stephens. *Clay Modeling in the School Room.* Springfield, Mass., 1892.

Hoyt, Deristhe L. *The World's Painters and Their Pictures.* Boston, 1899.

Krusi, Hermann. *Krusi's Drawing. Manual for Teachers. Inventive Course—Analytic Series.* New York, 1873.

———. *Krusi's Drawing. Manual for Teachers. Inventive Course—Synthetic Series.* New York, 1872.

———. *Pestalozzi: His Life, Work, and Influence.* Cincinnati, Oh., 1875.

———. *Recollections of My Life*, edited by Elizabeth Sheldon Alling. New York, 1907.

Lang, Ossian H., ed. *Educational Creeds of the Nineteenth Century.* New York: 1898. Reprint. New York, 1971.

Locke, Josephine C. "The Mission of Color." In *Proceedings, 1890.* Chicago: National Education Association, 1890.

Mann, Horace. *Common School Journal* 6 (July 15, 1844).

Marzio, Peter C. *The Art Crusade.* Washington, D.C., 1976.

Massachusetts Normal Art School. *The Antefix Papers.* Boston, 1875.

Maycock, Mark M. *A Class Book of Color; Including Color Definitions, Color Scaling, and the Harmony of Colors.* Pupils' ed. Springfield, Mass., 1896.

Minifie, William. *A Text Book of Geometrical Drawing for the Use of Mechanics and Schools.* Baltimore, 1849.

Parker, Francis W. *Talks on Pedagogics: An Outline of the Theory of Concentration.* New York, 1894.

Peale, Rembrandt. *Graphics: A Manual of Drawing and Writing for the Use of Schools and Families.* 2d ed. New York, 1835.

Pestalozzi, Johann Heinrich. *ABC der Anschauung-Lehre, der Massverhaltnisse.* Zurich, 1803. The title is translated as *ABC of Sense Impressions* or *Sense-Impression Study of Proportion.*

Platt, W. H. *Art Culture: A Handbook of Art Technicalities and Criticisms, Selected from the Works of John Ruskin.* New York, 1875.

Prang and Company [L. Prang and Company]. *Slate Pictures: Drawing School for Beginners.* Boston, 1863.

———. *The American Text-books of Art Education. Teachers' Manual. Part I, to Accompany Drawing Books I and II.* Rev. ed. Boston, 1880.

Prang Educational Company. *Text-Book to the Illustrations of the History of Art*, trans. by Margaret Hicks Volkmann. Boston, 1883.

Ruskin, John. *The Elements of Drawing: In Three Letters to Beginners.* New York, 1857.

Samson, G. W. *Elements of Art Criticism.* Abridged ed. Philadelphia, 1869.

Shattuck, W. B. *The Columbian Drawing Book. No. I.* 2d and improved ed. Cincinnati, 1840.

Sigourney, Lydia H. "The Perception of the Beautiful." *Connecticut Common School Journal* 2 (February 1, 1849): 117–18

Smith, H. P. *White's School Series of Industrial Drawing.* New York, 1878.

Smith, John Rubens. *The Juvenile Drawing Book.* 5th ed. Philadelphia, 1845.

Smith, Walter. *American Text-Books of Art Education.* Rev. ed. Boston, 1879. Cards, fourteen graded books, and teacher's manuals.

———. *Art Education, Scholastic and Industrial.* Boston, 1872.

———. *Teacher's Companion to the American Drawing Slates and Cards.* Boston, 1872.

———. *Teacher's Manual for Free-Hand Drawing in Intermediate Schools.* Boston, 1874.

———. *Teacher's Manual of Free-Hand Drawing and Designing.* Boston, 1873.

Stein, Roger B. *John Ruskin and Aesthetic Thought in America, 1940–1900.* Cambridge, Mass., 1967.

Sullivan, Christine Gordon. *The Eclectic System of Industrial Free-Hand and Mechanical Drawing.* Rev. ed. New York, 1884.

———. *Elements of Mechanical Drawing for Use in the Schoolroom and Workshop.* New York, 1893.

Thompson, Langdon S. *Educational and Industrial Drawing: Primary Freehand Manual.* Boston, 1896.

Tyrwhitt, R. St. John. *Our Sketching Club. Letters and Studies on Landscape Art. With an Authorized Reproduction of the Lessons and Woodcuts in Professor Ruskin's Elements of Drawing.* Boston, 1875.

Whittock, Nathaniel. *The Oxford Drawing Book.* New York, 1840.

Witter, James C., pub. *Art Education.* New York, 1894–1901.

Wygant, Foster. *Art in American Schools in the Nineteenth Century.* Cincinnati, Oh., 1983.

CHAPTER TWO: 1900–1915

Bailey, Henry Turner. *Art Education.* Boston, 1914.

Batchelder, Ernest A. *The Principles of Design.* Chicago, 1904.

Bradley, Milton. *Watercolors in the Schoolroom.* Springfield, Mass., 1900.

Caffin, Charles H. *A Child's Guide to Pictures.* New York, 1908.

———. *How to Study Pictures.* New York, 1905.

Casey, William C. *Masterpieces in Art: A Manual for Teachers and Students.* Chicago, 1915.

Chase, Joseph Cummings. *Decorative Design: A Textbook of Practical Methods.* New York, 1915.

Clark, Arthur B. *Design: A Text-Book for Students and Craftsworkers.* Stanford University, 1915.

Colby, Lou Eleanor. *Talks on Drawing, Painting, Making, Decorating for Primary Teachers.* Chicago, 1909.

Daniels, Fred Hamilton. *School Drawing: A Real Correlation.* Springfield, Mass., 1909.

Dewey, John. *The Child and the Curriculum.* Chicago, 1902.

Dow, Arthur W. "Training in the Theory and Practice of Teaching Art." *Teachers College Bulletin* 10 (May 1908): 49–50.

Farnum, Royal Bailey. "Present Status of Drawing in the Elementary and Secondary Schools of the United States." *Bureau of Education Bulletin*, no. 13 (1914). Department of the Interior. Bureau of Education. Washington, D.C.

Froelich, Hugo B., and Bonnie E. Snow. *Text Books of Art Education. Books 1–7.* New York, 1904–05.

Hall, Stanley, G. *Educational Problems.* New York, 1911.

Haney, James Parton, ed. *Art Education in the Public Schools of the United States*. New York, 1908.

Hurll, Estelle M. *How to Show Pictures to Children*. Boston, 1914.

Midgley, W., and A. E. V. Lilley. *A Book of Studies in Plant Forms with Some Suggestions for Their Application to Design*. Enlarged ed. New York, 1902.

Moffatt, Frederick C. *Arthur Wesley Dow (1867–1922)*. Washington, D.C., 1977.

Noyes, Carleton. *The Enjoyment of Art*. Boston, 1903.

Poore, Henry R. *Pictorial Composition and the Critical Judgement of Pictures*. New York, 1903.

Prang Company. *First Steps in Painting and Drawing with Some Suggestions in Manual Arts*. New York, 1909.

———. *The Graphic Drawing Books*. Books One–Eight. New York, 1914.

Prang Educational Company. *A Course on Water Color*. New York, 1900.

———. *Art Education for High Schools*. New York, 1908.

———. *Design*. New York, 1908.

Ridingsvard, Anna M. *Art Studies for Schools*. Chicago, 1903.

Ross, Denman Waldo. *On Drawing and Painting*. Boston, 1912.

———. "Design as a Science." American Academy of Arts and Sciences. *Proceedings* 36, no. 21 (March 1901): 357–70.

Sargent, Walter. *Fine and Industrial Arts in Elementary Schools*. Boston, 1912.

Sargent, Walter, and Elizabeth E. Miller. *How Children Learn to Draw*. Boston, 1916.

Stimson, John Ward. *The Gate Beautiful*. New York, 1903.

Sturgis, Russell. *The Appreciation of Pictures*. New York, 1904.

Thompson, Langdon S. "Report of the Committee of Ten on Elementary Art Education." In *NEA Proceedings, 1902*. Chicago: National Education Association, 1902.

Tillinghast, Ada Whitton. *Turner Picture Studies Adapted to the Several School Grades*. Boston, 1908.

Van Helden, Caroline West. *A Note on Color*. Springfield, Mass., 1912.

Wilson, L. L. W. *Picture Study in Elementary Schools*. New York, 1909.

Wright, Willard Huntington. *Modern Painting in Tendency and Meaning*. New York, 1915.

CHAPTER THREE: 1916–1929

Augsburg, D. R. *The ABC of Color*. Morristown, Tenn., 1923.

Beck, Minna McLeod. *Better Citizenship through Art Training*. Chicago, 1921.

Bennett, Charles Alpheus. *Art Training for Life and Industry*. Peoria, Ill., 1923.

Boas, Belle. *Art in the School*. Garden City, N.Y., 1924.

Boudreau, James C., and Harriet M. Cantrall. *Art in Daily Activities*. Chicago, 1929.

Cane, Florence. *The Artist in Each of Us*. New York, 1951.

———. "Art in the Life of the Child." *Progressive Education* 3 (April–June 1926): 155–62.

Child Study Committee of the International Kindergarten Union. *Children's Drawings*. Baltimore, 1924.

Cowley, Malcolm. *Exiles Return*. New York, 1934.

Cox, George J. *Art for Amateurs and Students*. Garden City, N.Y., 1926.

———. "Art Teacher Training for the Changing Curriculum." *Teachers College Record* 33 (October 1931): 54.

———. "Modern Trends in Art Education." *Teachers College Record* 31 (March 1930): 520.

De Garmo, Charles, and Leon Loyal Winslow. *Essentials of Design*. New York, 1924.

De Lemos, John T. *Instructor Picture Studies. Group One*, edited by Mary Owen. Dansville, N.Y., 1925.

Dewey, John. "How Much Freedom in the New Schools?" *The New Republic* (July 9, 1930): 204–06.

———, ed. *Art and Education*. Merion, Pa., 1929.

Farnum, Royal Bailey. "Art Education in the United States." Bulletin 1925, no. 38. Department of the Interior. Bureau of Education. Washington, D.C., 1926.

———. "Art Education: The Present Situation." Bulletin 1923, no. 13. Department of the Interior. Bureau of Education. Washington, D.C., 1923.

———. "Art Education." Bulletin 1931, no. 20, vol. 1. chap. 8. Department of the Interior. Office of Education. Washington, D.C., 1931.

Federated Council on Art Education. *Report of the Committee on Terminology*. Boston, 1929.

Frank, Waldo. *The Rediscovery of America*. New York, 1929.

Goldstein, Harriet, and Vetta Goldstein. *Art in Every Day Life*. New York, 1927.

Hartman, Gertrude, and Ann Shumaker, eds. *Creative Expression*. New York, 1932.

Kilpatrick, William Heard. "The Project Method." *Teachers College Record* 19 (September 1918): 319–35.

Klar, Walter, and Theodore M. Dilloway. *The Appreciation of Pictures*. New York, 1930.

Lynd, Robert S., and Helen Merrell Lynd. *Middletown*. New York, 1929.

Mathias, Margaret E. *Art in the Elementary School*. New York, 1929.

———. *The Beginnings of Art in the Public Schools*. New York, 1924.

———. *The Teaching of Art*. New York, 1932.

Mearns, Hughes. *Creative Youth*. Garden City, N.Y., 1925.

Mossman, Lois Coffey. "Project Method in Practical Arts." *Teachers College Record* 22 (September 1921): 327.

Naumburg, Margaret. "The Crux of Progressive Education." *The New Republic* (June 25, 1930): 145–46.

Neale, Oscar W. *Picture Study in the Grades*. Stevens Point, Wis., 1925.

Progressive Education Quarterly 3 (April–June 1926).

Rugg, Harold, and Ann Shumaker. *The Child-Centered School*. Yonkers, N.Y., 1928.

Sargent, Walter. *The Enjoyment and Use of Color*. New York, 1923.

Smith, Peter. "Franz Cizek: Problems of Interpretation." In *The History of Art Education: Proceedings from the Penn State Conference*, edited by Brent Wilson and Harlan Hoffa. University Park, Pa., 1985.

Snow, Bonnie E., and Hugo B. Froelich. *Industrial Art Text Books*. Eight books. New York, 1916. Rev. ed., 1923.

———. *The Theory and Practice of Color*. New York, 1920.

Stevenson, Sam. *Picture Studies Required by Course of Study for Elementary Schools*. Lincoln, Neb., 1925.

Thorndike, Edward L. "A Scale for General Merit of Children's Drawings." *Teachers College Bulletin*, 15th Series, no. 6. (December 1923): 3.

Whitford, William G. *An Introduction to Art Education*. New York, 1929.

Whitford, William G., and Jessie Mabel Todd. "Art for the Intermediate Grades." *The Classroom Teacher* 3 (1927): 7.

Williams, Lida M. *Picture Studies from Great Artists*. Chicago, 1922.

Winslow, Leon Loyal. *Elementary Industrial Arts*. New York, 1922.

———. *Organization and Teaching of Art*. Baltimore, 1925. 2d ed. Baltimore, 1928.

Woodbury, Charles H. *Visual Training through Drawing*. Boston, 1922.

Woodbury, Charles Herbert, and Elizabeth Ward Perkins. *The Art of Seeing: Mental Training through Drawing*. New York, 1925.

CHAPTER FOUR: 1930–1945

Alschuler, Rose H., and La Berta Weiss Hattwick. *Painting and Personality*. 2 vols. Chicago, 1947.

Art Digest 12, no. 1 (October 1937): 27.

Boswell, Peyton, Jr. *Modern American Painting*. New York, 1940.

Cole, Natalie Robinson. *The Arts in the Classroom*. New York, 1940.

Collins, M. Rose, and Olive L. Riley. *Art Appreciation for Junior and Senior High Schools*. New York, 1931.

Columbia University. Teachers College. Department of Fine and Industrial Arts. *Art Education Today*. 12 vols. New York, 1935–53.

Committee on the Function of Art in General Education. *The Visual Arts in General Education*. New York, 1940.

Counts, George S. *Dare the Schools Build a New Social Order?* New York, 1932. Reprint. New York: Arno Press, 1969.

Cox, George J. *Art and "the Life."* Garden City, N.Y., 1933.

Craven, Thomas. *Modern Art*. New York, 1934.

D'Amico, Victor. *Creative Teaching in Art*. Scranton, Pa., 1942. Rev. ed. Scranton, Pa., 1953.

De Lemos, Pedro J. *The Art Teacher*. Worcester, Mass., 1931.

———. "Art and Enthusiasm in New Russia." *School Arts Magazine* 34, no. 6 (February 1934): 322.

Department of the Interior. Office of Education. *Biennial Survey of Education in the United States, 1935–1938*. Washington, D.C., 1942.

Dewey, John. *Art as Experience*. New York, 1934.

Eng, Helga. *The Psychology of Children's Drawings*, trans. by H. Stafford Hatfield. New York, 1931.

Faulkner, Ray, Edwin Ziegfeld, and Gerald Hill. *Art Today*. New York, 1941. 4th ed. New York, 1964.

Gregg, Harold. *Art for the Schools of America*. Scranton, Pa., 1941.

Haggerty, Melvin. *Art a Way of Life*. Minneapolis, 1934.

Hardman, Maud R. "Crafts as Artistic Expression for the Child." *School Arts* 42, no. 9 (May 1943): 293–96.

Hilpert, Robert S. "Instruction in Music and Art, Part II." *National Survey of Secondary Education*. Bulletin 1932, no. 17, monograph no. 25. Department of the Interior. Office of Education. Washington, D.C., 1933.

Keppel, Frederick P., and R. L. Duffus. *The Arts in American Life*. New York, 1933.

Klar, Walter H., Leon L. Winslow, and C. Valentine Kirby. *Art Education in Principle and Practice*. Springfield, Mass., 1933.

Lowenfeld, Viktor. *The Nature of Creative Activity*. New York, 1939.

Martin, John. "Dancing." In *Art in American Life and Education*. Fortieth Yearbook of the National Society for the Study of Education, edited by Guy M. Whipple. Bloomington, Ill., 1941.

Matherly, Mildred. "Fourth Graders Enjoy Stravinsky's 'Firebird Suite'." *School Arts* 42, no. 8 (April 1943): 288.

Michalowski, Elizabeth. "An Inquiry into the Long-Range Effects of Intensive Art Stimulation on a Selected Group of Individuals: The Owatonna Art Education Project in Retrospect." Ed.D. diss., Columbia University, 1978.

Moholy-Nagy, Laszlo. *The New Vision*. New York, 1930.

New York City Board of Education. *Course of Study in Art for Elementary Schools*. New York, 1931.

Nicholas, Florence W., Nellie Mawhood, and Mabel B. Trilling. *Art Activities in the Modern School*. New York, 1937.

Obarr, Maud R. "Primary Murals." *School Arts* 38, no. 5 (January 1939): 176–77.

Payant, Felix. *Our Changing Art Education*. Columbus, Oh., 1935.

Pearson, Ralph M. *The New Art Education*. New York, 1941.

Perrine, Van Dearing. *Let the Child Draw*. New York, 1936.

Profitt, Maris M. *High School Clubs*. Bulletin 1934, no. 18. Department of the Interior. Office of Education. Washington, D.C., 1934.

Read, Herbert. *Education through Art*. London, 1943. 2d ed. New York, 1945.

Rugg, Harold. "After Three Decades of Scientific Method in Education." *Teachers College Record* 35, no. 3 (November 1934): 114–16.

Russell, Mable, and Elsie Pearl Wilson. *Art Training through Home Problems*. Peoria, Ill., 1933.

Saunders, Robert J. "First Steps: The FCAE and the NAAE: A Brief History." *Art Education* 31, no. 7 (November 1978): 18–22.

Tannahill, Sallie B. *Fine Arts for School Administrators*. New York, 1932.

Todd, Jessie, and Ann Van Nice Gale. *Enjoyment and Use of Art in the Elementary School*. Chicago, 1933.

University of the State of New York. State Education Department. *Correlated Syllabus in Art Education for the Junior High School Years*. Albany, 1936.

Viola, Wilhelm. *Child Art*. London, 1942.

Whipple, Guy M., ed. *Art in American Life and Education*. Fortieth Yearbook of the National Society for the Study of Education. Bloomington, Ill., 1941.

Whitford, William G., and Edna B. Liek. *Art Appreciation for Children*. Chicago, 1936.

Winslow, Leon Loyal. *The Integrated School Art Program*. New York, 1939.

Ziegfeld, Edwin, and Mary Elinore Smith. *Art for Daily Living: The Story of the Owatonna Project*. Minneapolis, 1944.

CHAPTER FIVE: 1946–1959

Arnheim, Rudolph. *Art and Visual Perception*. Berkeley, 1954.

Art Education for Scientist and Engineer: Report of the Committee for the Study of the Visual Arts at the Massachusetts Institute of Technology, 1952–4. Cambridge, Mass., 1957.

Artaud, Antonin. *Le Theatre et Son Double*. Paris, 1938. C. Richards, trans. *The Theater and Its Double*. New York, 1958.

Babbitt, Milton. "Who Cares If You Listen." *High Fidelity* 7, no. 2 (February 1958): 38–40, 126–27.

Barkan, Manuel. *A Foundation for Art Education*. New York, 1955.

Bland, Jane Cooper. *Art of the Young Child*. New York, 1958.

Bloom, Benjamin S., ed. *Taxonomy of Educational Objectives, Handbook I: Cognitive Domain*. New York, 1956.

Conant, Howard, and Arne Randall. *Art in Education*. Peoria, Ill., 1959.

Conant, James B. *The American High School Today*. New York, 1959.

Cresse, Else Bartlett. *The Instructor Art Packets for Kindergarten through Grade 8*. Dansville, N.Y., 1956.

D'Amico, Victor. *Experiments in Creative Art Teaching*. New York, 1960.

———. "Coming Events Cast Shadows." *School Arts* 58, no. 1 (September 1958): 14.

De Francesco, Italo L. *Art Education: Its Means and Ends*. New York, 1958.

———. "A New Dimension for Art Education." *Art Education* 12, no. 6 (June 1959): 12.

Ellsworth, Maud, and Michael F. Andrews. *Growing with Art*. Chicago, 1950.

Erdt, Margaret Hamilton. *Teaching Art in the Elementary School*. New York, 1954.

Esslin, Martin. *The Theatre of the Absurd*. Rev. ed. New York, 1969.

Gaitskell, Charles. *Children and Their Art*. New York, 1958.

Gaitskell, Charles D., and Margaret R. Gaitskell. *Art Education during Adolescence*. Toronto, 1954.

Hastie, Reid. "Current Opinions concerning Best Practices in Art for the Elementary Schools and for Elementary School Teacher Preparation." In *Research in Art Education*. Fifth Yearbook of the National Art Education Association, edited by Manuel Barkan. Kutztown, Pa., 1954.

Hausman, Jerome J., ed. *Research in Art Education*. Ninth Yearbook of the National Art Education Association. Kutztown, Pa., 1959.

Jones, Barbara A. "Point of View." *Annual Bulletin of the New Jersey Art Education Association* (1964).

Kainz, Luise C., and Olive L. Riley. *Exploring Art*. New York, 1949.

Kellogg, Rhoda. *What Children Scribble and Why*. San Francisco, 1959.

Kepes, Gyorgy. *The New Landscape in Art and Science*. Chicago, 1956.

Kysar, Flossie, Mabel E. Maxcy, and Jennie Roberson. *Young Artists*. Columbus, Oh., 1959.

Langer, Susanne K. *Philosophy in a New Key*. Cambridge, Mass., 1942.

Lanier, Vincent. "Affectation and Art Education." *Art Education* 12, no. 7 (October 1959): 10, 21.

———. "The Status of Current Objectives in Art Education." In *Art and Human Values*. Fourth Yearbook of the National Art Education Association. Kutztown, Pa., 1953.

Lowenfeld, Viktor. *Creative and Mental Growth*. New York, 1947. 2d ed. New York, 1952.

———. "The Adolescence of Art Education." *Art Education* 10, no. 7 (October 1957): 5–12.

Lowenfeld, Viktor, and Kenneth Beittel. "Interdisciplinary Criteria of Creativity in the Arts and Sciences: A Progress Report." In *Research in Art Education*. Ninth Yearbook of the National Art Education Association, edited by Jerome H. Hausman. Kutztown, Pa., 1959.

Mather, Bess Foster. "Camera Clubs for Junior and Senior High Schools." *School Arts* 52, no. 7 (March 1953): 219.

McCracken, Willard. "Artist-Teacher—A Symptom of Growth in Art Education." *Art Education* 12, no. 9 (December 1959): 4–5.

Mead, Margaret. *The School in American Culture*. Cambridge, Mass., 1951.

Moholy-Nagy, Laszlo. *Vision in Motion*. Chicago, 1956.

Munro, Thomas. *Art Education: Its Philosophy and Psychology*. Indianapolis, 1956.

———. "The Arts in General Education. *School Arts* 49, no. 9 (May 1949): 300.

New York City Board of Education. *Art in the Elementary Schools: A Manual for Teachers*. New York, 1952.

Nicholas, Florence W., Mabel B. Trilling, and Margaret M. Lee. *Art for Young America*. Peoria, Ill., 1946.

Powell, Lydia. *The Art Museum Comes to the School*. New York, 1944.

R. S. [Rose Slivka]. *Craft Horizons* 17 (March–April 1957): 47.

Riley, Olive L. *Your Art Heritage*. New York, 1952.

Rockefeller Brothers Fund, Inc. *The Pursuit of Exellence: Education and the Future of America*. New York, 1958.

Rose, Helen Cynthia. "Directions in Junior High School Art Education: A Pilot Study of City Junior High School Art Programs." In *Research in Art Education*. Ninth Yearbook of the National Art Education Association, edited by Jerome J. Hausman. Washington, D.C., 1959.

Schaefer-Simmern, Henry. *The Unfolding of Artistic Activity*. Berkeley, 1948.

Schneider, Dawn E. *Correlated Art*. Scranton, Pa., 1951.

Schultz, Harold A., and J. Harlan Shores. *Art in the Elementary School*. Urbana, Ill., 1948.

Schwartz, Julia. "Senior High School Problems." *School Arts* 56, no. 9 (May 1957): 43.

Snow, C. P. *The Two Cultures and the Scientific Revolution*. Cambridge, Eng., 1959.

Wickiser, Ralph L. *An Introduction to Art Activities*. New York, 1947.

Winebrenner, Kenneth. "Book Choices by 141 Art Educators." *School Arts* 56, no. 2 (October 1956): 27–30.

Witmeyer, Stanley. "The Camera-Man Has a Muse." *School Arts* 50, no. 7 (March 1951): 229.

Ziegfeld, Edwin, ed. *Education and Art: A Symposium*. UNESCO, 1953.

CHAPTER SIX: 1960–1969

Allen, Donald, ed. *The New American Poetry*. New York, 1960.

Anderson, Frances Elisabeth. "Aesthetic Sensitivity, Previous Art Experience, and Participation in the Scholastic Art Awards." *Studies in Art Education* 10, no. 3 (Spring 1969): 4–13.

Anderson, Walt, ed. *The Age of Protest*. Pacific Palisades, Calif., 1969.

Anderson, Yvonne. *Teaching Film Animation to Children*. New York, 1970.

Andrews, Michael. *Creative Printmaking*. Englewood Cliffs, N.J., 1964.

Argiro, Larry. "Mosaic Art." *School Arts* 64, no. 10 (June 1965): 10–14.

Barkan, Manuel. "Curriculum and the Teaching of Art." In *Report of the Commission on Art Education*, edited by Jerome J. Hausman. Washington, D.C., 1965.

———. "Curriculum Problems in Art Education." In *A Seminar in Art Education for Research and Curriculum Development*, edited by Edward L. Mattil. University Park, Pa., 1966.

———. "Transition in Education: Changing Conceptions of Curriculum Content and Teaching." *Art Education* 15, no. 7 (October 1962): 12–18, 27.

Barkan, Manuel, and Laura H. Chapman. *Guidelines for Art Instruction through Television for the Elementary Schools*. Bloomington, Ind., 1967.

Barkan, Manuel, Laura H. Chapman, and Evan J. Kern. *Guidelines: Curriculum Development for Aesthetic Education*. St. Louis, 1970.

Baumgarner, Alice A. D., ed. *Conference on Curriculum and Instruction Development in Art Education: A Project Report*. Washington, D.C., 1967.

Beardsley, Monroe. *Aesthetics: Problems in the Philosophy of Criticism*. New York, 1958.

Beittel, Kenneth R. *Selected Psychological Concepts as Applied to the Teaching of Drawing*. The Pennsylvania State University. U.S.O.E., C.R.P. no. 3149. ERIC document ED 012 804. University Park, Pa., 1966.

Beittel, Kenneth R., Edward L. Mattil et al. "The Effect of a 'Depth' vs. a 'Breadth' Method of Art Instruction at the Ninth Grade Level." *Studies in Art Education* 3, no. 1 (Fall 1961): 75–87.

Berg, Paul. "Twentieth Century Masks." *School Arts* 69, no. 6 (February 1970): 18–19.

Brittain, W. Lambert, ed. *Creativity and Art Education*. Washington, D.C., 1964.

Broudy, Harry S., B. Othanel Smith, and H. Burnett. *Democracy and Excellence in American Secondary Education*. Chicago, 1964.

Bruner, Jerome S. *On Knowing: Essays for the Left Hand*. Cambridge, Mass, 1962.

———. *The Process of Education*. Cambridge, Mass., 1960.

———. *The Relevance of Education*. Edited by Anita Gel. New York, 1971.

———. "The Process of Education Revisited." *Phi Delta Kappan* 52, no. 1 (September 1971): 18–21.

Burkhart, Robert C. *Spontaneous and Deliberate Ways of Learning*. Scranton, Pa., 1962.

Cataldo, John. *Graphic Design and Visual Communication*. Worcester, Mass., 1966.

Chapman, Laura H. "Subject Matter for the Study of Art." *Art Education* 20, no. 2 (February 1967): 20–22.

Clark, Gilbert A. "Beyond the Penn State Seminar: A Critique of Curricula." *Studies in Art Education* 25, no. 4 (Summer 1984): 227.

Cohen, Selma. *The Modern Dance: Seven Statements of Belief*. Middletown, Conn., 1966.

Cole, Natalie. *Children's Art from Deep Down Inside*. New York, 1966.

Collins, Jeremy. "Painting around a Volume," *School Arts* 68, no. 5 (January 1969): 8–9.

Colwell, Richard. *An Approach to Aesthetic Education*. 2 vols. Urbana, Ill., 1970.

Conant, Howard, ed. *Seminar on Elementary and Secondary School Education in the Visual Arts*. New York, 1965.

Conant, James B. *The Education of American Teachers*. New York, 1963.

Davis, Donald Jack. *Behavioral Emphasis in Art Education*. Reston, Va., 1969.

———. "Research in Art Education: An Overview." *Art Education* 24, no. 5 (May 1971): 7–11.

Day, Michael. "The Compatability of Art History with Studio Art Activity in the Junior High School Art Program." *Studies in Art Education* 10, no. 2 (Winter 1969): 56–65.

Dimondstein, Geraldine. "A Proposed Conceptual Framework in the Arts." *Studies in Art Education* 10, no. 2 (Winter 1969): 6–11.

Ecker, David W. *Improving the Teaching of Art Appreciation. Research and Development Team for the Improvement of Teaching Art Appreciation in the Secondary Schools*. Ohio State University Research Foundation. U.S.O.E., ERIC document 011-083. Columbus, Oh., 1966.

Dorn, Charles M. "Editorial." *Art Education* 22, no. 8 (November 1969): 31.

Educational Policies Commission of the National Education Association. "The Role of the Fine Arts in Education." *Art Education* 21, no. 7 (October 1968): 3–7.

Efland, Arthur. "Curriculum Concepts of the Penn State Seminar: An Evaluation in Retrospect." *Studies in Art Education* 26, no. 4 (Summer 1984): 205–211.

Eisner, Elliot W. *Think with Me about Creativity*. Dansville, N.Y., 1964.

———. "American Education and the Future of Art Education." In *Art Education*. Sixty-Fourth Yearbook of the National Society for the Study of Education, Part II, edited by W. Reid Hastie. Chicago, 1965.

———. "Curriculum Making for the Wee Folk." *Studies in Art Education* 9, no. 3 (Spring 1968): 48.

———. "Educational Objectives: Help or Hindrance." *The School Review* 75, no. 3 (Autumn 1967): 250–60.

———. "Graduate Study and the Preparation of Scholars in Art Education." In *Art Education*. Sixty-Fourth Yearbook of the National Society for the Study of Education, Part II, edited by W. Reid Hastie. Chicago, 1965.

———. "Is the Artist in the School Program Effective?" *Art Education* 27, no. 2 (February 1974): 20.

———. "Stanford's Kettering Project." *Art Education* 23, no. 8 (November 1970): 4–7.

———. "The Development of Information and Attitudes towards Art at the Secondary and College Levels." *Studies in Art Education* 8, no. 1 (Autumn 1966): 45–50.

———. "The New Rationality in Art Education: Promise or Pitfall?" *Art Education* 22, no. 2 (February 1969): 6–10.

Eisner, Elliot W., and David W. Ecker, eds. *Readings in Art Education.* Waltham, Mass., 1966.

Foshay, Arthur W. "Changing Goals and Art Education." In *Conference on Curriculum and Instruction Development in Art Education: A Project Report,* edited by Alice A. D. Baumgarner. Washington, D.C., 1967.

———. "How Fare the Disciplines." *Phi Delta Kappan* 51, no. 7 (March 1970): 349–52.

Frankston, Leon. "The Case for Depth in Art: A Reaction against the Kaleidoscopic Effects of the Breadth Approach to Teaching Art at the Secondary School Level." *Art Education* 20, no. 7 (October 1967): 4–9.

Friedman, Ruth. "Tragedy of the Tombs." *School Arts* 65, no. 9 (May 1966): 36–37.

Fuller, Buckminster. "The Condition of the Arts in Contemporary Science and Education." In *Seminar on Elementary and Secondary School Education in the Visual Arts,* edited by Howard Conant. New York, 1965.

Gaitskell, Charles D., and Al Hurwitz. *Children and Their Art.* 2d ed. New York, 1970.

Getzels, Jacob, and Philip W. Jackson. *Creativity and Intelligence.* New York, 1962.

Goodlad, John. *School Curriculum Reform in the United States.* New York, 1964.

———. *School, Curriculum, and the Individual.* Waltham. Mass., 1966.

Greenberg, Pearl. *Children's Experiences in Art: Drawing and Painting.* New York, 1969.

Gronborg, Erik. "The New Generation of Ceramic Artists." *Craft Horizons* 29, no. 1 (January–February 1969): 51.

Guilford, J. P. "Traits of Creativity." In *Creativity and Its Cultivation,* edited by Harold H. Anderson. New York 1959.

Hamilton, Norman K. "Alternatives in Secondary Education." In *Humanizing the Secondary School,* edited by Norman K. Hamilton and J. Galen Saylor. Washington, D.C., 1969.

Harris, Dale. *Children's Drawings as Measures of Intellectual Maturity.* New York, 1963.

Hastie, W. Reid, ed. *Art Education.* The Sixty-Fourth Yearbook of the National Society for the Study of Education, Part II. Chicago, 1965.

Hastie, Reid, and Christian Schmidt. *Encounter with Art.* New York, 1969.

Hastie, Reid, and David Templeton. "Profile of Art in the Secondary Schools—Report of a National Survey." *Art Education* 17, no. 5 (May 1964): 5–9.

Hausman, Jerome J. *The Museum and the Art Teacher.* George Washington University. U.S.O.E., ERIC document 010-443. Washington, D.C., 1966.

———. "Teacher as Artist and Artist as Teacher." *Art Education* 20, no. 4 (April 1967): 13–17.

———, ed. *Report of the Commission on Art Education.* Washington, D.C., 1965.

Hodgson, Godfrey. *America in Our Time.* New York, 1976.

Hoffa, Harlan. *Analysis of Recent Research Conferences in Art Education.* Final Report, Project no. 8-E-093. Bloomington, Ind., 1970.

Holt, John. *How Children Fail.* New York, 1964.

Hoving, Thomas. "Branch Out." *Museum News* 47, no. 1 (September 1968): 15–20.

Hubbard, Guy. *Art in the High School.* Belmont, Calif., 1967.

Hubbard, Guy, and Mary Rouse. *Art: Meaning, Method, and Media.* Westchester, Ill., 1973.

Hurwitz, Al. "Issues Relating to the Curriculum of Senior High School Art Programs." *Art Education* 21, no. 4 (April 1968): 16–19.

Kaelin, Eugene F. "Are 'Behavioral Objectives' Consistent with Social Goals of Aesthetic Education?" *Art Education* 22, no. 8 (November 1969): 4–11.

Kaufman, Irving. *Art and Education in Contemporary Culture.* New York, 1966.

Kellogg, Rhoda. *The Psychology of Children's Art.* New York, 1967.

Kelly, Perry. "Art Education in North Carolina." *Art Education* 20, no. 6 (June 1967): 26–27.

Keniston, Kenneth. "The Sources of Student Dissent." In *The Age of Protest,* edited by Walt Anderson. Pacific Palisades, Calif., 1969.

Kern, Evan J. "The Aesthetic Education Program and Curriculum Reform." *Studies in Art Education* 25, no. 4 (Summer 1984): 234.

Koerner, James. *The Miseducation of American Teachers.* Boston, 1963.

Kohl, Herbert. *36 Children.* New York, 1968.

Kostelanetz, Richard, ed. *The New American Arts.* New York, 1965.

Kozol, Jonathan. *Death at an Early Age.* Boston, 1967.

Krathwohl, David R., Benjamin S. Bloom, and Bertram B. Masia. *Taxonomy of Educational Objectives, Handbook II: Affective Domain.* New York, 1964.

Lally, Ann M., ed. *Art Education in the Secondary School.* Washington, D.C., 1961.

Lanier, Vincent. *Teaching Secondary Art.* Scranton, Pa., 1964.

———. "Talking about Art: An Experimental Course in High School Art Appreciation." *Studies in Art Education* 9, no. 3 (Spring 1967): 32–44.

Lansing, Kenneth M. *Art, Artists, and Art Education.* New York, 1969.

Lark-Horowitz, Betty, Hilda Present Lewis, and Mark Luca. *Understanding Children's Art for Better Teaching.* Columbus, Oh., 1967.

Lewis, Hilda, ed. *Child Art: The Beginnings of Self-Affirmation.* Berkeley, 1966.

Lidstone, John, and Don McIntosh. *Children as Film Makers.* New York, 1970.

Linderman, Earl C., and Donald W. Herberholz. *Developing Artistic and Perceptual Awareness.* 2d ed. Dubuque, Iowa, 1969.

Logan, Frederick M. "Artist in the Schoolroom: A Modern Dilemma." *Studies in Art Education* 1, no. 2 (Spring 1961): 66–84.

———. "The Development of Art Education in the Twentieth Century U.S.A." In *Report of the Commission on Art Education,* edited by Jerome J. Hausman. Washington, D.C., 1965.

Loundes, Douglas. *Film Making in Schools.* New York, 1970.

Madeja, Stanley S. *All the Arts for Every Child: Final Report of the Arts in General Education Project in the School District of University City, Mo.* New York, 1973.

————, ed., *Exemplary Programs in Art Education*. Washington, D.C., 1969.

Madeja, Stanley S., and Sheila Onuska. *Through the Arts to the Aesthetic*. St. Louis, 1973.

Manzella, David. *Educationists and the Evisceration of the Visual Arts*. Scranton, Pa., 1963.

Mattil, Edward L., ed. *A Seminar in Art Education for Research and Curriculum Development*. University Park, Pa., 1966.

McCarthy, Clifford T. "A Printing Experience." *School Arts* 64, no. 1 (September 1964): 8–13.

McFee, June K. *Preparation for Art*. Belmont, Calif., 1961. 2d ed. 1970.

————. "Art for the Economically and Socially Deprived." In *Art Education*. The Sixty-Fourth Yearbook of the National Society for the Study of Education, Part II, edited by W. Reid Hastie. Chicago, 1965.

————. "Poverty and Urban Aesthetics." In "A Report for Urban America, Inc., on the Education of Children and Adults in Aesthetic Awareness of the Environment of Man," edited by Frederick M. Logan. Madison, Wis., 1966. Mimeo.

McWhinnie, Harold. "Fourth Graders Are Printmakers." *School Arts* 60, no. 5 (January 1962): 17–19.

Mendelowitz, Daniel M. *Children Are Artists*. Stanford, Calif., 1963.

Meyer, Leonard B. *Music, the Arts, and Ideas: Patterns and Predictions in Twentieth-Century Culture*. Chicago, 1967.

Michael, John. A. "Women/Men in Leadership Roles in Art Education." *Studies in Art Education* 18, no. 2 (Winter 1977): 9.

————, ed. *Art Education in the Junior High School*. Washington, D.C., 1964.

Miller, Dorothy C., ed. *Americans 1963*. New York, 1963.

Miller, Louis J. "The Social Scene in Collage." *School Arts* 67, no. 8 (April 1968): 18–19.

Miller, Richard I. *Education in a Changing Society*. Washington, D.C., 1963.

Missouri State Board of Education. *The Allied Arts: A High School Humanities Guide for Missouri*. Jefferson City, Mo., 1963.

Montgomery, Chandler. *Art for Teachers of Children*. Columbus, Oh., 1968.

Morris, Robert. "Some Notes on the Phenomenology of Making: The Search for the Motivated." *Artforum* 8, no. 8 (April 1970): 65.

National Education Association. Research Division. *Music and Art in the Public Schools*. Research Monograph 1963-M3. Washington, D.C., 1963.

Newman, Thelma. "College and University Acceptance of High School Art Credits for Admission." *Art Education* 21, no. 7 (October 1968): 31–38.

Packwood, Mary, ed. *Art Education in the Elementary School*. Washington, D.C., 1967.

Panel on Educational Research and Development. *Innovation and Experiment in Education*. Washington, D.C., 1964.

Pattemore, Arnel. *Printmaking Activities for the Classroom*. Worcester, Mass., 1966.

Phillips, McCandlish. "Attention Soars: A New Outlook for Museums." *Museum News* 62, no. 7 (March 1962): 33–37.

Pilarski, Richard. "Introduction to Structure in Design." *School Arts* 61, no. 8 (April 1962): 17–18.

Rainey, Sarita. *Weaving without a Loom*. Worcester, Mass., 1966.

Rasmusen, Henry. *Printing with Monotype*. Philadelphia, 1962.

Rice, E. G., and Betty Rice. "What's on My Mind?" *School Arts* 66, no. 7 (March 1967): 5–11.

Rose, Barbara. *American Art Since 1900*. Rev. ed. New York, 1975.

————. "Problems of Criticism, IV." In *Looking Critically: 21 Years of Artforum Magazine*, edited by Amy Baker Sandback. Ann Arbor, Mich., 1984.

Rueschhoff, Phil H., and M. Evelyn Swartz. *Teaching Art in the Elementary School: Enhancing Visual Perception*. New York, 1969.

Russell, James E. "The Role of the Arts in Education." In *Conference on Curriculum and Instruction Development in Art Education: A Project Report*, edited by Alice A. D. Baumgarner. Washington, D.C., 1967.

Sandback, Amy Baker, ed. *Looking Critically: 21 Years of Artforum Magazine*. Ann Arbor, Mich., 1984.

Schinneller, James A. *Art: Search and Self-Discovery*. Scranton, Pa., 1961. 2d ed. 1968.

Screven, C. G. "The Museum as a Responsive Learning Environment." *Museum News* 47, no. 10 (June 1969): 7–10.

Silverman, Ronald H. "Guest Editorial." *Studies in Art Education* 11, no. 1 (October 1969): 3.

Simmons, Robert Hilton. "The Johnson Collection of Contemporary Crafts." *Craft Horizons* 29, no. 6 (November–December 1969): 66.

Smith, Dido. "A Report on the World of Marshall McLuhan, the Artist and the Electronic Environment." *Craft Horizons* 26, no. 6 (November–December 1966): 42.

Smith, Ralph A. "Aesthetic Criticism: The Method of Aesthetic Education." *Studies in Art Education* 9, no. 3 (Spring 1968): 12–31.

————. "An Exemplar Approach to Aesthetic Education: A Preliminary Report." Urbana, Ill., 1967. Mimeo.

————, ed. *Aesthetics and Criticism in Art Education*. Chicago, 1966.

Sontag, Susan. "Notes on 'Camp'." In *Against Interpretation*. New York, 1966.

————. "One Culture and the New Sensibility." In *Against Interpretation*. New York, 1969.

Stein, Elizabeth. "Pottery Goes Pop." *School Arts* 68, no. 8 (April 1968): 35.

Taba, Hilda. *Curriculum Development: Theory and Practice*. New York, 1962.

Tillim, Sidney. "Figurative Art 1969: Aspects and Prospects." In *Directions 2: Aspects of a New Realism*. Milwaukee, 1969.

University of the State of New York. State Education Department. *Division of the Humanities and the Arts*. Albany, 1970.

Van Meter, Eleria C. "The Developing Federal Government-Museum Relationship." *Museum News* 45, no. 9 (May 1967): 27.

Wachowiak, Frank, and Theodore Ramsay. *Emphasis Art*. Scranton, Pa., 1965.

Walker, John. *Self-Portrait with Donors*. Boston, 1969.

Weitz, Morris. *Problems in Aesthetics*. New York, 1959.

Wilson, Ray R. Jr. "Screen Printing in the Sixth Grade." *School Arts* 60, no. 7 (March 1961): 15–17.

Wilson, William S. "Operational Images." In *Directions 2: Aspects of a New Realism*. Milwaukee, 1969.

Woodruff, Asahel D. "Report of the Conference Evaluator." In *Conference on Curriculum and Instruction Development in Art Education: A Project Report*, edited by Alice A. D. Baumgarner. Washington, D.C., 1967.

DOCTORAL RESEARCH

Sources for this list include *Dissertation Abstracts* (to 1991) and Vincent Lanier's *Doctoral Research in Art Education* (University of Oregon, 1968). Many non-historical studies listed by Lanier would be important in relation to particular historical topics. This list includes a few such dissertations on topics closely related to public school art education in the United States. Mainly because some institutions have not regularly reported all theses to the publishers of *Dissertation Abstracts*, this list may be incomplete.

Baker, David. "Rousseau's Children: An Historical Analysis of the Romantic Paradigm in Art Education." Pennsylvania State University, 1982.

Barrese, Anthony Leonard. "The History and Programs of the New York State Council on the Arts." University of Michigan, 1973.

Belshe, Francis B. "A History of Art Education in the Public Schools of the United States," Yale University, 1946.

Bolin, Paul Erik. "Drawing Interpretation: An Examination of the 1870 Massachusetts 'Act Relating to Free Instruction in Drawing'." University of Oregon, 1986.

Briggs, Robert M. "The Central Theories, Aims, and Outcomes of Art Education as Seen by Frontier Thinkers." Colorado State College, 1957.

Brigham, Don Logan. "Dewey's Concept of Qualitative Thought as a Basis for the Teaching of Art." Boston University, 1984.

Coberly, Zoral H. "History and Trends of Graphic Arts Education." Oregon State College, 1952.

Cohen, Sharon Ginsberg. "Arthur Wesley Dow and Viktor Lowenfeld: Implications for Program Development in Art Education." Temple University, 1982.

Cole, Edgar B. "The College of Fine Arts of Syracuse University 1894–1922." Syracuse University, 1957.

Crump, Beverly Anderson. "An Historical Analysis of the Art Guides and Courses of Study for Art in the Elementary Schools of the United States, 1893–1910." George Washington University, 1967.

Davis, Donald Fred. "Contributions of Four Blacks to Art Education in the South, 1920–1970." Arizona State University, 1983.

Dobbs, Stephen Mark. "The Paradox of Art Education in the Public Schools: A Brief History of Influences." Stanford University, 1972.

Eyestone, June Elizabeth. "The Influence of Swedish Sloyd and Its Interpreters in American Art Education." University of Missouri, 1989.

Gaughan, Jane Murphy. "One Hundred Years of Art Appreciation Education: A Cross Comparison of the Picture-Study Movement with the Discipline-Based Art Education Movement." University of Massachusetts, 1990.

Gordon, Nadine Carol. "A Mechanical Vision: Reproduced Works of Art Used as Instructional Resources in the American Public School System, 1870–1929." Columbia University, 1988.

Grassi, E. V. "The Origin and Development of Aesthetic Education in the American Secondary School Curriculum." Marquette University, 1973.

Green, Harry Beck. "The Introduction of Art as a General Education Subject in American Schools." Stanford University, 1948.

Gross, Sally Lorensen. "American Manuals for Art Instruction in the Public Schools: Progress, Prophecy, and Art for the Millenium." Bryn Mawr College, 1987.

Hook, Dorothy Jean. "Fenollosa and Dow: The Effect of an Eastern and Western Dialogue on American Art Education." Pennsylvania State University, 1987.

Hooks, Richard Leon. "Identifying and Verifying Factors Facilitating Art Education in the Public Schools of Alabama between 1965 and 1978." University of Alabama, 1980.

Johnson, Ted Dean. "History of Art Education at the University of Arkansas at Pine Bluff." University of Oklahoma, 1985.

Johnson, Wallace Nils. "A Past and Present Study of Significant Art Educational Programs as a Foundation for Curriculum Planning Responsive to Contemporary Social Problems." University of Oregon, 1976.

Keel, John S. "The Writings of Sir Herbert Read and Their Curriculum Implications—The Aesthetic Education of Man." University of Wisconsin, 1960.

Kerr, Mary Price. "An Integrative Review of Studies in Methods of Teaching Art Production in the United States of America (1951–1981)." University of Alabama, 1985.

Kerriger, Patricia Ann. "Philosophy of Art in 'Progressive Education': 1919–1940." Loyola University of Chicago, 1973.

Kornfeld, Paul. "The Educational Program of the Federal Art Project." Illinois State University, 1981.

Krasnek, Phyllis D. "Peter Cooper and the Cooper Union for the Advancement of Science and Arts." New York University, 1985.

Lanier, Vincent. "The Status of Current Objectives in Art Education: A Study of the Current Objectives of Public Art Education in Terms of the Values of Art Activities." New York University, 1954.

Leach, Georgia B. "Art Requirements in Teacher Training Programs of Southern Colleges Since 1900." University of Oklahoma, 1962.

Leatherbury, Levin C. "Art Education in the Public Schools of Baltimore, Maryland: A Study of the History, Current Program, and Emerging Emphasis for Future Development." Columbia University, 1956.

Lehmann, Joyce Woefle. "The 'Albright Art School' of the Buffalo Fine Arts Academy: 1887–1954." State University of Buffalo, 1984.

Luca, Mark. "A History of the Educational Practices of the San Francisco Art Museums." University of California, Berkeley, 1956.

Mason, Phillip Lindsay. "Cultural Influences on the Arts and Crafts of Early Black American Artisans (1649–1865) towards Implications for Art Education." Ohio State University, 1983.

McCorkle, Robert H. "Recent American Educational Theories on the Place and Function of the Fine Arts in the Public School Program." University of Texas, 1942.

Michalowski, Elizabeth. "An Inquiry into the Long-Range Effects of Intensive Art Stimulation on a Selected Group of Individuals." Columbia University, 1978.

Mock-Morgan, Mavera Elizabeth. "A Historical Study of the Theories and Methodology of Arthur Wesley Dow and Their Contribution to Teacher-Training in Art Education." University of Maryland, 1976.

Monroe, E. G. "The Teaching of Art in the United States." University of Ottawa, 1958.

Nairne, Grigor, and Angela Geddes. "The One and the Many: Concepts of the Individual and the Collective in Art Education during the Progressive Era in Education, 1920–1960. Concordia University, 1985.

Nateman, David S. "An Historical Examination of the Development and Revision of Art Teacher Education and Certification Standards in Ohio between 1802 and 1974." Ohio State University, 1986.

Oswalt, Howard C. "Process and Product in Art and Education with Special Emphasis on the Philosophy of John Dewey." University of Southern California, 1960.

Palmer, Richard Dean. "A History of the Concept of Imitation in American Art Education." Pennsylvania State University, 1978.

Pellegrini, Helen Marie. "Art Education in the Public Schools of Newark, New Jersey: Historical, Current, and Future Perspectives." Columbia University, 1983.

Pennington, Clement J. "The Beginnings and Development of Craft in the Curriculum of the Public Schools of the U.S. from 1900 to 1930." Pennsylvania State University, 1975.

Peterie, Darl N. "A Study of the Status of Art Education in the Public Secondary Schools of Missouri, 1945–46, 1965–66." University of Missouri, 1966.

Phelan, Andrew L. "Change in the Appearance of Change: A Study of the School of Art and Design of Pratt Institute between 1870 and 1980." New York University, 1986.

Purdue, Peter. "Ideology and Art Education: The Influence of Socialist Thought on Art Education in America between the Years 1890–1960." University of Oregon, 1977.

Rawlins, Karin Elizabeth. "The Educational Metamorphosis of the American Art Museum." Stanford University, 1981.

Rhoades, Jane Ellen. "A History of the Origin and Development of the International Society for Education Through Art: The Edwin Ziegfeld Legacy." Ohio State University, 1987.

Richardson, Jeri Pamela. "The Freedom Quilting Bee Cooperative of Alabama: An Art Education Institution." Indiana University, 1969.

Rios, John F. "History of Art Education in the Secondary Schools of the United States from 1900–1950." University of Texas, 1954.

Roberts, M. C. "Art Education in the United States from 1883 to 1910 as a Reflection of Selected Philosophical and Psychological Thought of the Period." North Texas State University, 1974.

Saunders, Robert. "A Study of the Inter-Relationship between Horace Mann, Mary Peabody, and Elizabeth Peabody, and Its Influence on Art Education in the Public Schools of the United States." Pennsylvania State University, 1961.

Schnee, Alix Sandra. "John Cotton Dana, Edgar Holger Cahill, and Dorothy C. Miller: Three Art Educators (Newark Museum, New Jersey, MOMA, New York, WPA)." Columbia University, 1987.

Sherwood, Leland Harley. "The Federally Sponsored Community Art Centers of Iowa as a Part of the New Deal." Indiana University, 1973.

Shoaff, Susan Mary. "An Analysis of Selected Topics and Participants at National Art Education Association Conferences (1951 through 1980) (Gender, Occupational Background, Topical Categories)." North Texas State University, 1984.

Shuet-Wah Ng, Betty. "The Treatment of Current Curriculum Emphases in Art Education Books, 1964–65." University of California, Berkeley, 1966.

Smith, Peter Joseph. "An Analysis of the Writings of Viktor Lowenfeld: Art Educator in America." Arizona State University, 1983.

Stankiewicz, Mary Ann. "Art Teacher Preparation at Syracuse University: The First Century." Ohio State University, 1979.

Stewart, James Noble. "The Penn State Seminar in Art Education: An Oral History." Florida State University, 1986.

Weber, Joseph Alford. "The Jugendstil and Its Relation to the Development of Child-Centered Art Education." St. Louis University, 1983.

Weiley, Earl A. "Socio-Economic Influences in the Development of American Art Education in the Nineteenth Century." University of Michigan, 1957.

Wieder, Charles G. "An Analysis of Conceptions of Child Art Style, 1940–1960." Stanford University, 1982.

Winkelman, Roy Jay. "Art Education in the Non-Public Schools of Pennsylvania, 1720–1870." Pennsylvania State University, 1990.

Winsand, Orville M. "Art Appreciation in the Public Schools from 1930 to 1960." University of Wisconsin, 1961.

Wygant, Foster L. "A History of the Department of Fine and Industrial Arts of Teachers College, Columbia University." Columbia University, 1959.

Zahner, Mary. "Manuel Barkan: Twentieth-Century Art Educator." Ohio State University, 1987.

⚯ Index ⚯

1820–1899. *See* Nineteenth century

1900–1915
 anthropology, 20
 architecture, 22
 art curriculum, 29–31
 art education, 24–38
 conditions in education, 22–24
 contents of art curriculum, 31–38
 culture and the arts, 20–21
 dance, 21
 film, 21
 ideas about composition, 26–29
 ideas about design, 26–29
 industrial expansion, 19
 intellectual currents, 19–20
 international conferences, 25
 literature, 20
 music, 21
 painting, 21
 professional organizations for art educators, 22, 25
 psychology, 20
 publications for art educators, 25–26
 purposes and issues in art education, 29
 research, 37–28
 social factors, 19
 status of art education, 24–26
 theatre, 21
 visual arts, 22–23

1916–1929
 aesthetics, 45
 architecture, 44
 art curriculum, 51–55
 art education, 47–67
 conditions in education, 45–47
 contents of art curriculum, 56–62
 culture and the arts, 42–44
 dance, 43
 film, 43
 intellectual currents, 41–42
 international conferences, 48
 literature, 42–43
 music, 43
 professional organizations for art educators, 48
 publications for art educators, 48–49
 purposes and issues in art education, 49–51
 research, 64–67
 social factors, 41
 status of art education, 47–49
 theatre, 43–44
 visual arts, 44–45

1930–1945
 aesthetics, 75–76
 architecture, 74
 art curriculum, 82–87
 art education, 77–97
 conditions in education, 76–77
 contents of art curriculum, 87–96
 crafts, 73–74
 culture and the arts, 70–72
 dance, 71–72
 federal arts programs, 70, 76
 film, 72
 industrial design, 74
 intellectual currents, 70
 international conferences, 79
 literature, 70–71
 murals, 73
 museums, 74–75
 music, 71–72
 printmaking, 73
 professional organizations for art educators, 78–79
 publications for art educators, 80–81
 purposes and issues in art education, 81–82
 radio, 72
 research, 97
 sculpture, 73
 social factors, 69–70

status of art education, 77–81
theatre, 71
visual arts, 72–76

1946–1959
 aesthetics, 102–103
 architecture, 105–106
 art curriculum, 119–121
 art education, 111–135
 conditions in education, 109–111
 contents of art curriculum, 121–134
 crafts, 107–108
 culture and the arts, 101–104
 dance, 103
 industrial design, 106–107
 intellectual currents, 100–101
 literature, 101
 museums, 108–109
 music, 102–103
 painting, 104
 printmaking, 105
 professional organizations for art educators,
 112–113
 psychology, 100, 116
 publications for art educators, 113–115
 purposes and issues in art education, 115–119
 research, 134–135
 sculpture, 104–105
 social factors, 99–100
 status of art education, 111–115
 television, 103–104
 theatre, 101–102
 visual arts, 104–109

1960–1969
 architecture, 145–146
 art curriculum, 163–173
 art education, 153–194
 communications media, 142
 conditions in education, 150–153
 contents of art curriculum, 173–190
 crafts, 147–148
 culture and the arts, 139–142
 dance, 141–142
 federal funding of art education, 155–158
 film, 142
 industrial design, 146, 147
 intellectual currents, 138–139
 literature, 139–140
 museums, 148–150
 music, 141
 professional organizations for art educators,
 155

purposes and issues in art education, 159–163
research, 190–193
sculpture, 144–145
social factors, 137–138
status of art education, 153–159
theatre, 140–141
visual arts, 143–150

Abstract Expressionism, 73, 99, 101, 104, 111, 122
Activity curriculum, 47
Aesthetic education, 164–165
Aesthetic Education Curriculum Project, 157
Aesthetic literacy, 133
Aesthetic Movement, 9, 10, 27
Aesthetics
 nineteenth century, 4–5, 13–14, 17
 1916–1929, 45
 1930–1945, 75–76
 1946–1959, 102–103
 1960–1969, 164
Alcott, Bronson, 5, 36
America House, 74, 107
American Abstract Artists, 73
American Color Print Society, 73
American Craftsmen's Cooperative Council, 74
American Craftsmen's Council, 107
American Craftsmen's Educational Council, 74
American Federation of Arts, 22, 25, 48
American Friends Service Committee, 113
American Institute of Architects, 48
American Institute of Instruction, 12
American Luminists, 9
American Scene, 72, 73, 75, 82, 85, 101
American Writers' Congress, 70
Amory Show, 21, 22, 44
Appreciation
 as component of art curriculum
 1900–1915, 29, 36–37
 1916–1929, 62–63
 1930–1945, 95–96
 1946–1959, 132–133
 1960–1969, 188–190
 as subject for research, 190–192
Architecture
 1900–1915, 22
 1916–1929, 44
 1930–1945, 74
 1946–1959, 105–106
 1960–1969, 145–146
Arnheim, Rudolph, 109, 174
Art. *See also* Art curriculum, Art education, Art
 educators
 manual. *See* Manual arts
 search for principles governing, 9

Art curriculum
 late nineteenth century, 13–16
 1900–1915, 29–31
 1916–1929, 51–55
 1930–1945, 82–87
 1946–1959, 119–121
 1960–1969, 163–173
 contents of
 1900–1915, 31–38
 1916–1929, 56–62
 1930–1945, 87–96
 1946–1959, 121–134
 1960–1969, 173–190
Art in daily living, 36–37
Art Deco, 58, 74
Art Education, 13, 25, 113, 158, 189
Art education
 late nineteenth century, 12–18
 1900–1915, 24–38
 1916–1929, 47–67
 1930–1945, 77–97
 1946–1959, 111–135
 1960–1969, 153–194
 change and growth in, in late nineteenth century,
 12, 16–17
 conditions in
 late nineteenth century, 10–12
 1900–1915, 22–24
 1916–1929, 45–47
 1930–1945, 76–77
 1946–1959, 109–111
 1960–1969, 150–153
 contradictions in, in late nineteenth century,
 17–18
 creativity as a goal of, 47, 51, 63, 81, 116, 160
 purposes and issues in
 1900–1915, 29
 1916–1929, 49–51
 1930–1945, 81–82
 1946–1959, 115–119
 1960–1969, 159–163
 research in
 1946–1959, 134–135
 1960–1969, 190–194
 status of
 late nineteenth century, 12–13
 1900–1915, 24–26
 1916–1929, 47–49
 1930–1945, 77–81
 1946–1959, 111–115
 1960–1969, 153–159
Art educators
 international conferences of, 25, 48, 79, 113
 professional organizations for
 late nineteenth century, 12

 1900–1915, 22, 25
 1916–1929, 48
 1930–1945, 78–79
 1946–1959, 112–113
 1960–1969, 155
 publications for
 1900–1915, 25–26
 1916–1929, 48–49
 1930–1945, 80–81
 1946–1959, 113–115
 1960–1969, 158–159
 training of, 12, 16, 23–24, 79
Art and Humanities Branch, 149
Artists' Congress, 72, 73
Artists in the School Program, 155, 162
Art Nouveau, 9, 10, 27, 31
Arts and Crafts Movement, 9, 10, 19, 20, 22, 25, 27,
 31, 33, 36, 44, 49, 107
Arts in Education Program, 155
Arts in General Education Project at University City,
 Missouri, 157, 169
Arts and Humanities Act of 1965, 185
Arts and Humanities Branch, 156
Arts and Humanities Program, 155
Art Union, 9
Art for World Friendship, 112
Ash Can school, 21, 72
Assemblage, 144
Atelier 17 (Stanley Hayter), 73, 105

Bailey, Henry Turner, 25, 35, 48
Barbizon school, 9, 21
Barkan, Manuel, 127–128, 156, 157, 158, 161, 163,
 167, 171
Barnard, Henry, 3, 5, 36
Bartholomew, William, 4
Bauhaus, 27, 44, 91, 127, 128
Beck, Minna McLeod, 60
Behavioral curriculum, 152
Behaviorism, 42, 110, 152
Bell, Clive, 45
Bloom
 Benjamin S., 110, 152, 161, 162, 163, 164, 171
 Kathryn, 149, 150, 155, 157, 160, 169
Boas, Belle, 48, 53, 62
Books, on art
 1930–1945, 75
 1946–1959, 109
 1960–1969, 150
Breadth versus depth, 118, 170–171
Bruner, Jerome, 151, 152, 161, 171
Bureau of Elementary and Secondary Education,
 155

Cage, John, 102, 103, 104, 140, 141
Camp, 139
Cane, Florence, 64, 114
Carnegie Foundation for the Advancement of
 Teaching, 79
Cartooning, as component of art curriculum,
 1930–1945, 93
CEMREL. *See* Central Midwestern Regional
 Educational Laboratory
CEMREL *Guidelines*, 158, 162, 164–165, 168–169,
 188, 191
Central Midwestern Regional Educational Laboratory
 (CEMREL), 155, 157–158, 168–169, 185
Children's School, 20
Child Study Movement, 11, 17, 23, 29, 38, 64
Cinemagraphology, 88
Civil War, conditions of schools before, 1–7
Cizek, Franz, 63, 80
Cold War, 99, 115
Cole, Natalie, 80, 84–85
College Art Association, 48
Collography, 105
Color
 as component of art curriculum, 1916–1930, 56,
 61–62
 in early nineteenth-century school drawing, 4
 in late nineteenth-century school art, 12, 13, 16
 opposition to, in school art in early nineteenth
 century, 6
 use of, in design, 1900–1915, 33
Color-field painting, 143
Commission on Art Education, 160
Committee on Art Education, 112, 113
Committee of Ten, 17, 46
Common School Education, 13
Communication, in late nineteenth century, as means
 of informal education, 8
Communications media
 1960–1969, 142
Composer's Collective, 71
Composition
 in late nineteenth century, 15
 1900–1915, 26–29
Conceptual Art, 139, 145
"Conference on Curriculum and Instructional
 Development in Art Education," 156–157
Connecticut Valley Art and Industrial Teachers'
 Association, 12
Construction, 16, 29
 as component of art curriculum
 1900–1915, 33–34
 1916–1930, 59–60
Correlation
 in art curriculum, 13, 16, 29, 31–32, 52, 59–60,
 62–63, 82–85, 120, 173, 179
Council on Art Education, 161

Council for Basic Education, 110
Council of Supervisors of Manual Arts, 25
Cowley, Malcolm, 63
Cox, George, 49, 58, 62
Craft Horizons, 74, 107, 108, 185
Crafts
 1930–1945, 73–74
 1946–1959, 107–108
 1960–1969, 147–148
 as components of art curriculum
 1916–1929, 58–59
 1930–1945, 94
 1946–1959, 131–132
 1960–1969, 185–188
Craven, Thomas, 75
Creativity, 16, 47, 51, 63, 81, 116, 160
 as goal of education, 42
 in progressive schools of 1920s, 63
 as subject for research, 192–193
CUE project, 170
Cultural Affairs Branch, 139, 149
Cultural uplift, as purpose of art education, 29
Culture and the arts
 1900–1915, 20–21
 1916–1929, 42–44
 1930–1945, 70–72
 1946–1959, 101–104
 1960–1969, 139–142
Curriculum
 art. *See* Art curriculum
 books on
 1960–1969, 153
 movements
 1960–1969, 151–153
 planning. *See* Art curriculum
 research
 1960
 1960–1969, 167–170
 theory
 1916–1930, 46–47
 units, 47

D'Amico, Victor, 78–79, 80, 91, 113–114, 118–119,
 128, 133, 151
Dana, John Cotton, 36, 45, 95
Dance
 1900–1915, 21
 1916–1929, 43
 1930–1945, 71–72
 1946–1959, 103
 1960–1969, 141–142
Davis, Solon P., 12
Decoration, as component of art curriculum, 58
Decorative design, 16, 29, 33
Deep structure, 139
De Garmo, Charles, 49, 58

De Lemos, Pedro, 49, 78, 81
Design
 as component of art curriculum
 1900–1915, 33
 1916–1929, 57–62
 1930–1945, 90–94
 1946–1959, 126–131
 1960–1969, 179–185
Dewey, John, 19, 23, 29, 32, 34, 36, 46, 47, 48, 64,
 75–76, 95, 99, 109, 117
Disciplines approach, 151, 152
Dow, Arthur Wesley, 10, 26–29, 33, 36, 53, 95, 127, 131
Drawing
 as aid in teaching writing, 3
 as aspect of cultural attainment, 2
 as component of art curriculum
 late nineteenth century, 14–15
 1900–1915, 31–33
 1916–1929, 56–57
 1930–1945, 87–88
 1946–1959, 121–124
 1960–1969, 173–175
 industrial. *See* Industrial drawing
 as it relates to occupation, 2
 as language, 3
 in late nineteenth century, 17
 as means of developing appreciation of beauty, 3
 as means of developing perception, 3
 as means of expressing individual thought, 10
 Pestalozzian ideas of, 1–2
 public ideas of, in early nineteenth century, 2
 in public schools, in early nineteenth century, 2–4
 as representational skill, 2
 stages of development in children's, 67
 teaching, 12
Drawing cards, 4–5
Drip-paintings, 122
Dynamic psychology, 42

Early nineteenth century, conditions of schools in,
 1–7
Eastern Arts Association, 25, 48, 78, 135
Eastern Art Teachers' Association, 12
Eastern Manual Training Teachers' Association, 25
Ecker, David W., 159, 163, 191
Education
 art. *See* Art education
 new. *See* New education
 progressive. *See* Progressivism; Progressive
 Education Association; Progressive
 Movement
 scientific, 20, 46, 76
 unchanging public concerns in, in late nineteenth
 century, 12
Educational Policies Commission, 155

Educational Resources Information Center (ERIC),
 153, 155
Eighth International Congress for Drawing and Art
 Applied to Industry, 79
Eight-Year Study, 76, 78, 86, 94
Eisner, Elliot W., 156, 157, 159, 163, 168, 190
Elementary art curriculum
 1900–1915, 29
 1916–1929, 52–54
 1930–1945, 83–86
 1946–1959, 120–121
 1960–1969, 171–172
Elementary and Secondary Education Act of 1965,
 149, 151, 155, 163
Enameling, as component of art curriculum
 1946–1959, 132
 1960–1969, 187–188
Environmental Art, 145
ERIC. *See* Educational Resources Information
 Center
Essentialists, 76, 109
Ethical Culture School, 35, 124
European influences, on early nineteenth-century
 schools, 1–2
Evaluation, as component of art curriculum
 1916–1929, 50–51
 1946–1959, 119–120
Existentialism, 100

Faculty psychology, 1
Farnum, Royal B., 78
Federal Art Project, 76
Federal arts programs, 70, 76, 111, 139
Federal funding of art education, 155–158
Federalist liberalism, 69
Federated Council on Art Education, 48, 78
Fenollosa, Earnest, 27
Film
 1900–1915, 21
 1916–1929, 43
 1930–1945, 72
 1960–1969, 142
Film making, as component of art curriculum
 1960–1969, 177
First World Congress of Craftsmen, 147
Form study
 in late nineteenth century, 15, 17
 1900–1915, 31
Forum Show, 44
Foshay, Arthur, 151, 156, 157
Fowle, William Bentley, 2, 5
Frank, Waldo, 43, 44
Froebel, Friederich, 10
Fuller, Buckminster, 138–139
Fund for the Advancement of Education, 152

Gary system, 23
Gemini GEL, 145
General Education Board, 74, 75, 92, 96
Gestalt, 42, 100, 110, 116, 173–174

Haldane, J. B. S., 42
Hall, G. Stanley, 11, 20
Hamilton, George, 2
Happenings, 139, 140, 144
Hard Edge, 143
Harris, William T., 13, 17, 36
Hayter, Stanley William, 73, 105
Hellenists, 9
Herbart, Johann Friedrich, 10, 23
Hine, Lewis W., 35, 124
Hoffa, Harlan, 157, 188
Horace Mann School, 36, 53
Hubbard
 Elbert, 10
 Guy, 159, 169–170, 177, 183
Hubbard-Rouse Art Curriculum, 169–170
Humanizing the school, 152–153

Impressionism, 9
Industrial arts, as component of elementary art
 curriculum
 1916–1929, 53
Industrial design
 1916–1929, 44
 1930–1945, 74–75
 1946–1959, 106–107
 1960–1969, 146–147
Industrial Designers Society of America, 106, 146
Industrial drawing
 in early nineteenth century, 6–7
 era of, 6–7
 Smith's promotion of, 6
Industrial education, as component of art curriculum
 1900–1915, 34–35
 1916–1929, 53–54
Inland Educator, 13
INSEA. *See* International Society for Education
 Through Art
Installations, 144–145
Institute for Advanced Study in Aesthetic Education,
 182
Institute for International Education, 113
Institute for the Study of Art Education, 79
Intellectual currents
 1900–1915, 19–20
 1916–1929, 41–42
 1930–1945, 70
 1946–1959, 100–101
 1960–1969, 138–139

International conferences of art educators
 1900–1915, 25
 1916–1929, 48
 1930–1945, 79
International Council of Societies of Industrial
 Design, 146
International Federation for Art Education, 25, 113
International Society for Education Through Art, 113,
 155
International Style, 44, 74, 105

James, William, 8, 19
Japanese art and design, 9, 10, 27
JDR 3rd Fund, 155, 157, 169, 170
Jewelry making, as component of art curriculum
 1946–1959, 132
 1960–1969, 187–188

Kaufman, Irving, 159
Kilpatrick, William H., 42, 47, 76, 81, 109, 162
Krusi, Hermann, 10

Laboratory School, 5, 23, 34, 54
Language, drawing as a kind of, 3
Lanier, Vincent, 119, 159, 165, 177
Lindsay, Vachel, 21
Literature
 1900–1915, 20
 1916–1929, 42–43
 1930–1945, 70–71
 1946–1959, 101
 1960–1969, 139–140
Locke, Josephine, 16
Logan, Frederick, 161
London Congress (1908), 63
Lowenfeld, Viktor, 80, 97, 111, 113–114, 116, 117,
 119, 120, 131, 134, 158
Luminists, 9

McFee, June, 160, 166, 174, 177, 183, 184, 185
McLuhan, Marshall, 139, 142, 147
Mann, Horace, 3, 5, 36
Manual arts, in late nineteenth century, 11
Mathias, Margaret, 48, 52, 53, 56
Media, exploration of, in late nineteenth century,
 15–16
Meier, N. C., 65
Mental Hygiene Movement, 20
Milton Bradley, Inc., 13, 15, 16
Mimimalism, 144
Modeling, in late nineteenth century, 17
Moral education, as purpose of art education, 29

Moral values, of school art in early nineteenth
 century, 4–5
Morris, William, 10
Mumford, Lewis, 75
Munro, Thomas, 48–49, 116
Murals, 73, 89, 124
Museums
 1900–1915, 22
 1916–1929, 45
 1930–1945, 74–75
 1946–1959, 108–109
 1960–1969, 148–150
Music
 1900–1915, 21
 1916–1929, 43
 1930–1945, 71
 1946–1959, 102–103
 1960–1969, 141

National Art Education Association, 78, 112, 115, 117,
 134, 155, 156, 158, 160
National Assessment of Education Progress, 152
National Association for Art Education, 78
National Committee on Art Education, 78–79
National Council on the Arts, 142
National Defense Education Act, 110–111
National Education Association, 12, 17, 19, 23, 25, 45,
 48, 76, 78, 81, 150, 153, 167, 186
National Endowment for the Arts, 155, 156, 162
National Foundation on the Arts and Humanities, 139
Nationalism, during the period from 1930–1945, 69
National Science Foundation, 110
National Serigraphic Society, 73
National Society for the Study of Education, 81
National Theater Conference, 71
Naumburg, Margaret, 20, 63, 64, 99, 114, 117
Neo-neo-classicism, in architecture, 106
New Dance League, 72
New education, 10–11, 17, 22, 29
New Education Fellowship, 79
New formalism, in architecture, 106
Nineteenth century
 aesthetic study in late, 17
 art curriculum in late, 13–16
 change and growth in art education in late, 12
 composition, as new topic in art education in late, 15
 conditions in education in late, 10–12
 conditions of schools in early, 1–7
 cultural conditions in late, 7–9
 drawing in, 14–15, 17
 exploration of media in, 15–16
 form study in, 14–15, 17
 manual arts in late, 11
 modeling in late, 17
 pictorial study in late, 17

 publications relating to school art in late, 12
 social conditions in late, 7–9
 unchanging public concerns in education in late, 12
 visual arts in late, 9–10
Normal Instructor, 13
Norton, Charles Eliot, 9
Notan, 27, 56, 88

Object study, Pestalozzian ideas of, 2
Object teaching, 10
Op Art, 143
Oswego Movement, 10, 13, 36
Owatonna Project, 79–80, 82, 92, 131, 185

Pacific Arts Association, 48
Painting
 as component of art curriculum
 1916–1929, 56–57
 1930–1945, 87–88
 1946–1959, 121–124
 1960–1969, 173–175
Panel on Educational Research and Development, 162
Parker, Francis W., 11, 23, 29, 31, 52, 82, 116
Parkhurst, Helen, 46
Peabody, Elizabeth, 5
Peale, Rembrandt, 2–3, 5
Perception
 drawing as means of developing, 3
 as issue in art education, 116–117, 158, 173, 175,
 180
Perennialism, 77, 109
Perry Magazine, 13, 22
Perry Picture Company, 13, 36
Personalist theory, 109
Pestalozzi, Johann Heinrich, 1–2
Pestalozzian ideas, 1–2, 10
Photography
 as component of art curriculum
 1900–1915, 35
 1930–1945, 89–90
 1946–1959, 124–125
 1960–1969, 177
Picture study, 17, 96
 in art curriculum, in late nineteenth century,
 13–14
 as component of appreciation,
 1900–1915, 36
 1916–1929, 62
Platoon system, 23
Pluralism, during the period from 1930–1945, 69
Pointillism, 122
Pop Art, 143
Post-Impressionism, 9
Post-painterly Abstraction, 143

Pragmatism, in late nineteenth century, 8
Pragmatist theory, 109
Prang Educational Company, 13, 15, 16
Prang publications, 16–17, 25. *See also* Prang
 Educational Company
Pre-Raphaelites, 9, 21
Primary Education, 13
Printmaking
 1916–1929, 44
 1930–1945, 73
 1946–1959, 105
 1960–1969, 145
 as component of art curriculum
 1930–1945, 88–89
 1946–1959, 124
 1960–1969, 175–177
Process versus product, 118
Professional organizations of art educators, 12, 25, 48,
 112–113, 155
Progressive Education Association, 46, 76, 79, 80,
 110
Progressive Education Movement, 45, 47
Progressive Movement, 19, 23, 36
Progressivism, 63–64, 76, 81, 109
Project method, 47
Projects to Advance Creativity in Education, 155
Prussion system, 1
Psychology
 late nineteenth century, 8
 1900–1915, 20
 1916–1929, 42
 1946–1959, 110, 115
 1960–1969, 152, 173–174
 educational, 23
 faculty, 1
Publications for art educators
 late nineteenth century, 12
 1900–1915, 22, 25–26
 1916–1929, 48–49
 1930–1945, 80–81
 1946–1959, 113–115
 1960–1969, 158–159

Radio, 1930–1945, 72
Read, Herbert, 75, 80, 97, 116, 164
Regionalism, during the period from 1930–1945,
 69
Related arts, as components of art curriculum
 1930–1945, 94–95
 1946–1959, 133–134
 1960–1969, 164
Representation, 16, 29, 31–33
Research
 in art education
 1900–1915, 37–38

 1916–1929, 64–67
 1930–1945, 97
 1946–1959, 134–135
 1960–1969, 190–194
 curriculum, 167–170
Ross, Denman Waldo, 27, 33, 62
Rouse, Mary, 169–170
Rugg, Harold, 63, 76
Ruskin, John, 9, 31
Russell Sage Foundation, 73

Sargent, Walter, 38, 48, 119
Schinneller, James, 159, 183
School art
 aesthetic values of, in early nineteenth century,
 4–5
 beginnings of, in early nineteenth century, 2–5
 correlation of, with other cultures, 16
 moral values of, in early nineteenth century, 4–5
 in relation to manual training, 26
School Art League, 36
School Arts, 25, 49, 81, 87–88, 94, 113, 119, 183, 189
School Arts Magazine. See School Arts
Scientific education, 20, 46, 76
Scientific method, in late nineteenth century, 8
Scientific teaching, 10
Sculpture
 1900–1915, 21–22
 1930–1945, 73
 1946–1959, 104–105
 1960–1969, 144
 as component of art curriculum
 1930–1945, 90
 1946–1959, 125–126
 1960–1969, 177–179
SEARCH, 170
Secessionists, 9, 27, 44, 63
Secondary art curriculum
 1900–1915, 29–31
 1916–1929, 54–55
 1930–1945, 86–87
 1946–1959, 121
 1960–1969, 172–173
Self-contained classroom, 117
Self-culture, 8–9, 13, 36
"Seminar in Art Education for Research and
 Curriculum Development," 156
"Seminar on Elementary and Secondary School
 Education in the Visual Arts," 155–156
Seven Cardinal Principles, 45–46, 49, 51, 54, 55, 76,
 81
Seven guideposts to good design, 106–107
Sheldon, Edward, 10
Sherrington, Charles, 42
Silk Screen Group, 73

Smith
 Ralph A., 159, 160, 164, 185, 192
 Walter, 6–7
Smith-Hughes Act (1917), 46, 131
Snow, C. P., 101, 159
Social Realism, 72
Society of American Etchers, 73
Society of American Graphic Artists, 105
Society of Industrial Designers, 106
Southern Art Teachers' Association, 12
Southern Educational Association, 12
Southern Highlands Handicraft Guild, 73
Standardization, as condition of education from
 1900–1915, 23
Stanford-Kettering Project, 168
Stickley, Gustave, 10
Stieglitz, Alfred, 21, 44
Structural functionalism, 100
Structuralism, 139
Studies in Art Education, 158
Surrealism, 73
Symbolism, 122
Synthetic approach to art and design, in late
 nineteenth century, 9

Tamarind, 105, 145
Tamiris, Helen, 72
Teachers, training of, 12, 16, 23–24, 79
Teachers College, Columbia University, 17, 26, 27, 36,
 44, 46, 53, 80, 84
Television, 103–104
Terman, Lewis, 20
Theatre
 1900–1915, 21
 1916–1929, 43–44
 1930–1945, 71
 1946–1959, 101–102
 1960–1969, 140–141
Theatre of the absurd, 102
Thorndike, Edward L., 20, 23, 29, 38, 47, 51–55, 65
Todd, Jessie, 65, 87
Travel, in late nineteenth century, as means of
 informal education, 8
"TV Guidelines," 167–168, 191

U.S. Office of Education, 65, 67
Unionism, during the period from 1930–1945, 69
Universal Limited Art Editions, 145
University City Project, 157, 169

Vienna Art Congress, 79
Visual arts
 in late nineteenth century, 9–10
 1900–1915, 22–23
 1916–1929, 44–45
 1930–1945, 72–76
 1946–1959, 104–105
 1960–1969, 143–150

Walden School, 114
Washburn, Carleton, 46
Western Arts Association, 135
Western Drawing and Manual Training Association,
 25, 48
Western Drawing Teachers' Association, 12, 25
Whitford, William G., 48, 52, 54, 65
Winslow, Leon Loyal, 48, 49, 58, 62, 63
Woodruff, Asahel D., 157, 162, 163
Workbooks, instructional, 4, 26, 49
Wundt, William, 8

Ziegfeld, Edwin, 80, 131